THE LAST
WITCH CRAZE

THE LAST WITCH CRAZE

JOHN AUBREY, THE ROYAL SOCIETY AND THE WITCHES

TONY McALEAVY

AMBERLEY

For Chris

First published 2022

Amberley Publishing
The Hill, Stroud
Gloucestershire, GL5 4EP

www.amberley-books.com

Copyright © Tony McAleavy, 2022

The right of Tony McAleavy to be identified
as the Author of this work has been asserted
in accordance with the Copyright, Designs and
Patents Act 1988.

ISBN 978 1 4456 9842 7 (hardback)
ISBN 978 1 4456 9843 4 (ebook)

British Library Cataloguing in Publication Data.
A catalogue record for this book is available
from the British Library.

1 2 3 4 5 6 7 8 9 10

Typesetting by SJmagic DESIGN SERVICES,
India. Printed in the UK.

CONTENTS

Introduction

THE SCIENCE OF THE SATANIC AND THE LAST WITCH CRAZE

The seventeenth-century antiquarian and biographer John Aubrey believed in the reality of witchcraft. Among his papers at Oxford's Bodleian Library, a fragmentary handwritten note survives in which he listed the characteristic evil deeds of witches: raising tempests, wrecking ships, harming young children through illness, making men impotent and forcing women to miscarry.[1] Aubrey felt threatened by witchcraft. He believed that he was by nature someone who was easily attacked by malevolent magic. In the seventeenth century, the word *fascination* was a synonym for witchcraft or enchantment. The English word was derived from the Latin term for witchcraft, *fascinum*. As an adult, Aubrey looked back to his own childhood and stated that, from his youth, he was 'mightily susceptible of Fascination'.[2]

Aubrey's beliefs were part of a wider framework of ideas about the spirit dimension and the supernatural. Like many of his contemporaries, he believed that the universe could not simply be explained in terms of matter and mechanics. There was also an invisible world of angels and demons. This spirit world interacted with humanity. Houses could be haunted by evil spirits. Angels sent messages of warning through dreams and waking premonitions. Crystal ball magic could be used by humans wishing to communicate with spirits. Aubrey documented these phenomena in the only book he published in his lifetime, *Miscellanies*, released in 1696.

One of Aubrey's lifelong friends was his Wiltshire neighbour, Sir James Long, who in 1683 wrote to Aubrey of his intention to

write a book about an outbreak of witchcraft in the Wiltshire town of Malmesbury. His plan was to tell the story of a witchcraft trial that had taken place in 1672 and led to the execution of two local women, Judith Witchell and Anne Tilling. There is no evidence at all that either man had any concerns about the legitimacy of the judicial killings; both men believed in the authenticity of witchcraft. Indeed, Long's intention in his proposed book was to show that witchcraft was a scientific reality. Witchell and Tilling were witches, thought Long, and the correct punishment for the felony of witchcraft was death.

Long and Aubrey were both proud Fellows of the Royal Society, the pioneering organisation dedicated to the promotion of experimental science. Long saw nothing inconsistent about his position as both a member of the Royal Society and the author of a book advocating belief in witchcraft. On the contrary, he considered his proposed empirical study of witchcraft in Wiltshire to be a good example of the new science of the seventeenth century. For Long, scientific thinking was in no way opposed to belief in witchcraft. In his letter to Aubrey, he explained that he intended to dedicate the book to the President of the Royal Society. He suggested that Aubrey might like to act as his representative and formally present the book to the Society in London. Long took it for granted that Aubrey would be perfectly happy to be associated with the work.

Aubrey and Long were not the only Fellows of the Royal Society in the seventeenth century who believed in witchcraft. Several other early members of the Society publicly promoted the notion that it was very much real, among them Robert Boyle, Henry More, Joseph Glanvill, Robert Plot, Anthony Horneck and Elias Ashmole. This book tells the story of these men, who combined their convictions about witchcraft with a wholehearted commitment to the new experimental science.

Witchcraft, the Restoration and the Royal Society

The establishment of the Royal Society of London came on the heels of the Restoration in 1660, when Charles II returned from exile to begin his reign as king. This is sometimes seen as a time when the persecution of witches in England was in decline, but the truth is not so simple. Although most witchcraft trials after the Restoration resulted in acquittal, there were executions for witchcraft across England between 1660 and 1682, following trials held in Bury

St Edmunds, Lancaster, Salisbury, Northampton, Chester and Exeter. The last undoubted hanging of women for witchcraft in England took place at Exeter in 1682, when three women from the Devon town of Bideford were put to death. The final phase of the lethal persecution of witches would last even longer in Scotland and the colonies of New England in North America.

The Royal Society met for the first time on 28 November 1660 and was granted a royal charter by Charles II on 15 July 1662. It is sometimes assumed that the Royal Society set out from its inception to challenge belief in the supernatural, replacing superstitious ideas with more rational, modern thinking. This was not the case. The Royal Society formally ignored the supernatural in its deliberations and publications, allowing Fellows freedom to pursue their own thinking about this contentious topic in a private capacity. While there was no official Royal Society 'line' on witchcraft, the single most distinguished founding member, Robert Boyle, was indisputably a believer in witchcraft. At the same time, there was a range of opinions; many of the Fellows were enthusiastic believers in the supernatural, while some were sceptics.

A few Fellows of the Royal Society were particularly assiduous and energetic in their defence of belief in witchcraft. They included Henry More and Joseph Glanvill, who wrote influential books on the subject. More and Glanvill were interested in the development of a science of the supernatural, comparable to the experimentally based science of the material world that the Royal Society officially endorsed.

Henry More and Anne Bodenham, the witch of Salisbury

Dr Henry More of Christ's College, Cambridge University, was one of the leading English philosophers of the seventeenth century. Intrigued by witchcraft throughout his life, as a young academic he visited the county gaol in Cambridge to interview a woman called Goodwife Lendall who was accused of witchcraft as part of the Matthew Hopkins witch hunt. She was later hanged, and More had no doubt about her guilt. In 1653 he published a landmark book, *An Antidote against Atheism*, which sought to provide readers with hard evidence about the reality of witchcraft, using instances from England and the rest of Europe. More also set out principles that could be used to test the veracity of accusations of witchcraft.

In the same year that his book was published, More heard news of the trial and execution for witchcraft of Anne Bodenham in Salisbury. More studied the case closely, discussed it with people who had attended the trial, and became completely convinced of Bodenham's guilt. In 1655 he issued a new edition of *An Antidote against Atheism*, giving great prominence to the story of Anne Bodenham as an instance of genuine witchcraft. For More, Bodenham's manifest guilt was the definitive proof of witchcraft that the country needed.

An Antidote against Atheism caused a great stir. As the title suggests, the book was more than an attempt to prove the reality of witchcraft; it was also an attack on 'atheism'. There is no evidence that any educated people in the seventeenth century genuinely rejected the existence of God, but there was a widespread fear that questioning different aspects of religion would eventually lead to full-blown atheism. More was alarmed by this threat, and he saw the proof of witchcraft as a powerful counter to it. His logic was that if one could prove the reality of human interaction with the Devil through witchcraft then proof of the existence of God followed automatically. More, and many of his contemporaries, had a term of abuse for those suspected of atheist tendencies; they called them 'Sadducees', after a Jewish sect from the time of Christ which did not believe in physical resurrection. For More, the defence of the truth of witchcraft was an attack on the Sadducees.

Robert Boyle and The Devil of Mascon

The greatest luminary of the early Royal Society was the scientist Robert Boyle. He was also a believer in witchcraft and the power of magic. Like More, he publicly demonstrated his belief in witches before the founding of the Royal Society and maintained these views throughout his life. During the 1650s, Boyle shared More's concern about the dangerous, atheistic views of the Sadducees. Like More, he saw the proof of witchcraft as a useful weapon in the fight against those who questioned tenets of Christian belief. For this reason, in 1658 Boyle arranged the translation and publication of a book titled *The Devil of Mascon*, based on a French original. The treatise told the story of what we would today call a poltergeist. The devil in question was a spirit that had haunted a bewitched house in the town of Mâcon in Burgundy earlier in the century.

Boyle was particularly impressed by the story from France because he considered the standard of proof of authentic supernatural activity

in this case to be unusually high. Mâcon, at the time of the events, was a divided town, occupied by both Protestants and Catholics. Credible witnesses from both communities attested to the reality of the demonic infestation of the house. *The Devil of Mascon* remained, for the rest of the seventeenth century, a key text for those wishing to prove the truth of witchcraft.

More and Boyle saw the contemporary philosopher Thomas Hobbes as the chief advocate of atheism, the leader of the Sadducees, and a dangerous enemy of Christianity. While Hobbes denied vehemently the charge of atheism, it is true that he did not believe that the world possessed a supernatural dimension. For Hobbes, there were no evil spirits. Stories of magic, haunted houses and premonitions were nonsense. Those who imagined themselves to be witches were deluded. Curiously, given their diametrically opposed views about the supernatural, Thomas Hobbes and John Aubrey were great friends. Aubrey had met Hobbes as a child and later came to admire the intellectual daring of the older man.

Joseph Glanvill and the Drummer of Tedworth

One Fellow of the Royal Society was particularly dedicated to reconciling modern science with belief in witchcraft: Joseph Glanvill, Rector of Bath Abbey. To the modern eye, Glanvill appears to be a man of profound contradictions. He promoted both the case for experimental science and belief in the reality of witchcraft. He was known for insisting on the need for strong evidence for claims of scientific truth while he also ridiculed those who denied the existence of evil spirits. Much like some other members of the Society, Glanvill saw no inconsistency between his commitment to the new science and his defence of the reality of witchcraft.

Glanvill was a prolific writer. In a series of philosophical treatises, written during the 1660s, he described the problem of achieving certainty about knowledge and advocated, as the solution, the experimental science of the Royal Society. He argued against the dangers of overconfident 'dogmatising' based on weak evidence. The correct response to any truth claims should, he wrote, be one of caution, challenge and the pursuit of confirmatory empirical data. Glanvill was rewarded for his unofficial promotional campaign on behalf of the Royal Society by being elected to a Fellowship of the Society. In 1666 he published *A Philosophical Endeavour towards the*

Defence of the being of Witches and Apparitions. This book explicitly sought to establish a scientific justification for belief in witchcraft. On the title page, Glanvill proudly described himself as 'a member of the Royal Society'.

In 1668 Glanvill issued a new edition of his witchcraft book, renaming it *A Blow at Modern Sadducism.* In addition to the name change, the book was different to its predecessor because it contained new empirical data, intended to convince readers of the truth of witchcraft. The key real-world case study was an account of a poltergeist which had recently infested a bewitched house in Wiltshire.

Glanvill gave the Wiltshire poltergeist a name. He called it the Drummer of Tedworth because the evil spirit annoyed people with incessant drumming and haunted a house in the Wiltshire village of Tedworth, known today as Tidworth. Glanvill's Drummer of Tedworth was very similar to Boyle's Devil of Mascon. Both poltergeists could communicate with human observers and both haunted bewitched houses. These demons were intelligent, communicative and mischievous. In each case, trustworthy witnesses testified to the reality of the phenomenon. There was, of course, one important difference between the two demons: the Drummer of Tedworth was English, while the Devil of Mascon was French. Glanvill's mission was to persuade educated people in England that witchcraft was a reality, and it was immensely helpful for him to have powerful evidence of a home-grown demon which had been unleashed by witchcraft.

The science of witchcraft

Aubrey described supernatural events but rarely attempted to explain them. More and Glanvill were different. They were interested in the scientific processes that gave witches power to harm others. The challenge for them was to explain witchcraft in ways that were consistent with the laws of nature. Both men were convinced by accounts, found in the European literature of demonology, that the spirits of witches could fly about while leaving their physical bodies at home in a state of suspended animation. Witches used this power either to attend sabbat meetings or to make spectral visits to the homes of their victims. Spectral travel and the separability of spirit and body were particularly important to Henry More because, if proven, these phenomena could be used to show that Thomas Hobbes was wrong when he claimed that there was no immaterial soul inhabiting the human body.

Stories suggesting that witches could have sex with demons were a serious matter to More. He made use of a medieval idea, articulated by Thomas of Aquinas, that spirits, such as angels or demons, could create temporary bodies for themselves made of 'condensed air'. The nature of air and air pressure were, of course, topics of considerable scientific interest in the mid-seventeenth century. Tales of demonic sex often described the coldness of the Devil's touch, which made sense, said More, if the Devil's body was made from air that was both condensed and frozen. He even suggested that male demons could impregnate female witches, linking this speculation to the leading-edge embryological research of his contemporary, William Harvey.

Glanvill developed the science of witchcraft further. He pondered the repeated references in cases of witchcraft to a companion demon or 'familiar' and the way that familiars were said to suck on a special mark or teat on the witch's body. What, he wondered, was the scientific function underlying these phenomena? During this period, pioneering medical experts were investigating the idea that diseases were sometimes the result of a ferment in the blood. This view had been explored by Thomas Willis in his ground-breaking study of ferments and disease. Based in Oxford in the 1650s, Willis had collaborated with Boyle on the study of fermentation. Building on these new ideas, Glanvill concluded that familiars almost certainly infected witches with a toxic ferment through the process of 'sucking' on the teat or mark. The poisonous ferment corrupted the mind of the witch, giving her a malevolent power which she could transmit by gazing at victims and sending out rays of invisible, toxic particles.

Responding to the work of John Webster

In 1677 John Webster, a doctor from Clitheroe in Lancashire, published a highly sceptical book, *The Displaying of Supposed Witchcraft*, which included an extensive, hostile critique of the witchcraft science of More and Glanvill. Webster was not a member of the Royal Society but somehow managed to get one of its vice-presidents, Sir Jonas Moore, to approve the work. It seems that this was a personal favour on the part of Moore and did not in any way represent official approval by the Society.

Webster was very rude about Glanvill and More in his text but respectful in the way he referred to Boyle. However, he politely

suggested that Boyle was wrong to think that *The Devil of Mascon* was proof of the existence of witchcraft and evil spirits. He stated that many aspects of the story were 'contradictory or inconsistent'.[3] Incensed by this, Glanvill decided to answer every one of Webster's many criticisms. He immediately began work on a new edition of his own witchcraft book with this purpose in mind. He asked others for help. He corresponded with Robert Boyle to check that the great scientist had not changed his mind about witchcraft and the story of the French poltergeist. Boyle wrote back reassuring Glanvill that he remained convinced about witchcraft and the truth of *The Devil of Mascon*. He expressed support for Glanvill's scientific witchcraft investigations.

Glanvill sought more real-world instances of proven witchcraft. A Somerset friend, Robert Hunt, provided Glanvill with access to his notebook of interviews from a major witchcraft investigation conducted in that county in 1665, and Glanvill began writing several extra chapters for his book based on this material. He also decided to include fresh evidence from recent witch trials in Sweden. Another friend, and Fellow of the Royal Society, Anthony Horneck obligingly translated from German a pamphlet telling dramatic stories about Swedish witchcraft events. The pamphlet focussed on a trial in 1669 that resulted in a mass execution of 'witches', following the allegations of scores of hysterical local children. The children claimed that the witches transported them magically to an island called Blockula where they feasted with the Devil. Horneck, a well-known London preacher, found the news from Sweden entirely convincing. He translated the work into English, providing an introductory essay which endorsed the truth of the narrative and referenced the witchcraft science of Glanvill and More.

Glanvill did not live to see the final, greatly expanded edition of his work on witchcraft. He died before publication. His friend and mentor Henry More continued the work, editing the draft and adding further material of his own. The resulting book, *Saducismus Triumphatus* (meaning 'Sadducism triumphed over'), appeared in 1681. The publication of this substantial text represents the high-water mark of the project to reconcile witchcraft belief with modern science.

Influence and imitation

It is difficult to underestimate the significance of the fact that Boyle, the most brilliant scientist of his generation, endorsed the authenticity of witchcraft. Many people were also impressed by the confident,

empirically based witchcraft science of Glanvill and More, which culminated in the publication of *Saducismus Triumphatus*.

The readership of these works crossed the religious divide in Restoration England between conformist Anglicans and the Nonconformists, who advocated a more Puritan version of Protestantism. Boyle, More and Glanvill were Anglicans, but the greatest Nonconformist theologian of the period, Richard Baxter, admired their work. Influenced by the work of the other men, Baxter published his own defence of witchcraft, *The Certainty of the Worlds of Spirits*, in 1691. In it, he suggested that anyone with doubts about witchcraft needed to reflect upon the Devil of Mascon. The Mâcon poltergeist was for Baxter 'that most convincing Instance' of the reality of witchcraft, and the certainty of the case was greatly strengthened by the way that Boyle had personally verified its 'undoubted Truth'.[4]

The popularity of the key witchcraft texts associated with Boyle, More and Glanvill inspired others. Several learned witchcraft tracts appeared after the Restoration, often with flattering tributes to the three men. A Hertfordshire medical practitioner called William Drage was a great admirer of More's witchcraft science. In 1665 he published textbook for doctors intended to help them identify and treat illnesses caused by witchcraft. It is full of references to More's *An Antidote against Atheism*. In keeping with the investigative spirit of the age, Drage was keen to add his own empirical case study to the growing scholarly knowledge base relating to witchcraft. He provided a very detailed account of the symptoms displayed by a Hertfordshire girl called Mary Hall who was, he claimed, possessed by a demon as a result of being bewitched.

The early Royal Society had good connections with the intellectual world in Scotland. One Scottish scientist called George Sinclair was extremely enthusiastic about both experimental science and the promotion of the truth of witchcraft. Sinclair visited London in 1662 and met Robert Boyle. He had read about the French and English poltergeist phenomena highlighted by Boyle and Glanvill, and he wished to publicise an equivalent Scottish case. In 1672 Sinclair published a study of the science of atmospheric pressure and appended, without any apparent sense of incongruity, the story of the Devil of Glenluce. This was an account of supernatural events at Glenluce in south-west Scotland. A house had been possessed by an aggressive demon due to the witchcraft of a local beggar. To Sinclair's delight,

Henry More proceeded to incorporate the account of the Glenluce poltergeist, word for word, in his definitive guide to the science of witchcraft, *Saducismus Triumphatus*.

Inspired by the success of *Saducismus Triumphatus*, Sinclair decided to produce a very similar book of his own. In 1685 he published *Satan's Invisible World Discovered*, a work entirely dedicated to the presentation of verified accounts of witchcraft and the supernatural. This was a collection of stories from Glanvill and More, supplemented by other accounts of the supernatural from Scotland. Sinclair's book was more 'reader friendly' than *Saducismus Triumphatus*, concentrating on interesting stories without the theoretical framework provided in the work of Glanvill and More.

Salem and the science of the satanic

In the years before the famous 1692 witchcraft trials in Salem, Massachusetts, the English and Scottish scientific literature of the supernatural was influential across the Atlantic in New England. The intellectual and religious world of colonial Massachusetts was shaped and dominated by two Boston-based clergymen, Increase Mather and his son, Cotton Mather. They vigorously promoted beliefs about the reality of witchcraft through their own books, which were, in turn, shaped by the work of Glanvill, More and other British writers.

Increase and Cotton Mather believed that the fledgling society of New England was under threat from local witches. They were also great admirers of the new science of the Royal Society of London. Increase Mather, later President of Harvard College, diligently followed the discussions in London of the Royal Society through his reading of the Society's monthly journal, *Philosophical Transactions*. In 1683 he played a central role in the establishment of a New England version of the Royal Society in the form of the Boston Philosophical Society. His son, Cotton, was of a similar mind and was later elected a Fellow of the Royal Society of London.

These Americans read with approval the witchcraft texts of Boyle, Glanvill and More, and sought to emulate them through their own work. Like the authors who inspired them, Increase and Cotton Mather believed that the principles of experimental science were entirely in keeping with the reality of witchcraft. In 1681 Increase Mather read *Saducismus Triumphatus* with enthusiasm, and immediately set

about creating an equivalent collection of convincing supernatural instances from across New England. This led to the publication in 1684 of *Illustrious Providences*, in which Mather documented a series of American case studies which could be read alongside the empirical data about the supernatural documented by the English authors. Mather acknowledged his debt to Boyle, Glanvill and More. His most important case study concerned the trial and execution of Rebecca Greensmith at Hartford, Connecticut, in 1662. Mather asserted that this story provided conclusive proof of the reality of witchcraft, comparable in its high evidential quality to the proof cases from Europe.

> The Instance of the Witch Executed in Hartford, here in New-England ... is as convictive a proof as most single examples that I have met with.[5]

Cotton also looked for convincing instances of witchcraft in New England. In 1689 he published *Memorable Providences Relating to Witchcraft and Possessions*, explicitly stating his intention to imitate Glanvill and More, the 'Great Names' who had previously analysed witchcraft in England.

> Go then, my little book, as a Lackey to the more elaborate Essayes of those learned men. Go tell Mankind, that there are Devils & Witches.[6]

The centrepiece of Cotton Mather's *Memorable Providences* was the story of the demonic possession of a child, Martha Goodwin, supposedly through the witchcraft of an Irish immigrant called Ann Glover. Glover was hanged in November 1688. Just as Henry More had interrogated suspected witches in Cambridge in the 1640s, Cotton Mather personally interviewed Ann Glover when she was awaiting execution in Boston. He had no doubt about her guilt. Martha remained apparently possessed by demons after the execution. Determined to study the demonic possession of Martha in a particularly intensive, scientific way, Cotton took the girl to live with his own family for several weeks. He used his close observations to create and publish a detailed clinical case study of the operation of evil spirits. He was interested in the intellectual capacity of the evil

spirits, and he experimented on the girl in order to investigate the linguistic ability of the demons who possessed her.

Twenty people were executed at Salem in 1692. The precise impact of the ideas and actions of Increase and Cotton Mather on the hysteria and loss of life is contested. The story is not straightforward. As the events unfolded in 1692, Increase Mather and his son urged caution. Nevertheless, the scientific books about witchcraft that they had written, published in the years before the trials, contributed to an intellectual climate within which the mass killing of 'witches' was possible. This point was made at the time. In 1700 Robert Calef published *More Wonders of the Invisible World*, castigating Cotton Mather for his role in the trials. Calef stated that the publication of the case study of Martha Goodwin encouraged witchcraft hysteria and copycat behaviour in Salem, doing 'much to the kindling those Flames'.[7]

The rift between the witchcraft believers

The Fellows of the Royal Society who believed in witchcraft were not a unified, harmonious group of scholars. Although he was well known for his affability and love of friendship, there is no evidence that John Aubrey was on good terms with either Henry More or Joseph Glanvill. More was a well-known philosopher but was not included in Aubrey's biographical survey of distinguished contemporaries, *Brief Lives*. Furthermore, in one of his major works Aubrey went further and indirectly attacked the witchcraft claims of More and Glanvill.

Aubrey failed to publish his *Natural History of Wiltshire* during his lifetime. The Royal Society commissioned a definitive manuscript copy so that it would not be lost to scholarship and would be available for future researchers to consult. In this 'official' Royal Society version, Aubrey made statements challenging, at least by implication, key claims about witchcraft made by Glanvill and More. Joseph Glanvill had staked his reputation on the certainty of the truth of *The Drummer of Tedworth*. Aubrey ridiculed this poltergeist story in his *Natural History of Wiltshire*, accusing Glanvill of being 'a little too credulous' and suggesting that the event was almost certainly the result of a hoax. Aubrey also questioned the judgement of Henry More, who considered Anne Bodenham of Salisbury, beyond any reasonable doubt, guilty of real witchcraft. Aubrey provided a quite

different view of Bodenham, claiming that she had not been given a fair trial. In this way, Aubrey rejected, as false or unreliable, the two supposedly incontrovertible instances of authentic witchcraft proposed by Glanvill and More.

Why did Aubrey go out of his way to criticise the factual basis of the key witchcraft case studies of Glanvill and More? Why did he decide to ridicule *The Drummer of Tedworth* when it was similar to the anecdotes of the supernatural that he promoted personally in *Miscellanies*? Aubrey, Glanvill and More were all Fellows of the Royal Society. All three men believed in the reality of the supernatural. Aubrey, like Glanvill and More, was concerned to document empirically instances of supernatural phenomena. While they had much in common, there was, however, a great fault-line between them concerning astrology and the legitimacy of ritual magic. The most likely explanation for Aubrey's hostility is that he greatly disliked the way that Glanvill and More vehemently attacked the legitimacy of astrology and elite magic.

After the Restoration, Aubrey became increasingly friendly with Elias Ashmole, another Fellow of the Royal Society. Both men were extremely enthusiastic about the explanatory power of astrology. Ashmole was the patron and protector of the greatest astrologer of the mid-seventeenth century, William Lilly. Aubrey, meanwhile, became a close friend of Lilly's most important disciple, Henry Coley. When writing his biographical masterpiece, *Brief Lives*, Aubrey wanted to establish the connection between the careers of distinguished people and the planetary influences of their birth horoscopes. Aubrey and Ashmole were also admirers of the Elizabethan polymath John Dee, who advocated angel magic and the use of crystal balls.

While Aubrey and Ashmole promoted astrology, Henry More and Joseph Glanvill denounced it as a form of witchcraft. They were not alone in making this assertion. Throughout his life William Lilly faced accusations that he obtained his accurate predictions of future events by the use of witchcraft. In 1660 Henry More published a comprehensive assault on astrology in his book *An Explanation of the Grand Mystery of Godliness*. His intention was to destroy completely the reputation of astrology. Although Lilly was not mentioned by name, he was obviously the target. More raged against the folly and terrible moral dangers of 'the pretended

Art of Astrology'.[8] He urged readers to be particularly suspicious of successful astrologers as they almost certainly got their predictions with the help of the Devil. More's faithful disciple Glanvill later joined in the attack, describing astrology as a dangerous stepping-stone towards witchcraft.

Aubrey and Ashmole were not in any way deterred by the hostility of More and Glanvill. Indeed, Aubrey's own commitment to astrology *grew* during the 1670s as a result of his deep friendship with the astrologer Henry Coley.

Glanvill and More wrote from a clerical perspective. They were ordained ministers of the Church of England, determined to promote the truths of Protestant Christianity. Aubrey and Ashmole had quite different priorities. They had an occult perspective and were interested in uncovering arcane wisdom and previously hidden secrets about the supernatural world. The clerical writers were antagonistic towards astrology and suspicious also about ritual angel magic of the sort pioneered by John Dee. A conservative theologian called Meric Casaubon denounced the work of Dee as a form of witchcraft in 1659; Casaubon accepted the truth of Dee's claims to have the power to summon spirits but stated that the spirits concerned were not angels but demons. Again, Aubrey and Ashmole disagreed. They admired Dee and worked together on research into Dee's life.

Elias Ashmole had the highest possible regard for the work of Dee and personally practised a form of angel magic. He made and wore special magical talismans called 'sigils', intended to harness the protective and benign interventionist abilities of angels. Aubrey was also very positive about angel magic. His friend Henry Coley sold angel magic sigils to clients in London.

Aubrey was completely unapologetic about his belief in magic. In an unpublished paper on school education, he recommended that schoolboys should be taught how to call upon the help of angels through crystal magic. In his only published work, *Miscellanies*, Aubrey discussed how crystal balls could be used to communicate with angels. Conscious of the criticisms of those who equated this type of ritual magic with witchcraft, Aubrey emphasised the religious orthodoxy of angel magic.

Aubrey must have resented the attitude of More and Glanvill. The *Natural History of Wiltshire* provided Aubrey with an opportunity

to get his own back, dismissing as worthless their most cherished case studies of the authenticity of witchcraft. He attacked the idea that Anne Bodenham of Salisbury was guilty of witchcraft (a fundamental assertion of Henry More) and ridiculed the plausibility of the poltergeist event at Tidworth (the essential empirical case study promoted by Joseph Glanvill).

Lethal action against witches

Those members of the Royal Society who believed in witchcraft expressed no objection to the prosecution and execution of witches. Henry More interviewed Goodwife Lendall in prison in Cambridge in 1646 as she awaited her trial for witchcraft. He noted succinctly that she was later executed, with no indication that he was in any way disquieted by this. A year later he wrote a poem in which he mentioned, in an unsympathetic way, how witches dreaded being hanged. He described how 'wily hags' tried to avoid the 'fear and shame of the coarse halter'.[8] More clearly thought that an encounter with the noose or 'halter' was an appropriate end for a woman convicted of witchcraft.

Evidence survives indicating that two Fellows of the Royal Society, Joseph Glanvill and James Long, participated actively in the persecution of witches. Both men made it clear that they wanted the chief suspects in these cases to be hanged.

Almost certainly, Joseph Glanvill went beyond just writing about witchcraft. It seems that he assisted the investigations that took place in 1665 in two Somerset villages, concluding that the key suspects should be executed. He was angry when most of them were freed.

In 1662 Glanvill obtained his first job as a clergyman in the Somerset town of Frome. This gave him an opportunity to pursue his interest in witchcraft. He befriended Robert Hunt, a prominent Somerset landowner and justice of the peace. Hunt told Glanvill about how he had played a part in the prosecution of Jane Brooks from Shepton Mallett, who was executed in 1658. Glanvill was impressed. In 1665 people from the Somerset villages of Stoke Trister and Brewham complained to Hunt about the activities of local witches. Hunt concluded that organised covens of witches were active in these villages. There is compelling evidence indicating that Glanvill supplied Hunt with guidance on the questions that should be addressed to the suspects. It seems that he wanted verification of some

of the scientific hypotheses about witchcraft that had been articulated by his mentor, Henry More. This was an opportunity to confirm, for example, More's belief that witches could leave their physical bodies behind when they attended their coven meetings.

The confessions of the Somerset witches are highly suspicious. They read as if the suspects were simply agreeing to suggestions made by their interrogators, who were probably assisted by Joseph Glanvill.

Aubrey's great friend Sir James Long was the main investigating magistrate in the first phase of an enquiry into accusations of witchcraft in the Wiltshire town of Malmesbury. In 1672 hysterical parents from the leading families of the town claimed that a vicious coven of witches was responsible for the deaths of their children. Long recommended that three of the suspects had a case to answer and he signed the order to send them for trial in the county town of Salisbury. Two of them were subsequently hanged but the chief suspect, a woman called Elizabeth Peacock, was found not guilty. Evidence survives indicating that Long privately urged the trial judge to make sure that Peacock was convicted and executed. It seems that Long had promised the leading families of the town that she would be hanged. Long presumably believed that Peacock was guilty and deserved to be hanged, but he had another reason for wanting her to be executed. He hoped to become the MP for Malmesbury, and he needed votes from the men of the same families that accused Peacock of murdering their children.

Others were influenced by the learned witchcraft literature and took practical action against witches. A Scottish lawyer named Francis Grant was an enthusiastic reader of the work of Glanvill and More, and his profession enabled him to turn theory into practice. He prosecuted seven 'witches' who were strangled and burned at Paisley on one day in June 1697, an event that is sometimes described as the last mass execution of witches in western Europe. Grant's concluding speech to the jury was included in a treatise about the trial, *Sadducismus Debellatus* (1698). The title was a clear homage to Glanvill and More's earlier witchcraft book, *Saducismus Triumphatus*. Grant attempted to add to the scientific knowledge base about witchcraft; he considered that the new science of optics could be used to explain the apparent invisibility of malevolent witches. He lectured the jury on this topic, reassuring them that the claims that the suspects acted invisibly were entirely plausible. The speech seems to have been convincing as the jury found all the accused guilty.

The witchcraft of John Aubrey

Aubrey had no apparent qualms about the prosecution and execution of witches. He thought that the evidence against Anne Bodenham, the witch of Salisbury, was weak but he drew no general conclusions from this miscarriage of justice. When James Long wrote to him about the witches of Malmesbury, Long assumed that his friend shared his views both about the reality of witchcraft and the appropriateness of the death penalty for those guilty of it.

While Aubrey did not question the prosecution of witches, he personally practised a form of black magic. A magical notebook of Aubrey's survives and is kept at the Bodleian Library in Oxford, identified there as MS Aubrey 24. This unpublished manuscript resembles the working manual of an active magician, and some of the magic that it contains is very dark.

Eighty per cent of the notebook is given over to his meticulous transcription, dated 1674, of a black magic textbook that circulated only in secret manuscript form. It is a version of a guide to demon magic that is known as *The Key of Solomon*. This text provides precise instructions on how to summon and deploy evil spirits to harm others and induce women to be compliant in 'love' against their wishes.

Aubrey's transcript includes many designs for so-called 'pentacles', five-pointed talismans, drawn on virgin parchment in bats' blood and imbued with the power to force obedience from evil spirits. Some of these talismans are described in the text as *'pentacula destructionem et mortem'*, the pentacles of destruction and death. The manuscript explained that these were particularly useful when the magician wished to harm others.

The darkest of the spells describe the use of a wax image to harm enemies. Once the image has been treated with foul-smelling incense, an invocation should be said summoning a series of demons with strange names: Dilapidator, Tentator, Somniator and Seductor. These demons infused malevolent power into the wax through a process of 'consecration'. Instructions were provided as to how the image should be buried, its evil potency further enhanced with another application of foul-smelling incense.

The final twenty per cent of Aubrey's magic notebook is a collection of many shorter charms and ritual magic incantations. In transcribing these spells, Aubrey passed no comment other than to conclude

often with the words '*probatum est*', meaning 'it is proved'. On one occasion he wrote the equivalent statement in English, 'This hath bin often proved.' The implication is obvious: Aubrey appears to have used the spells and concluded that they worked.

The collection of shorter spells contains many 'love' charms, intended to alter the attitude of a woman towards a man who desires her, persuading her to have sex against her real wishes. One of these 'love' charms is undoubtedly a form of black magic, deriving its potency from the action of demons. Aubrey called the spell 'A charme to make your Girle appeare'. It was intended to force a woman to present herself at the house of a man who desired her and wanted her to be his 'girl'. The clear implication was that the enchanted woman would first 'appear' and then willingly participate in sex with a man who had used the ritual. The magic depended upon summoning Beelzebub and two other demons, who compelled the woman to act against her wishes.

There is no indication in the manuscript that Aubrey considered spells such as this to be at all morally problematic, or equivalent to the activities of witches.

I

JOHN AUBREY'S EDUCATION IN THE SUPERNATURAL

Aubrey believed in magic. This is clear from his book about the supernatural, *Miscellanies*, in which he provided readers with various spells and charms relating to topics as diverse as romance, toothache and the magic needed to counteract witchcraft. Aubrey explained, for example, how an amulet containing a paper with an arrangement of the letters ABRACADABRA could be used to cure a fever. He mentioned that a healer from the city of Wells in Somerset had cured over a hundred people using this charm.

Another charm that Aubrey appears to have believed worth trying was intended to bring about a dream in which a future husband or wife could be seen. At the first appearance of the new moon after New Year's Day, one should go out in the evening, climb on a gate and address the moon:

> All Hail to the Moon, all Hail to thee,
> I prithee good Moon reveal to me,
> This Night who my Husband (Wife) must be.[1]

Having recited this incantation, people hoping for an apparition of a future partner were recommended to go to bed and sleep. They could expect to see the future beloved in a dream. Aubrey endorsed the efficacy of the charm: 'I knew two Gentlewomen, that did thus when they were young Maids, and they had Dreams of those that Married them.'

There are several medical charms in *Miscellanies*. Perhaps the most alarming was intended to cure a child of a mouth 'thrush' or infection. The key ingredients were live frogs.

> Take a living Frog, and hold it in a Cloth, that it does not go down into the Childs Mouth; and put the Head into the Childs Mouth till it is dead; and then take another Frog.[2]

The charms Aubrey recounted were, for the most part, curious but relatively innocent. Some were darker. He described, with apparent approval, various magical techniques that could be used against witches.

How was it that John Aubrey, a cultivated man who was a friend to many of the most innovative thinkers of the seventeenth century, came to believe in the power of magic, including witchcraft? The answer can be found, in part, by considering his upbringing and the world he inhabited as a young man.

Aubrey was born in 1626 at his family home in Easton Piercy, Kington St Michael, a village near the town of Malmesbury in north Wiltshire. He spent much of his childhood there. The Aubrey family also leased property in Broad Chalke in south Wiltshire and owned land in Herefordshire. Aubrey attended local schools in Wiltshire until about 1637, when he became a boarder at Blandford School in Dorset. In May 1642, aged sixteen, Aubrey embarked on studies as an undergraduate at Trinity College, Oxford. Although he did not take a degree, and his studies were interrupted, he remained connected to intellectual circles in Oxford during the 1640s and 1650s. From 1646 onwards Aubrey was also a frequent visitor to London, where he spent time in the company of his elderly kinsman, Sir John Danvers.

As a child, Aubrey was exposed to belief in witchcraft as part of a wider set of beliefs about the existence of forces above and beyond the material world. It was widely held, by educated and uneducated alike, that there was a supernatural dimension to the world, encompassing angels, demons, fairies, astrological forces, apparitions and ghosts, as well as witchcraft and other forms of magic.

In 1656 Aubrey began research for his *Natural History of Wiltshire*. He attempted to catalogue almost anything distinctive or curious about his home county, including beliefs about the supernatural. The project continued for decades and the book would not be published in his

lifetime. He soon began to gather information about the supernatural from other parts of Britain. Towards the end of his life he removed much of the supernatural material from the manuscript and published this content, in 1696, as a separate book entitled *Miscellanies*. He also included some material about supernatural beliefs in the manuscript of another projected book, *The Remains of Gentilism*. This attempted to identify links between modern folklore beliefs and pre-Christian pagan practices. In all these works, it is possible to see the impact of Aubrey's encounter with beliefs about the supernatural during his formative years as a child and a young man.

Growing up with witches and fairies

As a boy, Aubrey saw female servants at the family home in Wiltshire examine the ashes in the hearth at the end of the evening in order to foretell the future.

> The maydes I remember were very fond of this kind of Magick, which is clearly a Branch of Geomantie.[3]

Aubrey later described other common forms of magic of this type, practised during his childhood. One ritual, involving the manipulation of the sheath of a knife, was used to find out whether an absent family member would return that night. Another common magical operation involved the use of a sieve and shears to identify a thief:

> The Sheers are stuck in a Sieve, and two maydens hold up the sieve with the top of their fingers by the handle of the shiers: then say, By St Peter & St Paule such a one hath stoln (such a thing), the others say, By St Peter and St Paul. He hath not stoln it. After many such adjurations, the Sieve will turne at ye name of ye Thiefe.[4]

In Wiltshire, before the Civil War, belief in magic of this sort was commonplace. People distinguished between acceptable white magic, such as divination using hearth ashes or the magic of the shears, and the malevolent black magic practised by those of their neighbours suspected of witchcraft.

As a child, Aubrey undoubtedly heard tales of the deeds of witches and wizards. He wrote about a notorious Wiltshire wizard, surnamed

Cantelow, who had operated in the county during the reign of James I. Aubrey told how he had heard 'severall odd stories' about Cantelow's witchcraft. The wizard came from Fonthill, near Salisbury, and had a bitter dispute with a local clergyman. According to Aubrey, Cantelow punished his clerical opponent by bewitching his house so that it was constantly filled with the deafening sound of his own church bells, although the bells could not be heard outside the house.

> When the minister was in bed, and going to his repose, he should heare in his chamber chimney the noise of a great passing bell, but without dore it was not heard. This noise continued every night for divers moneths, to the parson's great vexation.[5]

Aubrey encountered widespread belief in ghosts and other apparitions. He recalled a custom practised on the night before Midsummer's Day in which women gathered in church porches, hoping to see visions of those who would die the following year. Aubrey's account of this custom stated that he had heard 'strange stories' of what happened at these events, hinting that there might be some truth in these tales.

> Memorandum: the sitting-up on Midsommer-eve in the Churche porch to see the Apparitions of those that should dye or be buried there, that Yeare: mostly used by women: I have heard 'em tell strange stories of it.[6]

Belief in witchcraft, ghosts and premonitions was strongly connected to ideas about the spirit world. For many country people, there was a real but usually invisible world of malicious goblins, elves, sprites and fairies. Country tradition, in Wiltshire as elsewhere in Britain, promoted a view that fairies were typically mischievous, prone to pinching people invisibly and stealing cream from dairies. There was also a much darker side to fairy beliefs. Many Wiltshire people saw them as demonic spirits capable of real malevolence: kidnapping adults and stealing human babies, replacing them with so-called changelings, demons in human form. Aubrey later recalled this belief in the changeling.

> The Fairies would steale away young children and putt others in their places; verily believed by old woemen of those dayes: and by some yet living.[7]

The idea of the changeling was used by country people to explain why some children had profound learning difficulties. According to the changeling theory, children with limited cognitive ability were often demons, planted in the cradle by malicious fairies after the real human baby had been stolen.

Fairies could be dangerous in other ways. Aubrey's grandmother Israel Lyte lived at Easton Piercy until her death in 1660. She came originally from the Wiltshire village of Winterbourne Basset and her name before marriage was Israel Browne. We know that young Aubrey spent time in the company of this grandmother and visited his relatives in Winterbourne. While there, he heard stories of locals who had been briefly kidnapped by fairies, seen extraordinary things, and were never able to be happy afterwards. He cited two instances: an anonymous 'hind' or labourer who was taken by fairies when riding on Hackpen Hill in Winterbourne parish and a shepherd who had worked for his great-grandfather 'Mr. Brown'.

> Some were led away by the Fairies, as was a Hind riding upon Hakpen with corne, led a dance to the Devises. So was a shepherd of Mr. Brown, of Winterburn-Basset: but never any afterwards enjoy themselves. He sayd that the ground opened, and he was brought into strange places underground, where they used musicall Instruments, violls, and Lutes, such (he sayd) as Mr. Thomas did play on.[8]

An Oxford education in the supernatural

Aubrey had encountered many popular beliefs about magic and the supernatural while growing up in Wiltshire. When in 1642, aged sixteen, he went to Oxford University, he entered a different world, peopled by a learned elite. It might be imagined that in such an environment ideas about the supernatural would be dismissed as primitive superstition, but this was not the case at all. In academic Oxford, as in the Wiltshire countryside, people took the supernatural very seriously.

Many years afterwards, Aubrey wrote about how, as a freshman at Oxford University, he had personally heard the king, Charles I, discussing his experience of an omen of supernatural origin. Having lost control of London, the king was based in Oxford for much of the Civil War and stayed at Christ Church, the grandest

of the university colleges. Undergraduates from other colleges were apparently permitted to visit and watch the king as he dined. Aubrey got close enough one evening to hear Charles tell a tale of how he had once experienced a strange portent of future trouble when hawking in Scotland. In an inversion of the natural order, the king's powerful hawk was attacked by a flock of little partridges. The king saw this as a bad omen.

> When I was a Freshman at Oxford 1642, I was wont to go to Christ-Church to see King Charles I. at Supper: Where I once heard him say that as he was Hawking in Scotland, he rode into the Quarry, and found the Covey of Partridges falling on the Hawk; and I do remember this expression farther, viz. and I will swear upon the Book 'tis true.[9]

Aubrey had no doubt that this was an authentic omen, a supernatural warning. He described how he returned to Trinity College and explained to his tutor what he had just heard the king say. The tutor confirmed that this was, almost certainly, a genuine message from higher powers. He provided Aubrey with a metaphorical interpretation of the omen: the partridges attacking the hawk symbolised the citizens of London who would later turn on the king, as represented by the eagle. For Aubrey, Charles had been sent this warning by some well-meaning supernatural force.

Friendship was immensely important to Aubrey. At Trinity College Aubrey met Anthony Ettrick, beginning a lifelong relationship with the Dorset gentleman and lawyer. Ettrick, like Aubrey, was deeply interested in the supernatural. As an undergraduate, Ettrick got into trouble for practising ritual spirit magic. Ritual magic that involved the invocation of spirits was highly controversial, and was seen by many as a form of witchcraft. Aubrey's description of Ettrick's experiment with magic is brief but full of significance.

> In my time, Mr. Anthony Ettrick and some others frighted a poor young freshman of Magd[alen] Hall with conjuring.[10]

By 'conjuring' Aubrey meant not sleight-of-hand tricks but the calling up of spirits. One of the other students who took part in the illicit magical ceremony, supervised by Ettrick, was apparently terrified by

the experience. Ettrick was reprimanded by the President of Trinity College for experimenting with magic and frightening the poor 'young freshman' from Magdalen Hall.

Ettrick was four years older than Aubrey and had enrolled as a student two years earlier. It is likely that Aubrey was impressed by the older man, his new friend who knew how to summon spirits. We know that Ettrick had a lifelong interest in the supernatural, and believed, like Aubrey, in the power of premonitions. Long after their university days, they collaborated on important investigations into supernatural events. Ettrick provided Aubrey with first-hand information relating to the case of Anne Bodenham, the witch of Salisbury (1653), and the poltergeist phenomenon in Tidworth (1662–63).

It seems clear that Ettrick discussed his own premonitions with Aubrey while at Oxford, convincing the younger man that he frequently sensed supernatural insights into future events, which usually turned out to be correct. Many years later, Aubrey recalled their conversations in *Miscellanies* (1696). Aubrey wrote about discussions with an unnamed friend, almost certainly Ettrick. Although he was writing fifty years after first discussing premonitions with Ettrick, it is still possible to sense how powerfully struck he was by Ettrick's tales when he heard them as a sixteen-year-old.

A very good Friend of mine and old Acquaintance, hath had frequent Impulses: When he was a Commoner at Trin[ity] College Oxford, he had several. When he rode towards the West one time in the Stage-Coach, he told the Company, We shall certainly be Robbed, and they were so.[11]

Aubrey described premonitions as 'impulses'. He recounted another of Ettrick's 'impulses' in *Miscellanies*. Ettrick's brother had died, bequeathing him a share in a merchant ship which was trading with Spain. Ettrick had a strong 'Impulse', telling him that that the ship would be wrecked. Convinced of impending disaster, he sold his share in the ship, which was indeed wrecked as it made its way along the English coast. Typically, Aubrey's account of the shipwreck concludes with an amusing detail: 'Not a Man Perished; but all the Goods were lost except some Parrets'.[12]

Having recounted this tale in *Miscellanies*, Aubrey briefly and enigmatically described how the Greek philosopher Socrates was

advised by a kindly spirit, 'The good Genius of *Socrates* is much remembred [*sic*] which gave him Warning.' Here we have a hint of theory about the supernatural from Aubrey who, for the most part, avoided attempts to explain his beliefs about the spirit world. By his reference to Socrates, Aubrey was suggesting that Anthony Ettrick, just like the great philosopher, benefitted from a benign spirit who sent helpful messages from the spirit world. The word 'genius' is not a reference to his intellectual brilliance but to the guardian spirit who looked after Socrates. In Christian terms, both Socrates and Anthony Ettrick enjoyed the assistance of a 'guardian angel'.

We know that Ettrick believed in the reality of premonitions throughout his life. As an older man, he became convinced that he had received an 'impulse' that he would die in 1693. He had a sarcophagus prepared at his local church, Wimborne Minster in Dorset, inscribed with the date of his impending death. To his surprise, he did not die in that year and lived for another ten years. The inscription on his sarcophagus can still be seen at Wimborne. It was ineptly altered from '1693' to '1703', but the original date is still visible.

Aubrey concluded that premonitions could be received either through moments of insight, 'impulses', or through unexplained sounds, which he called 'knockings'. When his father was about to die, Aubrey received a warning of the impending event through such a 'knocking'.

> Three or four Days before my Father died, as I was in my Bed about Nine a Clock in the Morning perfectly awake, I did hear three distinct Knocks on the Beds-head, as if it had been with a Ruler.[13]

Although he was forced to abandon his formal university studies during the Civil War, Aubrey was a frequent visitor to Oxford in the late 1640s and early 1650s, when conditions were more settled. He also kept in touch by correspondence with an Oxford friend, John Lydall, who was a tutor at Trinity. Lydall wrote regularly, updating Aubrey on Oxford news. Lydall's letters survive, and one gives some indication of Aubrey's interest in the supernatural as a young man. In March 1650 Aubrey was at home in Broad Chalke in Wiltshire and heard rumours of peculiar supernatural occurrences at the manor house at Woodstock, near Oxford. Aubrey wrote for information to his good friend Lydall.

In 1649 the victorious parliamentary government confiscated royal lands and undertook a survey of these assets prior to their intended sale. As part of this process, surveyors were sent to the royal estate at Woodstock. By the end of 1649 a story was circulating that the surveyors had been driven out of the manor house at Woodstock by a highly antagonistic spirit or ghost. Aubrey heard these rumours and wrote to Lydall asking for information. Lydall duly made enquiries and wrote back, providing a full account of how the surveyors 'were frighted out by strange Apparitions'. Lydall expressed no scepticism about the strange story, and Aubrey appears to have accepted the authenticity of the royalist spirit or ghost of Woodstock Manor. He printed Lydall's letter in *Miscellanies* (1696), over forty years after he first received it.

The transformational impact of Thomas Browne

In Oxford Aubrey was moving in circles where portents, premonitions and ritual magic were widely accepted, and at an early stage in his university career he encountered a book that further strengthened his supernatural beliefs. In his notes towards an autobiography, John Aubrey described a transformational moment that took place in the summer of 1642: he bought a copy of Sir Thomas Browne's remarkable first book, *Religio Medici*, which had just been published. Aubrey said that reading Browne's book was the event that 'first opened my understanding'.[14]

Today Browne is famous for his message of toleration, and for his innovative and engaging prose style. There was, however, a darker side to Browne's ideas, and to the content of his famous book. *Religio Medici* contained a powerful and unambiguous endorsement of the reality of witchcraft, arguing that belief in witchcraft could be reconciled with modern thinking.

Browne's book was a highly personal reflection on the meaning of life. It was published at a time of conflict and extreme intolerance, just as the English Civil War was beginning. Browne urged his readers to be respectful of differences. He was an Anglican, but he could see value in other Christian traditions, and he had some respect for non-Christian faiths. A medical physician, Browne defined himself as a modern man. He was also a man of faith who understood the importance of two different ways of looking at the world, religion and science: 'Many things are true in Divinity, which are neither inducible by reason nor confirmable by sense.'[15]

It is easy to see why Aubrey liked Browne's book. Browne's message of tolerance was attractive to Aubrey, who had no time for religious fanaticism. Both men loved the obscure and the esoteric. Browne's approach was to focus on striking insights rather than systematic thinking, just as Aubrey did in much of his work. Aubrey was doubtless impressed by Browne's playful, creative, erudite use of language. Browne was an engaging writer, with a penchant for making up new words based on Greek or Latin originals. Many of these newly coined words proved useful and have stood the test of time. We owe a debt to Browne for such words as 'ambidextrous', 'anomalous', 'coma' and 'hallucination'.

Browne promoted tolerance, but there were limits to his open-mindedness. He had core, irreducible beliefs, including his complete conviction that witchcraft was completely real. For him, there was no doubt that evil spirits existed, as did their good counterparts, the angels. He expressed surprise that 'learned' or educated people might ignore the idea that there was a God-ordained hierarchy of earthly and spirit creatures, including demons and angels.

> It is a riddle to me ... how so many learned heads should so far forget the Metaphysicks, and ... question the existence of Spirits.[16]

For Browne, the existence of evil spirits and the reality of witchcraft were connected. Those who denied witchcraft implicitly denied the existence of evil spirits, and this was a step on a slippery slope towards the denial of God.

> For my part I have ever beleeved, and doe now know, that there are Witches; they that doubt of these do not onely deny them, but Spirits; and are obliquely, not consequently, a sort, not of Infidels, but Atheists.[17]

We know that Aubrey admired Browne's book. There is no reason to doubt that when the sixteen-year-old Aubrey read these words he found the case for the truth of witchcraft compelling. The argument was nuanced. Browne explained that some instances of witchcraft were fraudulent or the result of delusion, but he was emphatic that

it was not possible to explain away all cases of alleged witchcraft by reference to natural causes. In many cases the Devil was genuinely at work in the world. Demonic possession was a reality: 'I hold that the Devill doth really possesse some men.'[18]

Not all the popular beliefs about witchcraft were accepted by Browne. He rejected, for example, belief in the possibility of changelings. Aubrey, of course, had encountered this idea when growing up in Wiltshire, but Browne was not convinced by talk of changelings:

> Of all the delusions wherewith he [the Devil] deceives mortalitie there is not any that puzleth me more then the Legerdemaine of Changeling; I doe not credit those transformations of reasonable creatures into beasts.[19]

Browne also expressed reservations about the possibility that sex between people and demons could result in the birth of hybrid creatures, partly human and partly demonic. As we shall see, this was a topic that interested several serious scholars in the seventeenth century. Browne accepted that sex was possible between humans and embodied evil spirits, but he was not convinced that there could be offspring from such a union.

> I could beleeve that Spirits use with man the act of carnality, and that in both sexes I conceive they may assume, steale, or contrive a body wherein there may bee action enough to content decrepit lust, or passion to satisfie more active veneries; yet in both without a possibility of generation.[20]

There were complexities to Browne's world of witchcraft. While true witchcraft was diabolical, there was also a more innocent form of magic, based on the use of spells that worked mechanistically and not because of any direct complicity with the Devil.

> I believe that all that use sorceries, incantations, and spels, are not Witches, or as we terme them, Magicians; I conceive there is a Traditional Magicke, not learned immediately from the Devill.[21]

It seems likely that Aubrey was influenced by Browne in his view of the significance of angels. Browne had no doubt that angels were

active in this world. He promoted the idea of protective 'guardian angels' whose task was to help humans. Browne was keen to make clear that, although Catholics believed in such angels, the concept predated the period of the dominance of the medieval Catholic Church. He explained that ideas about protective angels could be traced back to pre-Christian philosophers, such as Pythagoras and Plato. Browne considered that angels were often the source of human scientific insights. These good spirits, as a kindness, revealed mysteries which we attributed to our own ingenuity.

> I do thinke that many mysteries ascribed to our owne inventions, have beene the courteous revelation of Spirits; for those noble essences in heaven beare a friendly regard unto their fellow natures on earth.[22]

For Browne, benevolent angels were also the source of premonitions and omens predicting catastrophe. The angels wished us to be forewarned and thereby forearmed. Browne explained that omens were probably the 'charitable' actions of angels.

> I ... therefore beleeve that those many prodigies and ominous prognosticks which fore-run the ruines of States, Princes, and private persons, are the charitable premonitions of good Angels, which more carelesse enquiries terme but the effects of chance and nature.[23]

Very similar ideas about angelic action feature in Aubrey's work. Angels were mentioned many times in *Miscellanies*, Aubrey's account of supernatural phenomena. He hinted that Anthony Ettrick, like Socrates, was guided by a kindly spirit. He dedicated *Miscellanies* to his friend and patron the Earl of Abingdon with the words, 'May the Blessed Angels be Your careful Guardians',[24] and the book advocated the use of crystal magic as a way of communicating with angels. Aspects of *Miscellanies* represent an application of Browne's ideas about angels. Like Browne, Aubrey thought that some omens and premonitions were caused by protective angels, who wished to alert people to forthcoming events.

For Aubrey, reading *Religio Medici* was a life-changing experience. He was also fascinated by Browne's second book, *Pseudodoxia*

Epidemica, published in 1646, when Aubrey was twenty. This work was an enormous collection of popular myths and misconceptions, each of which Browne systematically debunked. Do swans always sing a beautiful song before death? Are male beavers prepared to bite off their own testicles to avoid capture? Do badgers have legs on one side that are shorter than those on the other side? After proper examination of the evidence, the answer to all these curious questions was a resounding 'no'. Browne invited his readers to question myths and any authority that promoted them.

> The mortallest enemy unto knowledge, and that which hath done the greatest execution upon truth, hath beene a peremptory adhesion unto Authority, and more especially the establishing of our beliefe upon the dictates of Antiquities.[25]

This apparently enlightened approach is deceptive. While his book challenged human authority, it also promoted belief in the activity of the Devil and of his followers, the witches. For Browne, one of the main reasons why people were susceptible to ridiculous notions was that the Devil was at work, sowing confusion and discord, promoting untruth. The most dangerous myth was that he and his followers did not exist, and this myth was assiduously promoted by the Devil.

> But beside the infirmities of humane nature, the seed of error within our selves, and the severall wayes of delusion from each other, there is an invisible Agent, and secret promoter without us, whose activity is undiscerned, and playes in the darke upon us, and that is the first contriver of Error, and professed opposer of Truth, the Divell.[26]

Browne stated that the Devil 'endeavours to propagate the unbelief of witches' as part of his wicked master plan to destroy all faith in the truth of Christianity. Those who subscribe to the idea that there is no witchcraft will soon be prey to other myths: that Scripture itself cannot be trusted, that there is no afterlife, simply 'totall death', and that even God does not exist.

We know that Aubrey paid very careful attention to Browne's *Pseudodoxia Epidemica.* He made extensive notes after reading the book and these notes formed a substantial part of the draft manuscript

for his own proposed book *The Remains of Gentilism*. We can tell from extracts he copied from Browne that Aubrey was interested in topics such as the notion that the Devil sometimes manifested himself as a creature with cloven hooves. Browne expressed the view, which Aubrey diligently transcribed, that this apparently 'ridiculous' view might be true.

> A conceit there is that the Devill commonly appeareth with a cloven hoofe, wherein although it seeme excessively ridiculous there may be somewhat of truth.[27]

The witchcraft hysteria in Malmesbury: 1643–45

Aubrey loved being a student at Oxford. Unfortunately for him, his academic career was interrupted, just a few months after commencement, due to the disruptions of the English Civil War. Having begun his studies in May 1642, he was summoned home by his father in August, taking with him his newly acquired copy of *Religio Medici*. He attempted to return to Oxford in February 1643, surviving an attack of smallpox in the process, but was forced to return home in June 1643 and pause his academic career.

He spent the next three years living unhappily at home in Wiltshire with his parents. We know from his friend James Long that during these years there was an outbreak of witchcraft hysteria in the town of Malmesbury, close to the Aubrey family house in Easton Piercy. Aubrey was based during these years at the other family home in Broad Chalke, south Wiltshire, but he was almost certainly a frequent visitor to the house near Malmesbury where his grandparents were living.

When revising his *Natural History of Wiltshire* in the 1680s, Aubrey indicated that James Long had written a book about witchcraft in Malmesbury which he intended to give to the Royal Society. Until recently Long's book about the Malmesbury witches was considered lost, or perhaps never actually written, but a substantial fragment has come to light. The fragment in question was published by a journal called *The Gentleman's Magazine* in 1832, and the text makes clear that anxiety about witches swept the town of Malmesbury during the early days of the Civil War. This was precisely when Aubrey was living in Wiltshire because of his inability to attend Oxford University.

The town of Malmesbury was on the front line between parliamentary and royalist forces. It changed hands several times between 1643 and 1644 before finally coming under parliamentary control. In 1643 an unruly mob of local men and women ('some of the lowest of the people' according to Long) with some ill-disciplined parliamentary soldiers attacked a woman called Alice Elgar at the town's Market Cross. She was suspected of being a witch. Alice came from the suburb of Malmesbury known as Westport, the same district where Aubrey's friend Thomas Hobbes grew up. Traumatised by the attack at the Market Cross, she afterwards committed suicide by poisoning herself. As a suicide, Alice was denied a church burial and was buried instead at a local crossroads. All this information can be ascertained from Long's brief account of the death of Alice Elgar.

> Alice Elger, widow, dwelling in Westport, became so audaciously obnoxious to the good inhabitance, there being none but martial law then, it was about 1643; Malmesbury then being in the hands of the armys ranged against the King; that the soldiers and some of the lowest of the people did in the mercat place use her very roughly, moved by an instant emergent, so that shee, perhaps to avoyd the like, went home and poysoned herselfe, as was then beleeved, and was buried in a cross way as a felon of herself.[28]

Long expressed no sympathy for Alice Elgar's fate; after all, she had been 'audaciously obnoxious' to local people. This curious phrase appears to mean that she had a reputation for openly threatening to harm others, including 'the good inhabitants', through begging with menaces of harm by witchcraft. Long implied that she got what she deserved.

The next episode in Long's account concerned a friend of Elgar's, Goody or Goodwife Orchard, who was also thought to be a witch by the people of the town. In about 1645 Orchard came begging to the house of Hugh Bartholomew in Malmesbury. The door was opened by Hugh's daughter, a girl called Mary. It is possible to identify Mary in the baptismal register of Malmesbury Abbey, and we can tell that she was about ten years old when she opened the door to Goody Orchard.

Mary was terrified, since Orchard was known to all as a witch. Orchard asked for some yeast. The girl said that she had none and tried to turn her away. Orchard spoke menacingly, and was then alleged to have bewitched the house, damaging a wooden chest that contained the family's life savings before running off. Hugh Bartholomew, the little girl's father, was alerted to these events and demanded the punishment of the witch. Fearing retribution, Goody Orchard fled the town, becoming a vagrant. She reappeared months later, begging at a farmhouse in the village of Burbage in another part of Wiltshire. A young farmer's daughter opened the door and spoke to her harshly because she was begging. According to Long, Goody Orchard responded by bewitching the young woman from Burbage, causing agonising pains to her hands, before again going on the run.

Orchard was finally a caught a few days later in the village of Edington and taken to Salisbury to be tried as a witch. Hugh Bartholomew and several other people from Malmesbury went to Salisbury to testify against her. It seems likely that his daughter, Mary Bartholomew, aged ten, testified against Orchard.

> To prove her a witch, Mr. Bartholomew and divers of Malmesbury, that being discovered to be the place of her last abode, were bound to give evidence against her, which they did.[29]

Long describes how Goody Orchard was found guilty at Salisbury and executed for witchcraft. The narrative is confusing but suggests that, during the execution, either Orchard or her supporters placed a curse on the family of Hugh Bartholomew and his young daughter, Mary, for their role in her persecution and hanging, stating that the family would suffer 'dire revenges'.

It is inconceivable that Aubrey was unaware of these dramatic events. During the trial of Goody Orchard at Salisbury, Aubrey was living just 8 miles away in Broad Chalke. In addition, he was probably making regular visits to his grandparents at Easton Piercy, the family house near Malmesbury.

We also know that Aubrey was later personally acquainted with the principal accuser of Goody Orchard. Hugh Bartholomew, who testified against Orchard at Salisbury Assizes, was later to become a glazier and the sexton of the parish church at Malmesbury Abbey. Aubrey got to know Bartholomew while undertaking antiquarian

investigations into Wiltshire churches, and discussed with him the destruction of the stained-glass windows of the abbey by parliamentary soldiers during the war. In manuscript notes for his *Description of the North Division of Wiltshire*, written in the 1660s, Aubrey set himself the task of asking Bartholomew for more information about the heraldic shields or 'scutcheons' which were depicted in the destroyed windows in Malmesbury. He used the word 'Quaere' to mean that he needed to question or query Bartholomew on this matter: 'Quaere: Bartholomew the Glazier for the old Scutcheons in the church windows.'[30] This statement indicates that Aubrey knew Bartholomew, the man whose family was cursed by the 'witch' Goody Orchard before she was hanged in Salisbury.

Aubrey's Wiltshire associates Long and Bartholomew had no doubts about the guilt of Elgar and Orchard. Long's narrative of events was based on a view that Elgar and Orchard were authentic witches, and he raised no questions about the possible innocence of the women. In his account of her actions at Burbage, he described her as a 'hag' who performed witchcraft rituals. Long stated that 'when the hagg trotted about the garden, she muttered certayne words'.

It was in this world, where witchcraft belief was the norm, that Aubrey spent his enforced leisure time in Wiltshire from 1643 to 1646. The rediscovered fragment of the work by James Long provides significant evidence about the belief systems of ordinary people and members of the county elite at this formative time in Aubrey's life. Both the glazier, Hugh Bartholomew, and the local gentleman and later Fellow of the Royal Society, Sir James Long, believed that local women were real witches. Growing up in this environment, it is not surprising that Aubrey came to believe in witchcraft.

Aubrey's education in high level intellectual pursuits (and misogynism)

In April 1646 political conditions allowed Aubrey to resume his life and interests outside rural Wiltshire, and he promptly enrolled as a law student in the Middle Temple in London. Although he was not serious about pursuing a legal career, the Middle Temple gave him a good London base and congenial company. His great friend and fellow believer in the supernatural, Anthony Ettrick, was also a member of the Middle Temple. From November 1646 Aubrey also resumed regular and extended visits to Oxford, although he did not

formally re-join Trinity College as a student. For the next few years Aubrey divided his time between Wiltshire, Oxford and London while pursuing an informal, personal programme of education in such fields as mathematics, mechanics and medicine.[31] In Oxford and London he aligned himself to the followers of Francis Bacon, who was also known as Lord Verulam. In 1652 he introduced himself to the influential intellectual Samuel Hartlib at the latter's London house. Hartlib made a note of the encounter and was struck by the way the young man stressed his Baconian or 'Verulamian' credentials.

> Hee seemed to be a very witty man and a mighty favorer of all Ingenious and Verulamian Designes.[32]

In the 1650s, Aubrey was on a mission to complete his education. It is hardly surprising that while he improved his academic knowledge he also acquired misogynistic views of women because such attitudes were prevalent in the intellectual circles of the time. The men who inspired Aubrey, such as Francis Bacon and Thomas Browne, had little positive to say about the contribution of women to science and culture.

Although the exact meaning of his statements has been contested and interpreted in different ways, feminist historians have in recent years highlighted the use of sexist and sexualised metaphors in the work of Francis Bacon. In his *Advancement of Learning*, for example, Bacon made routine use of female stereotypes when describing how a gentleman should view scientific knowledge. The educated man should not see science as a source of pleasure (as one might view a prostitute or courtesan) or as a source of financial gain (as a gentleman might see a woman who was an indentured servant) but as a wife or spouse. It was the duty of the spouse to provide her man with 'generation, fruit and honest solace'; in other words, the purpose of a wife was to provide a man with 'sex, children and comfort'.

> ... that knowledge may not bee as a Curtezan for pleasure, & vanitie only, or as a bond-woman to acquire and gaine to her Masters vse, but as a Spouse, for generation, fruit, and comfort.[33]

In *Religio Medici*, the book that inspired young Aubrey, Thomas Browne was disparaging about women and considered male friendship

to be more important than any relationship that a man might have with any woman, including marriage.

> I never yet cast a true affection on a woman, but I have loved my friend as I do virtue, my soul, my God.[34]

An impressionable young man such as Aubrey would surely have been influenced by reading statements like this. Perhaps an even greater influence on the development of Aubrey's attitudes towards women derived from his friendship with the great medical pioneer William Harvey (1578–1657). From 1651 onwards Aubrey was on very good terms with Harvey and looked to the old man as a teacher and mentor. This was not a meeting of equals. Aubrey described how Harvey 'was very communicative and willing to instruct any that were modest and respectfull to him'.[35]

By the time that Aubrey was receiving instruction, Harvey was an old man. He had strong views about the natural inferiority of women and the scientific basis for the differences between men and women. In *Brief Lives* Aubrey recounted Harvey's belief that women should be kept in their place and had too much freedom in western European society. By contrast, Harvey spoke approvingly to Aubrey of the oppression of women that was prevalent in the Turkish empire. Aubrey also described in *Brief Lives* how Harvey, at the time that he was instructing him, employed a young woman in his household who acted as a servant and also kept him warm in bed at nights in the manner of King David in the Bible.

> I remember he kept a pretty young wench to wayte on him which I guess he made use of for warmeth sake as King David did.[36]

Aubrey had seen the unnamed 'pretty young wench' who was obliged to sleep with the old man. He made no comment on the correctness or otherwise of this behaviour but implied, to those familiar with the story of David in the Book of Kings, that, despite literally sleeping together, Harvey and the woman did not have sex.

Harvey is, of course, famous as the discoverer of the circulation of the blood. His ground-breaking work on this subject was published in 1628. By the 1640s Harvey's main scientific interest was the better understanding of sexual reproduction in humans and animals.

Harvey's book on sex and embryology, *De generatione animalium* (*On Animal Generation*), was published in 1651, the year that Aubrey met and fell under the influence of the older man. Without doubt Harvey instructed Aubrey in his views on the science of sex.

Aubrey recounted in *Brief Lives* how Harvey saw 'man' as 'but a great mischievous Baboon', meaning that humans were essentially little different from other animals. This theme of the parallel between human and animal biology and behaviour was explored by Harvey in *De generatione animalium*. Harvey suggested that aggressive sexual behaviour of male animals was commonplace and natural and that there were fundamental similarities between the natural sexual aggression males of many species. Through his choice of anthropomorphic language when describing animals, Harvey invited his readers to see similarities between human and animal sexual behaviour, emphasising the natural aggression of cocks towards hens and using anthropomorphic language to describe the behaviour of these male animals.

> And therefore the Cock, as he is well appointed in his weapons, brave in his plumes, haughty, ambitious, valiant, and a famous Duellist; so doth he also abound in Seed ... he will tire out his wives by frequent invitations, and compressions, and ... will cruelly handle them, with unseasonable advancings, and molestations.[37]

Readers were expected to recognise the type: an aggressive, over-sexed soldier who forced himself on multiple women against their wishes.

Many years after the death of William Harvey, Aubrey remembered his conversations with the great man when he made notes for a proposed comic play he intended to write called *The Country Revel*. The jokes in the play about sex were dark and misogynistic but meant to be in some sense 'scientific'. He intended to write about how country wenches were like relentlessly functioning machines in their insatiable sexual demands. Encounters between men and women were based not on love or affection but animal lust. In a way that was explicitly linked to the ideas of Harvey, Aubrey emphasised the similarities between animal and human sex. Country people in the play discussed how widows who remarried were like dog 'bitches' who had been infected by their previous sexual encounters with inferior dogs or 'curs'.[38]

It seems clear that Aubrey's fundamental view was that most women were intellectually inferior to men. He said of Elizabeth Danvers in *Brief Lives* that she possessed 'prodigious parts for a woman', meaning that she was surprisingly accomplished considering that she was a woman.[39] There are relatively few women whose lives were recorded in *Brief Lives*. He said nothing, for example, about the scientist, playwright and philosopher Margaret Cavendish.

Aubrey never married but he attempted to find a bride on several occasions. Aubrey stated that in April 1652, when he was twenty-six years old, he first set eyes on Mary Wiseman and identified her as a future bride. If Anthony Powell's research was correct, Mary was only aged about twelve years old at this time. Aubrey described her as 'that incomparable good conditioned Gentlewoman'.[40] In 1653, while planning to go on the Grand Tour, he wrote a draft will in which he bequeathed his 'best diamond ring' to Mary. There is a final, enigmatic reference to Mary in Aubrey's autobiographical note where he characterises the years 1655 and 1656 as a strange time of 'contradictions', summing up the period, mysteriously, with the words, 'Love Mary Wiseman and lawe-suites'.[41] We do not know what happened between Aubrey and Mary but they certainly did not marry.

Aubrey's infatuation with Mary Wiseman came to nothing, and by 1657 his focus had changed to possible marriage to one Katherine Ryves. Here his motivation appears to have been, in significant measure, financial. Katherine came originally from Blandford Forum in Dorset (Aubrey may have met her first as a schoolboy in Blandford) but by 1657 she was living with two aunts in the Cathedral Close in Salisbury. The close was also the home of the Goddard family who had been involved in the case of Anne Bodenham, the so-called Witch of Salisbury. Katherine Ryves died on 27 November 1657. She appears to have been fond of Aubrey and the match was, it seems, approved by Aubrey's mother, Deborah. The will of Katherine Ryves has survived; in it she bequeathed the large sum of £350 to Aubrey and gives a 'mourning ring' to his mother. Aubrey noted her death in his autobiographical notes, emphasising his disappointment at his failure to acquire her lucrative dowry of £2000.[42]

It is likely that Aubrey felt free to have opportunistic and transactional sex with other women. While Aubrey was looking for a suitable bride, such as Mary or Katherine, he was perhaps, at the

same time, paying for sex with prostitutes. On one occasion he caught a sexually transmitted disease. In a collection of personal astrological notes Aubrey noted for December 1656: 'Veneris morbus', meaning 'the disease of Venus' or 'venereal disease'.⁴³ Indeed, he was fascinated by high society prostitution and promiscuity. When his friend John Hoskyns was in Venice, Aubrey wrote to him asking for information about Venetian courtesans. This, and a request for some books, constituted his main enquiry related to Hoskyns' stay in the city.⁴⁴

Several of the women Aubrey described in any detail in *Brief Lives* were chosen for their sexual notoriety. He was intrigued by female promiscuity. He wrote at length about the infidelities of Venetia Stanley, Bess Broughton and Ann Overall. In each case he recorded scurrilous verse that was written about these women and their love lives. The prurient nature of his interest in women who broke the conventions of sexual behaviour is manifest in his biographical study of Mary Herbert, Countess of Pembroke.⁴⁵ Aubrey was particularly interested in the stories that circulated concerning her enthusiasm for sex. To him, Herbert 'was very salacious'. Harvey had used the same word, 'salacious', in *De generatione animalium* as an adjective that could be applied to women who had a marked enjoyment of sex. In an echo of Harvey's references to the parallels between human and animal sex, Aubrey provided a bizarre account of how Herbert liked to watch horses mating immediately before she had a tryst with a lover.

Although the precise story of Aubrey's later relationships with women is difficult to tell, he seems to have had a reputation for being particularly active in his pursuit of women. In a commentary on his horoscope the astrologer John Gadbury noted that although Aubrey was not married he was 'no enemye to the female sex'.⁴⁶ His friend John Hoskyns wrote to him from London in January 1663 saying, 'Some of your intimate acquaintance here have lately told mee how extremely Amorous you are by nature.'⁴⁷ Hoskyns referred to a previous, now lost, letter from Aubrey in which he had apparently described his unhappiness after 'an unsuccessful amour'. This sounds like failure in an attempted sexual relationship outside marriage rather than disappointment in a matter of courtship for marriage. Hoskyns tried to cheer his friend up by telling Aubrey that he could 'doe well enough' without the woman.

Aubrey appears to have had no moral qualms about sex outside marriage. In *Brief Lives* he alluded to a strange theory he apparently espoused that children born as a result of illicit sex were more creative

and courageous than those born to a wife and husband in wedlock. He had discussed this matter with Lady Dorothy Long, the wife of his friend Sir James Long. On the first page of his final draft of *Brief Lives* he included a curious quotation, attributed to Lady Dorothy:

> Poets and Bravo's have Punkes to their Mothers: from Dorothy Long.[48]

A 'punk' is an archaic word for a prostitute or a woman who behaved like a prostitute. Lady Dorothy was not saying that many poets and men of daring were literally the children of prostitutes but rather that they were often born to women from an aristocratic or gentry background who had acted like harlots in their personal lives through adulterous liaisons. It is surely significant that Aubrey chose to put this strange statement at the very beginning of his study of the lives of distinguished people.

Aubrey's cousin and the witch of Wapping

By the early 1650s Aubrey was trying to get known in London's elite intellectual circles. He spent substantial time with his well-connected, if controversial, cousin Sir John Danvers, who lived in some style in Chelsea. Aubrey was in awe of Danvers. He had known the great poet John Donne. He was the stepfather of another distinguished poet, George Herbert. The older man had undertaken the Grand Tour and brought back ideas of Italian garden design to England. Although the trip did not materialise, Aubrey planned to visit Italy himself and discussed his intentions with Danvers. Aubrey later planned to build an Italianate garden for himself in Wiltshire, modelled on Danvers' gardens.

It was fashionable for members of the London intelligentsia at this time to proclaim their allegiance to the reform programme and scientific methods outlined by Sir Francis Bacon (1561–1626). Aubrey declared himself to be a Baconian as a young man, and he was deeply impressed by the fact that his cousin had personally known Bacon. He quizzed his kinsman for information about Bacon and much of the biographical detail about Bacon presented in Aubrey's *Brief Lives* came from these conversations. Danvers told Aubrey how Bacon had sought out his feedback on some of his work because he valued his judgement so much.

Aubrey was, without doubt, susceptible to snobbery. Family background was very important to him. He was very proud of his

connection with the aristocratic Danvers family, whose main country house at Dauntsey in Wiltshire was near Aubrey's own home in Kington St Michael. During his childhood the leading members of the Danvers family were the brothers Henry and John. These men were not particularly close relations of Aubrey's; technically they were third cousins once removed. However, to Aubrey they were kinsmen. He was impressed by his relatives who had moved in the highest social circles. Henry Danvers was a leading courtier under both James I and Charles I. He was ennobled as the Earl of Danby. His younger brother, Sir John Danvers, was also a prominent political figure at the royal court before the Civil War. Danvers divided his time between Chelsea and his country house in West Lavington in Wiltshire, developing spectacular gardens at both his homes.

By the late 1640s, John Danvers was a controversial figure. He had sided with the Parliament in the Civil War, and agreed to serve as a judge at the trial of Charles I. He was one of the signatories of the Death Warrant of the king. This did not reduce his standing in the eyes of his young cousin, who described him in *Brief Lives* in complimentary terms. He was clever, well connected, remarkably good looking and highly cultured.

In his *Natural History of Wiltshire* Aubrey recalled the experience of visiting Danvers' magnificent Chelsea house and garden in about 1652. Danvers employed the finest musicians in England to provide entertainment for his guests. The chief musician was a distinguished composer called Christopher Gibbons (the son of another, more famous musician, Orlando Gibbons), who had previously worked for Charles I. As guests dined, they could enjoy two beautiful views: one window faced the Thames and countryside of Surrey, the other window overlooked the magnificent garden.

Danvers was a justice of the peace in London. In March 1652, about the same time that Aubrey was listening to the music of Christopher Gibbons in the magnificent setting of the house at Chelsea, Danvers played a central role in the prosecution for witchcraft of a 'cunning woman' from east London. Her name was Joan Peterson and she became known as 'The witch of Wapping', after the district in London where she lived and operated.

Aubrey must have been aware of the case of Joan Peterson. He was a frequent visitor to his cousin's house and the trial, in which Danvers was undoubtedly involved, attracted lots of publicity. Shortly after

the Old Bailey trial, two pamphlets were published denouncing Joan as a witch and asserting the correctness of her punishment.[32] The pamphlets were sensationalist, intended to intrigue readers with lurid details about the witch and her astonishing crimes.

Reading between the lines of these hostile accounts of Joan Peterson's life and death, we can discern some facts about magical beliefs and practices in 1650s London. Peterson operated openly as a 'white witch' or 'cunning woman'. Her services to paying clients included healing, love potions and counter-magic for those who thought they were bewitched. In addition to witnesses who denounced her as a witch, some testified positively about her at her trial. One woman consulted her over a sick, supposedly bewitched, cow. Peterson 'cured' the cow using a ritual that involved boiling the cow's urine and identifying the witch who was responsible for the enchantment. The use of a victim's urine, whether human or animal, features frequently in other reports that we have of the counter-magic or 'unwitching' at this time.

The accusations that led to Joan's conviction included, to modern eyes, some wildly implausible claims. Perhaps the least credible assertion was that Joan was a witch with a familiar spirit in the form of a squirrel. Joan's own son, aged seven or eight, was supposed to have told his schoolfriends that his mother took instructions from a squirrel. A maidservant who worked for Peterson confirmed to the court that she had a squirrel as her familiar. The maid shared a bedroom with Peterson and witnessed a late-night visitation from the demon squirrel. She gave testimony to the court about how, one evening, she was warned by Joan that a squirrel might appear, which it duly did.

> And accordingly about midnight there came a Squirrel (or a Familiar in that likenesse) and went over the wench to Peterson, which so affrighted her that she lay as if she were in a trance; and she further affirmeth, that her Mistresse and it talkt together a great part of the night; but being demanded what they discoursed on, she replied, that she heard her conference very perfectly, but she was so bewitched by it, that she could not remember one word.[33]

In addition to the hostile publications that presented Joan as an evil witch who was justly punished, another very different account exists. Not long after the execution, an anonymous pamphlet was published bearing the title *A declaration in answer to several lying pamphlets*

concerning the witch of Wapping.[34] This sets out a convincing case for an alternative narrative regarding the death of Joan Peterson. It identifies John Danvers as one of a gang who set out to 'frame' Peterson, as part of a wider plot to destroy a wealthy woman called Anne Levingston, with whom they were in conflict.

In 1651, a wealthy heiress named Lady Mary Powell died. Mary had no children but lots of nephews and nieces. Before her death, she disinherited all but her favoured niece Anne Levingston. The disinherited nephews and nieces were incensed and decided to seek redress. Sir John Danvers supported their campaign. He used his position as a Member of Parliament and as a justice of the peace to help the discontented relatives in their conflict with Anne Levingston.

Why was Danvers prepared to help? The answer lies in his financial situation. Danvers was notoriously extravagant and lived far beyond his means. By 1652 he was greatly in debt and pursued by creditors. Most importantly, he owed large sums of money to the estate of Lady Mary Powell. He had clashed previously with Levingston, and he knew that she disliked him. He seems to have feared that Anne Levingston, once confirmed as the heir to the estate, would demand repayment of these debts, thereby ruining him.

According to *A declaration*, the group of disgruntled relatives, supported by Danvers, decided to fabricate a claim that Anne Levingston had used the services of a witch. First, the witch was to put a spell on Lady Powell so that she was under the power of Anne Levingston and would alter the family settlement in Anne's favour. With this done, she was to use black magic to kill Lady Powell. Joan Peterson, a well-known cunning woman, was selected as a convenient scapegoat, and was falsely named as having carried out witchcraft against Lady Powell on Anne's instructions.

As a result of this fabricated accusation, Peterson was committed to custody in Newgate gaol to await trial at the Old Bailey. At this point, according to *A declaration*, John Danvers became particularly active. The first phase of the trial process was managed by local justices of the peace. Danvers was a London magistrate, although he had been largely inactive for some time. He made an exception for this case. Danvers met up with other London magistrates and the disinherited relatives to plan the prosecution of Joan Peterson. They convened at a tavern near Hicks Hall, the courthouse where preliminary hearings were conducted, prior to full trial at the Old Bailey.

The anonymous author of *A declaration* stated that Danvers set out to influence the outcome of the trial through private conversations with the Old Bailey judges. Danvers spoke to them about the case over dinner. He sought out the chief Old Bailey judge, the Recorder of London, and discussed the need to convict Joan Peterson of the murder of Mary Powell. He tried to influence the outcome of the trial by sitting alongside the judges at the Old Bailey.

> Sir John Danvers came and dined at the Sessions house and had much private discourse with the Recorder and many of the Justices and came and sate upon the Bench at her Trial, where he hath seldome or never been for these many years.[35]

During the trial the plan of Danvers and his fellow conspirators went wrong. Joan was urged to confess and to implicate Ann Levingston but refused to do so. The charges of murder collapsed when statements were submitted from some of London's top doctors, certifying that Mary Powell had died of natural causes. The jury refused to convict Peterson for the murder of Mary Powell, but she was found guilty of a lesser charge of harming one Christopher Wilson by witchcraft and, on this basis, sentenced to death.

While Joan Peterson was awaiting execution, the enemies of Levingston attempted to get her to implicate Levingston in return for a pardon. She refused to assist.

> And after that the said confederates and their agents went very often to her promising her a Repreive or Pardon if she would confesse that Mrs. Levingstone had Imployed her to make away the life of the Lady Powell, to which she replyed she could not, because it was altogether false.[36]

A declaration described the execution of Joan Peterson and how the clergyman, whose role was to give her spiritual advice before her death, repeatedly asked her to accuse Levingston of involvement in the witchcraft plot. The executioner intervened, telling the clergyman to leave Peterson in peace. He replied that 'he was commanded so to doe, and durst doe no otherwise'. The clear implication was that members of the gang pressurised the clergyman to harass Peterson, even as she was preparing to die because of their false accusations.

Can we trust a pamphlet that accused Danvers and others of causing the death of an innocent woman, Joan Peterson? Danvers was certainly capable of behaving very badly. By the early 1650s he had a reputation for extravagance, corruption and self-interest. Many people complained about his behaviour. In 1650, for example, a woman called Anne Smyth petitioned Parliament stating that Danvers had defrauded her of an estate of £1,000. A leading modern academic expert on Parliament in this period, Blair Worden, has stated that Danvers was one of a small group of corrupt MPs 'whose behaviour does leave a decidedly unpleasant taste in the mouth'.[37]

In 1649 Danvers had been an energetic member of the Commission that tried Charles I and sentenced him to death. He was conscientious in attending the trial sessions. It was widely held that he had agreed to join the prosecution of Charles I and sign the Death Warrant not through principle, but in order to gain parliamentary support relating to a dispute he had with his sister over the inheritance of the family estate.

If Danvers was prepared to sign the king's Death Warrant on grounds of financial self-interest, it is entirely possible that he was prepared to allow a poor cunning woman to die, on false charges of witchcraft, for similar reasons of personal benefit. There is no obvious reason to doubt the account of Danvers' role in the death of Joan Peterson as presented in *A declaration*.

While Aubrey celebrated his cousin's beautiful garden, he made no reference in his surviving work to the case of Joan Peterson and the role that Danvers played in her death. He must have known about the trial and the accusations against his cousin. The story, including claims about Danvers' involvement, was public knowledge and was in print. Despite this, Aubrey was silent about what happened.

Aubrey's own cousin, then, whom he admired for his cultivated sensibility and love of gardens, apparently played a leading role in the killing of an innocent woman accused of witchcraft. The tale of Joan Peterson demonstrates that in the capital city, as in rural Wiltshire, belief in magic was commonplace among both rich and poor. The story also indicates the gulf that existed between Aubrey's social class and ordinary people. The prosecution was based on a callous disregard, on the part of Danvers and his associates, for the life of Joan Peterson. This was a world in which the death of a poor cunning woman was considered a price worth paying by some members of the elite, including Danvers, who were preoccupied with their own self-interest.

2

BELIEF IN WITCHCRAFT AS THE ANTIDOTE TO ATHEISM

During the 1650s Aubrey befriended the philosopher Thomas Hobbes, who was one of the most controversial men in England because of his radical religious views. Theirs was an unlikely friendship because they had markedly different attitudes towards the world of magic. Aubrey was a believer in the spirit dimension, while Hobbes completely denied the reality of supernatural phenomena. For Hobbes, people who claimed that they possessed magical powers were completely deluded.

Aubrey felt a strong affinity with Hobbes. They were both originally from the same part of Wiltshire and, by coincidence, had both been taught by the same inspirational teacher as little boys. Aubrey called Hobbes his 'countryman', meaning not that they were both English but rather that they both came from the Malmesbury area. Aubrey was proud that his own neighbourhood had produced a philosopher who could hold his own with the likes of Descartes, and that he could call this great man his friend.

Aubrey's admiration for Hobbes is evidence of his considerable open-mindedness and flexibility. He liked daring and innovative thinkers, even when he disagreed with them. Aubrey was not a great admirer of the Church, and he was probably impressed by the courageous way in which Hobbes challenged its orthodoxy.

Hobbes, it seems, was also tolerant of his young friend's views about the supernatural, which were so different from his own. While Hobbes had no time for astrology, he was prepared to humour

Aubrey, providing him with very precise information about his birth (two minutes after five in the morning of 5 April 1588) so that Aubrey could prepare a horoscope of the philosopher for a proposed biography.

Although Hobbes was much older than Aubrey, they both encountered similar beliefs about witchcraft and evil spirits when growing up. In one of his books, Hobbes gave a brief and bleak summary of the fears that preoccupy the very young, echoing his own experiences: 'Children fear to go in the dark, upon imagination of spirits.'[1]

Hobbes' recollection of what he was taught about fairies in his childhood was consistent with Aubrey's account. Like Aubrey, Hobbes described the popular belief that fairies swapped human babies for demonic changelings, with limited intellectual capacity.

> The Fairies likewise are said to take young Children out of their Cradles, and to change them into Naturall Fools, which Common people do therefore call Elves, and are apt to mischief ... When the Fairies are displeased with any body, they are said to send their Elves, to pinch them ... The Fairies marry not; but there be amongst them Incubi, that have copulation with flesh and bloud ... They enter into the Dairies, and Feast upon the Cream, which they skim from the Milk.[2]

While Aubrey and Hobbes encountered the same folk beliefs, they came to completely different conclusions. For Aubrey, it was possible that fairies genuinely existed. For Hobbes, this was nonsense. While Aubrey saw some dreams as messages from the supernatural world, Hobbes explained dreaming as an entirely natural phenomenon. Aubrey considered that apparitions were authentic visitations from the spirit world. Hobbes explained apparitions as instances of overexcited imagination or fraud.

> If they be timorous and superstitious, possessed with fearful tales, and alone in the dark, are subject to the like fancies, and believe they see spirits and dead men's ghosts walking in churchyards; whereas it is either their fancy only, or else the knavery of such persons as make use of such superstitious fear to pass disguised in the night to places they would not be known to haunt.[3]

Thomas Hobbes and Henry More: contrasting responses to the witch craze of the 1640s

There was an extraordinary upsurge in the persecution of women for witchcraft in England during the years 1644–46. The centre of the outbreak was East Anglia, where Matthew Hopkins and his assistant, John Stearne, actively stirred up hostility towards those suspected of witchcraft. English intellectuals responded differently. This can be illustrated by comparing two philosophers, Thomas Hobbes and Henry More. Hobbes, who did not believe in the reality of witchcraft, was perplexed by the events in East Anglia and the tendency of women to confess at their trials. By contrast, More accepted that many of the accused women were indeed guilty of witchcraft.

Hobbes spent the 1640s in Paris as a political exile because of his royalist views. Lady Margaret Cavendish, later the Duchess of Newcastle, was also in Paris and she described how Hobbes and her husband, William Cavendish, in the late 1640s, fell 'into a Discourse concerning Witches'. The discussion was probably prompted by the recent witchcraft hysteria in Essex and Suffolk, promoted by Hopkins, the self-styled Witchfinder-General. Margaret described the conversation in her biography of her husband.[4]

During the Paris discussion, Hobbes told Cavendish that he 'could not rationally believe there were Witches'. Cavendish agreed with him that witchcraft had no reality. Hobbes told Cavendish that he was puzzled, given that witchcraft had no real potency, that so many suspects in witch trials, 'if strictly examined', confessed to being witches. He was probably influenced by some of the pamphlets that had been published at this time recounting the remarkable confessions of witches in East Anglia.

Cavendish explained the confessions by saying that some women genuinely thought that they were witches, deluding themselves into finding evidence to confirm this conviction. They called upon the Devil to harm their enemies and often, coincidentally, bad things did happen. They took this as proof that the Devil had genuinely granted them malevolent power. For Cavendish, the deluded women who considered themselves to be actual witches were also able to make sense of those occasions when their black magic was ineffective. The failure of their magic was proof that their service of the Devil was deficient in some way.

Cavendish and Hobbes discussed the likelihood that some of the delusions of 'witches' were the result of women confusing dreams and reality. Dreams of demonic flying or shapeshifting were incorrectly perceived as lived experiences. Margaret Cavendish documented their theorising about these deluded women, who were so out of touch with reality.

> They imagine that their Dreams are real exterior actions; for example, if they dream they flye in the Air, or out of the Chimney top, or that they are turned into several shapes, they believe no otherwise, but that it is really so.[5]

While Hobbes was entirely convinced that the witches of East Anglia were delusional, Henry More saw things very differently. More was a Fellow of Christ's College, Cambridge University and was, like Hobbes, a philosopher. Based in Cambridge, he lived not very far from the towns and villages where Hopkins and Stearne were active.

More, the Cambridge don, followed events in the nearby town of Huntingdon closely. Four local women and one man were hanged there for witchcraft in 1646. More had little doubt about their guilt. He later stated that he was particularly convinced by the confession of John Winnick, one of the people executed at Huntingdon. Winnick had confessed that he had agreed to a pact with the Devil many years earlier and that he possessed three familiars, demons in animal form. These evil spirits took the shape of a bear, a cat and a rabbit. The chief familiar was the bear. Winnick's confession related how the familiars visited him daily for twenty-nine years and sucked his special teat, helping him also with a campaign of supernatural malevolence directed against his neighbours. More considered the truth of this confession to be manifest. He commented that such a precise recollection could not be based on delusions or dreams, and that it was not possible to fantasise about such things over so many years.

> It is incredible that such a series of circumstances back'd with twenty nine yeares experience of being suck'd and visited dayly, sometimes in the day time, most commonly by night, by the same three Familiars, should be nothing but the hanging together of so many Melancholy Conceits and Phansie.[6]

Witchcraft and Leviathan

In 1651 Hobbes published his philosophical masterpiece, *Leviathan*. Although much of the book is an exploration of the nature of political authority, Hobbes also outlined his views about religion and the spirit world in *Leviathan*. He completely denied the existence of immaterial spirits. Dreams were generated by the impact of sense experience on the mind. They required no supernatural explanation. People supposedly possessed by demons in the Bible were suffering from mental illness. His message on witchcraft was unambiguous: 'As for Witches, I think not that their witch craft is any reall power.'[7]

Underpinning Hobbes' scepticism about all things supernatural was his radical and innovative materialist philosophy. In contrast with conventional Christian religious orthodoxy, Hobbes claimed in *Leviathan* that the spiritual dimension to the world simply did not exist. The human body was an exclusively physical object. There was no immaterial soul. There was no supernatural realm beyond the natural world. The mind operated on purely mechanical principles. Immaterial creatures were a fantasy. Since there were no evil spirits in Hobbes' world, it was, of course, impossible for witches to harness the power of spirits.

Hobbes' attack on witchcraft was part of a much bigger assault on the concept of the spiritual, immaterial world. His detractors said that his denial of the existence of the immaterial amounted to the terrible sin of atheism, for if there was no such thing as an immaterial soul, how was it possible to believe in the Christian God? His critics concluded that Hobbes was in danger of destroying belief in Christianity.

Henry More's attack on atheism

For many, Hobbes became a hate figure after the publication of *Leviathan*, but Aubrey was unwavering in his admiration. It seems that the two friends agreed to disagree about the supernatural. Their friendship blossomed during the 1650s, despite the notoriety of Hobbes' views. By the end of the decade, Aubrey was enthusiastically doing research into the life of Hobbes for a future biography and offering the philosopher advice on how to position himself with the new government after the Restoration.

While Aubrey remained on extremely good terms with Hobbes, many other contemporaries were deeply scandalised by *Leviathan*, claiming that Hobbes was challenging the fundamental tenets of Christian belief. The outrage at Hobbes' religious views grew during

the 1650s and the early 1660s. He was labelled as an 'atheist', even though he personally denied the charge. Hobbes was considered so outrageous in his religious views that he was not invited to join the Royal Society when it was established in the 1660s, despite his great reputation across the Continent.

In the years that followed the publication of *Leviathan*, there was deep anxiety about the spread of dangerous atheistic ideas such as the teachings of Hobbes. One of Hobbes' leading detractors was Henry More, the Cambridge philosopher who had believed the confession of John Winnick, hanged for witchcraft at Huntingdon. More concluded that the logic of thinkers like Hobbes, who denied the spirit world, inevitably led to the denial of the existence of God. His motto was 'No Spirit, No God'.

More was determined to show that Hobbes, and other alleged atheists, were fundamentally wrong about the non-existence of immaterial spirits. He decided to take a stand on the question of witchcraft. If witches could be shown to have authentic power, through their engagement with evil spirits, then Hobbes' fundamental proposition about the non-existence of spirits was fatally undermined. Convincing evidence of genuine witchcraft would amount to proof that there was a spirit dimension to the world, and that people like Hobbes were wrong.

More saw that some aspects of the campaign of Matthew Hopkins were disreputable and problematic. In 1650, by which time Hopkins was dead, More described him as 'that troublesome fellow, Hopkins the Witch-finder'.[8] More also acknowledged that harsh interrogation could lead innocent women to confess to witchcraft crimes of which they were innocent. He described the phenomenon of 'overwatched witches, that are forced many times to confesse that which they were never guilty of'.[9]

Despite these reservations, More fundamentally believed in the reality of witchcraft. In 1653 More published *An antidote against atheism*. The first two parts of this work contained philosophical arguments intended to prove the existence of God. The third part was different; it was a collection of examples of supposedly credible cases of witchcraft and other supernatural events. More believed that any reasonable reader of the cases he recounted would, first, be convinced that witches existed and had real power and, second, conclude that if witches and evil spirits existed then God must also exist.

While More accepted that some popular stories about witches were nonsense, he believed that it was possible to establish a systematic

approach to the evaluation of evidence relating to witchcraft. He proposed what he saw as a logically irrefutable way of categorising accounts of witchcraft as worthy or not worthy of trust. More set out three conditions that could be used to test whether an alleged witchcraft event was authentic.

> First if what is recorded was avouched by such persons who had no end nor interest in avouching such things. Secondly if there were many Eye-witnesses of the same Matter. Thirdly and lastly if these things which are so strange and miraculous leave any sensible effect behind them.[10]

The first two tests concerned the quality and quantity of the witnesses who could testify to the truth of the phenomenon. The third test involved consideration of the existence of observable, concrete evidence generated by the witchcraft event. For More, instances that passed the three tests could safely be categorised as genuine cases of witchcraft. Anyone who denied this was, he thought, acting unreasonably.

Most of the instances of supposedly credible witchcraft that he recounted were derived from the European literature of witchcraft. More drew particularly heavily on the demonological books of the French writers Jean Bodin (1530–96) and Nicholas Rémy (1530–1616). These two sources were used repeatedly by both More and other proponents of the truth of witchcraft. More supplemented stories from Bodin and Rémy with the most plausible accounts of witchcraft in England that he could find, such as the story of John Winnick, the male witch hanged at Huntingdon.

More's intention was to write a scientific treatise about witchcraft. In documenting real-life empirical data to support his theory, he saw himself as using the methods of a scientist rather than a philosopher. He called himself a 'naturalist', a scientific observer of the natural world: 'I appear now in the plaine shape of a meere Naturalist, that I might vanquish Atheisme.'[11]

More undertook what a modern academic would describe as a literature review, drawing evidence from his extensive reading of previous demonological studies that he considered trustworthy. He also used his own first-hand, empirical investigations of those suspected of witchcraft. He looked for opportunities to meet and

study witches face-to-face. Through talking to those accused of witchcraft, he concluded that they were not typically confused, elderly women with a weak grasp on reality, as sceptics suggested. The women he interviewed were perfectly lucid.

> To satisfie my own curiosity, I have examined several of them, and they have discours'd as cunningly as any of their quality and education.[12]

We know that, on at least two occasions in the 1640s, More personally interviewed women who were suspected as witches and were being held at Cambridge Castle awaiting trial. He described these events in the first edition of *An antidote against atheism*. The first instance involved the interrogation of four or five unnamed women. On the second occasion, probably in the early months of 1646, the main suspect was a woman whose surname More gave as Lendall. He noted, tersely, that she was subsequently executed: 'Lendall-wife … afterwards at Cambridge suffered for a Witch.'[13]

John Stearne, accomplice of the witchfinder Matthew Hopkins, also wrote about the trial of Goodwife Lendall, describing her as one of those deceptive witches who 'made outward shews, as if they had been Saints on earth'. Stearne's comment is intriguing because it suggests that Lendall was not considered disreputable before the Hopkins witch craze. Unlike Stearne, More took no interest in Lendall's personality and previous life.

When interviewing Goodwife Lendall in the county gaol in Cambridge, More took with him a friend called Ralph Cudworth, another philosopher who later became well known and was invited to join the Royal Society after the Restoration. The Cambridge academics talked with Lendall and her fellow suspect. In response to their questions, the other prisoner, whose name was not given, turned on Lendall. She accused Lendall of promising to find her a husband but instead introducing her to the Devil in the shape of a mysterious man in black. The woman explained how she was invited by Lendall to meet her future husband, only to find herself present at a witches' feast, presided over by the man wearing black. More admitted that he did not know quite what to make of this strange story. He suggested that it was consistent with evidence from continental Europe where the Devil sometimes appeared as a black man.

An expanded second edition of *An antidote against atheism* appeared just two years later, in 1655. In this More dropped the account of his interview in Cambridge Castle with witchcraft suspects; it seems that he had second thoughts about the tale of the man in black who had presided over the witches' banquet in Cambridgeshire. Instead, he included in the new edition a major new case study, relating to the 1653 trial and execution of Anne Bodenham for witchcraft in Salisbury. More devoted a substantial chapter of eighteen pages to this story. It constituted the most detailed, empirical case study of witchcraft in his revised book.

As we shall see, the Bodenham case also interested John Aubrey; however, the two men would reach very different conclusions about her guilt. More had absolutely no doubt that Bodenham was a genuine witch. He considered the Salisbury case to be highly significant, providing a recent English example of witchcraft that met his credibility criteria.

More's work on witchcraft proved popular. One enthusiastic reader was the apothecary and physician William Drage, who lived and worked in Hitchin, Hertfordshire. In 1665 he published *Daimonomageia*, a guide to witchcraft for medical practitioners and others. In this work, Drage explained to other physicians how they could diagnose and treat diseases caused by witchcraft. The book contains several complimentary references to More's work. Drage had absolutely no doubt about the correctness of More's claims. He cited More's account of Anne Bodenham as evidence that evil spirits were, undoubtedly, attracted by foul-smelling incense.

> Anne Bodenham, we read in Henry More, when she raised Spirits, made a stinking perfume on Coals, after her Circle was drawn, and conjuring Charmes in her Book read; the Devil loves, it seems, evil base Odours.[14]

Drage considered that More, and other learned authors, vindicated his own, largely traditional, beliefs about the truth of witchcraft. He promoted, for example, the use of 'swimming' – throwing suspects bound into a lake or river – as a means of confirming the guilt of a witch. He described, approvingly, how swimming had been used successfully as a way of establishing the guilt of witches at the towns of Baldock and St Albans in his home county of Hertfordshire.

At the same as he validated folk beliefs, Drage also attempted to demonstrate his own modern, scientific credentials. He provided a detailed clinical study of a local girl called Mary Hall, who was, he asserted, possessed through witchcraft. He described, approvingly, attempts to cure the girl with modern chemical drugs, selected for their power to drive out the possessing demon.

Robert Boyle and demonic poltergeist of Mâcon

Henry More was an important philosopher, but the scientist Robert Boyle was an even more significant figure in the history of ideas. During his lifetime he achieved international fame for his scientific discoveries. Boyle, like More, took a stand on witchcraft as a way of attempting to defend Christianity from Hobbes and his followers.

Boyle was deeply religious. During the 1650s he became extremely worried by the ideas of Thomas Hobbes and his denial of the existence of the spirit world. For Boyle, Hobbes appeared to be promoting atheism. Boyle's logic was identical to that of Henry More; just one proven instance of witchcraft would destroy the Hobbesian position that spirits did not exist. More considered that he had found such a case in the story of Anne Bodenham, and Boyle, too, thought that he knew about an irrefutable instance of genuine witchcraft.

Boyle's witchcraft story came from a French town in the Burgundy region known today as Mâcon but which seventeenth-century English writers called 'Mascon'. In 1658 Boyle organised the translation and publication of a book entitled *The Devil of Mascon*, describing demonic poltergeist events, caused supposedly by witchcraft.

As a teenager in the 1640s, Boyle undertook the Grand Tour and was introduced, while visiting Geneva, to an elderly French Protestant minister called Francois Perreaud, who was originally from Mâcon. Perreaud told Boyle about an episode of witchcraft that he had personally experienced, many years earlier in 1612. He allowed Boyle to read the manuscript of a book that he had written recounting the events. This told how his own house in Mâcon had been bewitched and, as a result, haunted by a highly articulate demon. The spirit sang offensive songs and frequently engaged in conversation. A stream of credible witnesses, both Protestant and Catholic, came to visit the house and vouched for the reality of the demon.

Perreaud had no doubt that his house had been cursed by a witch but he was unable to prove who, in particular, was responsible.

He speculated about several suspects, including a household servant, before concluding that the single most likely witch was a woman he had evicted from the house before taking up residence. For no apparent reason, the Mâcon poltergeist eventually gave up tormenting the Perreaud family. The day after his final appearance, a mysterious viper was seen departing from the house.

Boyle was impressed, not so much by the curious story but by the level of proof. The two men kept in touch after Boyle had returned to England. In 1653 the French text of Perreaud's manuscript was published in Geneva, under the title *Démonologie*. In 1658 Boyle arranged for the text to be translated into English. He wrote a foreword endorsing the truth of its claims. The English translation was published as *The Devil of Mascon*.

Boyle's foreword took the form of a letter to the translator of the French original. In this Boyle made it clear that his starting point was that of a modern, sceptical scientist; he had an 'in disposednesse to believe strange things'. In other words, his default position was not to believe curious tales. Boyle was keen to reassure his readers that he was not at all gullible in questions of the supernatural. Quite the contrary, he required a particularly high level of proof. He was well aware that many claims about witchcraft were 'fictions and superstitions'. However, for Boyle this case was different. He considered that the evidence of the reality of the demon of Mâcon met the highest standards of proof and credibility:

> The conversation I had with that pious Author during my stay at Geneva, and the present he was pleased to make me of this Treatise before it was printed, in a place where I had opportunities to enquire both after the writer, and some passages of the booke, did at length overcome in me (as to this narrative) all my settled in disposednesse to believe strange things.[15]

Boyle was careful in his choice of translator. He asked Peter du Moulin, a well-known Anglican clergyman and theological writer of French Huguenot extraction, to undertake the translation. Du Moulin's father was also a theologian and had personally enquired into the truth of Perreaud's story while he lived in France. Boyle was looking for more than an accurate translation; he wanted du Moulin (and indirectly his father) to endorse the credibility of the claims in

the book by agreeing to be the translator. He made this clear in his introductory letter to du Moulin.

> The reputation which your and your learned Fathers names will give it, will prove as effectuall as any thing of that nature can be, to make wary readers as much believe even the amazing passages of it.[16]

Du Moulin was happy to oblige Boyle. He produced both a version of the text in English and an effusive introductory note that explicitly associated the pamphlet with the contemporary controversy about the existence or otherwise of immaterial spirits and the threat of atheism. This story needed to be told, asserted du Moulin, because it established the existence of spirits, thereby confounding the atheists. By showing that 'Devills' existed, Perreaud's text provided all the reassurance a doubter might need about the existence of God.

> I have translated this admirable story, worthy to be knowne of all men, and of singular use to convince the Atheists and halfe believers of these times: Most of which will perswade themselves that there is no such thing in the world as any spirituall, immateriall, intelligent substance; And some of them will say that which most of them thinke: That if they could have any certainty that there are Devills, they would believe also that there is a God.[17]

Du Moulin enthusiastically affirmed the truth and significance of the Mâcon poltergeist. Like Boyle and More, he was interested in questions of proof. Most cases of witchcraft happened in remote rural settings, but the Mâcon events took place in a populous urban environment. What was particularly distinctive about the Devil of Mascon for du Moulin was that there were so many credible witnesses and a remarkable consensus among enemies because both Catholic and Protestant observers agreed that they had heard the demon speak. The Catholic witnesses had a strong motive to disparage the claims of Perreaud, a Protestant minister, but they did exactly the opposite.

> It was not in a corner, or in a desert, but in the midst of a great city, in a house where there was daily a great resort to heare him speake, and where men of contrary religions met together:

whose pronenesse to cast a disgrace upon the dissenting parties did occasion the narrow examining and the full confirming of the truth thereof.[18]

The impact of Boyle's public advocacy of belief in witchcraft was dramatic. On publication, the book caused a sensation in educated circles in England. We get some sense of the excitement created by *The Devil of Mascon* from the correspondence of Samuel Hartlib. On 10 June 1658, less than a week after publication, Hartlib wrote to John Pell telling him of the new work. Pell was the ambassador of the English government to the Protestant cantons of Switzerland, a distinguished mathematician and a future Fellow of the Royal Society. Hartlib told Pell that he must take 'special notice' of the book, which 'had come forth this week'. Less than two weeks later, on 22 June 1658, John Beale wrote to Hartlib from Herefordshire about the book. Beale was a great admirer of Robert Boyle and saw the publication as a moment of profound significance. He immediately accepted the truth of *The Devil of Mascon*, although he said that he took no pleasure 'in reading [about] such diabolicall conferences & witch-craft'. Beale was later a particularly active Fellow of the Royal Society. For him, the publication of the book was a sign from God, intended to demonstrate, through evidence and reason, the existence of a demonic spirit world.

> I thinke it is Gods present designe, & his Work in hand, to declare all over the World, that such as cannot waite for the Visite of his holy Spirit ... should by humane Arguments bee convinced of the power & converse of Devills.[19]

Soon, it seemed, almost everyone in polite society knew about the book. In December 1659, John Gauden, the preacher at a funeral in London, simply assumed that all members of the congregation would know what he was talking about when he compared the troublesome fuss created by religious extremists to the demonic noise generated by the activities of 'the Devil of Mascon'.[20] Thirty-five years later, in 1693, William Freke was still thinking about the case, and recalled how the events at Mâcon were the talk of the town in London back in 1658.

> Was not the Story of the Devil of Mascon (attested by the Famous Mr. Boyle) notorious through the whole City?[21]

The Devil of Mascon was, in effect, a companion piece to More's *Antidote against atheism*, providing additional, supposedly credible empirical evidence for the existence of the world of spirits. Boyle and More were serious scholars who believed in the new science. They found the time to publish books about witchcraft because it helped in their war of words against Thomas Hobbes and others suspected of atheism. Readers immediately saw the connection between the work of Boyle and More. On reading *The Devil of Mascon*, Beale wrote straightaway to Samuel Hartlib, identifying the link: 'The Divell of Mascon is fitt to bee cited in the next edition of Mr. Mores Antidote.'[22] This was precisely what happened. When More produced a new edition of his *Antidote against atheism*, he added a fulsome reference to the book about Mâcon, as endorsed by Robert Boyle.

> And lastly, that nothing may be wanting to convince the incredulous, we adjoyn the Testimony of that excellently-learned and noble Gentleman Mr R. Boyle, who conversed with Mr Perreand himself at Geneva, where he received from him as a present a Copie of his Book before it was printed, and where he had the opportunity to enquire both after the Writer and several passages of his Book; and was so well satisfied, that he professes that all his settled indisposedness to believe strange things was overcome by this special Conviction[23]

By the time of the Restoration of 1660, battle lines were drawn. Thomas Hobbes had outraged many with his religious radicalism, his rejection of the concept of immaterial spirit and his denial of the authenticity of witchcraft. Henry More and Robert Boyle had fought back, publishing what they saw as compelling real-world evidence of the truth of witchcraft and the existence of evil spirits. They did this as a way of trying to undermine fatally the materialist views proposed by Hobbes.

In a characteristic way, Aubrey's position was ambivalent. He believed in witchcraft and the spirit world, but he also admired Hobbes and had no wish to denigrate him. Ignoring the contradictions, Aubrey continued to cultivate his friendship with Hobbes while pursuing his own investigations into the reality of the supernatural.

3

THE ROYAL SOCIETY AND THE SUPERNATURAL

The Royal Society of London met for the first time in 1660 and was granted its charter by Charles II in 1662. It played a pivotal role in the establishment of experimental science as a means of creating reliable knowledge about the natural world. Aubrey was elected as a Fellow in 1663. He was immensely proud of being a core member of the Society.

During the eighteenth and nineteenth centuries a narrative developed that the birth of the Royal Society signalled a new rationality and modernity, which swept away the superstition of the past. This orthodoxy prevailed for much of the twentieth century. However, this view does not stand up to scrutiny. Aubrey was one of several early members of the Royal Society who saw no inconsistency between belief both in the power of experimental investigation and in the reality of the supernatural. The picture was complex. Not everyone in the Royal Society took supernatural matters seriously. Influential figures such as Henry Oldenburg and Robert Hooke were, undoubtedly, highly sceptical about the supernatural.

As Michael Hunter has shown, as an *institution*, the fledgling Royal Society was a broad church which studiously avoided controversy about witchcraft. It did not have an official position on the possibility of supernatural occurrences. However, while the Royal Society as an institution neither attacked nor defended belief in witchcraft, many influential Fellows publicly and privately endorsed the reality of witchcraft.[1]

The debate about the authenticity of witchcraft was part of a much bigger argument concerning the relevance of the spiritual dimension to explanations of physical phenomena. During the seventeenth century an influential school of scientific thought developed that is sometimes described as 'mechanical philosophy'. This approach was the work of several scientists and philosophers and culminated in the theories of Pierre Gassendi, Thomas Hobbes and René Descartes. The most famous proponent of the mechanical philosophy was Descartes, and his followers were known as Cartesians. Many Cartesians explained the laws of physics in purely mechanical terms, without any reference to any spiritual forces.

John Aubrey has sometimes been dismissed as a superstitious eccentric. In fact, his view of the supernatural was shared by many other influential people. Those advocates of the truth of witchcraft who were members of the Royal Society were concerned that some versions of the Cartesian mechanical philosophy denied any role in the working of the world to spiritual or supernatural forces. Aubrey, Ashmole, Boyle, More, Glanvill, and many others believed that intelligent spirits, angels and demons, were active in the world and could influence terrestrial phenomena. These Fellows of the Royal Society were not the enemies of modern science. They welcomed aspects of mechanical philosophy, but they considered that it was insufficient as an explanatory framework. Proof of the authenticity of witchcraft was important because it was a way of highlighting the limits of Cartesian mechanical philosophy.

Beyond the Fellows, there was a wider circle of admirers of the work of the Royal Society, and many of them also subscribed to the view that science and the supernatural were entirely compatible and that Cartesian explanations were insufficient. Nathaniel Fairfax was one such individual. He was a doctor who practised in Norfolk and later Suffolk. Although not a Fellow, Fairfax was extremely enthusiastic about the scientific programme of the Royal Society and corresponded frequently with the Society's Secretary, Henry Oldenburg on scientific matters, informing him, for example, of his reflections as to whether swallowing venomous creatures would lead to death by poisoning.

In 1674 Fairfax published a treatise that attempted to popularise aspects of the new science, and which celebrated the achievements of the Royal Society. He identified Boyle as 'the glory' of both the Society and England, upon whose genius the 'whole world besides

us' depended. Fairfax both promoted the new science and celebrated the fact that Boyle had demonstrated that immaterial spirits could act in the material world through the account of the demonic poltergeist activity at Mâcon. Fairfax suggested that *The Devil of Mascon* was doubly impressive because of the importance of the evidence from France and the status of the man who endorsed the truth of the story. The treatise was important, 'whether you look upon the feats done, or the witness of the story that speaks them so'.[2] On the basis of this story, and the testimony of someone as eminent as Boyle, even the doubting apostle Thomas could not dispute the reality of the spirit world.

Angels, demons and Robert Boyle

Robert Boyle was the pre-eminent figure of the first generation of the Royal Society. He had no doubt about the existence of angels and demons, and the reality of witchcraft. As we have seen, Boyle publicly proclaimed his belief in witchcraft in 1658 when he sponsored the translation of the French text *The Devil of Mascon*. In the decades that followed, Boyle did not change his mind about the authenticity of witchcraft and the existence of a demonic and angelic spirit world.

Robert Boyle thought a lot about the supernatural. Not only was he sure about the reality of angels and demons, he also speculated on the possible existence of enormous numbers of spirits of other types, 'an inestimable multitude of Spiritual Beings, of various kinds'.[3] Distant planets and stars might contain alien spirits about which we know nothing. There could be spirits inhabiting 'all the Celestial Globes, (very many of which do vastly exceed ours in bulk)'. This raised, for Boyle, interesting theological questions. Angels and demons were known to be saved or damned, respectively, but in other worlds there might be spirits who were still being tested by God, just as Adam and Eve were tested in the Garden of Eden.

Boyle was interested in the mechanisms whereby immaterial spirits could be temporarily embodied. Human intellectual and spiritual faculties were 'vitally associated with Gross and Organical Bodies'.[4] How did spirits operate in the material world? Boyle expressed puzzlement as to whether angels and demons might ever possess a distinctive type of 'gross' or material body like humans. He posed the question: 'whether in each of those two kinds of Spirits, the Rational

Beings be perfectly free from all union with Matter, though never so fine and subtile; or whether they be united to Vehicles, not Gross, but Spirituous, and ordinarily invisible to Us?'[5]

The nature of demons fascinated Boyle. He sought to use scriptural evidence and Christian tradition to establish a base of secure knowledge about these non-human creatures. Spirits are seldom or never seen by us so one might assume they were not numerous, but the scriptural evidence suggested the opposite. One possessed man was described in the Gospels as being infested by a 'legion' of demons. Taking a literal view that this was a reference to the size of a Roman legion, Boyle explained that this probably meant six or seven thousand demons could possess just one man.

Boyle's reading of Christian scripture led him to conclude that there was a whole invisible world of evil spirits, which was well organised politically, with its own government structures and a collective mission to harm humanity.

> There is a Political government in the kingdom of darkness; that the Monarch of it is exceeding powerfull, whence he is styl'd the Prince of this World, and some of his officers have the titles of principalities, powers, rulers of the darkness of this World, &c. that the subjects of it are exceeding numerous; that they are desperate enemies to God and Men.[6]

The power of demons was real but circumscribed by God. Demons, Boyle thought, could be resisted and defeated by good angels and good people. It was the responsibility of dutiful Christians to fight against demons. Although they were at liberty to do harm now, demons would be restrained and punished after the Day of Judgement, together with their human followers: 'They shall be doom'd to suffer everlasting torments, in the company of those wicked men that they shall have prevail'd on.'[7]

There was, for Boyle, a symmetry and similarity between the well-organised world of demons and that of angels. The angelic domain possessed many of the same characteristics as the demon world: scale, complexity, hierarchy, rules. However, the purpose of angels was entirely at odds with that of demons. While evil spirits devoted themselves to harming humanity, angels were dedicated to assisting people.

Baconian 'natural history' and the supernatural

The great hero of Boyle, and the other founding members of the Royal Society, was Sir Francis Bacon. The early Fellows of the Society saw themselves as implementing Bacon's programme for the transformation of the world through systematic scientific investigation. Some Fellows set out to apply Baconian principles to the study of the supernatural. These Baconian students of the science of the spirit world included not only Aubrey but also Robert Boyle, Henry More, Joseph Glanvill, Robert Plot and James Long.

For this group of scholars and virtuosi an important stage in a Baconian investigation was the creation of a so-called 'natural history'. The phrase had a very specific meaning. Bacon considered that scientific investigators first had a responsibility to collect large amounts of data about specific topics, with a focus on cataloguing curious phenomena that required further analysis. The preliminary collection of interesting or anomalous data was a 'natural history'. The data would then be subject to further investigation.

Robert Boyle endorsed the 'natural history' approach, further refining it, and emphasising the need to gather as much testimony as possible from knowledgeable, trustworthy witnesses using a standardised list of questions.

John Aubrey was, from a very early stage in his career, a great enthusiast for Bacon's methods. When young Aubrey introduced himself to the influential intellectual Samuel Hartlib, in 1652, he was keen that Hartlib should know both that he was acquainted with Robert Boyle and that he was interested in promoting Baconian projects.

In keeping with the principles of Baconian 'natural history', Aubrey saw his primary role as documenting interesting occult phenomena, without providing detailed evaluation and analysis of the evidence; that was a task that he left to others. There is no doubt that Aubrey consciously undertook his investigations into the natural and supernatural characteristics of his home county as a Baconian project. The title of his *Natural History of Wiltshire* is a clear allusion to Bacon's ideas. Aubrey's book about the supernatural, *Miscellanies*, was also intended as a Baconian 'natural history'.

In *Miscellanies*, Aubrey described different forms of magic and implied, if sometimes in a non-committal way, that they might be genuinely effective and were worthy of further study. He included charms intended to prevent different forms of sickness and to predict the

identity of a future spouse. Aubrey described, with apparent approval, several different ways of countering the malevolent magic of witches: herbal remedies, protective horseshoes, the burying of 'witch bottles' containing the urine of bewitched animals and placing of flints round the necks of horses to ward off witches. In the case of counter-magic against witches using herbs, he gave a form of endorsement based on the word of his friend, the astrologer Henry Coley. A mix of poplar, vervain and hypericon, heated with a red-hot iron, was applied to the backbone in order to fend off a witchcraft attack. Aubrey commented that the result had been, according to his friend, 'great success'.[8]

Aubrey's *Natural History of Wiltshire* was only published, in partial form, long after his death. Others were more successful in seeing their 'natural history' investigations through to print, and the most notable of these was the work of another Fellow of the Royal Society, Robert Plot.

Plot was younger than Aubrey. He was an academic at Oxford University. He began his Baconian investigation of Oxfordshire in 1674. His *Natural History of Oxfordshire* was published in 1677, to considerable acclaim. Another county study, *The Natural History of Staffordshire*, was published in 1686.

Aubrey provided some assistance to Plot when he was writing his book about Oxfordshire. Plot was not very gracious in acknowledging this help. Aubrey lent Plot a range of materials including manuscripts of his own 'natural history' investigations into Wiltshire and Surrey, together with additional material on Oxfordshire. Aubrey was extremely disappointed that Plot failed to acknowledge his contribution in the first edition of the *Natural History of Oxfordshire*, although the book is packed with grateful references to other scholars.

Plot's work on Oxfordshire was largely scientific. He presented a carefully researched picture of the geology, agriculture, flora and fauna of the county. His observations about fossils were particularly pioneering and included the first printed illustration of a dinosaur bone; Plot thought that it was the bone of a giant.

One chapter in Plot's book was different to the rest. Entitled 'Men and women', it presented substantial material about the supernatural. In ways that foreshadowed Aubrey's *Miscellanies*, Plot recounted Oxfordshire stories of apparently authentic premonitions. For Plot, as for Aubrey, dreams sometimes predicted future events. Plot was convinced, as was Aubrey, that some people were given supernatural

warning about their imminent death, through unexplained noises or 'knockings'. Plot used his Oxfordshire study to suggest that miracles were possible. In 1650 a woman called Anne Green, wrongly convicted of murder and hanged at Oxford, revived just before she was about to be dissected by anatomists. For Plot, it seemed that God was not prepared to tolerate the injustice of her death.

> The reviviscence of Anne Green, innocently condemned to dye, and executed at Oxford for the murther of an abortive Infant, is rather ascribed to the Justice of Heaven, than to the strength or other conveniencies of nature.[9]

In his Oxfordshire study, Plot took an interest in the supernatural events that supposedly took place in Woodstock, near Oxford, in 1649 when parliamentary surveyors were attacked by a spirit or ghost with royalist sympathies. As we have seen, John Aubrey was also fascinated by this story. Plot reviewed the evidence at length and concluded that there was a case for believing that the events were genuine and that 'immaterial beings might be concern'd in this'.[10]

Plot's second county study, *The Natural History of Staffordshire*, followed a similar pattern to the work on Oxfordshire. Having surveyed the geology, flora and fauna of the county, he again devoted a chapter to 'Men and women', which contained supernatural material. As in the Oxfordshire volume, Plot provided what he saw as credible instances of premonitions of death in the form of mysterious 'knockings'. Plot also identified more instances of women who had apparently come back to life having been hanged. Plot was convinced that these women had genuinely returned from the dead and speculated as to why the physiology of women might make them more prone to this than men. He proposed a theory that the soul was more 'tenacious' in a woman's body after death; it stayed around longer, making possible a miraculous resurrection.

> Margery Mousole of Arley in this County ... came to life again, as it has been much more common for women to doe in this case, than it has been for men: I suppose for the same reason that some Animals will live longer without Air, than others will ... the juices of Women being more cold and viscid, and so more tenacious of the sensitive soul than those of men are.[11]

Plot's Staffordshire book devoted considerable space to the topic of crop circles, and the possibility that they might be caused by the dancing of witches or fairies. Plot confidently asserted that the reality of outdoor dancing by witches was well established by several reputable authors. He also reviewed, approvingly, the literature which supported belief in the existence of fairies and elves, who might also be responsible for trampling crops. Plot did not completely discount the dances of witches or fairies as the possible cause of crop circles but concluded that lightning was a more likely cause of most crop circles.

In his study of Staffordshire, Plot told one extraordinary story of divine punishment that might seem surprising to a modern reader as the work of a Fellow of the Royal Society and the first Professor of Chemistry at Oxford University. It reads like an extract from a medieval book of miracles. The story goes that a healthy but depraved young man stole a Bible. The accused man denied his guilt. According to Plot, he 'cursed himself, *wishing his hands might rot off*, if the thing were true'.[12] He came to regret these words because he duly developed a wasting condition that did, indeed, lead to his hands, and also his feet, rotting and eventually becoming detached from his body. He died shortly after this terrible punishment for his wicked acts. Plot suggested that he knew of other similar examples of divine intervention but decided that this one would suffice to make his moralistic point.

Publicising superstitious stories such as this did no harm at all to Plot's scientific career. His book on Oxfordshire was received very positively in intellectual circles and led to his election to the Royal Society in 1677. In 1683 Plot was promoted to a joint post as Oxford University's first Professor Chemistry and as the founding curator of the Ashmolean Museum at the university. He owed his preferment to the patronage of another Fellow of the Royal Society, Elias Ashmole.

Plot's intention, which was never realised, was that he would oversee a comprehensive set of natural histories for the whole of England, covering both the scientific and the supernatural. He published a questionnaire, setting out the topics that should be covered. This included substantial references to the supernatural, as well as to more conventional scientific topics. Plot proposed to ask prominent gentlemen in each county about such matters as premonitions, people coming back from the dead and evidence of ghostly apparitions.

Know you of any ... Dreames that have strangely come to passe? of men of extreame Age, of sudden deaths? of any that have been dead and raised to life againe? Know you of any thing remarqueable that attends a family in their lives or death? ... Ha's there been any certain apparition? or Know you of any Monstruous creatures to be seen in this Countrey?[13]

The idea of the need for a 'natural history' of each geographical area, covering both scientific and supernatural phenomena, reached America. When the Puritan clergyman Increase Mather documented instances of supernatural, including witchcraft, in New England in his book *Remarkable Providences* (1684), he saw his work as one part of a larger potential 'natural history', as advocated by Boyle.

I have often wished, that the Natural History of New-England, might be written and published to the World; the Rules and method described by that Learned and excellent person Robert Boyle Esq. being duely observed therein.[14]

Joseph Glanvill's mission to establish the science of witchcraft

One Fellow of the Royal Society particularly dedicated himself to promoting belief in the reality of the spirit world through the creation of a 'natural history' of witchcraft. This was Joseph Glanvill, the Rector of Bath Abbey. He saw himself as a Baconian, and a thoroughly modern scholar. His starting point was the conventional Baconian position that the scientist should first collect and analyse observations, before experimenting in order to establish theories about how the world works. Glanvill summarised the Baconian 'natural history' method as follows:

Instances must be aggregated, compared, and critically inspected, and examined singly and in consort ... We must seek and gather, observe and examine, and lay up in Bank for the Ages that come after. This is the business of the Experimental Philosophers.[15]

Glanvill applied this scientific method to his study of witchcraft. He was an Anglican clergyman with a broadly tolerant view of different interpretations of Christianity. He wrote about philosophy

as well as witchcraft. In his philosophical works, Glanvill criticised the traditional academic curriculum that was taught in the universities, particularly the dominance of the teachings of Aristotle. While attacking those who promoted Aristotelian ideas, he defended vigorously the new experimentalism of the Royal Society. Glanvill became an unofficial ambassador in the 1660s for the Royal Society and its experimental methods.

For Glanvill, the authority of ancient authors, particularly Aristotle, needed to be questioned and could not be accepted on trust. In this context, he proudly proclaimed his adherence to the motto of the Royal Society, '*Nullius in verba*', meaning 'Take no-one's word for it'. Glanvill's view was that we should not assume that even revered authors were necessarily correct. Serious scholars always need to challenge accepted truths and require compelling evidence before making truth claims.

In 1668 Glanvill published *Plus Ultra*, a comprehensive affirmation of the experimental programme of Robert Boyle and other members of the Royal Society. He contrasted the tremendous advancement of science in recent times with the limitations of traditional Aristotelian thinking. He highlighted the great progress that had been made during the modern age, particularly in the fields of chemistry, anatomy and mathematics.

Glanvill contrasted the benefits of Baconian science with the sterility of traditional university teaching and its reliance on Aristotle. Baconian discoveries were based on empirical evidence gathered from the real world. The Aristotelians used a 'notional' approach. They started with 'notions' or axioms about the world and then speculated as to the implications of these 'notions'. For Glanvill, this was circular thinking: 'The work of the Mind turned in upon it self, and only conversing with its own Idaeas.'[16] Glanvill endorsed the alternative Baconian approach: start not with 'notions' or axioms but with observations of things as they are in the real world.

Plus Ultra shows that Glanvill had immersed himself in the works of key contemporary scientists. He demonstrated an impressively detailed knowledge of such technical matters as the specific anatomical features of the body, as revealed by modern medical research, and the ways in which modern mathematics had been transformed. A substantial section of the book was devoted to a detailed and eulogistic description of the achievements of Robert Boyle. For this Glanvill had undertaken a painstaking reading of the works of the great scientist.

It may seem strange to us when we read his works in defence of witchcraft, but Glanvill was clear in his own mind that he was *the enemy* of irrational and superstitious beliefs. In his philosophical treatises he presents himself as the opponent of foolish, outmoded superstitions. We see this, for example, in the way he dismissed the idea that comets had a supernatural meaning as omens sent from Heaven. The link between catastrophic events and the appearance of comets was, he stated, purely coincidental. At the same time, Glanvill held core tenets about the existence of the spirit world which, he believed, he had validated by the application of modern scientific principles.

In about 1665, Glanvill became particularly interested in witchcraft. His first book on the subject explicitly sought to establish a scientific framework through which to consider it. This was *A Philosophical Endeavour towards the Defence of the being of Witches and Apparitions*, published in 1666. Glanvill omitted his own name from the title page; the author was simply described as 'a member of the Royal Society', in a way that was intended to add lustre and credibility to the book's claims. The term 'philosophical' in seventeenth-century usage covered the natural sciences as well as what we call 'philosophy' today; so 'a philosophical endeavour' could be paraphrased in modern terms as 'a scientific attempt' to explain the truth of witchcraft and apparitions.

Glanvill's book on witchcraft proved popular. Further editions, with additional material, rapidly followed. On the title pages of the third edition, published in 1668, anonymity was abandoned, and Glanvill's name as the author was proclaimed. The revised edition had a new title, *A blow at modern Sadducism*. The word 'Sadducism' was a barbed reference to the alleged atheism of followers of Hobbes. Those accused of atheism were abusively named 'Sadducees', after a Jewish sect, existing at the time of Christ, that denied the resurrection of the body.

Joseph Glanvill articulated his ideas about witchcraft during 1667 in a private debate conducted by correspondence with Margaret Cavendish, Duchess of Newcastle. We saw earlier how she documented the discussions about witchcraft between her husband and Thomas Hobbes in the 1640s. Margaret was also a distinguished philosopher in her own right. She was the first woman to attend a meeting of the Royal Society, and she was extremely well connected with many of the founders of the Society. Margaret was not convinced about the authenticity of witchcraft.

In her letters to Glanvill, Margaret Cavendish developed several arguments against the proposition that witchcraft was authentic. One of her points was that Christ had made no reference to witches in the Gospels, so there was no basis in Christ's teaching for belief in witchcraft. Glanvill considered this to be poor logic. Several undisputed facts, such as the existence of America, were not mentioned by Christ. We should not question the existence of witchcraft on this basis any more than we should doubt the reality of America.

Glanvill was proud of what he saw as the superiority of his own logic, compared to that of his distinguished, aristocratic opponent. He repeated, almost word for word, the arguments he developed in his debate with Margaret, in his new edition of his text on witchcraft.

Joseph Glanvill: Letter to Margaret, Duchess of Newcastle, 1667[17]	Joseph Glanvill: *A blow at modern Sadducism.* 1668[18]
He said nothing of those large unknown Tracts of America, gives no intimations of the Existence of that numerous People, much less any instructions about their Conversion. He gives no particular account of the affairs and state of the other World, but only that general one, of the happiness of some, and the misery of others. He makes no discovery of the Magnalia of Art, or Nature, no not of those whereby the propagation of the Gospel might have been much advanced; *i.e.*, The Mystery of Printing, and the Magnet. And yet no one useth his Silence in these Instances as an Argument against the being of things, which are the evident Objects of Sense.	He said nothing of those large unknown Tracts of America, nor gave he any intimations of as much as the Existence of that numerous people; much less did he leave instructions about their conversion. He gives no account of the affairs and state of the other world, but only that general one of the happiness of some, and the misery of others. He made no discovery of the magnalia of Art, or Nature; no, not of those, whereby the propagation of the Gospel might have been much advanced, viz. the Mystery of Printing, and the Magnet; and yet no one useth his silence in these instances as an argument against the being of things, which are evident objects of sense.

Glanvill tried hard to persuade Margaret Cavendish that she was wrong about witchcraft. Writing in 1667, in the same letter in which he discussed the significance of Christ's silence on the subject, Glanvill informed her that he had some powerful empirical proof of the certainty of witchcraft. This was a reference to the story of the events in Wiltshire that became known as the case of the Drummer of Tedworth.

A year after mentioning the case to Margaret Cavendish, Glanvill revealed his new empirical evidence to the world in the revised 1668 edition of his witchcraft book. Glanvill had for some years been seeking to document authentic case studies of demonic activity, and there was one that impressed him more than any other. During 1662 and 1663, the Mompesson family of the Wiltshire village of Tidworth (or 'Tedworth' as it was also known at the time) claimed that their house had been bewitched by a disgruntled beggar, and as a result they were tormented by a malevolent spirit. The poltergeist of Tidworth became known as the Drummer of Tedworth because of his habit of making anti-social drumming noises.

The Tidworth story was very similar to Boyle's earlier case study from France, the Devil of Mascon. In both cases, apparently credible witnesses described how a house had been bewitched and the occupants then terrorised by a malicious demon. However, while the French events had taken place in 1612, the English poltergeist was active as recently as 1663 and the key witnesses were still alive.

Joseph Glanvill visited Tidworth to investigate the case, and he became convinced that an authentic demonic event had taken place. The Drummer of Tedworth gave Glanvill an English case study that could equal the famous French tale promoted by Boyle. A substantial account of events at Tidworth appeared in the two 1668 editions of *A blow at modern Sadducism*.

Glanvill's expanded edition of his witchcraft book included not only an in-depth account of the Drummer of Tedworth, but also an extraordinary public letter to Lord Brereton, a founding Fellow of the Royal Society, calling on him to institute a formal Society programme of investigation into the world of spirits.

The LAND of SPIRITS is a kinde of AMERICA, and not well discover'd Region; yea, it stands in the Map of humane Science like unknown Tracts, fill'd up with Mountains, Seas, and Monsters.[19]

Glanvill expressed confidence that the Royal Society's methods of experiment, and the careful documentation of phenomena, could generate reliable knowledge about the immaterial as well as the material world.

> For we know not any thing of the world we live in, but by experiment, and the Phoenomena; and there is the same way of speculating immaterial nature, by extraordinary Events and Apparitions, which possibly might be improved to notices not contemptible, were there a Cautious, and Faithful History made of those certain and uncommon appearances.[20]

Perhaps Glanvill envisaged a prominent role for himself in the proposed official enquiry into the spirit world. In any case, the Royal Society failed to respond to his suggestion, and he was forced to continue his own supernatural investigations on an unofficial, personal basis.

Webster's attack on the witchcraft science of Glanvill and More

To their considerable annoyance, the learned witchcraft theorists Glanvill and More were systematically ridiculed in a book published in 1677 titled *The displaying of supposed witchcraft*. The author was John Webster, a medical practitioner and former clergyman based in Clitheroe, Lancashire. To make matters worse for Glanvill and More, Webster's book was published with the endorsement of Jonas Moore, who was a vice-president of the Royal Society. Glanvill and More were incensed.

Webster set out to demolish all the arguments presented by More and Glanvill and other defenders of the truth of witchcraft. He suggested that Boyle was mistaken in taking seriously the story of the Devil of Mascon. He completely repudiated the key propositions of the literature of demonology, itemising the foolish notions that he intended to refute:

> That there is a Corporeal League made betwixt the DEVIL and the WITCH, Or that he sucks on the Witches Body, has Carnal Copulation, or that Witches are turned into Cats, Dogs, raise Tempests, or the like, is utterly denied and disproved.[21]

Webster was highly dismissive of More's tendency to repeat stories found in European witchcraft texts by the likes of Bodin and Rémy. For Webster, these anecdotes could not be taken seriously. He accused More of a ridiculous level of gullibility, expressing mock surprise that a distinguished scholar from Cambridge University could believe such manifest nonsense.

> I cannot but much wonder that Dr. Henry Moore, a grave person, and one that for many years hath resided in a most learned and flourishing Academy, whose name is much taken notice of both at home and abroad, having published so many books, should make such bad choice of the Authors from whom he takes his stories, or that he should pitch upon those that seem so fabulous, impossible and incredible.[22]

While Webster savaged More for his lack of judgement, he reserved even more scorn for the work of Glanvill. Webster's book is replete with derisory comments about the quality of Glanvill's thinking about witchcraft. He dismissed out of hand Glanvill's flagship case study, the story of the Drummer of Tedworth. Webster asserted that the events at the Mompesson family house in Wiltshire were, by common consent, known to be the result of an elaborate hoax.

> Must not all persons that are of sound understanding judge and believe that all those strange tricks related by Mr. Glanvil of his Drummer at Mr. Mompessons house, whom he calls the Demon of Tedworth, were abominable cheats and impostures (as I am informed from persons of good quality they were discovered to be) for I am sure Mr. Glanvil can shew no agents in nature, that the Demon applying them to fit patients, could produce any such effects by, and therefore we must conclude all such to be impostures.[23]

Both More and Glanvill claimed that witches could, almost certainly, undertake out-of-body activity due to the separability of the mind/soul and the body. Webster correctly highlighted the significance of this issue to the proponents of witchcraft.

> Dr. Moore and Mr. Glanvil do seem to agree, namely that the Soul may for a time depart forth of its Body, and return again.[24]

For Webster, this was a ludicrous proposition. He further attacked Glanvill's attempt to construct a scientific explanation for the existence of witches' familiars and the nature of the interaction that took place when a familiar sucked on a witch's special teat. He stated that he would have made no reference in his book to such an absurd idea were it not for the fact that Glanvill had taken it seriously.

> As for the Devils sucking the Teats, Warts, or such like excrescences of the Witches bodies, we should have passed it over ... but only that Mr. Glanvil hath taken up the Cudgels to defend it.[25]

The idea that ferments were transmitted into the bloodstream of witches by real demonic familiars was ridiculed by Webster. He asked where the evidence could be found to justify this nonsense.

> But we must know of Mr. Glanvil, how he comes to know that the Devils sucking of the Witches bodies is a truth, or ever was proved to be matter of fact, who were by and present that were ear or eye-witnesses of it?[26]

Webster's own sceptical position is not quite what it might seem to the modern reader. He was a deeply religious man and his was not the voice of modern, secular rationalism. He was an alchemist, an astrologer and a mystic. Although he rejected the idea that witches possessed demonic powers, he was a believer in a form of magic. Following in the tradition of European and English writers, such as Paracelsus, Fludd and Dee, Webster advocated a 'natural magic' that harnessed hidden natural powers, rather than the power of spirits. He disliked More and Glanvill, who equated 'natural magic' and astrology with witchcraft.

Curiously, the title page of Webster's 1677 book stated that it had the 'imprimatur' or official authorisation of Jonas Moore, in his role as vice-president of the Royal Society. Modern research by Michael Hunter indicates that Moore's approval was a highly irregular personal initiative on the part of Moore and was not based on a proper corporate endorsement of Webster's work by the Royal Society.[27]

The publication of Saducismus Triumphatus

In the immediate aftermath of the publication of Webster's book, Glanvill corresponded with Robert Boyle, seeking support and reassurance. Webster had questioned the authenticity of *The Devil of Mascon*. Glanvill had also heard rumours that Boyle had changed his mind about the Mâcon poltergeist. He wrote asking Boyle about this: 'I have bin often told of late that you do now disown the story of the Devill of Mascon, & that a clear imposture hath bin discover'd in it.'[28] Boyle reassured Glanvill that he had not changed his mind about the authenticity of the demonic poltergeist events at Mâcon.

During the crisis created by Webster's book, Boyle stood firmly on the side of those who believed in witchcraft. In September 1677 Boyle wrote to Glanvill expressing concern about the apparently rising level of scepticism that existed about witchcraft.

> For we live in an age, and a place, wherein all stories of witchcrafts, or other magical feats, are by many, even of the wise, suspected; and by too many, that would pass for wits, derided and exploded.[29]

Like Glanvill, Boyle profoundly disapproved of those 'wits' who considered it to be smart and fashionable to question the reality of witchcraft. Boyle endorsed Glanvill's work and encouraged him to persevere. He urged him to persist in his attempts to understand better why it was that witches had the Devil's Mark, and why these marks were impervious to pain. Boyle had no difficulty accepting the plausibility of what he called 'the insensible marks of witches'. He wrote enthusiastically about how investigations into the mechanics of witchcraft, such as those conducted by Glanvill, could 'help to enlarge the somewhat too narrow conceptions men are wont to have of the amplitude and variety of the works of God'.[30]

With a view to the new edition, Glanvill discussed with a friend, Anthony Horneck, the possibility of a translation of a German pamphlet describing witchcraft trials that had taken place in Sweden in 1669. Horneck was an Anglican clergyman, a well-known London preacher and a Fellow of the Royal Society. The events in Sweden were dramatic and had led to mass executions of the accused. Horneck, a fluent German speaker, began work on the translation.

Glanvill died in 1680, before the much expanded edition of his witchcraft book was ready for publication. He did not live to see his rebuttal of Webster in print. However, his great friend and mentor Henry More completed the task, editing the manuscript and adding new material of his own. The book was finally published in 1681, bearing the new title *Saducismus Triumphatus*, meaning 'Sadducism triumphed over'.

This was a massive book; the first edition was over 600 pages in length, and a second edition, published a year later, was even longer. Most content from the earlier editions of Glanvill's witchcraft text was retained. The scientific and philosophical reflections on the nature of witchcraft remained, and there was an updated account of the Drummer of Tedworth. Before his death, Glanvill had written a very substantial response to the criticisms of Webster, and this appeared in the new text. More also added a translated version of several chapters from an earlier Latin philosophical work of his, exploring the relationship between the spirit and material world. The second half of the text mostly comprised an extensive collection of case studies of the supernatural, assembled by Glanvill and More. The book concluded with Horneck's translation of the treatise concerning the 1669 witch trial in Sweden.

Saducismus Triumphatus had a considerable impact. Reprinted many times, it was seen by many as the definitive text that proved the authenticity of witchcraft. As late as 1825, over 150 years after publication, Horace Welby praised the scientific approach taken by Glanvill, describing the book as a work that embodied 'the true spirit of enquiry and research'.[31]

A Scottish enthusiast for the science of the supernatural

The work of More and Glanvill attracted admiration and imitation as well as criticism. One enthusiastic imitator was George Sinclair, a pioneering Scottish mathematician and scientist. Sinclair's thinking was closely aligned to that of those members of the early Royal Society who sought to promote both experimentalism and belief in witchcraft.

As a scientist, Sinclair was particularly interested in hydrostatics, the impact of atmospheric pressure on fluids. Between 1654 and 1666 he taught at Glasgow University. His researches overlapped, to some extent, with those of Robert Boyle. Sinclair was on good terms with

another Scottish intellectual, Sir Robert Moray, who was influential in the founding of the Royal Society. Sinclair visited Moray in London in 1662 and met Boyle. Sinclair gave the unpublished manuscript of a treatise about gravity to the Royal Society for its consideration, and thereafter felt it had not been taken seriously.[32]

Robert Boyle had endorsed the story of the poltergeist of Mâcon in France as an authentic example of demonic action prompted by witchcraft, and Glanvill later provided an English instance of the same phenomenon when he published his account of the Drummer of Tedworth. Sinclair was impressed, but also thought that he had come across a similar, convincing instance of a demonic poltergeist in Scotland.

In 1672 Sinclair published his scientific treatise, *The hydrostaticks*. The bulk of the work was devoted to the science of atmospheric pressure. In addition, Sinclair added some miscellaneous 'observations', including his account of a poltergeist event that had supposedly taken place at the village of Glenluce in south-west Scotland. Sinclair considered that it was not incongruous to juxtapose his reflections on his experiments into hydrostatics with his tale of the demonic haunting at Glenluce. He linked his story to similar case studies from the past:

> I find likewise, that several Writers have remarked such strange accidents, and have transmitted them to posterity, which may serve for good use.[33]

This was a reference, of course, to the poltergeist literature which Boyle and Glanvill had pioneered. Sinclair described his observations about the poltergeist of Glenluce in Baconian terms. He explained that he was keen to contribute to the 'Historical part of Learning' relating to the actions of evil spirits because 'the Scientifical part', that is the explanatory phase of the scientific process, depended on gathering empirical case studies of this kind. Sinclair expressed his hopes that the account from Glenluce would change the minds of those who ventured to deny the existence of spirits.

Sinclair's story was that in October 1654 at Glenluce the house of a weaver called Gilbert Campbell was subject to a curse because his family had refused to give anything to Alexander Agnew, a wandering beggar. Sinclair stated that Agnew was later hanged at Dumfries for

blasphemy. Independent sources corroborate the fact that a man called Agnew was indeed hanged for his religious views in 1656.

The narrative of events at Glenluce had striking similarities to the earlier accounts of the Devil of Mascon and the Drummer of Tedworth. In Glenluce, as in Tidworth, the culprit was an itinerant beggar who clashed with a local family and retaliated by invoking an evil spirit, which then infested the family house and terrorised the inhabitants. Gilbert Campbell's weaving equipment was damaged. At night, while the family slept, bedclothes were mischievously removed by the spirit. After some weeks, the Glenluce demon began to speak. The demon had also spoken at Mâcon. In Glenluce, as in Mâcon, apparently trustworthy local people visited the haunted house and heard the demon speaking. In both places, witnesses warned against engaging the spirit in conversation. The Glenluce demon spoke with a strong Galloway accent, using 'the proper Countrey Dialect' of the region. When a local clergyman with some other gentlemen visited the house, the demon denounced five local people as witches. The minister and the demon debated with each other, each citing relevant passages from the Bible in a learned way. Finally, the demon became partially visible.

> The Devil said ... I am an evil Spirit, and Satan is my Father, and I am come to vex this house; and presently there appeared a naked hand, and an arm, from the elbow down, beating upon the floor, till the house did shake again ... The Minister said, I saw indeed an hand, and an arm, when the stroak was given, and heard. The Devil said to him, Saw you that? It was not my hand, it was my fathers.[34]

To Sinclair's delight, his account of the Devil of Glenluce attracted the attention of Henry More and was printed in the 1682 edition of *Saducismus Triumphatus*. More found Sinclair's case study compelling, but he also made enquiries from others about this story in order to check its veracity. He discussed the story with Gilbert Burnet, a Fellow of the Royal Society and a great friend of Robert Boyle. Burnet was Scottish and had been a professor at Glasgow University at the time of the publication of the story of the Devil of Glenluce. By the early 1680s he was based in London. Burnet confirmed that both he, and other reputable Scottish people, considered the story to be true.

In 1685 Sinclair published his own book about witchcraft, *Satan's invisible world discovered*. This was heavily influenced by Glanvill and More but intended to be more 'reader friendly' than their work. The English writers had combined scientific and philosophical theory with empirical case studies. Sinclair, meanwhile, provided readable stories of authentic supernatural happenings, but avoided discussion of more abstruse, theoretical ideas. In his preface Sinclair explained that this was deliberate because 'the common and vulgar sort of Readers' were unlikely to be able to cope intellectually with arguments based on philosophical theorising. Such readers were more likely to be persuaded of the truth of witchcraft by 'relations' or stories rather than philosophy.

> Therefore I judge they are best convinced by proofs which come nearest to Sense, such as the following Relations are, which leave a deeper impression upon minds and more lasting, than thousands of subtile Metaphysical Arguments.[35]

Sinclair aligned himself completely with those Fellows of the Royal Society who were proponents of the authenticity of the supernatural: Boyle, Glanvill, More, Horneck and Plot. He retold the key stories found in their work, including Horneck's account of witchcraft in Sweden, the poltergeist events at Mâcon and Tidworth and Plot's assessment of the royalist spirit at Woodstock. He recycled these stories together with his own narrative of the Glenluce demon, adding further tales of the supernatural from Scotland.

The 'weake experiment' of William Harvey

Several of the learned witchcraft believers felt that they were superior in their logic and scientific thinking to the witchcraft sceptics. In his correspondence with Glanvill, Boyle reiterated his view that the existence of some fraudulent claims regarding the truth of supernatural phenomena did not invalidate the possible truth of other claims. Even if nineteen out of twenty cases were false, this was not proof of the impossibility of witchcraft. All that was needed to prove the reality of witchcraft was one validated instance. 'Any one relation of a supernatural phaenomenon being fully proved, and duly, verified,' he wrote, 'suffices to evince the thing contended for.'[36]

Glanvill agreed with this principle and had made precisely the same point in print a decade earlier. He was dismissive of what he saw as the logical weakness of those who tried to disprove witchcraft through unmasking individual examples of fraud.

A single relation for an Affirmative, sufficiently confirmed and attested, is worth a thousand tales of forgery and imposture, from whence cannot be concluded an universal Negative. So that, though all the Objectors stories be true, and an hundred times as many more such deceptions; yet one relation, wherein no fallacy or fraud could be suspected for our Affirmative, would spoil any Conclusion could be erected on them.[37]

Aubrey's great friend Sir James Long adopted a similar line, and was also dismissive of the arguments of witchcraft sceptics. In the early 1680s, Long began writing a treatise on witchcraft which he initially intended to present to the Royal Society. The text combined accounts of witchcraft from the town of Malmesbury and wider reflections on the authenticity of witchcraft. Long expressed astonishment that there were highly educated people who rejected the reality of witchcraft: 'I acknowledge with wonder sufficient I have heard severall persons, very learned otherwyse, affirme there were not, neyther could be, any witches.'[38]

Long intended to prove these learned critics wrong, through the application of rigorous scientific methods. His approach was to take what he considered to be the best argument of the most respected sceptic, and then demolish this proposition. He identified William Harvey as the most distinguished representative of the sceptical camp. For Long, Harvey's position, although wrong, was the most impressive example that he had found of an attempt to disprove witchcraft using modern 'experimental' thinking: 'I am certayne this, for an argument against spirits or witchcraft, is the best and most experimentall I ever heard.'[39]

William Harvey was of course famous for his discovery of the circulation of blood, and he was also physician to both James I and his son, Charles I. He was a well-known sceptic regarding the possibility of witchcraft, and in 1634 had been an expert witness in the examination of alleged witches from Lancashire. He was not convinced and, following his advice, the suspects were pardoned.

Long considered himself to be Harvey's intellectual peer. He described how he had spent much time in Harvey's company, and their main topic of conversation was science or 'natural philosophy'. The two men agreed about most scientific matters.

> I was very familiarly acquainted with him, and was often abroad with him, and had severall discourses with him of things in his faculty, but principally about natural philosophy, I agreeing with him for much the more part.[40]

While they had similar views about the majority of scientific topics, Harvey and Long disagreed strongly about witchcraft. Long challenged Harvey to justify his position on witchcraft.

> I once asked him what his opinion was concerning witchcraft; whether there was any such thing. Hee told mee he believed there was not. I asked him what induced him to be of that opinion.[41]

Harvey's response to Long's challenge was to tell the story of his investigation of an alleged 'witch' in Newmarket. This story has become well known, but the context is rarely explained. The 'witch' of Newmarket was a deluded old woman whose 'incubus' or familiar was nothing more than a harmless, tame toad. Harvey was in the area, in attendance on the king. He befriended the woman, claiming that he was himself a wizard who wanted to compare notes with a fellow practitioner of the magical arts. Harvey saw the woman summon a toad which she fed with milk. He tricked her into leaving him alone in her cottage. She went off with his money to buy some beer so that they could share a drink. With the woman gone, Harvey could examine the toad. He proceeded to kill and dissect it in order to demonstrate that it was not a demonic spirit. When the woman returned with a pitcher of beer, she was incensed to see that her beloved familiar had been killed. She assaulted Harvey, flying 'like a tigris at his face'. With some difficulty, Harvey extricated himself from the cottage. According to Long, Harvey considered that this anecdote disproved the authenticity of witchcraft.

> He concludes there are no witches very logistically; his argument in effect is this: A woman had a tame toade, which she believed

to bee a spirit and her familiar; the toad upon disection proved an arrant naturall toad, and had really eaten milk, and not in appearance onely, therefore there are no witches.[42]

For Long this was not good enough. Harvey's story proved nothing. The fact that one foolish woman wrongly thought that she had diabolical power did not demonstrate that this power was not real. Using the language of the Royal Society, Long dismissed the dissection of the toad in Newmarket as 'a very weake experiment'. This was the same logic that Boyle and Glanvill had used when asserting the superiority of their scientific thinking over the witchcraft sceptics.

Divisions among the witchcraft believers of the Royal Society

Fellows of the Royal Society disagreed about the supernatural. Within the membership, there were both believers and deniers. The picture was more complex still because the proponents of the authenticity of witchcraft were divided among themselves.

John Aubrey, Elias Ashmole, Joseph Glanvill and Henry More were all believers. For each of these members of the early Royal Society, the supernatural dimension was real. They did not doubt the existence of demons and angels. They felt it was possible to engage with the Devil through witchcraft, and that angels were active in the world, sending warnings to humanity of impending catastrophe. None of these men spoke out against the persecution of suspected witches; while they were aware that miscarriages of justice were possible, they expressed no principled objection to the witch trials of the time.

Despite this measure of consensus, there was a profound difference of attitude between these men. Aubrey and Ashmole can be characterised as having an *occult* perspective that was very significantly at odds with the *clerical* perspective of Glanvill and More. From the occult viewpoint, the sorcery of witches was forbidden but some other forms of ritual magic were permitted.

Glanvill and More were ordained clergymen of the Church of England, concerned to defend their version of Protestant Christian truth. From their clerical viewpoint, all forms of magical activity were sinful. There was a major fault line between the occult and clerical perspectives, then, over the matter of astrology. Aubrey and Ashmole

were extremely enthusiastic about the truth and benefits of astrology, while Glanvill and More saw it as a highly dangerous pursuit akin to witchcraft.

It is hardly surprising, given this clash of views, that there was an apparent frostiness between John Aubrey and leading clerical writers More and Glanvill. These men were not part of Aubrey's extensive and diverse friendship circle. Although he was an intellectual figure of some standing, More was not granted the accolade of a biographical study in Aubrey's *Brief Lives*.

Instead, Aubrey used his own work to challenge, indirectly, key supernatural claims made by both More and Glanvill. Aubrey questioned the guilt of Anne Bodenham from Salisbury, who was identified by Henry More as a genuine witch. For More, the manifest guilt of Anne Bodenham was immensely important as a proof of the wider authenticity of witchcraft. In his *Natural History of Wiltshire*, however, Aubrey laconically implied that the execution of Bodenham was a miscarriage of justice. Similarly, he was sceptical about the reality of the poltergeist event at Tidworth, which was for Glanvill a definitive proof case of the reality of witchcraft. Aubrey had no problem believing in supernatural phenomena and yet he scoffed at Glanvill's credulity at Tidworth in his *Natural History*.

Aubrey's critique of the views of More and Glanvill needs to be seen in the context of the debate between the occult and the clerical believers in the supernatural. Aubrey's private magical activities, as documented in a notebook that has survived in the Bodleian Library in Oxford, would have confirmed the worst fears of More and Glanvill. Unbeknown to them, Aubrey privately practised ritual magic and, it seems, was prepared to summon demons. If Henry More had been given an opportunity to read this notebook, he would, without any doubt, have accused Aubrey of witchcraft.

Strange Reports *and* Miscellanies: *the final Baconian endeavours of Boyle and Aubrey*

By 1690 both John Aubrey and Robert Boyle were elderly men, but their interest and belief in the supernatural was undiminished. Boyle died in December 1691, and Aubrey died in June 1697. In their final years both men were contemplating the publication of Baconian studies of the supernatural.

Having failed to see any of his many draft manuscripts of books through to publication, Aubrey finally assembled much of his 'supernatural' material and published it under the title *Miscellanies* in 1696, the year before his death. This text is sometimes seen as a peculiar, superstitious aberration; however, Aubrey's beliefs and interests as articulated in *Miscellanies* were entirely in keeping with the Baconian tradition and previous studies of the supernatural, such as those of Robert Plot.

In *Miscellanies*, Aubrey followed a classic Baconian model for a 'natural history'. He collected anecdotes that he thought were significant, apparently credible and worthy of further investigation. He then arranged these case studies thematically, covering a variety of topics including several relating to messages to humans from the spiritual realm: unlucky dates, omens and portents, unexplained knocking sounds, apparitions. Many of the testimonies had enhanced credibility in the eyes of Aubrey because they came from other Fellows of the Royal Society.

Boyle did not live to see Aubrey's *Miscellanies*, but before his death he was considering a similar publication of his own. Boyle's fascination with the spiritual and the unexplained in the last years of his life is reflected in many entries in his unpublished work diaries. On 10 January 1690, for example, he held a conversation with an explorer recently returned from America:

> Among other discourse that past between us about his journeys farre up into the continent of the northern America I desird him when our Company withdrew to tell me freely whether he had observd any thing of supernaturall among the savages he had had conversd with.[43]

At his death, Boyle left behind a draft of a treatise on atheism. In this text, Boyle reflected both on the reality of the spirit world and how little was known about the nature of demonic forces. Clearly he felt that much more serious enquiry was needed into the nature of the supernatural.

> We men understand very little of the nature, customes, & government of the Intelligent creatures of the spirituall world: and particularly what concernes the Falne Angells or bad

Daemons. And therefore they being themselves invisible to us, and capable of working in wayes that our sences cannot discerne; and being Agents of great craft & long experience; tis no wonder that many of their actions...should seem irrationall to us: who know so little of their particular inclinations & designes, and the subtil & secret methods in which they carry them on.[44]

In 1691, the last year of his life, Boyle published *Experimenta et Observationes Physicae*. As an appendix to this very late work, Boyle also included the first part of a Baconian treatise documenting anomalous occurrences, entitled *Strange Reports*. His preface made it clear that he envisaged *Strange Reports* as a two-part publication; part one would cover curious natural phenomena and part two would encompass a study of apparently authentic supernatural instances.

I Presume, Sir, you may yet remember, what I Wrote about the Nature and Scope of my Collection of Strange Reports ... for distinction's sake, I thought fit to divide the ensuing Particulars into two Parts, because they are indeed of two sorts: One relating to things purely Natural, and the other consisting of Phaenomena, that are, of seem to be, of a Supernatural Kind or Order.[45]

Boyle stated that he had not yet decided whether to publish the second part of *Strange Reports*, with its natural history of the supernatural, for fear that it would be badly received.

I must likewise give you notice, That you are not to expect the II. Part at this time: Discretion forbidding me to let that appear, till I see what Entertainment will be given to the I. Part, that consists but of Relations far less strange than those that make up the other Part.[46]

In the end, Boyle did not publish part two of *Strange Reports* and any draft of the text that may been written has been lost. However, the preface of this supernatural section of *Strange Reports* survives in Latin and has been translated by the leading Boyle expert, Michael Hunter. It indicated both Boyle's belief in the reality of the spirit world and his fears of being criticised for his credulity.

I am well aware that we live in an age when men of judgment consider it their part to greet a report of supernatural phenomena with contempt and derision, particularly when these phenomena are spiritual apparitions and the unusual communication of rational creatures with rational creatures that do not belong to the human race.[47]

By the 1690s the intellectual mood had changed and belief in witchcraft in elite intellectual circles was becoming distinctly unfashionable. The new mood of rejection of witchcraft beliefs is symbolised by the thinking of Isaac Newton. He replaced Boyle, in the second generation of the Royal Society, as the leading luminary of the Society. In 1692, a year after Boyle's death, Isaac Newton wrote to John Locke ridiculing belief in the authenticity of witchcraft: 'To believe that men or weomen can really, divine, charm, inchant, bewitch or converse with spirits is a superstition.'[48]

4

THE SCIENCE OF SORCERY

How did learned believers in witchcraft accommodate magic within their understanding of the functioning of the universe? What scientific explanations did they give for the power of witches?

Many of the witchcraft theorists combined their enthusiasm for science with a grudging respect for evil spirits as fellow scientists. Their starting point was a view of the Devil and many of his demons as brilliant but evil creatures, with access to a level of knowledge of nature far in advance of the most expert natural philosophers of the human race. By the seventeenth century there were well-established theories about the nature of angels and demons. Theologians taught that good and evil spirits had existed for thousands of years, predating the creation of humanity and the Fall. Demons were fallen angels, so it was unsurprising that they had extraordinary powers; they'd had millennia in which to learn.

The vast intellectual superiority of demons over humans was pointed out by Meric Casaubon, a conservative Anglican theologian, in 1672. Casaubon explained that demons were immensely more capable than humans as a result of both natural ability and length of experience. They had existed since before the creation of humanity and possessed profound knowledge 'of things natural'. For Casaubon even the most knowledgeable humans were 'but as children; yea very babes, and simpletons' when compared to demons.[1] Robert Boyle made a similar point in his unpublished treatise on atheism, written towards the end of his life, where he described demons as 'Agents of great craft & long experience'.

It was widely held that the extraordinary power of demons was based on their superior scientific knowledge rather than any capacity to do miracles. The notion that evil spirits operated within, and not above, the laws of nature can be seen in learned attempts to rationalise bewitchment processes. In 1662, Aubrey's hero Thomas Browne was called as an expert witness in the trial of two Lowestoft women at Bury St Edmunds. Having examined the 'victims' – girls who were suffering from convulsions – Browne reassured the jury that they had genuinely been bewitched. He then proceeded to explain his view that witchcraft had acted as a catalyst for the development of the girls' ailments. They had an underlying condition that was greatly exacerbated by the action of the Devil, stimulated by witchcraft. Using the language of learned medicine, he explained that the girls had a superfluity of certain bodily liquids or 'humours'. This was a naturally occurring condition. The witchcraft had disturbed these humours, triggering the convulsions. For Browne, this was unsurprising. 'Such cases' illustrated the way the Devil operated on behalf of witches by harnessing natural forces.

> His Opinion was, That the Devil in such cases did work upon the Bodies of Men and Women, upon a Natural Foundation, (that is) to stir up, and excite such humours super-abounding in their Bodies to a great excess, whereby he did in an extraordinary manner Afflict them with such Distempers as their Bodies were most subject to, as particularly appeared in these Children.[2]

Joseph Glanvill took a similar approach. To him, witchcraft was not miraculous and beyond explanation; witches were confederate with demons, and the cleverest of the diabolical spirits possessed profound scientific knowledge. They understood how to manipulate the physical world in a way that was beyond our understanding, just as the virtuosi of Restoration England understood mysteries beyond the ken of uneducated people.

> Doubtless the subtilties and powers of those mischievous Fiends are as much beyond the reach and activities of the most knowing Agents among us, as theirs are beyond the wit and ability of the most rustick and illiterate.[3]

The scientific ability of the Devil became a commonplace among learned believers in witchcraft. The influential New England clergyman Increase Mather took it for granted that many demons had a level of scientific understanding that went far beyond human knowledge. In a treatise about angels published in 1696 he made the point that trying to communicate with angels was dangerous because a demon was perfectly capable of appearing to be a virtuous angel. The ability of a demon to take on the form of a benign being was a direct consequence of demonic scientific ability in the field of optics, where their knowledge was 'perfect'.

> How easy then is it for Daemons, who have a perfect Understanding in Opticks, and in the Power of Nature to deceive the Eyes, and delude the Imaginations of Silly Mortals.[4]

Particle theory and the 'evil eye'

Thomas Browne thought that evil spirits manipulated bodily 'humours' on behalf of their confederate witches. After the Restoration the classical ideas of the humours were becoming rather old-fashioned. Newer scientific and medical theories had emerged, relating to the way matter was constituted of minute particles and the possibility of disease caused by fermentation within the blood. Joseph Glanvill took these more fashionable concepts and used them in his attempts to rationalise the mechanics of witchcraft in a way that was consistent with modern science.

The central idea of Cartesian mechanical philosophy was that matter was made up of minute, invisible particles that were in constant motion. Descartes wrote about the 'effluvia', the minute particles emitted by magnetic materials. Robert Boyle's distinctive version of particle theory was known as corpuscularianism because he used the term 'corpuscles' to describe the tiny particles that made up all matter, whether solid, liquid or gas.

Contemporary particle theory was applied to explanations of 'the evil eye'. It was widely held that witches possessed a real power to harm through gazing upon their victims. On more than one occasion, John Aubrey reflected on how witches had the capacity to hurt through the 'evil eye'. He thought that there was some 'subtil' or fine, invisible matter that shot from the eyes of witches and infected victims of witchcraft.

> The Glances of Envy and Malice, do shoot also subtilly; the Eye of the Malicious Person does really Infect (and make Sick) the Spirit of the other.[5]

Aubrey went no further in his theorising; he tended to describe rather than explain. Joseph Glanvill was different. He wanted explanations, aligned to the findings of experimental science.

Empirical data suggested to Glanvill that the 'evil eye' was a real physical power possessed by witches and was particularly potent when used against the immature bodies of children: 'I am apt to think there may be a power of real fascination in the Witch's eyes and imagination, by which for the most part she acts upon tender bodies.'[6]

But how did the 'evil eye' operate? Using the mechanical philosophy concept of minute particles in motion, Glanvill hypothesised that the 'evil eye' was a mechanism for transmitting malignant particles that poisoned the victims. This was in keeping, he said, with the emerging consensus about general principles of matter: 'Nature for the most part acts by subtil streams ... of minute particles, which pass from one body to another.'

It seems that in developing his view of the science of the 'evil eye' Glanvill had been reading Walter Charleton, an English exponent of the new science. In keeping with the ideas of the French writers Gassendi and Descartes, Charleton claimed in 1654 that rays of light had substance, being 'tenuious streams of Igneous Particles'.[7] Glanvill took this notion and applied it to the emanations from the eyes of the witch, using Charleton's phraseology to explain to readers that infection can 'pass in certain tenuious streams through the air'. Glanvill therefore concluded that witches had the power to transmit minute and invisible poisonous particles from their own eyes to the those of their victims.

Witchcraft and the transmission of toxic ferments

We have seen that at the trial of the Lowestoft women in 1662, Thomas Browne considered that they had manipulated the humours of the victims. In explaining disease with reference to an imbalance of humours, Browne used ideas derived from classical medical experts, particularly the Greek physician Galen, who practised in the Roman era. By the mid-seventeenth century such Galenic ideas were being challenged by doctors with alternative explanatory concepts,

however, and Glanvill enlisted some of the newer thinking into his explanation of the natural mechanics of witchcraft.

Glanvill tried to make scientific sense of the relationship between witches and their familiars. It was widely thought that each witch had at least one familiar, and Glanvill speculated on the processes that took place when these demonic familiars sucked on the teats that witches were supposed to possess. His analysis drew upon contemporary scientific thinking about fermentation, which was the focus of considerable interest among leading scientists in the 1650s and 1660s. In 1659, a member of Boyle's circle, Thomas Willis, published an influential and innovative treatise on fermentation and illness. Willis saw fermentation of the blood as the cause of much disease, and Glanvill applied this logic to the diseased body and mind of the witch. He speculated that the sucking of the familiar transmitted a toxic ferment into the witch's body, contaminating her blood and infecting her mind.

> To which I adde That which to me seems most probable, viz. That the Familiar doth not onely suck the Witch, but in the action infuseth some poisonous ferment into her...The evil spirit having breath'd some vile vapour into the body of the Witch ... may taint her bloud and spirits with a noxious quality, by which her infected imagination, heightened by melancholy and this worse cause, may do much hurt.[8]

For Glanvill, it was this poisonous ferment that almost certainly gave the witch her power to use the 'evil eye'. He described how the witch's 'power of hurting consists in the fore-mention'd ferment, which is infused into her by the Familiar'.

Glanvill's theory combined two key concepts drawn from the leading-edge science of the time: the significance of minute particles, and possible links between fermentation and disease. The demonic familiar, sucking at the teat of the witch, also injected a poisonous ferment into her. This poison entered her body and could eventually be emitted in the form of minute toxic particles sent out from the witch's eyes towards enemies.

> For the pestilential spirits being darted by a spightful and vigorous imagination from the eye, and meeting with those that

are weak and passive in the bodies which they enter, will not
fail to infect them with a noxious quality, that makes dangerous
and strange alterations in the person invaded by this poisonous
influence: which way of acting by subtil and invisible instruments
is ordinary and familiar in all natural efficiencies.[9]

Glanvill's final phrase was an affirmation of the proposition that
witchcraft was a manipulation of natural processes and not a
miraculous act. Although the mechanisms used were 'subtil and
invisible', they utilised naturally occurring forces.

The science of out-of-body witchcraft

More and Glanvill promoted belief in out-of-body activity by witches.
This idea had a wider significance for the theorists of the supernatural
because it could be used to demonstrate that the soul, or immaterial
spirit, was distinct from the material body, and that those mechanical
philosophers who ignored the spirit dimension were mistaken. This
debate mattered because proof of the separability of soul and body
before death was relevant to the dispute with followers of Hobbes.
If witches could separate their spirit from their body, then Hobbes'
claim that there was no immaterial human spirit was disproven.

Henry More developed thinking about the science of spectral
witchcraft: the idea that the disembodied mind/spirit of a witch could
attend ritual meetings or attack enemies, while the body of the witch
remained at home. More had been preoccupied with this possibility
since his time as a young Cambridge academic. In his 1647 poem
Praeexistency of the soul, More had described how 'wily hags' sought
to hide their witchcraft by leaving their 'carkasses' at home, as a way
of avoiding the hangman's noose or 'halter'.

And wily Hags, who oft for fear and shame
Of the coarse halter, do themselves with-hold
From bodily assisting their night game
Wherefore their carkasses at home retain.[10]

More returned to the concept of out-of-body witchcraft in his *Antidote
against atheism*, published in 1653. In this book he reviewed the
debate about whether the disembodied spirits of witches leave their
bodies and travel about. European experts had different views. More

noted the fact that the respected French witchcraft writers Jean Bodin and Nicholas Rémy disagreed about 'whether the Souls of Witches be not sometimes at those nocturnall Conventicles, their bodies being left at home'. Rémy thought this was beyond the Devil's power but Bodin considered that out-of-body witchcraft was possible. More sided with Bodin and concluded that there was no logical reason why the Devil should not be able to uncouple the soul and the body of a witch on a temporary basis.

> Can it be a hard thing for him [the Devil] ... to have the skill and power to loosen the Soul, a substance really distinct from the Body and separable from it; which at last is done by the easy course of Nature, at that finall dissolution of Soul and Body which we call Death?[11]

Tales of witches leaving their physical bodies behind them sometimes included the detail that they anointed themselves beforehand. More latched on to this detail and concluded that the anointing must be a mechanism for maintaining basic bodily functions in the absence of the spirit. He stated his view that the 'conservation' of the spiritless body was probably made possible by the anointing, explaining this in mechanical terms: 'Ointment filling the pores keeps out the cold and keeps in the heat and Spirits, that the frame and temper of the Body may continue in fit case to entertain the Soul again at her return.'[12]

The ointment blocked the pores of the witch's skin and, as a result, the body could effectively hibernate, and later be fully reactivated when the witch returned from her nocturnal assignment.

> So the vital streames of the carcasse being not yet spent, the pristine operations of life are presently again kindled, as a candle new blown out and as yet reeking, suddenly catches fire from the flame of another, though at some distance, the light gliding down along the smoke.[13]

Based on these assumptions, More endorsed the notion that witches attended sabbat meetings and attacked enemies, while leaving their bodies at home. More's belief in the separability of the witch's spirit from her body was significant. It justified witchcraft accusations based on 'spectral evidence', claims that apparitions of witches had been seen

by those who thought they were bewitched. This belief undermined the ability of an accused person to use the defence that she was known to be elsewhere at the time of an alleged witchcraft event. Accusations of spectral witchcraft can be found in several of the trials of witches that took place after the Restoration. They featured prominently in the Salem trials in New England.

In his *Antidote against atheism*, More also considered the possibility that there might be werewolves, humans able to turn themselves temporarily, through witchcraft, into wolves. Although absent from the confessions of English 'witches', tales of werewolves occurred in continental accounts of demonology. John Aubrey met a man who claimed to have been attacked by a werewolf during a visit to France.[14]

More stated that there was no reason to doubt the Devil's fundamental ability to assist one of his devotees to transform into a wolf. It was logically possible, and continental confessions of men who had been werewolves were, he argued, persuasive. Accounts from France of werewolves contained convincing details; sometimes the 'werewolves' were wounded during their attacks and the wounds could be still seen once they had transformed back to human form.

> Therefore it being plain that nothing materiall is alledged to the contrary, and that men confesse they are turn'd into Wolves, and acknowledge the salvage cruelties they then committed upon Children, Women and Sheep, that they find themselves exceeding weary, and sometimes wounded; it is more naturall to conclude they were really thus transformed, then that it was a mere Delusion of Phansy.[15]

The likely physiological mechanics of the transformation of a human into a werewolf were considered by More. A man could be possessed by the Devil, and infected 'by his subtile substance' which might melt the matter of his body, rendering it 'plyable' and capable of being reshaped into any shape, including the form of a wolf. The Devil's 'substance' was more powerful 'than any fire or putrifying liquour'. More saw the making of a werewolf as a parallel process to the creation of demonic bodies from condensed air (of which more later), and entirely plausible, given the known scientific power of the Devil.

It is as easy for him [the Devil] to work it into what Shape he pleaseth, as it is to work the Aire into such forms and figures as he ordinarily doth. Nor is it any more difficulty for him to mollify what is hard, then it is to harden what is so soft and fluid as the Aire.[16]

Given that learned experts such as Henry More believed in the possibility of shape-shifting werewolves, it is no surprise that less educated people also considered similar animal transformations to be plausible. In More's hometown of Cambridge in 1659, a local woman called Mary Philips made the extraordinary claim that she had been bewitched, magically removed from her bed and transformed into a horse. A witch rode Mary, in the form of a horse, around the district and towards the university. Afterwards, Mary was magically transformed back into human shape, but her skin was torn as if she had been cut by a rider's spurs, and her mouth was bleeding as if injured by a bridle bit.[17]

Explaining sex with demons

The possibility that the Devil or his demons could have sex with witches intrigued Henry More. He considered that both the European witchcraft literature and the confessions of English witches in contemporary trials supported this idea. The frequency of these reports persuaded More that sex with demons did take place.

Wherefore Witches confessing so frequently as they do, that the Divel lyes with them ... it is a shrewd presumption that he doth lie with them indeed, and that it is not a mere Dreame.[18]

The idea of sex between demons and humans interested More, just as out-of-body spectral witchcraft did, because it related to the metaphysical question of the interaction of the material and spirit worlds. More asked: how could an immaterial evil spirit be embodied in such a way that sex with a human was possible? His answer drew upon ideas that had been in circulation long before the age of Descartes and Boyle. The medieval scholastic philosopher Thomas Aquinas had stated that angels and demons, although disembodied spirits, could take on bodily form through the manipulation of condensed air.

More may have heard people discuss these ideas during the Matthew Hopkins witch craze in East Anglia in the 1640s, which

took place when he was living nearby in Cambridge. Hopkins himself stated that the Devil's ability to manifest himself 'in any shape whatsoever' was 'occasioned by him through joyning of condensed thickned aire together'.[19] More developed a version of this 'condensed air' theory in his 1653 book *An antidote against atheism*, using scientific language to describe the process. He said that the Devil had the ability 'to coagulate the aire', thereby creating a body for himself. The possibility of the 'coagulation' of the air into the form of a body, which could then be inhabited by a demon, enabled More to explain frequent reports of sexual intercourse with the Devil or his demons. Some of these accounts described how those witches who had sex with the Devil were struck by the intense cold of the Devil's touch. He described how he had noticed several accounts, 'of his tedious and offensive coldnesse'.[20]

For More, the coldness of the embodied Devil and his demons was easily explicable because the air that constituted their bodies was 'coagulated' through freezing. It followed that witches would feel intense cold when embracing an embodied demon. Frozen air was likely to be even more stinging to the touch than frozen water because of differences between particles of air and water.

> It stands to very good reason that the bodies of Divels being nothing but coagulated Aire should be cold, as well as coagulated Water, which is Snow or Ice and that it should have a more keen and piercing cold, it consisting of more subtile particles, than those of water, and therefore more fit to insinuate, and more accurately and stingingly· to affect and touch the nerves.[21]

More concluded that demonic sex was not uncommon and could be explained scientifically. He returned to the topic of sex with demons in a later work, *An explanation of the grand mystery of godliness*, published in 1660. His comments in this work suggest a rather prurient interest in those accounts of demonic sex found in witches' confessions. He had noticed that, when confessing, some witches suggested that sex with demons was more pleasurable for women than conventional human sexual intercourse.

> Why may not an Aiery Spirit transforming himself into the shape of a Man, supply his place effectually, he being able, as Witches

have confessed, to raise as high pleasure and indeed higher then any man can doe?[22]

In this 1660 work More also explored the idea that babies might result from the union of a demonic male and a human female. He considered this to be plausible, although he denied the possibility of offspring from sex between a demonic female and a human male. More explicitly linked these views to contemporary innovations in embryological science. He believed that demonic seed could activate the growth of a foetus within the human womb of a witch. He asserted that such an occurrence was consistent with ideas of 'the manner of Conception' described by the great medical expert William Harvey.

More's view was that, during the act of sex, a male demon was probably capable of 'a transmission of such principles and particles as will prove in their conflux in the wombe vital and prolifical'. These particles were 'vital' in their impact, meaning they had the potential to stimulate new life. More connected his theory about demon babies to the innovative embryological ideas of William Harvey. He explained that his theory was worthy of respect because it was consistent with Harvey's view of the role of male semen as the stimulus for the development of a foetus but not the source of the 'Matter' of the new human body, which lay exclusively within the woman's egg.

> Which may be the easilier admitted, if we consider that the Seed of the Male gives neither Matter nor Form to the Foetus it self; but like the Flint and Steel only sets the Tinder on fire, as Dr. Harvey expresses it.[23]

More made this statement in a work published in 1660. The metaphor of male semen as a spark that lit the fire but was external to the matter of the fire was found in Harvey's book *Anatomical exercitations*, published in 1653. More was taking up-to-date concepts from medical science and seeking to harness them in support of his witchcraft theory. He did not mention that Harvey personally rejected the reality of witchcraft.

Glanvill: More's devoted disciple
More developed his science of witchcraft in two books, *An antidote against atheism* and *An explanation of the grand mystery of godliness*.

Joseph Glanvill saw himself as the disciple of More and sought to refine and develop his master's ideas in his own books on witchcraft, published from 1666 onwards.

Building on More's explanation of the way that spirits became visible to the human eye, Glanvill noted that demons seemed to appear more often than angels. His explanation was that the act of embodiment was likely to be particularly painful for angels because 'compressing' refined spirits into a temporary body was problematic.

> And this is perhaps a reason why there are so few Apparitions, and why appearing spirits are commonly in such haste to be gone, viz. that they may be deliver'd from the unnatural pressure of their tender vehicles.[24]

It seemed likely to Glanvill that baser spirits, such as the lower forms of demon, found material embodiment less painful: 'The wicked ones ... are more foeculent and gross, and so nearer allyed to palpable consistencies, and more easily reduceable to appearance and visibility.'[25]

Glanvill accepted More's reasoning that witches could readily have out-of-body experiences when attending their meetings and harming their victims. The key to this for both men was the principle of the separability of the soul/mind and body. For Glanvill, 'great philosophers' rightly taught that the soul and body could be prised apart temporarily before death through the power of witchcraft. Each witch had a 'confederate Spirit', an assigned demon or familiar, who had the power to facilitate the departure of the witch's mind/spirit from her body in order that she should be able to attend a meeting or 'Rendezvous'.

> That the confederate Spirit should transport the Witch through the Air to the place of general Rendezvous, there is no difficulty in conceiving it; and if that be true which great Philosophers affirm concerning the real separability of the Soul from the Body without death, there is yet less; for then 'tis easie to apprehend, that the Soul, having left its gross and sluggish Body behinde it, and being cloath'd only with its immediate vehicle of Air, or more subtile matter.[26]

Both More and Glanvill were interested in the nature of the temporary body, or 'vehicle' as they called it, that the witch's spirit inhabited during her out-of-body adventures. Glanvill considered More's view that the 'vehicle' might be made of air rendered solid, speculating also that the temporary body might be constructed from some 'more subtile matter' not currently understood.

More had suggested that out-of-body travel by witches was enabled by a mysterious ointment that, according to some of the European literature, witches applied before their spectral journeys. Glanvill explored the idea that the toxic ferments imbibed from the witch's familiar in some way assisted the separation of soul and body, helping the witch to cope with the physical trauma caused when the spirit re-entered the body after an out-of-body adventure.

> And 'tis very likely that this Ferment disposeth the Imagination of the Sorceress to cause the ... separation of the Soul from the Body, and may perhaps keep the Body in fit temper for its reentry.[27]

Zoology and political science in Glanvill's world of demons

Joseph Glanvill saw the cataloguing and understanding of different demons as a scientific enterprise, comparable to the work of contemporary botanists or zoologists. He mused about how, just as the application of the microscope was revealing many previously unknown minute creatures, the proper study of the spirit world was likely to reveal many types of previously unknown demons. Modern zoological ideas could probably be applied to demons. Just as animals had distinctive habits and habitats, the same was likely to be true of demons. It was difficult to spot a demon, but then it was also difficult to spot some terrestrial creatures: 'Nor is't any more strange that evil Spirits so rarely visit us, then ... that we see not the Batt daily fluttering in the beams of the Sun.'[28]

Glanvill also applied aspects of political theory to his analysis of the world of evil spirits. He saw the Devil as a collective name for all evil demons. Together, they constituted a society, similar to human society, with different social groups and ranks.

> The Devil is a name for a Body Politick, in which there are very different Orders and Degrees of Spirits, and perhaps in as much variety of place and state, as among our selves.[29]

What drove demons to ensnare weak humans into witchcraft? Glanvill used a commonplace idea from the political discourse of the time and proposed that 'desire of dominion' over others was probably a powerful motivational force. Glanvill considered that demons were probably driven by a wish to achieve 'dominion' just as humans, restlessly and insatiably, looked for opportunities to control their fellow men and women.

It seemed logical to Glanvill that only the lowest forms of demonic life would demean themselves by enslaving those miserable humans who turned to witchcraft. Evil spirits reduced to enslaving witches must be members of a demonic underclass, so lowly that they could not control any other demons and were forced to seek control over humans.

Ideas from law and constitutional theory were taken and used to make sense of relationships in the demonic world. The contract between the witch and her familiar was a specific legal relationship between two parties, one human and one demonic. Each witch made a binding contract with her individual demon, rather than a generic contract with the Devil or all demons 'so that 'tis not one and the same person that makes all the compacts with those abused and seduced Souls, but they are divers'.[30]

Glanvill theorised that demonic society, like human society, must be constrained by laws enforced by the governing demons. These laws permitted contractual relationships between demons and humans, enslaving any witch who was foolish enough to agree to serve her demon.

> 'Tis like enough to be provided and allowed by the constitution
> of their State and Government, that every wicked spirit shall
> have those Souls as his property, and particular servants and
> attendants, whom he can catch in such compacts.[31]

The property rights of the demon over the witch were enshrined in demonic law and the constitution of the demonic state. Perhaps Glanvill was thinking of the legal protection offered to slaveowners in the English plantations of the Americas of his own day. He reminded his readers that, in human contexts, 'those Slaves that a man hath purchas'd, are his peculiar goods'. The same principle applied to the ownership of witches by demons; each witch was the property of a specific demon rather than the Devil.

Those 'tis like of the meanest and basest quality in the Kingdom of darkness ... That having none to rule or tyrannize over within the Circle of their own nature and government, they affect a proud Empire over us.[32]

Henry Hallywell: developing the 'science' of the supernatural

The witchcraft science of More and Glanvill was further refined and developed by one enthusiastic supporter called Henry Hallywell. He was, for a while, a Fellow at Christ's, More's college at Cambridge University before leaving to pursue a career as a country clergyman in Sussex. He wrote extensively on different religious topics and in 1681 published his study of witchcraft, *Melampronoea*. This was heavily influenced by the ideas of More and Glanvill. The appearance of his book was overshadowed by *Saducismus Triumphatus*, which was published during the same year. *Melampronoea* lacked the stories of supposedly authentic witchcraft that made the other book so popular, Hallywell focussing instead on the theory of evil spirits and witchcraft.

Hallywell reminded readers that demons were fallen angels, confined after their rebellion against God, to the atmosphere of the earth. Here, within certain limits, the demons were free to do evil and to attempt to corrupt weak and sinful human beings. Like Glanvill, Hallywell was taken with the idea that there were parallels between the demonic world and both animal zoology and human political science. The realm of evil spirits was likely to be as diverse as the animal kingdom.

They are not all of the same rank and quality, but may probably have as many divisions among them as there are diversities of Animals upon Earth.[33]

Their propensions and inclinations are not all alike, but are as various and different as those of mankind.[34]

For Hallywell, a diversity of demons, including some that were intellectually distinguished and others that were particularly debased, seemed to be a logical necessity in order to explain how some demons chose to associate themselves with such unattractive human beings

as witches, while others consorted with gentlemen through ritual magic. Hallywell used the insulting word 'hag' to describe the typical witch. He asked the question: why would self-respecting demons demean themselves by taking 'delight in sucking the Bloud of these accursed Hags'? His answer was that, while elite gentlemen wizards consorted with the more cultivated evil spirits, common witches associated with a particularly base type of demon, the underclass of the diverse sociology of evil spirits. As Hallywell put it, only the 'fouler and grosser Fiends' were so despicable that they agreed to seek out the common witch, 'daily sucking her bloud, and nestling in her loathsome rags'.[35]

Within the context of this highly hierarchical set of assumptions about demonic society, Hallywell speculated on the likely political arrangements that governed the daily lives of demons. He believed that some demons were by nature 'more powerful and politick', and they assumed positions of authority in a way that was very similar to human government.

> There is an Order and Government among the dark Fiends ... [some] take the reins of Government and Authority into their hands, and prescribe Laws to the rest, such as may both establish and preserve the Empire and Kingdom of Darkness from domestick and intestine broils and dissentions, and uphold it when assaulted by forein Invasions.[36]

Towards the end of his text, Hallywell attempted to deal with some of the 'frequently asked questions' about the way in which demons engaged with humans through witchcraft. Here, he endorsed More's position on the likelihood of witches having the power to leave their bodies behind them at home while attending meetings and attacking enemies.

Hallywell was struck by the passage in More's early poem, which described how 'wily Hags' were able to avoid 'the coarse halter' by leaving their bodies at home during 'their night game'. Hallywell repeated the same idea, using similar language about evading the noose or 'halter'. He explained his view that witches often attended their meetings in a bodily form but sometimes in spirit form, particularly when they were afraid of being caught and hanged.

Sometimes they may be present at them, when their Bodies are at home; perhaps among other reasons, that they may act with more safety and security, and the better preserve their necks from the halter.[37]

The logical possibility of out-of-body witchcraft seemed compelling to Hallywell, and he went further than More in speculating about how this remarkable phenomenon probably operated. He proclaimed his modernity by locating this theorising within both the philosophical framework established by René Descartes and the new medical science of William Harvey. For Hallywell, the latest philosophical ideas and medical discoveries were consistent with spectral witchcraft.

Descartes was a dualist. He considered that each human had both an immaterial spirit and a material body. The soul or spirit had the power to make the body act in the world but did not have control over physiological processes, which happened automatically because the material body functioned in some respects like a self-regulating machine. Referencing the ideas of Descartes, Hallywell argued that it was perfectly possible to explain how the witch's body continued to function like an animal or machine while the soul or spirit was absent. The witch's body, temporarily bereft of her soul and controlling mind, would operate physiologically in the same way that animal bodies functioned.

And if withal we suppose Brutes to be but Machines or Automata, it will be very clear that all those Motions which we call Vital in the Body may be performed without the actual presence of the Soul.[38]

Hallywell proceeded to link his analysis of the mechanical nature of the functioning of the witch's abandoned body to the findings of William Harvey about the working of the heart. Using technical terms to emphasise his scientific credentials, he described the circulation of the blood and how the 'Systole and Diastole of the Heart' functioned operated through automatic 'Muscular Constriction and Relaxation' to illustrate how a body could function temporarily without a controlling mind or spirit. Hallywell's implication was that the findings of Harvey, who was a witchcraft sceptic, were in fact consistent with the idea that witches could fly through space to attend

witchcraft rituals or attack victims, while fooling others into thinking they were sleeping.

In this way, Hallywell endorsed and further refined More's explanation of the likely mechanics of out of body witchcraft. Hallywell also pondered the scientific function of the sucking of the witch by her familiar demon. As mentioned above, Glanvill had viewed this as a means of transmitting toxic 'ferments' into the bloodstream of the witch. Hallyday, however, suggested another explanation.

Hallywell's reflections on the scientific nature of the familiar–witch relationship were influenced by his ideas about how immaterial evil spirits could become embodied. Henry More had used the medieval idea of condensed air to explain the embodiment of demons, but Hallywell applied a more modern theory about matter as a collection of minute particles to explain the demonic body. The familiar was a demon in the apparent form of an animal. Since the natural habitat of demons was the outer reaches of the earth's atmosphere, a demonic body was likely to consist of distinctive minute particles of matter drawn from these regions. Just as human bodies required food, demonic bodies needed nutrition because some of the atmospheric matter of the bodily 'vehicle' was emitted or exhaled. A form of sustenance was needed to replenish these lost 'effluvia', and this was provided by the blood of the witch. It was to obtain nutrition that familiars sucked on the special marks or teats of witches.

> They have their Effluvia, and exhale and wear away by a continual deflux of Particles, and therefore require some Nutriment ... which is done by sucking the Bloud and Spirits of these forlorn wretches.[39]

Hallywell concluded with a suggestion that demons found the sucking of blood both good for their health and pleasurable, just as the breathing of fresh air is pleasantly invigorating for humans.

> No doubt but those impure Devils may take as much pleasure in sucking the warm Bloud of Men or Beasts, as a chearful and healthy constitution in drawing in the refreshing gales of pure and sincere Air.[40]

Francis Grant: modifying the theories of Glanvill and More
Scientific ideas played an important part in a major witchcraft trial
that took place in Scotland in June 1697 and led to the execution
of seven 'witches' in one day in the town of Paisley. A treatise was
published in 1698 that both recounted these events and explored
scientific ideas about witchcraft. Its writer was the lawyer Francis
Grant, who had been the main scientific theorist present at the Paisley
trial.

Grant had read Glanvill's work and understood his ideas about the
witch's apparent ability to transmit 'ferments' or 'pestilential spirits'.
Developing these ideas, Grant told the jury in Paisley that witches
were, in all likelihood, able to oblige their demonic familiars to infect
victims with 'poisonous humours'. The transmission of these invisible
toxins might, he thought, be comparable to the way rabies or the
plague was spread.

> The confederate Devil may, upon the Witches desire, infuse
> poisonous Humors, extracted from Herbs, of the same invisible
> Operation with the Steem of Mad-dogs, or the Pestilence.[41]

The treatise containing Grant's ideas expressed absolute conviction
that witchcraft was authentic and explicable scientifically, but the text
was not deferential towards the science of More and Glanvill. Quite
the contrary, the text provided a critique and alternative to three of
the English writers' core witchcraft propositions: that spectral flight
was possible, with the body of the witch left behind in suspended
animation; that the physical transformation of witches from human to
animal form was possible; and that witches, when disembodied, could
operate invisibly and thereby harm their victims unnoticed.

For More and Glanvill, each of these three assertions constituted
a plausible hypothesis because it was based on their beliefs regarding
the possible separability of the body and the spirit before death.
The treatise about the Scottish case gave an accurate paraphrase
of the More–Glanvill position on out-of-body witchcraft and flight
before proceeding to question its validity and likelihood.

> When by God's Permission, Satan with the parties Consent, gets
> power over both Soul and Body; whereby he may carry away
> the one from the Helm of the other, and bring it back again into

its Seat; provided the vital Spirits which make the Body a fit Receptacle, be well preserved by Ointments, that constrict the Pores, till the return of its Guest.[42]

Having recapitulated, but also challenged, some of the fundamental ideas of More and Glanvill, Grant effectively proposed an alternative set of scientific propositions: first, that the flight of witches was real but the witches physically travelled through the air without leaving their bodies behind; second, that the apparent transformation of witches from human to animal form was a magically induced optical illusion; and third, that witches could operate invisibly but were not disembodied when invisible. Grant theorised that they used optics magic to fool observers and were in fact physically present at their meetings and in the houses of their enemies.

In other words, Grant contended that the out-of-body witchcraft posited by More was not required to explain the characteristic witchcraft powers of flight, animal transformation and malevolent invisibility. For Grant, the science of optics had more explanatory power than the metaphysics of the relationship between mind/spirit and body.

Experiments with witches and demons

The Royal Society promoted experimentation as an essential means of establishing scientific knowledge. It was hardly surprising, therefore, that scholarly believers in witchcraft tried to apply experimental methods to investigations of witchcraft.

At the trial of the witches of Lowestoft at Bury St Edmunds in 1662, the judge was the eminent jurist Sir Matthew Hale, who was also an amateur scientist. Sir Thomas Browne was called as expert witness. During the trial Hale permitted an experiment that involved the suspects touching the alleged victims, who were blindfolded, with a 'control group' of people not accused of being witches also being touched. The description of the discussion of the experiment in the account of the trial is reminiscent of the Royal Society *Philosophical Transactions*, with an anonymous 'ingenious person' commenting on a possible design fault. 'The touching took the same Effect as before. There was an ingenious person that objected, there might be a great fallacy in this experiment.'[43]

The experiment in the courtroom did not save the lives of the accused. It did suggest that the 'victims' were faking their symptoms, but the jury did not take this into account. Instead they accepted the view of Sir Thomas Browne that, based on his clinical examination, the girls were genuinely bewitched.

Similar experiments were conducted in several other investigations and trials. In 1658 Jane Brooks was hanged for bewitching a young boy named Richard Jones in Somerset. Glanvill retold this story and was impressed by the way an experimental method was used to test the veracity of the boy's testimony. The suspect was obliged to touch the boy, and his body convulsed at the touch. An experiment was then organised. The boy was blindfolded. The justice called out that the accused should touch him but had secretly arranged for others to do the touching. The boy had no convulsions when touched by a random spectator rather than the suspect.

> The youth being blindefolded, the Justice call'd as if Brooks should touch him, but winked to others to do it, which two or three successively did; but the Boy appeared not concern'd.[44]

The magistrate then announced that his father should come forward next but in fact, without the boy's knowledge, the 'witch' was brought forward and forced to touch Richard Jones. The attempt to fool the boy failed. He sensed that he was being touched by the 'witch' and not his own father, and the touch triggered violent convulsions. Glanvill approved of the use of this experimental technique, which demonstrated, he thought, that there was no possible fraud on the part of Jones.

In the 1697 trial of the Renfrewshire witches that led to the execution of seven people, similar experimental evidence was used. Christian Shaw, a girl who was supposedly bewitched, had her head covered with a cloak and was touched both by one of the suspects and by other random bystanders. The touch of the 'witch' induced instant agony for Christian, but she had no reaction to being touched by other people. The prosecuting lawyer, Francis Grant, highlighted the significance of the 'Experiment' during his concluding speech to the jury.

> Her falling in Fits upon the sight, or touch of her Tormenters, was no effect of Imagination: For she was fully hood-winked

with a Cloak, so as she saw no Body whatsomever; yet upon the approach of her Tormenter, she immediatly fell down dead: Whereas she remained no ways startled upon the touch of any other: Which Experiment was tried for ascertaining this Mean of Discovery.[45]

Another type of experiment involved testing the linguistic ability of alleged demons in cases of possession caused by witchcraft. Since the Devil was superbly adept, demons were expected to be skilled at languages. In his *Natural History of Staffordshire*, Robert Plot explained, approvingly, how a case of fake possession had been exposed, using a linguistic test, by Thomas Morton, Bishop of Lichfield and Coventry. A boy called William Perry had accused Jane Clarke of having bewitched him, causing him to suffer convulsions when certain verses were read from the Bible in English. Bishop Morton experimented by reading scriptural texts in Greek in front of the bewitched boy. His rationale was that if the possession was genuine the possessing demon would have no problem understanding ancient Greek.

> If it be the Divel, he (being almost 6000 years standing) knoweth and understandeth all languages in the world, so that he cannot but know when I receit the same sentence out of the Greek.[46]

It became obvious that young William's demon could not understand Greek, and his fraud was thereby exposed. In his *Natural History of Wiltshire* Aubrey suggested a similar test, offering that the famous Tidworth poltergeist should have been tested by being spoken to in Latin or French.

Engaging with the science of witchcraft in Massachusetts

The leading figures in the intellectual world of late seventeenth-century New England were the father-and-son Puritan clergymen, Increase Mather and Cotton Mather. They immersed themselves in the works of Glanvill, More and other British advocates of the authenticity of witchcraft. Indeed, they generally read very widely; there are references to many European sources in their work. Suitably inspired, they proceeded to promote ideas about the science of witchcraft in New England.

Cotton Mather's breadth of reading is clear from the way he engaged with Henry Hallywell's ·*Melampronoea* (1681). This was a relatively obscure text and was largely overshadowed by the work of More and Glanvill. However, it is clear that Mather had studied Hallywell's work closely and internalised some of its messages and language. Direct echoes of Hallywell can be heard in Mather's *Wonders of the invisible world*. In one passage in his witchcraft text, Hallywell made the point that elite wizards probably consorted with a much higher class of demons than impoverished country witches. Mather said the same. Hallywell described the familiars of low-class witches as 'those fouler and grosser Fiends that attend a wicked Sorceress, daily sucking her bloud, and nestling in her loathsome rags'.[47] Mather repeated this, paraphrasing only slightly, when he referred to the demons associated with impoverished witches as 'those Baser Goblins that chuse to Nest in the filthy and loathsome Rags, of a Beastly Sorceress'.[48]

Increase and Cotton Mather approved of experimental enquiries into witchcraft. Inspired by his reading, Cotton Mather undertook a thorough study of the demons that he thought were possessing a girl from Boston called Martha Goodwin. After taking Martha into his home to study her demons in action, Cotton Mather discovered by accident, when speaking Latin, that the demons appeared to understand that language, and this led him to do further tests of the linguistic ability of the demons.

> I was in some surprize, When I saw that her Troublers understood Latin, and it made me willing to try a little more of their Capacity.[49]

Cotton Mather experimented by reading the Bible in Greek and Hebrew in the girl's presence but so quietly that she could not hear. Martha's convulsions worsened during these readings, and he concluded that the demons possessing the girl understood these learned languages. Cotton Mather experimented further, using a Native American language in her presence. This elicited no response. His view of this was distorted by his absolute conviction of the reality of this case of demonic possession, and he continued to believe that Martha was bewitched and possessed. Her inability to understand the Native American language simply indicated that these specific demons had some intellectual limitations.

In his study of the demons of Martha Goodwin, Cotton Mather was deliberately seeking to apply scientific experimental principles. He also reflected on the ethics of his investigation, perhaps influenced by the tale of the Devil of Mascon, which warned against dialogue with demonic spirits. Cotton Mather had some scruples, believing that you could only go so far as an investigator in communicating with evil spirits: 'I was not unsensible, that it might be an easie thing to be too bold, and go too far, in making of Experiments.'[50]

Despite these ethical concerns, Cotton Mather did try one more experiment, intended to test whether demons were capable of 'mind reading'. He determined to see if he could investigate experimentally 'Whether the Devils know our Thoughts, or no'. His investigation into how far demonic spirits had mind-reading powers was inconclusive. On the one hand, it seemed to be possible to trick the possessing spirits by saying one thing but simultaneously thinking the opposite. On the other hand, Martha went into a fit when he entered the room intending to propose some religious activities, as if the demons had read his mind. His provisional conclusion was that the mind-reading capacity might vary from demon to demon, with some being more adept than others: 'Perhaps all Devils are not alike sagacious.'[51]

After the Salem trials of 1692, Cotton Mather reflected further on the intellectual ability of evil spirits. In 1693 he published his thoughts in *Wonders of the invisible world*. He stressed that there was known to be a complex hierarchy of demons, with different levels of skill and aptitude.

> It is not likely that every Divel do's know every Language; or that every Divel can do every Mischief. Tis possible that the Experience, or, if I may call it so, the Education, of all Divels, is not alike, and that there may be some Difference in their Abilities. If one might make an Inference from what the Divels Do, to what they are, One cannot forbear Dreaming, that there are Degrees of Divels.[52]

In *Wonders of the invisible world*, Cotton Mather presented a novel theory as to how the Devil could cause the Plague.

> 'Tis no uneasy thing, for the Divel, to impregnate the Air about us, with such Malignant Salts, as meeting with the Salt of our

Microcosm, shall immediately cast us into that Fermentation and Putrefaction, which will utterly dissolve all the Vital Tyes within us; Ev'n as an Aqua-Fortis, made with a conjunction of Nitre and Vitriol, Corrodes what it Siezes upon. And when the Divel has raised those Arsenical Fumes, which become Venemous Quivers full of Terrible Arrows, how easily can he shoot the deleterious Miasms into those Juices or Bowels of Mens Bodies, which will, soon Enflame them with a Mortal Fire![53]

Cotton Mather's account used the language of contemporary science and medicine. Robert Boyle was very interested in the corrosive properties of acids, such as nitric acid or 'aqua fortis'. The medical writer John Mayow had suggested in a ground-breaking work on respiration, published in 1668, that during breathing 'nitro-aerial' particles were taken in from the atmosphere and combined with particles in the blood. In 1672, Nathaniel Hodges took the idea of 'nitro-aerial' particles and applied the concept to the causation of the plague.[54] The absorption by people of nitrous plague particles from the atmosphere, according to Hodges, caused 'putrefaction'. Mather had read the work of these writers, together with the witchcraft theorising of More and Glanvill. He synthesised the new scientific and medical ideas with his concept of the Devil as a brilliant but malevolent scientist. He set out to merge innovative scientific and medical concepts with belief in the action of the Devil in this world, and the result was a new theory of the plague as a manipulation of pestilential particles by the Devil.

Science and the Salem prosecutions

There were links between the promotion of scientific witchcraft theory and the events in Salem, where twenty people were executed for witchcraft in the summer of 1692. Glanvill's particle theory of the functioning of the 'evil eye' was influential in Massachusetts during the Salem witch hysteria. In October 1692, within weeks of the last hanging in Salem, a Boston merchant and intellectual, Thomas Brattle, wrote a letter condemning the trials and the use of pseudoscience by the prosecutors of the Salem witches. Brattle described how magistrates at Salem saw themselves as followers of the 'Cartesian philosophy'. They obliged suspects to take part in experiments, gazing at their 'victims' who promptly fell into convulsions. This confirmed

the magistrates in their view that 'malignant particles' had been emitted from the eyes of the 'witches'.

> The Salem Justices, at least some of them, do assert, that the cure of the afflicted persons is a natural effect of this touch; and they are so well instructed in the Cartesian philosophy, and in the doctrine of effluvia, that they undertake to give a demonstration how this touch does cure the afflicted persons; and the account they give of it is this; that by this touch, the venemous and malignant particles, that were ejected from the eye, do, by this means, return to the body whence they came, and so leave the afflicted persons pure and whole.[55]

Belief in 'spectral witchcraft', of the type that was rationalised and legitimised by More and Glanvill, featured prominently in the Salem witchcraft allegations. The English scholars had argued that it was entirely possible for witches to leave their bodies behind temporarily and, in spirit form, either attend ritual meetings or attack their enemies. The girls who denounced the Salem suspects claimed that they were attacked by the 'spectres' or disembodied spirits of the witches. The magistrates, influenced by the scientific witchcraft literature, took these accusations seriously. They had no doubt that out-of-body witchcraft was possible.

5

HENRY MORE, JOHN AUBREY AND THE WITCH OF SALISBURY

In the early 1650s, Henry More was searching for convincing stories from England about the work of witches. He had read thoroughly the continental demonological literature and identified many accounts of witchcraft that he considered to be credible, but that was not enough. He was on a mission to convince the people of England that witchcraft was authentic, as part of his larger plan to defeat atheism by proving the undoubted existence of the spirit world, and persuading the English about the reality of witchcraft ideally required English examples of sorcery that were beyond the scoffing and reproach of the sceptics.

In 1653 More published his *Antidote against atheism*, which included a collection of the most convincing instances that he could find of the apparent authenticity of witchcraft. More did the best he could to present English case studies within his anthology of witchcraft stories, but there was a preponderance of material from French and other continental sources. The English case studies included an account of More's own interview with two women on trial for witchcraft in Cambridge in 1646. One of his interviewees, Goodwife Lendall, was condemned to hang after her fellow suspect spoke against her, accusing her of hosting banquets where the Devil was the guest of honour. More presented this account as evidence of the truth of witchcraft.

In the same year that *An antidote against atheism* was published, More was intrigued to hear about a witchcraft trial in the city of

Salisbury. The news seemed particularly relevant to his campaign to promote belief in witchcraft. A woman called Anne Bodenham had been executed after a trial at which sensational evidence had been presented. Damning testimony was given against Bodenham by the star witness, Anne Styles, a maid working for a leading Salisbury family. Styles claimed that Bodenham had recruited her as a witch. She described Bodenham's extraordinary powers: transforming herself into a cat, summoning spirits in the form of ragged boys, transporting Styles from Salisbury to the town of Wilton in an instant to gather herbs needed for magical rituals. Style's most damaging accusation was a claim that Bodenham had persuaded her to sign, in her own blood, a solemn contract with the Devil.

The story of Anne Bodenham caused an immediate, national sensation. The text of the title page of one contemporary pamphlet gives a good flavour of the bizarre claims that were made about the powers of Bodenham as witch:

Strange and terrible News from Salisbury; BEING A true, exact, and perfect Relation, of the great and wonderful Contract and Engagement made between the Devil, and Mistris Anne Bodenham; with the manner how she could transform her self into the shape of a Mastive Dog, a black Lyon, a white Bear, a Woolf, a Bull, and a Cat; and by her Charms and Spels, send either man or woman 40 miles an hour in the Ayr.[1]

An account of the Bodenham trial was printed soon after the trial in the form of a ballad called *The Salisbury Assizes, or, the Reward of Witchcraft*. It presented a very simple account of a Faustian pact between Bodenham and the Devil. In the following verse, Bodenham invites Anne Styles to become her apprentice, offering her a comfortable life in return for the sale of her soul to the Devil.

Sweet heart, quoth she, if that you please,
I will teach you my art,
So you may live in wealth and ease
According to your heart.
If you your Soule the Divell will give,
In health and wealth you then may live.[2]

While the public was entertained with these accounts, More's interest in the case was intensely serious. For him, the Salisbury case study served two important purposes. Firstly, he thought that the level of proof of guilt in the case of Anne Bodenham was extremely high and beyond reasonable doubt; if properly communicated this story could confound those sceptics who questioned the reality of witchcraft. Secondly, More considered that the case could be used to show that there was no real difference between the witchcraft of country women and the elite ritual magic practised by some London astrologers. Anne Bodenham's career and her magic spanned both worlds.

More's investigation into the witchcraft of Anne Bodenham drew heavily upon the account of events provided in a contemporary pamphlet written by Edmund Bower,[3] an eyewitness to the trial. Bower played an active role in the proceedings and interviewed Anne Bodenham and Anne Styles in gaol. His pamphlet was extremely hostile towards Bodenham, but it was carefully researched and provided readers with a large amount of contextual detail.

In addition to the Bower pamphlet, More had access to extra information about the case from other eyewitnesses who were present at the trial. More's account made use of both Bower's narrative and these additional sources. More explained that, as well as reading Bower, he was informed by 'others who were than at the Assizes'.

> He that has a minde to read the Story more at large, he may consult Edmond Bower. But I shall onely set down here what is most material to our present purpose, partly out of him, and partly from others who were than at the Assizes, and had private Conversations with the Witch, and spoke also with the maid that gave evidence against her.'[4]

We do not know the names of these 'others' who had attended the trial and had private interviews with the suspect, but More manifestly trusted them. Many years later he described one of them as 'a worthy and Learned Friend of mine'.

The news from Salisbury came too late for the first edition of More's book, but he issued a revised edition of *An antidote against atheism* two years later in 1655, and gave pride of place to the tale of Anne Bodenham. At the same time, his second edition dropped the account of Goodwife Lendall, the witch of Cambridge, and her

banquets with the Devil. The allegations against Lendall were no longer needed because he had found, in the story of Anne Bodenham, a better case study, with a stronger supporting evidence base.

The life and death of Anne Bodenham

Bower's account provided More with important information about the events leading to the destruction of Anne Bodenham. She was about eighty years old in 1653. Before the trial she had worked openly for several years as a 'cunning woman', a provider of healing and magical services to people in Salisbury. Bodenham was not a stereotypical witch. She was married to a 'clothier', a businessman engaged in the manufacture of woollen cloth. She was literate and taught local children to read and write. She was known as 'Mistress Bodenham', indicating that she had some social status; the names of poorer women were prefixed with the courtesy title 'Goodwife' rather than 'Mistress'.

The chief witness for the prosecution, Anne Styles, was a servant in the household of the Goddard family, who lived in one of the grand houses in the cathedral close of Salisbury. The Goddard household made extensive use of Anne Bodenham's skills, asking her to provide magical advice on such matters as love affairs and the whereabouts of stolen property. Anne Styles was the intermediary between the family and Anne Bodenham.

It is clear from Bower's pamphlet that the Goddards of Salisbury were not a happy family. Bower explained that 'Mistress Goddard' feared that her 'daughters in law' were trying to poison her. Bower did not give her first name, but we know from other sources that the household was headed by one Hester Goddard and her lawyer husband, Richard Goddard. Hester was 'Mistress Goddard'. Hester Goddard wanted help from Anne Bodenham. The two women did not meet, instead relaying their communication through Anne Styles. Hester Goddard wanted to know whether her suspicions about the murderous intentions of her 'daughters in law', Sarah and Anne Goddard, were correct, and whether Bodenham could provide any magical assistance to thwart the plot to kill her. Bodenham told Hester that she was right to suspect her 'daughters in law' and agreed to help.

Bower's account suggests that Sarah and Anne Goddard began to suspect that there was a plot to 'plant' evidence of poison, implicating

them in the attempted murder of Hester Goddard. They made enquiries and discovered that Anne Styles had recently purchased arsenic from an apothecary in the city. Hester Goddard heard about this discovery. She urged Anne Styles to leave Salisbury and go to London. Styles fled, as instructed, but only got as far as the nearby village of Sutton Scotney, where she was captured. Taken to an inn in the town of Stockbridge, she diverted attention from the charge of fabricating evidence of attempted murder by accusing Anne Bodenham of witchcraft and of enticing her to become a witch.

Styles explained to her captors that, at the instigation of Anne Bodenham, she had signed a contract with the Devil shortly before she left Salisbury. Styles spent much of the night at Stockbridge having convulsions and, between fits, explaining that the Devil was unhappy with her for reneging on her deal with him. These claims were taken seriously by her interrogators, and by the time Styles was returned to Salisbury, the focus was beginning to shift from an investigation into the suspicious purchase of arsenic to an enquiry into Bodenham's witchcraft.

Following her denunciation by Styles, Anne Bodenham was arrested on suspicion of witchcraft and taken to the county gaol for questioning and to await trial. Styles was also remanded in the same gaol, 'on suspicion of the poyson pretended to be provided for her Mistris', but her status changed in the days that followed. The poison allegations were given little attention, and she became instead the key witness in the prosecution of Bodenham.

Public opinion, for the most part, took the side of Anne Styles, the alleged victim of witchcraft. When Edmund Bower first heard about Anne Styles, she was already seen as someone bewitched.

> And the Monday morning following I comming to Sarum, where there was a great rumour about the City of a Witch that was found out, that had bewitched a Maid, and they both were in prison, and that the Maid was often troubled with such strange fits that drew both pity and admiration from the beholders.[5]

Styles continued to have violent fits in gaol, claiming in her lucid moments between convulsions, that the Devil possessed her and was angry because she had broken her contract with him. Bodenham angrily denied the accusations of Styles.

The scenes in the gaol were chaotic, as many members of the public were allowed in to see both Bodenham, the accused witch, and Styles, her accuser. Shortly before the trial commenced, the 'bewitched' maid, Styles, was brought into the presence of Anne Bodenham at the behest of Bower. A large crowd of unfriendly members of the public witnessed the encounter between the 'victim' and the 'witch'. Anne Bodenham was understandably upset at the arrival of her accuser, and tried to hide under a bed, but was pulled into view by the mob. She screamed and hit out at and cursed onlookers.

At the trial, Styles stuck to her story that Bodenham had persuaded her to sign a contract with the Devil. Additional evidence was provided by women who had searched Bodenham's body in gaol for signs of the suspicious teats or marks associated with witches. The jury accepted both the testimony of Styles and evidence derived from the physical examination of Bodenham. She was found guilty and sentenced to death.

Bower described how Bodenham was unrepentant at the gallows. It was traditional for the condemned to forgive the executioner at the final moment. Bodenham refused to do this. Her last words were a curse upon the executioner. For Bower, Bodenham's lack of remorse at the gallows was final, confirmatory proof of her guilt as a witch.

> She replyed, Forgive thee? A pox on thee, turn me off; which were the last words she spake: She was never heard all the while she was at the place of Execution to pray one word, or desire any others to pray for her, but the contrary. Thus you have her wicked life, her wofull death. Those that forsake God in their lives, shall be forsaken of him in their deaths.[6]

The true story of Anne Bodenham

More was entirely convinced that Bodenham was a witch, with supernatural powers derived from her compact with the Devil. His main source was the treatise by Edmund Bower, who was also unequivocal about Bodenham's guilt.

Despite the hostility of Bower and More towards Bodenham, and their portrayal of her as a proven witch, it is possible to use their accounts to construct a plausible alternative explanation of how an innocent woman came to be condemned as a witch.

Anne Bodenham clearly saw herself as a 'white witch', who could summon good spirits to help her clients. She had worked openly in Salisbury for many years, providing healing and magic services, and was simply unfortunate to become caught up in an internal family dispute in a prominent Salisbury household.

Other sources enable us to understand the family context and that Hester Goddard was, in fact, the stepmother of Sarah and Anne Goddard, who were sisters. They were the daughters of Richard Goddard and his previous wife, Mary, who had died some years before. Bower described Hester as 'mother in law' to Sarah and Anne. In the seventeenth century, this term could cover both the mother of a spouse (as today) but also a stepmother.

The antagonism between the Goddard sisters and their stepmother was almost certainly exacerbated by the catastrophic financial circumstances of the family. Richard Goddard, who had twelve children to support from his previous marriage, including Sarah and Anne, had been ruined by the events of the Civil War. A very active royalist, he fought on the side of the king and in 1644 was taken prisoner at Christchurch in Dorset. Goddard was eventually released on promises of future good behaviour. Afterwards he was both fined and deprived of any income as a lawyer because he was forbidden to practice by the parliamentary authorities.[7] In 1646 he explained that he was in debt for the massive amount of £2,000 and that his personal estate was worthless. The intense animosity between his wife and his daughters from a previous marriage was probably made worse by this calamitous, impoverished state.

Bower makes it clear that when Anne Styles visited Bodenham she was acting on behalf of Hester Goddard but taking day-to-day orders from Hester's personal assistant, Elizabeth Rosewell. Hester was genuinely convinced that she was being poisoned. Her immediate response to the perceived attacks of her stepdaughters was twofold: she needed evidence that they were trying to kill her and she also wanted counter-magic to stop the conspirators in their tracks. She turned, via Rosewell and Styles, to the 'white witch' Anne Bodenham, who confirmed her fears and provided some protective magic.

Hester Goddard and Elizabeth Rosewell seem to have decided that Bodenham's magical charms were not enough. They concluded that there was a need to manufacture some 'evidence' to support their allegation that the sisters were planning to poison Hester. Styles was

ordered to buy arsenic from an apothecary in Salisbury which would be 'planted' in the belongings of Sarah and Anne. The plot was discovered. Hester and Rosewell panicked and told Styles that she must go immediately to London and disappear.

This explanation is entirely consistent with information found in Bower's account, in which it was Hester Goddard who insisted that Styles go to London and try to vanish for fear that otherwise the plot would be discovered by the authorities:

> Her Mistris [Hesther Goddard] wished her to goe away and shift for her selfe, otherwise they supposed that she should be examined before some Justice, and so there might some trouble and disgrace come upon them in the businesse.[8]

This plan failed when Styles was captured on her way to London and returned to Salisbury. Under arrest, and under suspicion because she had purchased arsenic, Styles decided to create an alternative narrative about the witchcraft of Anne Bodenham. This ploy proved highly successful. There was an appetite for stories of witchcraft, and so the allegations of the purchase of arsenic were quietly forgotten and Hester Goddard played no part in the trial. Styles was able to set aside her role in the vicious family argument and, instead, persuade a Salisbury jury that she was the victim of the witchcraft of Anne Bodenham.

Henry More's 'proof' of the guilt of the witch of Salisbury

For More, the story of Anne Bodenham was extremely significant. This case study provided incontrovertible evidence of the existence of the spirit world. The empirical data from Salisbury could be used to confound completely the witchcraft sceptics. The key evidence for More was the testimony of Anne Styles. No reasonable person could, he claimed, fail to be convinced by what 'the Maid' said.

> It cannot, I say, but gain the full assent of any man, whom prejudice and obstinacy has not utterly blinded, that what the Maid confessed concerning her self and the Witch is most certainly true.[9]

Henry More's eighteen-page chapter on the Bodenham case set out to provide a detailed, systematic explanation of the proof of her

guilt. More went through the events, step by step, emphasising the plausibility of the account of Anne Styles. He could see no evidence of 'melancholy' or mental incapacity that might invalidate her confession. Sceptics criticised confessions on the grounds that those confessing were deluded and suffering from mental health problems, but More argued that in this case the young woman seemed lucid and perfectly capable.

Physical evidence had a great significance for More as proof of the authenticity of witchcraft events. He itemised the tangible material that was shown at the trial: magical powder, a coin presented by the Devil and the visible hole in Styles' finger from which she took blood and signed her compact with the Devil.

> All these things the Maid deposed upon Oath; and I think it now, beyond all controversie, evident, that unless she did knowingly forswear her self, that they are certainly true. For they cannot be imputed to any Dreamings, Fancy, nor Melancholy. Now that the Maid did not forswear her self, or invent these Narratives she swore to, many Arguments offer themselves for eviction.[10]

For More, the credibility of Anne Styles was the key. Having given an overview of the evidence, he proceeded to explain four 'arguments' that proved the complete trustworthiness of the confession of Styles.

The first 'argument' or proposition sheds incidental light on More's rather haughty view of the capacity of common people. He contended that it was highly unlikely that an uneducated servant such as Anne Styles could invent the specific details of magic ritual that she described in her court testimony:

> It is altogether unlikely that a sorry Wench, that could neither write nor read, should be able to excogitate such Magical Forms and Ceremonies, with all the circumstances of the effects of them, and declare them so punctually, had she not indeed seen them done before her eyes.[11]

More's next 'argument' was that the woman's testimony could be trusted because she did not benefit from her claims. This question of benefit was important to More when evaluating the quality of testimony in cases of witchcraft. His view of the Styles confession

was that it showed her own behaviour in a poor light. Why would anyone describe their own poor behaviour unless the testimony was true? More focussed on the role that Styles had played in the plots and counter-plots that had taken place within the Goddard household. The maid had admitted that she had bought arsenic. Why would she make such a damaging admission unless it was true? He argued that we can trust a confession if it is to the disadvantage of the person confessing.

> Confession I say cannot be any figment or forged tale, but certain truth, it making nothing for the parties advantage, or theirs that imployed her, but rather against them, and mainly against her self.[12]

The third 'argument', or proof of trustworthiness, was that the claims Styles made about the compact between Bodenham and the Devil had 'real effects', observable consequences attested to by reliable witnesses. The idea of 'real effects' as an indicator of authentic supernatural events had been highlighted in the first edition of *An antidote against atheism*. There were 'real effects' after Anne Styles confessed; she had been sworn to secrecy by the Devil but she broke this trust and he punished her with violent convulsions, which were witnessed, and considered authentic, by many credible witnesses.

> What befell the Maid after her revealing those secrets she was intrusted with, was not counterfeited, but reall, nay, I may safely say, Supernatural.[13]

More's fourth and final 'argument' as to why the testimony of Styles should be considered impeccably trustworthy related to her demeanour in court. Eyewitnesses told him that her behaviour in court was very convincing. After Bodenham was convicted, Styles acted as if she was very upset, with 'floods of tears' and 'bitter weepings'. Styles expressed great remorse for her 'own wickedness and madness' and called on the judge to spare the life of Bodenham. More claimed that this behaviour was conclusive evidence of Styles' honesty and could 'wash away all suspicion of either fraud or malice'.

Towards the end of his report of the case, More moved away from Styles' evidence and analysed Bodenham's comments. An unnamed

friend of More's had been able to interrogate her in gaol. She presented herself to this witness as a misunderstood practitioner of permitted angel magic. Bodenham did not hide the fact that she practised magic. She proudly described how she used her astrological knowledge to communicate with benign spirits or angels. The common people who accused her of witchcraft did not understand that her spirits were angelic and not demonic.

> She did also highly magnifie her own art to him, venturing at Astrological terms and phrases, and did much scorn and blame the ignorance of the people, averring to him that there was no hurt in these Spirits, but that they would do a man all good offices, attending upon him and garding him from evil all his life long.[14]

This evidence about her use of the jargon of astrology, and her claims that her spirits were benign, is not found in the Bower pamphlet. It offers confirmation that Bodenham was not a typical rural magic practitioner. She was, it seems, practising angel magic of the type used by the Elizabethan magus John Dee. More understood this and it served his purpose. For More, the angel magic of John Dee was completely misguided. Communicating with any spirits was forbidden and highly dangerous as evil spirits were perfectly capable of masquerading as 'angels of light'. By condemning Bodenham, More was also shaming those members of fashionable society who experimented with angel magic.

With the benefit of hindsight, More's arguments in favour of the manifest guilt of Anne Bodenham look extremely weak. It is less surprising to us than it was to More that a smart servant woman could have the wit and knowledge to invent a plausible story about magic rituals and contracts with the Devil. Styles was, it seems, intelligent and determined. There is no reason at all to think that she was, as More said, 'a sorry Wench', incapable of successful deception. More's informants were impressed by her confident demeanour at the trial but, of course, this can be explained by her strength of personality and determination to save herself and tells us nothing of substance about the truth of her claims.

Perhaps More's key argument in favour of the guilt of Bodenham was his proposition that Styles must have been telling the truth because

her testimony damaged her own reputation. This was obviously flawed logic. Anne Styles was forced to flee from Salisbury because of accusations that she had purchased arsenic as part of a plot instigated by her mistress, Hester Goddard, to fabricate evidence implicating Sarah and Anne Goddard in an attempt to kill Hester. Styles was pursued and captured. At the moment of capture she was in very big trouble, and it was precisely then that she began her denunciation of Bodenham. Styles' testimony about the witchcraft of Anne Bodenham was hugely in her own favour because it distracted attention away from her guilt in the attempt to frame Sarah and Anne. It also provided an alternative narrative that explained away her highly suspicious action in purchasing arsenic. The court accepted her claim that she had bought the arsenic for some magic ritual undertaken by Anne Bodenham. Through this testimony, Anne Styles succeeded in transforming her fortunes from a prime suspect in an investigation that could have led to her own hanging to the key witness responsible for the prosecution and death of another. More was quite wrong to suggest that Styles did not benefit from her testimony in court.

More's assertion that Bodenham condemned herself by her testimony tells us a lot about his own view of the supernatural. Bodenham did not confess to witchcraft, but she did say openly that she had the power to invoke spirits. She meant good spirits or angels and not demons. She saw herself as a 'white witch', able to harness benign supernatural powers. More did not accept the distinction between benign angel magic and malevolent demon magic. Any form of 'conjuring' of spirits was witchcraft for him.

More recounted how Anne Styles had called for mercy for Anne Bodenham after the guilty verdict was declared. He described 'her willingness notwithstanding, if it might be done without sin, that the Witch might be reprieved'. According to More, Styles' call for clemency conclusively established her own innocence. This seems to be very naïve thinking. It is much more likely that Styles' plea for mercy was motivated by her sense of personal guilt, since she was responsible for the death sentence that the court ordered for Anne Bodenham.

More's certainty regarding Bodenham's guilt was strengthened by the results of her physical examination. On grounds of decency, he omitted the detail found in Bower that Bodenham, aged about eighty, was subjected to a humiliating inspection of her genitalia. There is

no indication at all that More disapproved of the intimate physical examination of women for signs that they were sucked by their demonic familiars. Quite the contrary, he saw the physical evidence as useful confirmation of the testimony of Anne Styles. He presented the results of the physical examination as additional information that supplemented the key witness statements.

> Add unto all this, that this Ann Bodenham was searched both at the Gaol and before the Judges at the Assizes, and there was found on her shoulder a certain mark or teat about the length and bigness of the nipple of a womans breast, and hollow and soft as a nipple, with a hole on top of it.[15]

Henry More concluded his eighteen-page report on the Bodenham case with a summary of his findings. There was, he believed, extensive, varied and compelling evidence proving that Anne Bodenham was a witch. While the evidence base was diverse and impressive, the argument was clinched by the testimony of Anne Styles. She denounced Bodenham, without having anything to gain and much to lose by what More saw as her manifestly honest account of Bodenham's witchcraft. The case against Bodenham was so strong that no reasonable person could fail to agree that the authenticity of witchcraft had been convincingly demonstrated.

More had established to his own satisfaction the guilt of Anne Bodenham and, by implication, the undeniable reality of witchcraft. He maintained these beliefs for the rest of his life. Over twenty-five years after publishing his account of the events at Salisbury, More put in print the text of a letter to his great friend Joseph Glanvill, describing Bodenham as a person 'whose History, I must confess, I take to be very true'.[16]

More, Anne Bodenham and the world of elite magic

Henry More had two targets in mind when he promoted the truth of Bodenham's witchcraft: those who denied the truth of witchcraft, and the proponents of astrology and ritual magic.

More was deeply concerned both about the rise of religious scepticism and the moral threat caused by the fashion for angel magic and astrology. Bodenham, in More's eyes, was no rustic witch; she possessed some of the characteristics of a learned magician. She was

literate. She used a book of invocations and elaborate rituals to summon evil spirits, creating a magic circle and placing foul-smelling incense on a pan of coals as a way of attracting demons. She had a green crystal ball for the summoning of spirits and in order to see what was happening in other places.

More explicitly associated Bodenham with elite and learned forms of magic rather than crude rural witchcraft. He said that she practised the same arts that 'the more notable sort of Wizards and Witches are said to pretend to and to practise'. Before her arrest she operated openly, without attempting to conceal 'her skill in foretelling things to come, and helping men to their stolen goods, and other such like feats'.[17] More was implying that Anne Bodenham was similar to fashionable London astrologers such as William Lilly, who provided precisely these types of service, predicting the future and recovering stolen goods.

The link between Bodenham and this elite magic was highlighted by the fact that she had spent time as a young woman in London where she was trained by John Lambe, a notorious society wizard who worked for the Duke of Buckingham, royal 'favourite' to James I and his son, Charles I. Lambe was unpopular during his life because of his reputation for black magic and his association with Buckingham. He was killed by a lynch mob in London in 1628. Both Bower and More emphasised that Bodenham openly acknowledged that she had been taught to summon spirits by Lambe.

The significance for Bower of the Lambe connection is reflected in the full title he gave to his treatise: *Doctor Lamb revived, or, Witchcraft condemn'd in Anne Bodenham a servant of his*. More also drew attention to Bodenham's connection with John Lambe. It was from Lambe, he said, that Bodenham had 'learnt the art of raising Spirits'. While Anne Bodenham was apparently happy to acknowledge her previous association with Lambe, for Bower and More, Lambe had been an evil practitioner of the dark arts who deserved his death at the hands of a London mob.

Bodenham was also associated with another highly controversial figure, the astrologer William Lilly, who later became an associate of John Aubrey. Unlike Lambe, Lilly was alive and active in 1653. He was the leading astrologer of the age. Lilly divided opinion, with many people openly accusing him of using witchcraft to obtain his predictions. Bower was keen to point out that Bodenham used

astrology as part of her magical practice. She told him that Jupiter was 'the best and fortunatest of all the Planets'.[18] She also compared her own magic to that of William Lilly. Bower's pamphlet described how she claimed powers that equalled those of Lilly, saying that she could 'do more than master Lilly or any one whatsoever'.[19]

Lilly had influential friends and clients, but he was also seen by many as an agent of the Devil. For his critics, Lilly's astrology was no different to witchcraft. There was a pamphlet war about Lilly's astrology in the early 1650s, with many religiously motivated writers condemning it as witchcraft. In 1653, the same year that Bodenham was prosecuted and hanged, John Brayne, a radical clergyman operating not far from Salisbury in Winchester, published a treatise whose full title made clear his views: 'Astrologie proved to be the old doctrine of demons, professed by the worshippers of Saturne, Jupiter, Mars, sunne and moon in which is proved that the planetary and fixed starres are the powers of the ayre, which by Gods permission are directed by Satan'. It was within this climate of widespread clerical antagonism towards elite astrology that Bodenham was prosecuted.

Henry More had no time at all for the astrology of William Lilly. He was also worried by the danger posed by those who experimented with spirit magic of the sort proposed earlier in the century by John Dee. More made his views clear in his commentary on Bodenham. She foolishly and naively imagined that the demons she was summoning were angels. Bodenham was convinced, wrongly, that she was working with good spirits. This was the same error made by other practitioners of ritual magic, such as John Dee.

> It is likely these Wise women take the Spirits they converse with to be good Angels, as Anne Bodenham the Witch told a worthy and Learned Friend of mine, That these Spirits, such as she had, were good Spirits, and would do a man all good offices all the days of his life.[20]

More made known his contempt for elite magic and astrology in other works. In 1650 he published a treatise ridiculing the pretensions of the Welsh alchemist and mystic Thomas Vaughan (1623–1666), who promoted the esoteric magic of the mysterious German Rosicrucian fraternity. More accused Vaughan of dabbling in witchcraft. In 1660 Henry More attacked astrology of the type practised by William

Lilly in another book, *An explanation of the grand mystery of godliness*. In this work he suggested that elite astrology was closely related to witchcraft.

Henry More's worries about the links between witchcraft and fashionable ritual magic and astrology were connected to his wish to expose the guilt of Anne Bodenham. The story of Bodenham was useful to More because it demonstrated both the reality of witchcraft and the connection between witchcraft, ritual magic and astrology.

John Aubrey's defence of Anne Bodenham

There is no evidence that John Aubrey had much sympathy for any uneducated women who were accused of being witches. He did not dispute the reality of witchcraft. Yet, curiously, Aubrey challenged More's hostile view of Anne Bodenham. When, in 1685, Aubrey edited his notes and produced his final version of the *Natural History of Wiltshire*, he decided to tell the story of the trial of Anne Bodenham in a way that was radically different to Henry More's account. For Aubrey, Bodenham was a possible victim of a miscarriage of justice because she had not received a fair trial.

Placing this alternative narrative on the record was surely a deliberate act. Henry More's version of events was extremely well known and had been in print for thirty years. Aubrey did not mention More by name, but the implication of his sceptical account of the Bodenham case was that the learned Dr Henry More was mistaken.

Aubrey's narrative drew upon the testimony of another witness to the trial, his great friend Anthony Ettrick. As we have seen, Ettrick was a fellow believer in the supernatural and a man Aubrey held in the highest regard. His name appears first on Aubrey's list of special friends, the 'Amici'. Aubrey's style is extremely succinct, but his message was unambiguous: Ettrick was there, his judgement was excellent, and he was not convinced by the outcome of the trial.

> Mr. Anthony Ettrick, of the Middle Temple (a very judicious gentleman), was a curious observer of the whole triall, and was not satisfied.[21]

Aubrey recounted how Ettrick considered the trial to be flawed because it was conducted in a chaotic atmosphere, with a hostile crowd of local people demanding the death of the 'witch'. Ettrick

was a young lawyer, called to the Bar the previous year. It is not clear whether he was present for professional reasons or out of curiosity.

Ettrick suggested that the public gallery noisily interrupted proceedings. People were baying for blood. Ettrick explained that the judge could not even hear Anne Bodenham when she testified in her own defence, due to the level of noise in the courtroom. The judge relied upon a clerk who gave him inaccurate written notes of the testimony of the accused.

> The crowd of spectators made such a noise that the judge could not heare the prisoner, nor the prisoner the judge; but the words were handed from one to the other by Mr. E. Chandler, and sometimes not truly reported.[22]

Why was Aubrey keen to point out that More's proof case study of authentic witchcraft was flawed? One possible explanation lies in the way More used the Bodenham case to attack not only the witchcraft of the lower social orders but also elite ritual magic and astrology, subjects close to Aubrey's heart.

Aubrey was a believer in the legitimacy and power of angel magic and astrology. There were similarities between Bodenham's practice and the magic promoted by Aubrey. Bodenham admitted that she could invoke spirits, but that they were benign spirits or angels. Aubrey wrote in positive terms about the possibility of 'conversing' with angels in *Miscellanies*. Bodenham used a green glass ball to summon her spirits and foretell the future. Aubrey was also fascinated by crystal ball magic.

Bodenham stated that she was a disciple of the London wizard John Lambe, who was known for his use of spirit magic and crystal balls. Lambe's approach to magic appears to have been within the tradition made famous during the Elizabethan period by the wizard John Dee. Aubrey was very interested in Dee and assisted Elias Ashmole in a project to preserve as much information as possible about his life.

According to More, Bodenham was a witch and an astrologer. For him, witchcraft and astrology were closely related. More was particularly struck by the views of his anonymous friend who interviewed Bodenham in gaol and described her tendency to use astrological terminology when describing her work. Aubrey believed passionately in the truth of astrology. Aubrey's commitment to

astrology grew in the 1670s during the period when he was operating in the circle of Elias Ashmole and developing a deep friendship with the astrologer Henry Coley.

Henry More and John Aubrey were Fellows of the Royal Society who believed in the real power of witches. At the same time, the two men disagreed strongly in their view of the legitimacy of astrology and ritual spirit magic. More used his attack on Anne Bodenham as an indirect assault on those who indulged in these activities. In his *Natural History of Wiltshire*, Aubrey had an opportunity to get his own back. He used his account of the Bodenham trial as a way of mocking the clerical perspective of Henry More and defending the spirit magic/astrology tradition.

6

JOSEPH GLANVILL AND THE WITCHES OF SOMERSET

In 1665 a major investigation into organised witchcraft took place in rural Somerset. The driving force behind this enquiry was a local magistrate, Robert Hunt. He was a friend of Joseph Glanvill who, much later, publicised the results of the Somerset cases in the first edition of *Saducismus Triumphatus*. It will be suggested here that Glanvill not only documented the results of the 1665 enquiry, but also played an active part in its design. Glanvill's close involvement in the actual prosecution of witches helped him to clarify his own ideas about the science of witchcraft, which he described in a series of publications from 1666 onwards.

Joseph Glanvill was ordained as a priest in the Church of England in 1662. Soon after his ordination, he was appointed as vicar of St John the Baptist church in Frome, Somerset. Having moved to Somerset, he befriended a local justice of the peace named Robert Hunt. The two men shared an unshakeable belief in the reality of witchcraft. For Glanvill, the friendship with Hunt was fruitful. Glanvill theorised about witchcraft, and Hunt provided empirical evidence to support the theories based on his first-hand experience as a prosecutor of witches.

Hunt's involvement in the rooting out of witches went back several years. In 1658 he had personally investigated the witchcraft of Jane Brooks, a woman from the town of Shepton Mallet. Hunt was persuaded of her guilt and, in his role as investigating magistrate, recommended that she should be tried by the assize judges. Duly found guilty, Brooks was hanged in March 1658.

The 1665 investigation set out to expose and punish witches in two Somerset villages: Brewham and Stoke Trister. Brewham was only about 8 miles away from Glanvill's vicarage in Frome. Glanvill shared Hunt's view that dangerous, organised groups of witches were operating in these villages and deserved the harshest punishment. As we shall see, it is highly likely that Glanvill played an important role in the investigation, suggesting questions that were addressed to the suspected witches during their interrogation.

In 1666, stimulated by these events in Somerset and his discussions with Hunt, Glanvill published his first book about witchcraft, *A Philosophical Endeavour towards the Defence of the Being of Witches and Apparitions*. The publication took the form of an extended letter from Glanvill to his friend Robert Hunt. On the title page, Glanvill proudly identified himself as a Fellow of the recently formed Royal Society. The detail of the text also made clear that he undoubtedly approved of the prosecution of witches. Glanvill was fulsome in his praise for Hunt as an energetic investigator of witches. The country owed him a debt for his 'Ingenious Industry for the Detecting of those Vile Practicers'.

A Philosophical Endeavour did not describe any of the specific events that had taken place in Somerset. Instead, as Glanvill's introductory remarks to Hunt explained, the book was intended to provide a theoretical framework, within which such instances could be understood. Glanvill made a direct reference to recent witchcraft in Somerset, telling Hunt that his aim was to establish 'a way of accounting for some of those strange things you have been a witness of'. Glanvill hinted at the possibility that Hunt might, in the future, want to share with the world what he knew about witchcraft in practice: 'You can abundantly prove, what I have but attempted to defend.'[1]

In 1668 Glanvill produced a substantially expanded edition of his book on witchcraft. Although this was a revised version of the earlier book, he gave it an entirely new title, *A blow at modern sadducism*. In addition to the theory of witchcraft found in the first edition, Glanvill included substantial new empirical evidence intended to prove the existence of a world of evil spirits. The main, real-world case study focussed on the poltergeist events at Tidworth, the so-called Drummer of Tedworth. Glanvill also included information about the 1658 Somerset trial of Jane Brooks, largely in the form of the notes that Hunt had taken during the investigation. He did not provide an account of the 1665 investigation; this appeared in print much later in the 1681 book *Saducismus Triumphatus*.

The witch of Shepton Mallet

Before telling the story of Jane Brooks in *A blow at modern sadducism*, Glanvill made some introductory remarks in the form of a letter to Lord Brereton, a prominent Fellow of the Royal Society. Glanvill was looking for support from Brereton for his proposal that the Royal Society should launch a major official enquiry into the supernatural. He indicated that he had discussed the case of Jane Brooks with Brereton in person and reminded him that the story contained convincing evidence of the reality of 'WITCHES and Diabolick Contracts'.[2] He explained that he was now honouring a promise to provide, in addition to the description of the Tidworth poltergeist, a full account of the Brooks case, based on information supplied by Robert Hunt, the investigating magistrate in the case.

> I shall adde the other NARRATIVE which I promised your Honour, and which I received from the Justice of Peace, who took the Examination upon Oath: 'Tis the same Gentleman to whom I directed my Letter about WITCHCRAFT, and a very judicious, searching, and sagacious person. He was pleased to give me his own Copy of the Examination.[3]

The case against Jane Brooks centred on charges that she had bewitched a boy called Richard Jones. The story began in November 1657 when, according to the boy, an unknown woman appeared at his house, giving him an apple and stroking the side of his body. He soon fell violently ill. He did not know the name of his attacker, so his father arranged for the women of the town to be brought in batches to the house in order that Richard could identify the woman who had bewitched him. Eventually, Jane Brooks was brought in and the boy indicated to his father that she was the one. His father immediately scratched Brooks in the face. Scratching was a traditional way of seeking to reduce the power of a witch. This action immediately brought some relief to the boy.

Richard's illness returned a week later, after he had met Brooks' sister, Alice Coward, on the street. Afterwards, he claimed that he could see Brooks and Coward in his house, in spectral form, tormenting him. Glanvill was fascinated by this evidence because such spectral appearances were consistent with Henry More's contention that witches could leave their bodies behind and travel in a spirit form. He recounted how Richard described the appearance of the apparitions of the women

with great precision. The local constable raced to the house of Jane Brooks and was able to confirm that she was dressed in exactly the way described by the boy. On one occasion, Richard was at home with his cousin when he claimed to see Jane Brooks. The apparition was invisible to his cousin, but Richard was able to point to Jane's whereabouts in the room, and his cousin used a knife to slash in that direction. Richard cried out that his cousin had successfully cut the witch's hand. His father called on the local constable, and they went to visit Brooks to see if her hand was injured. They found her sitting in her house, attempting to hide one hand under another. The hidden hand was eventually revealed and was cut in a way that was consistent with what Richard saw in the apparition.

Using evidence from Hunt's notebook, Glanvill recounted some other remarkable features of the case of Richard Jones. Perhaps the most curious evidence related to the way the bewitched boy was magically levitated and transported. The boy was in the house of a man called Richard Isles in Shepton Mallet on 25 February 1658, when he was lifted by invisible forces and carried over a garden wall to another property in the town, where he was found unconscious. On other occasions he disappeared, only to be discovered levitating in another room.

Glanvill accepted the truth of these and other peculiar claims. He noted tersely that Jane Brooks was 'condemned and executed' on 26 March 1658, following assizes held in the town of Chard. He had no doubt about the rightness of the verdict and expressed no reservations about the justice of the punishment. He concluded his account of the witchcraft of Jane Brooks with some observations addressed directly to Lord Brereton. He told Brereton that the truth of the allegations against Jane Brooks was beyond doubt. Even a so-called 'Sadduce', that is a sceptical atheist, could not demand a higher standard of proof.

> THIS, I think, my Lord, is good evidence of the being of Witches; and if the Sadduce be not satisfied with it, I would fain know, what kinde of proof he would expect? Here are the testimony of sence, the Oaths of several credible Attestors, the nice and deliberate scruteny of quick-sighted and judicious Examiners, and the judgment of an Assize upon the whole.[4]

Glanvill fulminated at the end of his account about what he saw as the absurdity of anyone disputing this manifest proof of witchcraft.

No one in their right mind could possibly question the evidence of witchcraft from Somerset: 'If such proof may not be credited, no Fact can be proved, no wickedness can be punish'd, no right can be determined, Law is at an end.'[5]

Responding to the attack of John Webster

In 1677 Glanvill decided that there was an urgent need to produce a substantially expanded version of his book on witchcraft. The stimulus for this decision was the publication, that year, of John Webster's work *The displaying of supposed witchcraft*. Webster had set out to destroy the science of witchcraft as articulated by Glanvill and More. Unsurprisingly, Glanvill and More were deeply unhappy about Webster's book.

Webster was brutal in his attack. Glanvill believed in the possibility that a witch's soul or spirit could temporarily depart from her body. It was this phenomenon that he described in his account of how Jane Brooks and her sister, Alice Coward, were able to visit and torment Richard Jones, while their bodies remained back in their cottages. Webster was completely dismissive of this idea. He rejected 'That old Platonical Whimsie, of the Souls real egression forth of the body into far distant places, and its return again, with the certain knowledge of things there done or said'.[6] The truth, asserted Webster, was that delusional old women merely imagined that their spirits had left their bodies.

After some reflection, Glanvill identified a way of answering Webster's critique. He knew that the unpublished transcripts of Robert Hunt's 1665 Somerset investigation contained detailed references to witches and their familiars. Webster had sneered at the reliance on continental stories of witchcraft, but Glanvill thought that critics would be unable to dismiss the strong English evidence contained in Robert Hunt's notebook.

Spurred on by his urgent wish to refute Webster, Glanvill began work on a new edition of his book. He contacted Hunt who lent him his notebook which contained transcripts from his interviews during the 1665 Somerset investigation. Glanvill did not live to see the revised, expanded edition of his book. He died in 1680, with the new text unfinished. His great friend Henry More completed the work. Although Glanvill died before publication, he had managed to write substantial new material concerning the activities of two Somerset covens that Hunt had uncovered in 1665. Before he died, Glanvill wrote an introduction to this case study, explaining that Hunt's

investigation into the organised witchcraft in two Somerset villages would convince 'any modest doubter'.

> Having resolved upon this Reenforcement, I writ again to my Honoured Friend Mr. Hunt, knowing that he had more materials for my purpose, and such as would afford proof sufficient to any modest doubter. In Answer he was pleased to send me his Book of Examinations of Witches, which he kept by him fairly written.[7]

Exposing the 'hellish' covens of Somerset witches

Joseph Glanvill believed that Robert Hunt's interview notes from 1665 contained sensational evidence, capable of rebutting the attacks of Webster and demonstrating, even to the most hardened sceptics, the reality of witchcraft.

The Somerset witchcraft crisis of 1665 began when a local farmer, Richard Hill, complained to Robert Hunt about the behaviour of an alleged witch called Elizabeth Style, who lived in the village of Stoke Trister, near Wincanton. Hunt made enquiries and eventually concluded that Style was indeed a witch. Worse than that, Style was the central figure in an organised network of Devil worshippers operating around Stoke Trister village.

Richard Hill's complaint was that Style had bewitched his thirteen-year-old daughter, Elizabeth. She had been unwell for two months with 'strange fits'. During her convulsions, she claimed that she could see apparitions of Elizabeth Style tormenting her. As proof of the veracity of the girl's claims, her father commented that she was able to describe accurately the clothes that Style was wearing at the time of the spectral visitation. The sickness continued and worsened, with convulsions that involved violent levitation events. The girl could not be restrained by as many as four or five adults. After these fits, Elizabeth Hill's body was marked with holes, apparently caused by the pricking of thorns, with some of the wounds containing visible thorns.

More witnesses from Stoke Trister confirmed the account given by Richard Hill regarding the strange torments and convulsions of Elizabeth Hill. Further testimony against Style was provided by Richard Vining, a local butcher. He used the opportunity of the investigation into Elizabeth Hill's bewitching to make a separate accusation, claiming that Style had bewitched to death his wife, Agnes, two or three years earlier.

Glanvill recounted these events in the text he wrote for the new edition of his book and then stood back from the narrative and provided a few words of exasperated commentary. How, he asked, could anyone question the guilt of Elizabeth Style given such compelling evidence? There were credible witnesses. The girl accurately described the actual appearance of the suspect when she saw the witch attacking her in spectral form. These facts, stated Glanvill, could only be explained if the bewitching of Elizabeth Hill was an authentic example of witchcraft.

Having explained his frustration, Glanvill returned to the story of the Stoke Trister witches and, using Hunt's notes, described how Elizabeth Style eventually confessed. On 26 January 1665, having heard evidence against her, Hunt interrogated her, saying, 'You have been an old sinner ... You deserve little mercy.'[8] Style responded by admitting her guilt and she was taken into custody.

A few days later, Style gave a very full confession, recounting how she had agreed a pact with the Devil about ten years previously. The Devil had promised her money and a comfortable life for twelve years if she signed a contract in her own blood, agreeing to give him her soul and to allow him to suck her blood. She had at first declined, but after the offer had been repeated four times she succumbed to temptation and signed. The Devil appeared regularly and sucked her blood from a special mark on her head. He sometimes took the form of a man but more usually appeared as a dog, cat or fly.

Style denounced others who had been, she said, part of her coven. Initially, she named three women: Alice Duke, Anne Bishop and Mary Penny. They had all met together recently with the Devil on the local common. Alice Duke brought a wax effigy of Elizabeth Hill. The Devil anointed the effigy in a ceremony parodying Church baptism, with the Devil as 'godfather' and Style and Anne Bishop acting as 'godmothers'. They proceeded to stick thorns into the effigy and afterwards celebrated with a feast of wine, cakes and meat. Style described how, on other occasions, they had used similar effigy magic to harm people they disliked.

Style was formally interviewed three times, giving different accounts on different occasions. In later interviews she provided a fuller version of the membership of the Stoke Trister coven, listing a total of fourteen people including several men. Her descriptions of the Stoke Trister witches were very similar to accounts of the witches' sabbat found in

the European literature of demonology. Stories of the sabbat are much less common in an English context.[9] Style described how the Devil transported his worshippers magically to the Stoke Trister meetings and returned them home. The meetings often involved rituals, parodying baptism, intended to harm others through wax effigy magic. Sometimes another method of harm was used, involving the use of a bewitched object infused magically with 'power to hurt the person that eats or receives it'. In addition to various malevolent witchcraft rituals, the meetings of the Stoke Trister coven involved partying, presided over by the Devil, with food, drink, music and dance. Elizabeth Style described how the Devil himself sometimes provided the musical entertainment.

Exposing the activities of the Brewham coven

Hunt's 1665 investigation into organised witchcraft in Somerset, which started in Stoke Trister, extended a few weeks later to Brewham, a village near the town of Bruton. Illustrating his account with material from Hunt's notebook, Glanvill described what happened. Allegations of witchcraft had been circulating in Brewham since the previous year, following the mysterious death of Joseph Talbot, overseer of the poor for the parish. Talbot appears to have antagonised one Margaret Agar by forcing her daughter into indentured service against her will. On 7 March 1665, Talbot's daughter told Hunt that she blamed Agar for bewitching her father to death. Other villagers also denounced Agar as a witch. One Mary Smith had argued with Agar two years previously and had been abused and threatened; three of her cows had then died mysteriously, two of them right outside Agar's front door. Mary Smith herself was suffering from a strange wasting disease. She attributed all these mishaps to Agar's witchcraft.

Agar and other suspects were rounded up. Three of her associates proceeded, when questioned, to confess to witchcraft, naming her as the leading member of an organised group of witches. Christian Green explained to Hunt that she had been recruited to join a Devil-worshipping coven, whose other members included Agar. She accused Agar of killing Talbot by witchcraft. She said that Agar had told her, a few days before his death, that it was her intention to 'rid him out of the World'. Two other Brewham women, Catharine and Mary Green, told Hunt similar stories when examined under oath. Catharine claimed that she had tried to dissuade Agar from bewitching Talbot. Mary Green described how an effigy of Talbot was harmed in a ritual presided over by the Devil. She told Hunt how other villagers besides

Talbot had been harmed through witchcraft. A man called Richard Green had even been murdered by the coven.

The confession of Christian Green of Brewham, as recounted by Glanvill, is very similar to the confessions of the women from Stoke Trister. Like the women in the other village, Christian explained how she had been recruited to join the coven and had signed a contract in her own blood, selling her soul to the Devil in return for a life of material comfort. As was the case in Stoke Trister, Christian had a familiar who sucked her. Her spirit took the surprising form of a hedgehog.

> Since that time the Devil (she saith) hath and doth usually suck her left Brest about five of the Clock in the Morning in the likeness of an Hedg-hog, bending, and did so on Wednesday Morning last. She saith it is painful to her, and that she is usually in a trance when she is suckt.[10]

The frustration of Joseph Glanvill

Glanvill considered that the witches of Stoke Trister and Brewham deserved death for their witchcraft. To Glanvill's intense annoyance, no executions resulted from the many accusations levelled by his friend Robert Hunt in the 1665 investigation. Elizabeth Style was taken to Taunton for trial, where she was found guilty and sentenced to death; she died in prison of natural causes before her execution. For reasons that are not precisely clear, the prosecution of the other women was stopped. The prime suspect, Margaret Agar, was freed. Glanvill mysteriously stated that the suspects were protected by 'some then in Authority'. He did not explain what he meant, but clearly he found the outcome intensely frustrating.

The account of the witchcraft investigation of 1665 presented by Glanvill was not a neutral, objective exercise. Glanvill positioned himself unambiguously as the enemy of the witches of Somerset. He believed that the associates of Elizabeth Style deserved death, and that they had wrongly escaped just punishment. Glanvill reserved a particularly marked level of antagonism for Margaret Agar of Brewham, devoting a whole chapter of *Saducismus Triumphatus* to her. The title he gave to this chapter made clear the high level of hostility he felt: 'Testimonies of the villainous feats of that rampant hagg Margaret Agar of Brewham, in the County of Somerset.'[11]

For Glanvill, Margaret Agar was a perfect example of the kind of witch that Moses had in mind when he articulated God's law

'Thou shalt not suffer a Witch to live'. He attacked the sceptics, such as Webster, who were prepared to protect wicked women like Agar. Glanvill called these commentators 'the Hagg-advocates', and ridiculed them for imagining that seriously evil women such as Agar might be dismissed either as charlatans or delusional, melancholic people.

Summarising the story of the 1665 investigation into the witches of Somerset, Glanvill opined that Hunt's notebook of interviews contained just about the best available evidence of the truth of witchcraft. Sadly, opposition from some in authority allowed the 'hellish Knot' of witches to escape the punishment that they richly deserved.

> His Book of Examinations of Witches … contains the discovery of such an hellish Knot of them, and that discovery so clear and plain, that perhaps there hath not yet any thing appeared to us with stronger Evidence to confirm the belief of Witches. And had not his discoveries and endeavours met with great opposition and discouragements from some then in Authority, the whole Clan of those hellish Confederates in these parts had been justly exposed and punished.[12]

Who provided intellectual leadership to the witchcraft investigation of 1665?

There is something very strange about several of the confessions made by the women accused of witchcraft in Somerset in 1665 as documented by Hunt and Glanvill. Three suspects made depositions stating how they had sold their souls to the Devil using the same ideas, in the same logical sequence, expressed in very similar and sometimes identical language. The women were interviewed separately and came from two different villages. The only possible explanation seems to be that the women were provided with the wording of their confessions by their interrogators.

It is instructive to look closely at the almost identical way that these three women confessed and described their dealings with the Devil.[13] The women described how they had been promised material comfort in return for their souls. They agreed to be sucked by the Devil and signed a contract with the Devil using blood taken from the middle joint of the fourth finger of the right hand. The Devil gave each of them money as a gift and then vanished.

The confession of Elizabeth Style	The confession of Alice Duke	The confession of Christian Green
The Devil about Ten years since, appeared to her in the shape of a handsome Man, and after of a black Dog. That he promised her Mony, and that she should live gallantly, and have the pleasure of the World for Twelve years, if she would with her Blood sign his Paper, which was to give her Soul to him, and observe his Laws, and that he might suck her Blood. This after four solicitations, the Examinant promised him to do. Upon which he prickt the fourth Finger of her right hand, between the middle and upper joynt (where the sign at the Examination remained) and with a drop or two of her Blood, she signed the Paper with an [O]. Upon this the Devil gave her Sixpence, and vanished with the Paper.	About Eleven or Twelve years ago ... the Devil appeared to her in the shape of a Man, promising that she should want nothing... in case she would give her Soul to him, suffer him to suck her Blood, keep his Secrets, and be his instrument to do such mischief as he would set her about. All which, upon his second appearing to her, she yielded to, and the Devil having prickt the fourth finger of her right hand between the middle and upper joynt (where the mark is yet to be seen) gave her a Pen, with which she made a cross or mark with her Blood on Paper or Parchment ... And as soon as the Examinant had signed it, the Devil gave her Sixpence, and went away with the Paper or Parchment.	About a year and a half since ... the Devil, who appeared in the shape of a Man in blackish Clothes...told the Examinant that she should want neither Clothes, Victuals, nor Money, if she would give her Body and Soul to him, keep his secrets, and suffer him to suck her once in twenty four hours, which at last upon his and Catharine Greens perswasion she yielded to; then the Man in black prickt the fourth finger of her Right-hand between the middle and upper joints, where the sign yet remains, and took two drops of her blood on his finger, giving her fourpence halfpenny, with which she after bought Bread in Brewham. Then he spake again in private with Catharine and vanished.

The three women were clearly agreeing to a script provided by their interrogator. Who wrote the script? It seems unlikely that Robert Hunt was the author. There is no reference to ideas of this kind in his account of the witchcraft of Jane Brooks in 1658. The reference to the contract signed in blood only appears in Hunt's notes of the interviews conducted in 1665. The obvious difference between 1658 and 1665 is that Joseph Glanvill had appeared on the scene by the later date, and was able to influence the way Hunt questioned the suspects.

In 1665 Joseph Glanvill was on a mission to prove the correctness of the theories about the supernatural articulated by his mentor Henry More. These ideas had been articulated in three editions of More's book *An antidote against atheism*, published in 1653, 1655 and 1662. More had confirmed his belief in the likelihood of a contractual pact, signed in blood, between witches and the Devil.[14]

Perhaps we need to picture Glanvill as an active participant in the 1665 Somerset investigation, helping Hunt to shape the enquiry. The curiously consistent confessions are not the only evidence of intellectual leadership from Glanvill in the investigation, either; it is possible to see Glanvill's (and indirectly More's) influence in the questions that were asked of the suspects.

In *Saducismus Triumphatus*, Glanvill provided an edited version of the statements made by suspected witches during the 1665 investigation. We can try to reconstruct the questions that the suspects were asked from the answers they gave. It seems that one of the chief suspects, Elizabeth Style, was repeatedly asked a curious question as to whether she was in her own body when she attended meetings with the Devil and her fellow witches. Hunt's notes, as edited by Glanvill, are based on a series of interrogations conducted on three different dates: 26 January, 30 January and 7 February 1665. Two of her answers suggest that she responded to a question about possible out-of-body attendance at coven meetings. Style insisted that she was physically present at the sabbat meetings.

> They danced and were merry, were bodily there, and in their Clothes ...
> They eat and drink really when they meet in their bodies.[15]

Her interrogators, it seems, continued to press her on this point. In another answer, Elizabeth Style gave a different account and

stated that the witches sometimes appeared using their bodies and conventional clothes but sometimes left their bodies behind and travelled in a purely spiritual way to the meetings.

> They are carried sometimes in their Bodies and their Clothes, sometimes without, and as the Examinant thinks their Bodies are sometimes left behind. When only their Spirits are present, yet they know one another.[16]

This confession attracted the attention of George Kittredge, a Harvard professor who published a study of witchcraft in England and America in 1929. Kittredge had looked at *Saducismus Triumphatus* and read the account of the confession of Elizabeth Style. He was puzzled by Elizabeth's answers, particularly a statement that made a learned distinction between body and spirit.

> The remark about bodily or spiritual presence indicates a distinction which Elizabeth herself could never have thought of. It must have been elicited, of course, by a definite question from one of the educated examiners who was acquainted with the age-old debate on this point among theologians, philosophers, and physicians.[17]

Kittredge was surely right. Elizabeth's answer indicates that she had been asked a leading question by her interrogators about whether she left behind her physical body and real clothes when attending coven meetings. Kittredge did not speculate about the identity of the 'educated examiners', but Joseph Glanvill is overwhelmingly the obvious source of such a question about out-of-body witchcraft. The question as to whether a witch had the power to remove her spirit or soul from her body was immensely important to Glanvill and to his mentor Henry More. They wanted to prove the possible separability of body and spirit before death in order to confute those materialists, such as Hobbes, who said there was no such thing as an immaterial spirit. It seems that Glanvill was looking for empirical proof from the Somerset villages of the link between witchcraft and the separability of the body and spirit, in line with More's theories.

It is highly likely that Joseph Glanvill suggested asking Style this question about bodily presence. Glanvill may have been personally

present during Style's interrogation; Hunt noted that her confessions were 'Taken in the presence of several grave and Orthodox Divines', meaning that Church of England clergymen were present during the interviews. We know that the rector of Stoke Trister was there, but Hunt is quite precise in suggesting that several clergymen were present. This statement would be consistent with the idea that the erudite local clergyman Joseph Glanvill witnessed the interrogation sessions.

The possibility of out-of-body witchcraft also featured in the interrogation of a suspect from Brewham. While Elizabeth Style emerged as the leader of the Stoke Trister witches, the main suspect in the Brewham investigation was Margaret Agar. As established above, Glanvill had an intense antagonism towards Agar. She was in gaol by early June awaiting trial while further enquiries relating to the Brewham coven continued. On 3 June, one Mary Green from Brewham was interviewed and confessed to taking part in the meetings of the Brewham coven. At the end of Hunt's transcript is a reference to her statement that Agar had not attended the coven meetings since her imprisonment. This curious answer must have been the result of a question from a learned examiner who believed that it was technically possible for a witch to leave her body behind and attend a sabbat in a disembodied way, even when in gaol. Again, by far the most obvious person to pose such an abstruse question was Joseph Glanvill.

Repeated questions about out-of-body witchcraft are consistent with the idea that Glanvill was heavily involved in the interrogation and that he directed aspects of the questioning. In addition to the issue of separability of soul and body, there are several other clues indicating that Glanvill used the Somerset investigation as a way of finding confirmatory empirical 'facts' for theoretical claims about witchcraft articulated in More's *Antidote against atheism*.

One odd answer that Elizabeth Style gave was 'That she never heard the name of God or Jesus Christ mentioned at any of their meetings'.[18] She had clearly been asked about the impact of sacred names on witches attending coven meetings. This was a topic highlighted by Henry More, who was struck by claims in continental demonological texts about the power of holy words. More had identified several references in European sources to the power of sacred names, when uttered, to cause the dispersal of sabbat meetings. More used precisely the same phrase as Style did in her answer when he wrote about how

their meetings often 'dissolved & disappeared' at 'the Name of God or Jesus Christ'.[19]

Glanvill, impressed by this idea in the work of his mentor, apparently tried to see if he could find evidence from the Somerset witches about the power of holy names. He was, presumably, disappointed that Elizabeth Style had no recollection of the names of God or Jesus ever being mentioned at the Somerset coven meetings.

Further evidence consistent with the idea that Glanvill was the directing mind behind the 1665 investigation can be found in other facets of the confessions of the Somerset suspects. No fewer than five of the interrogated women described how the Devil appeared at their coven meetings in the form of a man wearing black clothes. Their accounts are strikingly similar:[20]

'A Man in black Clothes with a little Band, to whom they did Courtesie and due observance...' (Elizabeth Style: Stoke Trister)

'They met a Man in black Clothes ... They all make very low obeysances to the Devil, who appears in black Clothes.' (Alice Duke: Stoke Trister)

'The Devil, who appeared in the shape of a Man in blackish Clothes...' (Christian Green: Brewham)

'They saw a little Man in black Clothes.' (Catharine Green: Brewham)

'The Fiend ... in the shape of a little Man in black Clothes with a little band, to him all made obeysances.' (Mary Green: Brewham)

Five women, from two different villages, interviewed separately, each stated that the Devil appeared as a man wearing black clothes. The obvious explanation for this degree of consistency is that there was a schedule of standard questions posed to all the suspects which included one about whether the Devil wore black clothes at meetings.

Glanvill appears to have suggested questions about whether the Devil appeared in black. More had discussed the frequent references to the Devil as a black man in continental demonology literature in *An antidote against atheism*. More was struck by

the fact that when he personally interviewed suspected witches in Cambridge, one woman described the Devil as a man dressed in black. The Devil in black was treated with formal respect by the witches at a banquet.

> Of his appearance in the shape of a man in black at least, if not a black man, a young woman committed for the suspicion of Witchcraft, at the castle in Cambridge told my learned friend Dr. Cudworth and my self this story ... He that did sit at the upper end of the table was all in *black,* to whom the rest gave very much respect, bowing themselves with a great deal of reverence whenever they spake to him.[21]

More mentioned the deference shown to the man in black. Three of the five responses also refer to the gestures of respect made by the witches at the sabbats. They talked about 'courtesie' and 'obeysances'. Again, these answers come from interviews in two different villages. The learned word 'obeysances' was used by both Alice Duke from Stoke Trister and Mary Green from Brewham. It seems highly unlikely that such a word would be used unprompted and coincidentally by two illiterate Somerset villagers. The obvious explanation is that this obscure word was put to the suspects in the form of a question, suggested by Glanvill. He was inviting them to comment on whether they acted deferentially towards the Devil at sabbat meetings through 'obeisances' in line with More's witchcraft theory. More had stated in his work that witches in confessions talked about the need to demonstrate 'obeisance' towards evil spirits.

> If we would but admit the free confessions of Witches concerning their Impes, whom they so frequently see and converse withall, know them by their names, and do obeisance to them.[22]

The witness statements are completely consistent with the explanation that Glanvill was the expert who proposed the questions to the Somerset suspects, driven by his wish to find confirmatory evidence of the witchcraft theories of Henry More. In summary, it seems that Glanvill worked with Hunt to establish a list of questions intended to test a series of hypotheses that had been proposed by More and to elicit the right empirical data for a scientific study of witchcraft.

Propositions about witchcraft found both in More's Antidote *and in the Somerset witness statements*

- *The Devil often appeared as a man dressed in black who was treated with formal respect and obeisance by his adherents.*
- *The names of God or Jesus had supernatural power and could never be uttered at a sabbat meeting and if said the assembly of witches would be dispersed.*
- *The Devil had the power to give witches real objects such as money.*
- *Witches entered into a legal contract with the Devil that was signed in the blood of the witch.*
- *Witches had the power to leave their bodies at home in order to attend sabbat meetings.*
- *Special ointments and rituals were associated with the magical process of being transported to sabbat meetings.*
- *Each witch had an attendant demon in the form of a familiar which sucked the witch once every twenty four hours.*

All the questions posed to the Somerset suspects were consistent with hypotheses about witchcraft proposed in More's *Antidote against atheism*. It seems that Glanvill, with Hunt's assistance, had been able to test More's witchcraft theory through his real-world investigation into the Somerset witches.

7

JAMES LONG, JOHN AUBREY AND THE WITCHES OF MALMESBURY

One of Aubrey's closest lifelong friends was Sir James Long, who lived at Draycot Cerne in Wiltshire, midway between the market towns of Malmesbury and Chippenham. The two men were, for many years, near neighbours. The site of Aubrey's birthplace and childhood home was less than 3 miles away from Long's home. Both men became enthusiastic members of the Royal Society and shared a wide range of interests, including archaeology, geology and natural history. After his bankruptcy and the loss of his own property in Wiltshire in the early 1670s, Aubrey often spent time at Draycot with Long and his wife, Lady Dorothy Long.

Both Long and Aubrey were fascinated by the history, geology and wildlife of Wiltshire. It was while hawking with Long near Avebury in about 1656 that Aubrey began his ground-breaking archaeological analysis of the Avebury prehistoric stone circle. The two men worked together on Aubrey's 'natural history' of the county.

Long, like Aubrey, was invited to join the Royal Society soon after it was founded. In its early years, Long was an active participant at Society meetings in London, making contributions as an expert on the biology of insects and fish. In later years, he spent more time in the country and attended London meetings less frequently. He kept in touch through letters with leading members, corresponding often with Robert Hooke.

Aubrey identified Long as one of his 'Amici', his most special friends. He created a flattering portrait of Long for *Brief Lives*,

praising him as a fine swordsman, horseman, falconer, orator and historian. Aubrey's account suggested that Long had a voracious interest in nature in all its forms, describing him as 'exceeding curious and searching long since, in naturall things'. Aubrey also recounted how Long, although a royalist, was befriended by Cromwell in the 1650s. The two men met by chance when they were both hawking on Hounslow Heath. Cromwell engaged in conversation with Long and was impressed by him. Cromwell asked Long to join him hawking in the future, 'which made the strict cavaliers look on him with an evil eye'. Tactfully, Aubrey failed to mention that his friend had encountered Cromwell in less happy circumstances during the Civil War. Long was involved in a military disaster in 1645 when, as a commander of Wiltshire royalist forces, he was captured near Devizes with all his troops by a parliamentary force commanded by William Waller and Oliver Cromwell.

When finalising his *Natural History of Wiltshire* in the mid-1680s, Aubrey noted that Long had written a book about witchcraft, which he intended to present to the Royal Society. The book concerned the discovery of an organised coven or 'cabal' of witches in the town of Malmesbury. As a local magistrate, Long had undertaken initial 'examinations' of the suspects. After his preliminary investigation, he had sent suspects to Salisbury for trial at the assizes. Unfortunately, writing a decade later, Aubrey could not remember the exact date and so put '167_'.

> About 167__ there was a Cabal of Witches detected at Malmsbury: They were examined by Sir James Long of Draycot-Cerne, and by him committed to Salisbury Gaol. I think there were seven or eight old women hanged. There were odd things sworne against them, as the strange manner of the dyeing of H. Denny's horse, and of flying in the aire on a staffe. These examinations Sir James hath fairly written in a book which he promised to give to the Royall Societie.[1]

Aubrey's account included the claim that the Malmesbury witches were alleged by witnesses to have flown 'in the aire on a staffe'. The story was that they flew on something like a broomstick.

Aubrey claimed that seven or eight women from Malmesbury were executed. If true, this would have been the highest death rate

resulting from any witchcraft trial in England conducted after 1660. Was Aubrey correct in his recollection? As we shall see, other sources establish, beyond doubt, that a major witchcraft trial of women from Malmesbury did take place in 1672 but some aspects of Aubrey's recollection, including his memory of the resulting death toll, were seriously inaccurate.

A letter from Long to Aubrey, written in 1683, confirms that Long was planning to write a book about witchcraft for the Royal Society, based on his own role as an investigating magistrate who interrogated suspects in Malmesbury a decade earlier. The letter outlines the contents of the proposed book. The synopsis is striking. Long intended to describe an extraordinary feud between an organised 'cabal' of witches and other townsfolk that had persisted for over a hundred years.

Why in 1683 did Long decide to write a treatise concerning a witch trial that had taken place in 1672? There was a flurry of publications about witchcraft in the early 1680s and it seems Long concluded that he could make a valuable contribution to this discourse, drawing on his own experience interrogating suspects in Wiltshire. Long believed in witchcraft and he wanted to speak out against the sceptics.

There was much discussion of witchcraft in elite circles in the early 1680s following the publication in 1681 of *Saducismus Triumphatus*. In 1682 a trial of 'witches' in Exeter achieved considerable national prominence when three women from Bideford were hanged. This is now generally regarded as the last definite occasion when people in England were executed for witchcraft. The alleged misdeeds of the Bideford witches, and details of their trial, were widely publicised in pamphlets that circulated soon after the trial. Another pamphlet was published in 1682, providing an account of the trial of two Lowestoft women for witchcraft at Bury St Edmunds twenty years earlier, in 1662. The trial had been presided over by the famous judge, Matthew Hale, who later became Lord Chief Justice of England. Expert scientific evidence, arguing in favour of the guilt of the accused, was presented by the distinguished doctor and writer, Thomas Browne.

It was, it seems, the publication of the account of the Lowestoft witches that was the immediate stimulus for Long's decision to write his 'book'. On 1 March 1683 Long wrote to Aubrey from Wiltshire requesting that Aubrey, who was in London, buy him a copy of a publication 'concerning some trialls of whitches' presided over by

Matthew Hale.[2] Aubrey bought the pamphlet and sent it to Long, who wrote again thanking his friend for his kindness: 'Sir I have received my Lord Hales book and I am y[ou]r debtor for it.' This letter is not dated but presumably was sent later in the spring of 1683.[4] By the time he wrote his letter, Long had begun to plan, and indeed write, his book.

The undated letter in which Long thanked Aubrey for the pamphlet about the witches of Lowestoft survives in Aubrey's papers in the Bodleian Library in Oxford. It contains Long's thoughts about the book he was envisaging about witchcraft in the town of Malmesbury. Although we have lost Aubrey's reply, there is no reason to think that he had any reservations about the proposed book and its endorsement of the authenticity of witchcraft. On the back of Long's letter is a line of Latin poetry, in what looks like Aubrey's handwriting. It is a quotation from the Roman poet Juvenal in which he described one 'Crispus', a genial, eloquent, elderly senator. This was presumably written by Aubrey on reading Long's letter. He was picturing Long as Crispus, an entertaining, old friend who, despite his advancing years, remained keen to contribute to the contemporary debate about witchcraft.

Long's immediate motive for wanting to write his book was his disappointment with the pamphlet about the Bury St Edmunds trial that Aubrey had bought for him in London. Despite the eminence of the trial judge, Long found the evidence insufficient to justify the hanging of the two Lowestoft women. Long had been hoping for more compelling proof of guilt. The pamphlet described evidence, such as how the women had made threats of harm against neighbours who had subsequently died. This was not good enough for Long: 'Those light words which the woman spake would beare smale [=small] stresse with me.'[4]

Long suggested to Aubrey that the level of proof of guilt in the Malmesbury case was much higher than that found in the account of events at Lowestoft. It was, therefore, his duty to write about it. Long outlined his proposed work. It was highly ambitious. His intention was to set the scene by explaining about Malmesbury and the functioning of local government in the town. The dramatic story of witchcraft in the town would then be told. He would narrate how a well-organised coven of witches, a 'Caball', had been terrorising the 'good people' of the town for at least a century. A 'war' had been waged by the witches

against decent townsfolk. Anyone who challenged the power of the witches, and attempted to prosecute them, risked terrible vengeance. Despite this intimidation, some of the witches had been tried in court and punished. Long promised to tell these stories.

> Then to set forth the ways by w[hi]ch this Caball w[hi]ch hath now been taken notice of about 100 yeares was planted there and the wars it continued makes against the good people of that Burrow [= Burough]. And also the revenges of the Caball hath taken upon those or the familyes of those who have prosecuted theyr predecessors or any of it. I shall also set forth the Historyes of that Caball and the publique punishment w[hi]ch have been inflicted on the members of it.[5]

The proposed emphasis on the organisational history of the Malmesbury coven is striking, and highly unusual within the English witchcraft literature of the seventeenth century. Long was claiming that the Malmesbury coven had sufficient organisational strength to continue in operation for at least a century, passing down knowledge and grievances through generations of witches.

Having established this background of longstanding antagonism between an organised group of witches and the community of respectable citizens, Long planned to explain the events that he had personally witnessed. Here, his emphasis would be on proof of the truth of the allegations of witchcraft. In keeping with the principles of the new science, Long intended to provide compelling evidence, underpinned by the manifest trustworthiness of his witnesses. To guarantee complete assurance of the quality of his claims, Long intended to provide the names and addresses of witnesses who could verify his account.

> And then I shall come to the relation of the occurrants where I was present and the tryalls where the witnesses shall bee named with the places of theyer present residence and how letters may dayly bee sent to them or any of them.[6]

Long explained that the Malmesbury case study would form just part of the planned book. Having told the story of the witches of Malmesbury, he proposed to address other instances of witchcraft, previously not properly documented, for which convincing testimony

Right: 1. John Aubrey was a prominent member of the Royal Society. He was also a great believer in the power of the supernatural. (Courtesy Ashmolean Museum)

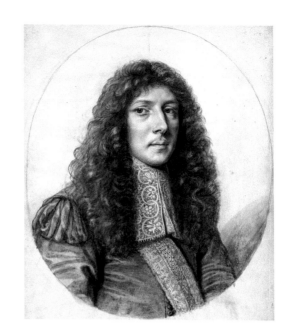

Below: 2. 'White witches' or 'cunning women' could be found throughout rural and urban Britain in the seventeenth century. They offered help for a range of problems: illness, love, lost property. (Wellcome Collection. Attribution 4.0 International: CC BY 4.0)

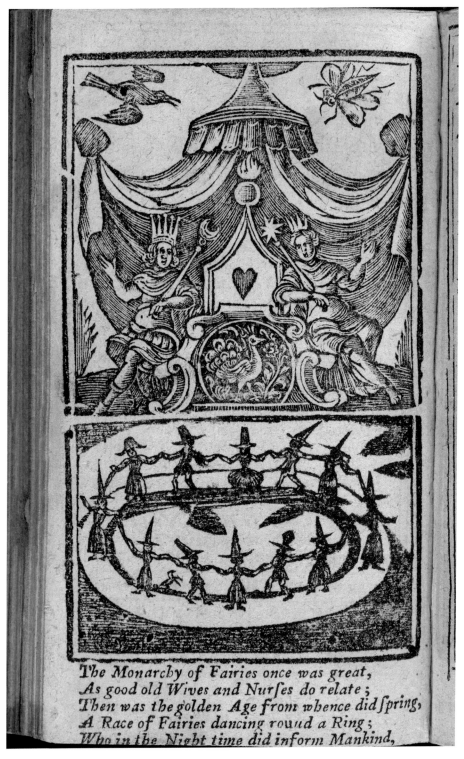

The Monarchy of Fairies once was great,
As good old Wives and Nurses do relate;
Then was the golden Age from whence did spring,
A Race of Fairies dancing round a Ring;
Who in the Night time did inform Mankind,

3. Belief in fairies was widespread during Aubrey's childhood, and there was a dark side to fairy belief. They were feared because they stole babies, leaving 'changelings' behind. (Wellcome Collection. Attribution 4.0 International: CC BY 4.0)

Above: 4. Aubrey was a student at Trinity College, Oxford. Here he encountered ritual magic and belief in portents and premonitions. (Wellcome Collection. Attribution 4.0 International: CC BY 4.0)

Right: 5. As a young man Aubrey was influenced greatly by the work of Sir Thomas Browne. In his groundbreaking book *Religio Medici*, Browne promoted both modern science and certainty about the reality of witchcraft. (Wellcome Collection. Attribution 4.0 International: CC BY 4.0)

Effigies Viri Doc-tissimi Tho:Browne Med: Doctoris.

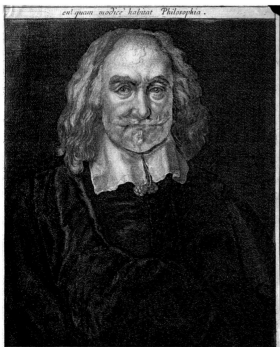

en! quam modice' habitat Philosophia.

Verá & Vivá Effigies THOMÆ HOBBES Malmesburiensis.
Ætat: suæ 92 obiit 4 Dece 1679.

Left: 6. Thomas Hobbes denied the authenticity of witchcraft. Aubrey and Hobbes were friends who agreed to disagree about their different beliefs about the supernatural. (Wellcome Collection. Attribution 4.0 International: CC BY 4.0)

Below: 7. The 'Drummer of Tedworth' was a demonic poltergeist who supposedly infested a house in Wiltshire in the early 1660s. Joseph Glanvill claimed that the story provided conclusive proof of the truth of witchcraft. (Wellcome Collection. Attribution 4.0 International: CC BY 4.0)

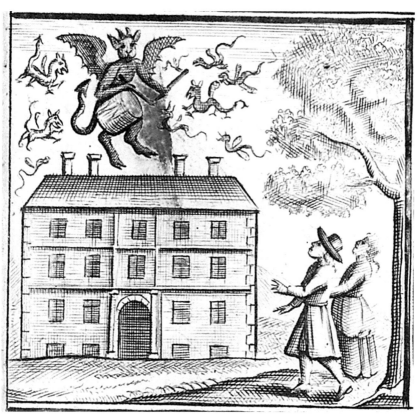

Saducismus Triumphatus:

OR,

Full and Plain E V I D E N C E

Concerning

WITCHES

A N D

APPARITIONS.

In Two P A R T S.

The Firſt treating of their

POSSIBILITY,

The Second of their Real

EXISTENCE.

By *Joſeph Glanvil* late Chaplain in Ordinary to his Majeſty, and Fellow of the Royal Society.

With a Letter of Dr. *H E N R Y M O R E* on the ſame Subject.

And an Authentick, but wonderful ſtory of certain *Swediſh* Witches; done into Engliſh by *Anth. Horneck* Preacher at the *Savoy*.

LONDON : Printed for *J. Collins* at his Shop under the *Temple-Church*, and *S. Lownds* at his Shop by the *Savoy*-gate, 1681.

8. Joseph Glanvill and Henry More were the authors of *Saducismus Triumphatus* (1681), the most detailed statement of the seventeenth-century science of witchcraft. (Wellcome Collection. Attribution 4.0 International: CC BY 4.0)

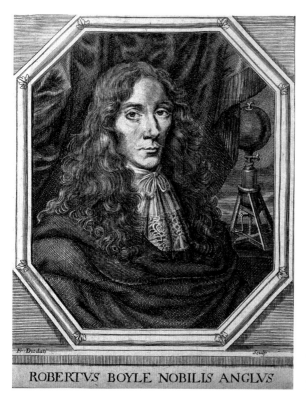

ROBERTVS BOYLE NOBILIS ANGLVS

9. Robert Boyle was the greatest scientist in Restoration England. He also believed in the reality of angels, demons and witchcraft. (Wellcome Collection. Attribution 4.0 International: CC BY 4.0)

AIMONO AGEIA. 52781

A Small

TREATISE

OF

S ickneſſes and Diſeaſes

FROM

Witchcraft,

AND

Supernatural Cauſes.

Never before, at leaſt in this compriſed
Order, and general Manner, was the
like publiſhed.

Being uſeful to others beſides Phyſicians,
In that it Confutes

Atheiſtical, Sadduciſtical, and Sceptical
Principles and Imaginations.

LONDON, Printed by J. Dover, living in
St. Bartholomews-Cloſe, 1665.

10. The title page of *Daimonomageia* by William Drage. This book, by a Hertfordshire doctor, advised doctors how to identify and treat cases of witchcraft. (Wellcome Collection. Attribution 4.0 International: CC BY 4.0)

A. Fornax cum fibi incamerato inftrumento ferreo , & recipiente.
B. Artifex finiftrâ auferens operculum,dextrâ autem injiciens materiam deftillandam præparatam.
C. Forma Vafis externa.
D. Forma Vafis interna.
E. Aliud quoddam vas non incameratum, incur bens carbonibus.

Above: 11. Some members of the Royal Society, such as Robert Boyle and Elias Ashmole, were enthusiasts for alchemy and believed that there was an important connection between alchemy and magic. (Wellcome Collection. Attribution 4.0 International: CC BY 4.0)

Right: 12. The medical pioneer William Harvey was sceptical about the truth of witchcraft. James Long, Aubrey's close friend, argued that Harvey's approach to witchcraft was flawed and illogical. (Wellcome Collection. Attribution 4.0 International: CC BY 4.0)

Above: 13. John Aubrey and Elias Ashmole admired the Elizabethan magus John Dee. Other commentators considered Dee to be a fool who had dabbled in dangerous demon magic. (Wellcome Collection. Attribution 4.0 International: CC BY 4.0)

Left: 14. Some proponents of the science of sorcery believed that witches could leave their bodies at home and fly in spectral form to sabbat meetings, where they danced with the Devil. (Wellcome Collection. Attribution 4.0 International: CC BY 4.0)

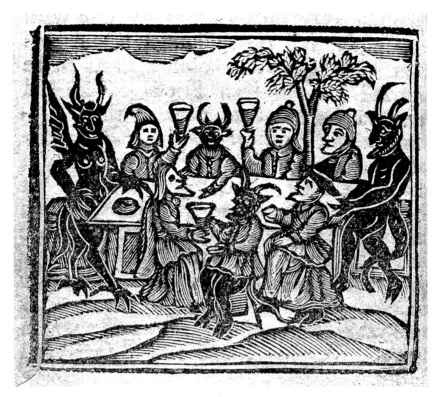

Above: 15. A male and female demon preside over a sabbat meeting. Henry More and others promoted the idea that demons could have sex with humans. (Wellcome Collection. Attribution 4.0 International: CC BY 4.0)

Right: 16. John Webster published this attack on the science of witchcraft in 1677. He ridiculed the work of Glanvill and More and raised questions about the judgement of Robert Boyle. (Wellcome Collection. Attribution 4.0 International: CC BY 4.0)

THE

DISPLAYING

OF SUPPOSED

WITCHCRAFT.

Wherein is affirmed that there are many forts of

Deceivers and Impostors,

AND

Divers perfons under a paffive *Delufion* of
MELANCHOLY and *FANCY.*

But that there is a *Corporeal League* made betwixt the
DEVIL and the WITCH,

Or that he fucks on the *Witches Body*, has *Carnal Copulation*, or
that *Witches* are turned into *Cats*, *Dogs*, raife Tempefts, or
the like, is utterly denied and difproved.

Wherein alfo is handled,

The Exiftence of Angels and Spirits, the truth of Apparitions, the Nature of
Aftral and Sydereal Spirits, the force of Charms, and Philters;
with other abftrufe matters.

By *John Webfter*, Practitioner in Phyfick.

*Falfa etenim opiniones Hominum praoccupantes, non folùm furdos, fed & cæcos faciunt, ita ut
videre nequeant, qua aliis perfpicua apparent.* Galen. lib. 8. de Comp. Med.

LONDON,
Printed by J. M. and are to be fold by the Bookfellers in London. 1677.

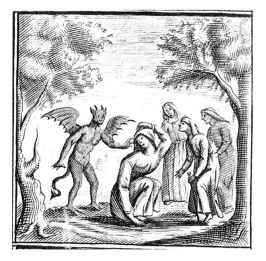

17. Most people accused of being witches were women. The learned theorists of witchcraft showed little empathy with uneducated women, and routinely described accused witches as 'hags'. (Wellcome Collection. Attribution 4.0 International: CC BY 4.0)

18. The levitation of the bewitched boy Richard Jones in 1658, supposedly caused by the witch Jane Brooks. Joseph Glanvill welcomed the fact that she was executed for her spectral attacks on the boy. (Wellcome Collection. Attribution 4.0 International: CC BY 4.0)

19. The Devil conducts a ritual with witches in Somerset, 'consecrating' the effigy of a victim. A major 'scientific' enquiry into covens in two Somerset villages took place in 1665. (Wellcome Collection. Attribution 4.0 International: CC BY 4.0)

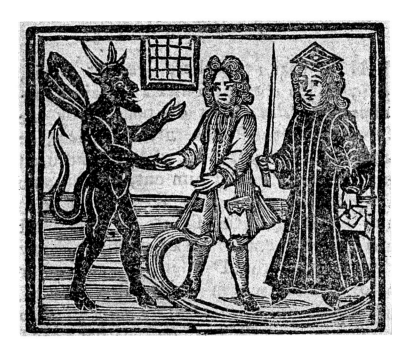

20. The Devil engages with two 'gentlemen' who are participants in ritual magic. Aubrey and Ashmole were enthusiastic about the benefits of spirit magic, and Robert Boyle was also tempted to try it out. (Wellcome Collection. Attribution 4.0 International: CC BY 4.0)

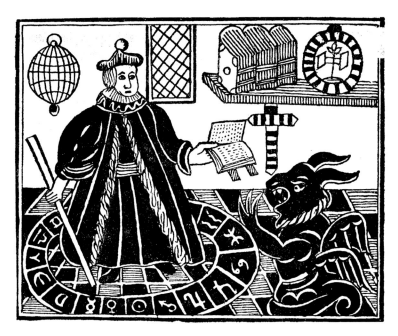

21. The ritual magic of Faust. Glanvill and More believed that followers of John Dee were, like Faust, engaged in a form of witchcraft. (Wellcome Collection. Attribution 4.0 International: CC BY 4.0)

Witches Apprehended, Examined and Executed, for notable villanies by them committed both by Land and Water.

With a strange and most true triall how to know whether a woman be a Witch or not.

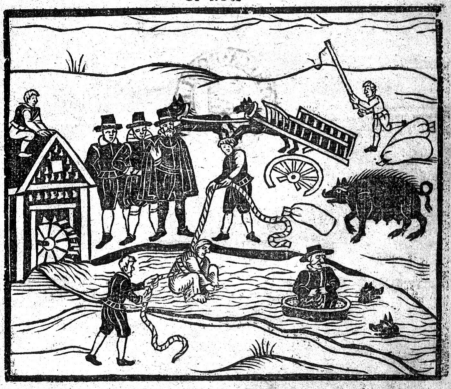

Printed at London for *Edward Marchant*, and are to be sold at his shop ouer against the Crosse in Pauls Church-yard. 1 6 1 3.

22. Scholarly witchcraft experts legitimised some traditional beliefs. For instance, William Drage spoke approvingly about the tradition of 'swimming' suspects to prove that they were witches. (Wellcome Collection. Attribution 4.0 International: CC BY 4.0)

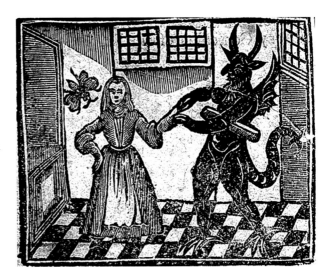

23. Elizabeth Styles shown making a compact with the Devil. The witchcraft of this Somerset woman featured prominently in *Saducismus Triumphatus*. (Wellcome Collection. Attribution 4.0 International: CC BY 4.0)

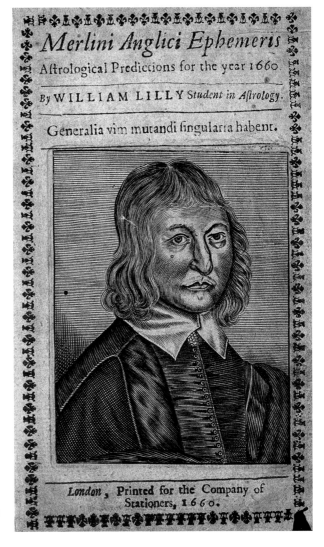

24. William Lilly was the leading astrologer of mid-seventeenth-century England. He was accused many times of deriving his insights from witchcraft. (Wellcome Collection. Attribution 4.0 International: CC BY 4.0)

25. A close friend of John Aubrey, the astrologer Henry Coley was criticised for selling magical 'sigils' to his customers. (Wellcome Collection. Attribution 4.0 International: CC BY 4.0)

26. Astrologers in Restoration England made elaborate horoscopes. Henry More ridiculed their 'science' and associated it with witchcraft. (Wellcome Collection. Attribution 4.0 International: CC BY 4.0)

Above: 27. King's College, Aberdeen. Francis Grant studied here and later prosecuted seven suspects who were executed for witchcraft at Paisley in June 1697. (Wellcome Collection. Attribution 4.0 International: CC BY 4.0)

Right: 28. John Dee's crystal ball. Like Dee, John Aubrey was an advocate of the possibilities of contacting spirits via crystal balls. (Wellcome Collection. Attribution 4.0 International: CC BY 4.0)

29. Increase Mather enthusiastically promoted the science of the Royal Society in New England. He also encouraged belief in witchcraft. (Wellcome Collection. Attribution 4.0 International: CC BY 4.0)

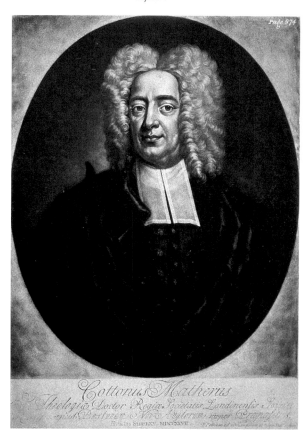

30. Increase's son, Cotton Mather, used the science of witchcraft to justify the executions of witchcraft suspects in Salem. He continued to believe in the reality of witchcraft long after the events of 1692. (Wellcome Collection. Attribution 4.0 International: CC BY 4.0)

existed. He would describe 'some proceedings fallen happening in my owne time of w[hi]ch there are very considerable witnesses now alive'. Long also intended to use little-known instances from his reading of European witchcraft literature, establishing analogies between the Malmesbury events and these parallel cases.

> I also intend to adde some analogous history as not yet seen in English out of authentique authors with the sentences passed by the Judicatoryes uppon the delinquents in w[hi]ch the proofes of the crimes are set forth.[7]

His intentions were very similar to those of Joseph Glanvill and Henry More, and the book, as proposed, would have complemented their work, making use of undocumented English case studies and Latin or French sources not previously translated into English. This similarity is not a coincidence. Long was planning his work in 1683 and Glanvill and More's *Saducismus Triumphatus* had appeared in 1681.

Long told Aubrey that he would conclude his work with some theorising about the nature of different forms of magic, including witchcraft and benign 'natural magic': 'Lastly I shall add a brief discourse conjecturall in deed of natural magique.' Intriguingly, Long told Aubrey that this section would involve, among other things, some reflections on unicorns![8]

By the time Long wrote the letter to Aubrey, he had already begun work on the treatise. He told Aubrey that he intended to preface the work with a dedicatory letter to the President of the Royal Society, and that he had already drafted this letter. Once he had completed the entire manuscript, Long intended to send it to Aubrey, who would then be able to present the text formally to the Royal Society: 'All which I will send to you by whose hand I intend to present it.'

What did Aubrey make of this? We do not have his reply but Long obviously anticipated that his friend would be pleased and would have no trouble endorsing the proposed treatise, which would argue in favour of the reality of witchcraft and the need for witches to be identified and punished.

The rediscovery of a fragment of the lost book

Until recently Long's work on witchcraft, as described by Aubrey, was considered lost. Some questioned whether it had ever been written at

all. It is now clear that a substantial fragment of Long's 'book' has survived. The rediscovered fragment tells an extraordinary story of witches, fear and vendetta in Malmesbury.

In 1832 a letter arrived in the office of *The Gentleman's Magazine*, a long-established London periodical. Accompanying the letter was the transcript of a seventeenth-century manuscript. The covering letter explained that the manuscript contained 'some curious particulars upon the subject of demonology'. This manuscript was none other than a section of Long's lost account of the witches of Malmesbury. The magazine duly published the transcript and the accompanying letter from the sender, signed with the initials 'BCT'. Over the years, the text has attracted some attention from historians of science because it contains an extraordinary story about William Harvey and a witch in Newmarket. However, it is only relatively recently that historians have realised that the author of the fragment was James Long and that this is the opening section of the supposedly lost book.

'BCT' were the initials of Benjamin Coffin Thomas, a Malmesbury solicitor and keen local historian. He often wrote to *The Gentleman's Magazine* about his researches into the history of the town. Thomas did not explain how he had come across the fragment of Long's book. He did, however, write a brief covering note expressing sadness at the folly of belief in witchcraft as expressed in the manuscript.

> I send you a copy of a manuscript containing some curious particulars upon the subject of demonology. It presents a melancholy picture of the ignorance that once prevailed, and of the debased state to which it is possible that the human mind may be reduced.[9]

Benjamin C. Thomas did not know that the author of the text was Sir James Long. He was struck by the fact that the writer showed not the 'slightest remorse' about sending women to an 'ignominious death', and he was not impressed by the writer's attempts to justify belief in the reality of witchcraft.

The rediscovered fragment corresponds in several important ways to the synopsis described by Long in his letter to Aubrey.[10] The story of witchcraft in the town was prefaced by an account of the constitution of the borough of Malmesbury. Long's focus was on the events of 1672, the period when he was an examining magistrate concerned

with the interrogation of witchcraft suspects. However, he set out to place the 1672 investigation in a much longer historical context. For Long, the witches of Malmesbury had been well organised for decades. The coven had an institutional memory. Long's letter to Aubrey talked about the 'war' between the witches and the good people of the town. The fragment of the book told the story of the war, and how grievances on the part of the town's well-organised witches, generated in the 1640s, led to a terrible revenge in the 1670s.

The significance of the letter of dedication

The 'book' started with a dedicatory letter intended to establish Long's credentials both as a pious Christian and as a 'virtuoso' with a high level of interest and expertise in scientific matters. The letter is dated, with reference to the Church calendar, 'Ash Wednesday 1685-6'; in other words, 20 February 1686. Long had written to Aubrey in 1683 describing his plans to write the book. It is not clear why it took him three years before properly starting.

Ash Wednesday was the first day of the penitential season of Lent, and Long mentioned that he was fasting and refraining 'even from a bit of bread'. In the opening letter Long promised that, in addition to his reflections on witchcraft, he hoped to share other scientific findings including 'several observations of animals and phaenomena of meteors, especially of some lately observed heere and neere this place by myself and others'. He was deliberately locating his scientific reflections on witchcraft within a framework of both Christian orthodoxy and the new science.

One significant difference between the book as written and the book as proposed to Aubrey three years before is that it was no longer intended for formal presentation to the Royal Society. The fragment of the 'book' that was sent to *The Gentleman's Magazine* did not contain a dedicatory letter to the President of the Royal Society, in keeping with the original plan. Instead, a letter of dedication was directed to an anonymous but distinguished scholar addressed as 'Most Honoured and Reverend Sir', indicating that the recipient was a clergyman. Although no name is given, the probable intended target for the dedicatory letter was Henry More.[11] The letter does not explicitly identify More, but there is a reference to the fact that the addressee lived in Cambridge. Long informed the recipient of the letter that he hoped soon to explain his treatise in person in

Cambridge, as soon as the weather improved and the roads from Wiltshire to Cambridgeshire were better for travel.

> Reverend S[i]r, I have so much certaynty of your candour, that I can beleeve no other, but that you will be pleesed to suspend your judgment of these papers and my purpose, until I have the happiness to attend you at Cambridge, which, God willing, shall be as soone as the wayes are good.[12]

By dedicating his work to Henry More, Long indicated that he saw the work as part of the wider campaign of scientific witchcraft research championed by More. The surviving fragment of the treatise is entirely consistent with the approach taken by More and Joseph Glanvill. Long, like More and Glanvill, was interested in convincing empirical data that demonstrated the authenticity of witchcraft. It made sense, therefore, for Long to ally himself to More through the dedication.

Long's letter sets out to show that belief in witchcraft could be reconciled with modern scientific thinking. It is in this letter that Long recounted the anecdote of William Harvey and the witch of Newmarket. Harvey was known to have been a witchcraft sceptic. Long presented himself as the intellectual peer of Harvey and one who could see the logical weakness of Harvey's denial of the reality of witchcraft. Harvey, as previously explored, had discovered a foolish old woman in Newmarket who thought herself to be a witch. She claimed that her pet toad was her spirit familiar, so Harvey dissected the toad, demonstrating that it was no demon and suggesting that this demonstrated the folly of belief in witchcraft. Long rejected this argument. Harvey could not deny the general truth of witchcraft simply because he had exposed the delusions of one person.

The introductory letter provides some fascinating information about the Malmesbury witchcraft enquiry of 1672. Frustratingly, the text submitted to *The Gentleman's Magazine* is no more than a fragment of a larger work. The text breaks off at an early stage in the narrative. Fortunately, the letter provides the bare bones of the whole story.

Long's summary account is at variance with that provided by Aubrey in his *Natural History*. Long explained that two Malmesbury women were hanged as a result of the investigation. Aubrey had stated,

'I think there were seven or eight old women hanged.' His recollection was wildly incorrect. The number of women hanged is mentioned by Long in a rather confusing passage where he explained his intention to keep the identities of his fellow magistrates anonymous.

> I doubt not but you will thinck it very strange that I name not the justices for this county in the relation of those miserable women's tryals at Malmesbury, in which to you I acknowledge I myself was principally engaged, so that I being the last who came thither, even when the mittimus was made for 13, 12 women and one man, I brought it to pass, that but three of those were committed, of which 2 were convict and executed.[13]

This important statement is characteristically convoluted. Long was not a good writer. What he was trying to say was that he was the last of several unnamed local justices of the peace who came to the town to investigate allegations of witchcraft. On his arrival he found that no fewer than thirteen people – twelve women and one man – had already been provisionally charged by the other magistrates with witchcraft offences. The legal document, called a 'mittimus', had already been completed for each of the thirteen, ordering that they should be sent to the county gaol in Salisbury, to await trial for witchcraft at the next assizes. Long intervened, ensuring that only three people were committed for trial, of whom two were ultimately found guilty and executed. Long was also implying that he omitted to name the other magistrates because he did not want to embarrass them by reminding them that their actions had been somewhat precipitate. They wanted to send thirteen people for trial but the evidence only justified the trial of three.

In the dedicatory letter Long explained how he had put the investigation on a proper systematic footing. He established some key principles with his fellow magistrates, including the need to ensure that confessions were genuine and had not been forced through the mistreatment of suspects. Long ordered that all the suspects be kept under house arrest while he conducted a thorough re-examination of the evidence. This phase of the enquiry appears to have taken about three weeks. His introductory letter stated, 'The business was long, I having employed twenty days at least about the examinations.' Long described how he had the good sense to instruct two local clergymen

to interview the suspects to make sure that they were not suffering from any delusional or suicidal thoughts that might have prompted a false confession. Long emphasised that he set the bar high in terms of the quality of any evidence. More weight was given to the testimony of 'prudent, sober, and subtle persons' such as the local mayor or alderman rather than any 'meane or unadvised people'.

The text is markedly self-congratulatory. Long presents himself as an intellectual who was at least equal to the great medical expert William Harvey, and able to point out errors in Harvey's thinking about witchcraft. Long wanted the reader to see him as a highly effective man of action, imposing order and good sense in a time of crisis. He expected praise for insisting that best practice for witchcraft investigation should be adopted; such methods included repeated interrogation conducted without threats or coercion and careful reflection on reasons why an innocent suspect might confess. The starting point for the use of these methods was not scepticism about the reality of witchcraft. It was intended to filter out weak evidence in order to establish compelling evidence of guilt.

The evidence of the Gaol Book of the Western Circuit

In his 'book' about the Malmesbury witches, Long named the three suspects that he recommended for trial at Salisbury: Anne Tilling, Judith Witchell and Elizabeth Peacock. He also indicated that Peacock was the woman he saw as the leader of the Malmesbury witches.

Confirmation of the accuracy of the details of the suspects can be found in the Gaol Book of the Western Circuit Assizes, which survives from 1670 onwards.[14] It lists charges of witchcraft offences against Tilling, Witchell and Peacock. The women were taken from Malmesbury to Salisbury Gaol, held on remand, and then tried for these offences at the Salisbury Assizes in March 1672. Mysteriously, a fourth woman, not mentioned by Long, also appears on the charge sheet: Elizabeth Mills, alias Williams.

The Gaol Book evidence supports Long's contention that the woman seen as the leader of the witches of Malmesbury was Elizabeth Peacock. The Gaol Book also indicates that Peacock had been tried previously for witchcraft. The earliest surviving Gaol Book entries for 1670 state that Peacock was found not guilty, in that year, of bewitching Mary Webb's son, Thomas Webb.

Peacock faced the greatest number of accusations and the most serious charges. She was accused of murdering four female victims by witchcraft. None of the other suspects were charged with murder.

There were also charges that some valuable horses had been killed maliciously by witchcraft. This last charge is consistent with what John Aubrey said in his *Natural History of Wiltshire*. He had stated that at the trial of the Malmesbury witches the court had heard about 'the strange manner of the dyeing of H. Denny's horse'. This was obviously a reference to the charge against Peacock and Witchell that they had destroyed fifteen horses belonging to one Henry Dennyng. It is curious that Aubrey should accurately recall this detail a decade later while forgetting that only two of the women were ultimately executed and claiming that seven or eight of them were hanged.

The Gaol Book identified the judge at the trial of the Malmesbury women in 1672 as Sir Richard Rainsford. He was one England's most distinguished judges and became Lord Chief Justice in 1676, succeeding Sir Matthew Hale in this post. The Gaol Book stated that two Malmesbury women were found guilty, condemned to death by Rainsford and 'left for execution'.

Witchcraft charges against Malmesbury women at Salisbury Assizes March 1672

Elizabeth Peacock, Judith Witchell, Ann Tilling:
Feloniously laming of Thomas Webb by witchcraft

Elizabeth Peacock:
Killing and murdering by witchcraft Mary Tanner, Margery Neale, Mary Sharp, Margery Browne

Judith Witchell:
Laming of Julyan Webb by witchcraft

Elizabeth Mills, alias Williams:
Laming of Thomas Peters and Alice Webb by witchcraft

Elizabeth Peacock, Judith Witchell:
Killing of 8 geldings and 7 mares, value £150 of goods of Henry Dennyng by witchcraft

James Long and the events of 1672

Long's fragmentary account provides a graphic picture of a town in crisis in the early weeks of 1672. There had been a widespread belief for decades that some local women operated as an organised group of witches. Simmering antagonism towards those suspected came to a boiling point in 1672, prompted by accusations of one Mary Webb against Elizabeth Peacock and her associates.

Long saw the accusations of 1672 as a result of the long-term organisational resilience of the Malmesbury coven and the persistence of feuds between the 'witches' and the 'good people' of the town. As we saw in Chapter One there had been an outbreak of witchcraft hysteria in Malmesbury three decades earlier during the Civil War. To set the scene for the events of 1672, Long's book described how in the 1640s, two local women died following accusations of witchcraft. In about 1643, Alice Elgar was set upon by a mob of local people and parliamentary soldiers, accused of witchcraft and beaten up. She then committed suicide. Alice's friend Goodwife Orchard was 'universally' viewed as a witch; she was accused in about 1645 by members of the Bartholomew family of bewitching their house. Orchard fled the town but was ultimately captured, and eventually tried and executed at Salisbury. Those who testified against her included a girl, aged about ten, called Mary Bartholomew. Other members of the Malmesbury coven swore that they would revenge themselves on Mary.

Having described in some detail the events of the 1640s, culminating in the threats of revenge by the coven following the death of Orchard, Long's narrative then skips forward to 1672. Little Mary Bartholomew, who denounced Goody Orchard, has grown up and become 'Mistress Mary Webb' following her marriage to prominent businessman Robert Webb. Mary and Robert had several children, and they were convinced that the Malmesbury witches, led by Peacock, were trying to kill these children as revenge for the death of Goody Orchard many years before. While most people were intimidated by the 'witches', Mary and Robert Webb were, according to Long, sufficiently courageous to challenge them. They initiated the prosecution of Peacock for attacking their son Thomas by witchcraft in 1670. We know from the Gaol Book that this trial took place and that Peacock was acquitted.

Long described the events that unfolded in the town during 1671 and 1672. Thomas Webb fell ill again and, in his delirium, denounced

three women for bewitching him: Elizabeth Peacock, Judith Witchell and Ann Tilling. Peacock and Witchell were sisters, and Tilling had formerly worked for the Webb family. Young Thomas claimed that he could see the spectral forms of all the three 'witches' in his bedroom, harming him, although no one else could see anything.

Mary Webb angrily confronted Ann Tilling on the street, accusing her of making her son ill through witchcraft. Tilling broke down and confessed, implicating Peacock and Witchell. Following on from this confession, Robert Webb sought out the town alderman, who arrested the three women. Tilling repeated her confession and went further, describing how she had been recruited to join the Malmesbury coven. The group was well organised. It comprised nine witches, structured as three groups of three. They sometimes met as 'threes' and sometimes as a 'nine'. Malevolent magic, such as the attack on Thomas Webb, was only effective when the witches worked together, 'three witches being needful to doe things of that nature'.[15] The core team of nine witches was assisted by a wider group of accomplices. Tilling had been invited to join the same 'three' as Witchell and Peacock. A vacancy had arisen because a previous member of the three, Goody Clark, was bedridden and unable to participate in their rituals.

Long summarised Tilling's account of how the Malmesbury coven worked. The full complement of nine met often in their houses. Their main 'business' was harming their enemies through black magic.

> They had consultations often with other two threes, so that they were 9, about avenging themselves upon theyr enimys, and that the three threes had often mett since shee was admitted into the first 3; shee alsoe named 3 or 4 men and women confederates, but not frequently conversing with them. That when they mett altogether, it was late at night, in some one of their houses; and that there and then they did eate and drink all together, and consulted of their business, which was the avenging themselves uppon theyr enimys.[16]

This account has some distinctive features. The conventional witches' sabbat of European demonology took place outdoors, but the Malmesbury witches met indoors. They feasted and used witchcraft to harm others, but there was no reference to the presence of the Devil at their meetings.

Tilling named the other eight witches who together formed the 'three threes' of the coven, along with five other accomplices. These people were all taken into custody and interrogated before Long arrived in the town. Three local magistrates got there before him. They had provisionally decided to send all the suspects to Salisbury for trial. At this point, Long appeared on the scene and effectively took over the investigation. He presented himself in his own account as a calming, authoritative figure who emphasised the need for careful analysis of the evidence.

The learned speech of James Long

In his treatise Long reconstructed the speech he gave to his fellow magistrates shortly after arriving in town and taking charge of the investigation.[17] He probably saw the speech as worthy of record because it demonstrated his own standing as a particularly learned and thoughtful expert on both the science and law of witchcraft.

In the speech Long positioned himself as the senior magistrate, the first among equals. He told his colleagues that they were in danger of looking foolish if they proceeded to send too many people for trial, as they had intended before his arrival. Long had no doubt about the existence of authentic witchcraft, but there was a need for great care in the gathering and evaluation of evidence.

Long used his speech to instruct the other magistrates in the science and law of witchcraft. He told them about the need to distinguish between different types of witchcraft. His taxonomy of witchcraft included the 'involuntary witchcraft' that some innocent people undertook if they were afflicted with a naturally occurring 'evil eye'. Another category included people who unwittingly undertook real witchcraft by calling upon the assistance of the Devil, through swearing with oaths, such as 'The Divell take you or him!' or 'The Divell break your or his neck!' People did not realise that these words had real diabolical potency, and that the Devil might well act as requested. Such oaths were therefore extremely dangerous, and technically constituted an invocation of the Devil. Long identified another form of unwitting but authentic witchcraft which took place when people bought magical charms that had been infused beforehand with power through black magic. The final type of witchcraft was the full-blown version that took place when a person consciously agreed a pact with the Devil or his demons, and then used the power of evil

spirits to harm animals or people. Long had no doubt that this form of full witchcraft was a reality. He reminded the magistrates that those guilty of this type of witchcraft justly deserved death.

Having established that witchcraft was a complex but real phenomenon, Long turned to the question of proof in the Malmesbury case. He highlighted two important items of evidence: the confession of Ann Tilling and the claims of the boy, Thomas Webb, that he had seen apparitions of three of the suspects attacking him. The testimony of both witnesses needed to be considered cautiously. Tilling's confession should not necessarily be taken at face value. For instance, she might be in league with Mary and Robert Webb, as part of a plot against Peacock and her sister.

> As for Ann Tilling's evidence against herselfe, Peacock, and Witchell, it may, for ought I yet see, bee a confederacy with the boyes parents, who are sayd to be ever good to her, to bring in Peacocke and Witchell.[18]

Long also argued that questions needed to be asked about the claims of Thomas Webb. Long told the other magistrates that there were two possibilities: either the boy was pretending that he had seen the spectral presence of the witches, or he was telling the truth and had genuinely seen apparitions. Both explanations were possibly correct, but as mature, responsible magistrates they must take great care that they were not the victims of a hoax.

> If he imposes on us who are auntient and should be prudent, it will be our perpetuall shame, that a boy of 12 years old should not be discovered to impose on us; but if his fitts are not fayned, they must be effected by some spiritual foreigne power.[19]

Long proposed not to send anyone straight to Salisbury for trial but to spend more time gathering more evidence and examining the testimony of the two key witnesses through a more extended investigation: 'I would perswade that the boy be very well observed, and Tilling examined at several times, and with prudence to observe whether she alters her confession or information.'

Long recommended that most of the suspects should be released but Tilling, Witchell and Peacock retained in custody locally. They should

be repeatedly interrogated. There should, however, be no examinations for the Devil's Mark. The supposedly possessed boy, Thomas Webb, should also be kept under observation. These proposals were accepted by the other magistrates.

Here, maddeningly, the fragment of Long's 'book' comes to an end. We do not know if the remaining sections of the text were ever written, or were lost, but what we have is incomplete. Long had, in effect, described Day One of his investigation but we know from his introductory letter that he devoted twenty days to the total preliminary investigation, before the three core suspects (and one other not mentioned by Long) were sent to Salisbury for trial. We know nothing definitive from Long about what happened during the remaining days of the investigation other than the fact that some women were ultimately sent to Salisbury for trial and that two of them were executed.

The Gaol Book gives us some clues as to the evidence that came to light during the rest of the investigation. Long only mentioned the accusations of the Webb family. The Gaol Book states that the women were, in addition, charged with offences based on complaints from other families. Elizabeth Peacock faced four counts of murdering four female victims from four different families. Long did not mention these allegations in his account of the beginning of the investigation. It seems likely that other witnesses came forward during the twenty days, including the relatives of the 'murder' victims and Henry Dennyng, whose horses had died mysteriously. The charge sheet indicates that members of six families, besides the Webbs, were prepared to testify against the suspects. Presumably, these further allegations came to light during the full investigation.

No accounts exist describing the evidence that was presented at the trials of the four women from Malmesbury who faced capital charges of witchcraft offences at Salisbury Assizes in March 1672. We do, however, know the verdicts because they were reported in the Gaol Book. Not guilty verdicts were returned for almost all the charges. However, Ann Tilling and Judith Witchell were found guilty of harming Thomas Webb. For this, they were sentenced to death and, soon after, hanged. While her sister, Judith, was executed, Elizabeth Peacock, the alleged leader of the Malmesbury coven, was found not guilty on all charges.

These outcomes seem, at first sight, strange. The chief suspect was acquitted, but two other women were hanged. In the absence of more detailed evidence it is impossible to know precisely what happened. The most likely explanation for the execution of Tilling and Witchell is that they both confessed their guilt. Similarly, Peacock's acquittal on all charges was probably a consequence of her refusal to confess. We have seen that Tilling's confession sparked the investigation. It seems that she continued to insist upon her own guilt. Perhaps Judith Witchell, after weeks of incarceration and relentless questioning, also confessed and agreed that she was guilty.

Elizabeth Peacock lived for another three years, dying in 1675. She was buried in the churchyard of Malmesbury Abbey. She left a will which survives in the Wiltshire records office.[20] She was not completely destitute; her goods were valued at £5 10s. She left a bed to her 'kinsman', William Witchell, possibly the son of her executed sister, Judith. The will was a religious as well as a legal document, and by leaving a will Elizabeth signalled her respectability and religious orthodoxy. She gave her soul into 'the hands of Almighty God'. Her will and her Christian burial were final acts of defiance directed towards those prominent Malmesbury families who had called for her hanging as a notorious witch.

Why did Long press for the death of Elizabeth Peacock?

Long is the hero of his own narrative. He is the man who insists that the investigation should be carried out to a high standard and evidence gathered carefully. He stops the use of vulgar methods, such as the physical examination of the women suspects. Long presents himself as a man who believes in the reality of witchcraft but also insists that great care is taken to ensure that justice is done properly.

An additional source exists that shows James Long's behaviour in a very different light. A lawyer called Roger North told a revealing story about Long's behaviour at the trial of the Malmesbury witches. His source was reliable, derived from information provided by his own brother, Francis North, also known as Lord Guilford, who was a judge with Rainsford on the Western Circuit. Rainsford had told Francis North how he had been pestered in his chambers during the trial by Long, who was insistent that one unnamed suspect, surely Elizabeth Peacock, must be found guilty. Long was extremely anxious that she should be convicted, and of course hanged, not because

of her guilt but on account of the unpopularity that he would face if she was acquitted. The implication was that Long had assured Malmesbury people that she would be convicted and executed. To Long's considerable annoyance, she was found not guilty.

> I cannot omitt one story, for the enterteinement it gave. In Wiltshire, a witch was prosecuted by her parish before Judge Rainsford, and Sir James Long, in the head, urging the judg against her, saying she ruined the country by her malignitys, and his estate in particular, which would be deserted by all mankind, if she returned. But she was acquitted, which made Sir James clamour as if he were undone.[21]

Having failed to secure her conviction, Long sought out the judge after the verdict and described again the problems that she had caused him. Rainsford offered to help, promising that Peacock could remain in detention in Salisbury Gaol despite her acquittal if the cost of her maintenance was met by the town. Long accepted the offer but had to return to the judge on his next visit to Salisbury to explain that the authorities in Malmesbury wanted a different arrangement, whereby she was to be detained in Malmesbury, because that would be less expensive.

> The judg to gratifie him, ordered that the woman should remaine in prison, and the parish should allow her 2.6d a week, for which he was most submissively thankfull. Next assises, the same person sued to the judg, that she might be brought to the towne, and being demanded why? Answered that they could maintaine her for 1 and 6d a week, and so save 1s. The judg granted this request, and he was no less submissively thanckfull.[22]

What happened next is not exactly clear. If Peacock was returned to Malmesbury and confined in some way, it seems that this arrangement did not last indefinitely. She was a free woman in 1675, when she made her will, shortly before her death.

Roger North was amused by Long's behaviour. He said that he included the story in his autobiography 'for the enterteinement it gave', suggesting that the judges laughed at Long's antics. North concluded the anecdote with another reference to the 'comedy' of the

story: 'Such comedy will happen when men put on vizors, either to conceal their ignorance, or their knavery.'

Long does not emerge well from this incident. North accused him of wearing a mask (a vizor) to hide either his stupidity (his 'ignorance') or his duplicity (his 'knavery'). It is possible to put an even more sinister interpretation on Long's private discussions with the judge. At face value, Long's alleged words to Rainsford don't quite make sense. He is supposed to have said that 'his estate ... would be deserted by all mankind, if she returned'. It was not the case that his landed estate in north Wiltshire would be deserted or rendered worthless if Peacock was acquitted, and yet Long acted 'as if he were undone' when Peacock was found not guilty.

There is a possible explanation for Long's unhappiness about Peacock's acquittal. It seems probable that Long had been attempting to win support from the leading citizens of Malmesbury – the very same people who thought their children were under attack from Peacock – in his campaign to become an MP. His failure to ensure the destruction of the witch threatened to thwart his political ambitions.

We know that in 1672, at the time of the trial of the Malmesbury witches, Long wanted to become an MP.[23] The town of Malmesbury, close to his home at Draycot Cerne, was an obvious target. Malmesbury returned two members of parliament and the only electors were the thirteen capital burgesses who constituted the inner council of the borough. There was no vacancy in 1672, but Long knew that vacancies would eventually arise and that all he had to do to get elected was to persuade just seven local men – a majority of the capital burgesses – to choose him. There were close connections between the capital burgesses and the families who felt that their children were being attacked and killed by the witches. The electors included Robert Webb who, together with his wife, Mary, was the chief accuser of Elizabeth Peacock. Another burgess with parliamentary voting rights was Henry Dennyng, the man who thought that Peacock had killed fifteen of his horses. Webb and Dennyng and their friends controlled the fate of the parliamentary seats, and they loathed Elizabeth Peacock.

If Long was campaigning for their electoral support, he needed to assist these men in their bitter conflict with Elizabeth Peacock. It was this, perhaps, that led Long to suggest to the trial judge that his fortunes would be ruined by Peacock's acquittal. By ensuring

that Peacock was hanged, Long would win their approval and their support for his political aspirations.

In 1673, one year after the acquittal of Peacock, a Malmesbury parliamentary seat did become available, due to the death of one of the two sitting MPs. Long did not put himself forward. He had concluded that he had no chance. Robert Webb and Henry Dennyng were presumably smarting from the failure of the attempt to bring down Peacock. Instead, Long looked elsewhere and stood, albeit unsuccessfully, in a by-election in Boroughbridge in Yorkshire, where he also had property interests.

It seems that James Long, Fellow of the Royal Society, argued for the conviction and execution of Elizabeth Peacock because it would help him in his quest to become an MP. There is no reason to doubt that he also thought that she was guilty of witchcraft, but it was self-interest, rather than a wish to see justice done, that led him to lobby Richard Rainsford to ensure the conviction and hanging of Peacock.

James Long was eventually successful in his attempt to become MP for Malmesbury. He was elected as one of the town's representatives to the House of Commons in 1679, by which time Elizabeth Peacock was dead and his failure to ensure her conviction had, perhaps, been forgiven.

8

SALEM AND SCIENCE

The most famous witch trials of the late seventeenth century took place at Salem, Massachusetts in 1692. There has been a very lively debate about the causes of this extraordinary episode in recent years. Several important factors have been identified, among them heightened tensions because of war with French forces in North America, social and economic conflict among Salem residents and the impact of political upheavals in England at the time of the Glorious Revolution. However, another element has attracted less attention: the impact of scientific ideas from England that justified belief in witchcraft.

The intellectual and religious world of colonial Massachusetts in the early 1690s was shaped and dominated by two Boston-based clergymen, Increase Mather and his son, Cotton Mather. In the years before the trials, these men had vigorously promoted beliefs about the reality and prevalence of witchcraft in New England through books published in Boston. Their publications, arguing in favour of the truth of witchcraft, contributed to the widespread belief and fear of witches in Massachusetts.

Increase and Cotton Mather espoused both the threat represented by witchcraft and the value of the new science of the Royal Society of London. Increase Mather enthusiastically promoted experimental science. His son, Cotton, was of a similar mind, and later became a Fellow of the Royal Society. These Americans read with approval the work of Boyle, Glanville and More, and sought to emulate them. Like the English authors they admired, they

believed that the principles of experimental science were entirely in keeping with the reality of witchcraft.

In the years before the accusations at Salem in 1692, Increase and Cotton Mather had both published important books about witchcraft that were heavily influenced by English writers, particularly Glanvill and More. Increase Mather combined a severe Puritan perspective with great enthusiasm for the latest scientific thinking. He diligently followed the discussions in London of the Royal Society through his reading of the Society's monthly journal, *Philosophical Transactions*, which was published regularly from 1665. In 1683 Mather played the central role in the establishment of a New England version of the Royal Society in the form of the Boston Philosophical Society.

Inspired by communications from the Royal Society in London, there was considerable interest in New England during 1682 at the appearance of what we now know as Halley's Comet. Increase Mather made careful observations of the progress of the comet using the telescope at Harvard College. He published two treatises on the comet describing both its scientific and its religious significance. Mather exhaustively identified apparent connections between the appearance of comets and dramatic historic events. He surmised that the comet of 1682 was 'a signal Providence', a manifest sign from God that He was unhappy about human behaviour. Mather concluded that God obviously wanted to punish New England for manifest acts of immorality, such as the scandalous hairstyles of some women in the colony.

Between 1681 and 1684, Increase Mather initiated and supervised a new project intended to report credible 'providences' from across New England. By 'providences' he meant strange incidents which indicated that God was intervening in the world. This project culminated in the publication in 1684 of *An essay for the recording of illustrious providences*. The inspiration for this enquiry was the 1681 release of Glanvill and More's *Saducismus Triumphatus*, which sought to document proven cases of witchcraft, poltergeists and apparitions in England. Mather's book provided, in effect, a series of additional American case studies of similar phenomena, thereby providing further evidence of the demonstrable reality of the supernatural. In *Illustrious Providences*, Mather acknowledged his debt to Glanvill and More. He directed his readers who wanted more information towards their work.

And as there are Witches so many times they are the causes of those strange disturbances which are in houses haunted by Evil Spirits, such as those mentioned in the former Chapter. Instances concerning this may be seen in Mr. Glanvils Collections, together with the continuation thereof; published the last year by the Learned Dr. Henry More.[1]

Mather used the church network in New England to gather testimony about the supernatural. In May 1681 the elders in churches across New England were invited to send Mather any information they had relating to 'providences' such as 'Tempests, Floods, Earth-quakes, Thunders as are unusual, strange Apparitions or what ever else shall happen that is Prodigious, Witchcrafts, Diabolical Possessions, Remarkable Judgements upon noted Sinners'.

In *Illustrious Providences* Increase Mather made it clear that he was fervent in his admiration for the Royal Society and its most distinguished scientist, Robert Boyle. He explained that the context for his work documenting the supernatural in New England was a wish to follow the model of a 'natural history' as advocated by Robert Boyle. Such a work needed to be completed in stages but would ultimately constitute a comprehensive collection of instances of the abnormal, covering both strange phenomena that could be explained with reference to natural causes and occurrences where the likely explanation was supernatural. Mather did not have the time personally to write a comprehensive *Natural History of New England* but saw his pamphlet as an initial contribution to this wider work. He invited other American scholars to put themselves forward to continue his work.

In keeping with the approach to the study of the supernatural advocated by the English writers, Increase Mather was keen to show that he was not gullible and that he expected a high standard of proof before endorsing the authenticity of supernatural events. Like Glanvill and More, he looked at the truth of claims on a case-by-case basis. He wanted his readers to understand that he often rejected purported sightings of ghostly apparitions. However, like Glanvill, More and Boyle, he was also keen to point out that some instances of delusion and fantasy did not invalidate the possibility of real as well as imaginary apparitions by spirits.

Some indeed have given out, that I know not what Spectres were seen by them; but upon enquiry, I cannot find that there was any thing therein, more than Phansie, and frightful Apprehensions without sufficient ground. Nevertheless, that Spirits have sometimes really (as well as imaginarily) appeared to Mortals in the World, is amongst sober Men beyond controversie.[2]

Increase Mather endorsed the argument that it was necessary to prove that witchcraft was a reality in order to defeat the arguments of 'atheists'. He used the same derogatory term as Glanvill and More, 'Sadducees', to describe the followers of Thomas Hobbes. The debate about witchcraft had a wider significance for him, just as it did for Boyle, Glanvill and More. Defence of the reality of witchcraft for all these men was part of a wider attempt to defend belief in Christianity itself. Their starting point was a concern that those who doubted the works of the Devil and the existence of witches could easily begin to doubt the existence of the Christian God.

Building on his reading of the English writers, Mather believed both in the power of witches who were in league with the Devil and the reality of the infestation of houses by malevolent spirits. Glanvill and More had provided case studies of both phenomena, and Mather set out do the same in *Illustrious Providences*.

The book combined sober scientific observation with dramatic claims about the supernatural. In addition to witches, poltergeists and apparitions, Mather documented strange but apparently true tales relating to death by lightning strike, floods, earthquakes and other catastrophes. Mather saw both natural and supernatural elements in the phenomena he described. He applied this approach, for example, to the analysis of thunder and lightning events. Mather attempted to explain lightning with reference to the kind of ideas about chemistry that Boyle was pioneering. Using scientific language and concepts, he described lightning as a 'Nitro-sulphurious Spirit'. At the same time, he asserted as undoubted fact that there was very often a supernatural cause to thunder, which could be either demonic or angelic or divine: 'Thunder-Storms are often caused by Satan; and sometimes by good Angels. Thunder is the Voice of God, and therefore to be dreaded.'[3]

For Mather, the Devil had the resources needed to create thunderstorms. He repeated the idea found in his English sources that the Devil and his supporting demons had profound scientific

knowledge and understanding. In a striking phrase, he described the Devil as an 'Infernal Chymist'. The Devil was a spectacularly brilliant, evil scientist. His extraordinary level of scientific proficiency was demonstrated by his capacity to make thunder.

> An orthodox & rational Man may be of the Opinion, that when the Devil has before him the Vapors and Materials out of which the Thunder and Lightning are generated, his Art is such as that he can bring them into form. If Chymists can make their aurumfulminans, what strange thing may this Infernal Chymist effect?[4]

In his account of how the Devil caused thunder, Increase Mather described how human 'Chymists' had the ability to create '*aurum fulminans*', a highly explosive chemical compound used by alchemists. His logic was that if humans could develop such explosive substances it was hardly surprising that the Devil had the scientific knowledge to bring about explosions on a grander scale.

The witch of Hartford

In *Illustrious Providences* Increase Mather presented a 'flagship' instance of what he considered an undoubtedly credible witchcraft event concerning the bewitching of a young woman called Ann Cole during 1662 and 1663 at Hartford, Connecticut. The great bulk of his information came from a letter about the case written to him by John Whiting, a Hartford minister and a witness to the Ann Cole case. Mather's account is, for the most part, a paraphrase and summary of the information contained in the letter, which is preserved today at the Boston Public Library. Whiting was responding to Mather's call for strange but true instances of Divine providence.

Although Mather did not explain the context of the case of Ann Cole, her 'bewitching' was, in fact, part of a great outbreak of hysteria about witchcraft in the town of Hartford and other parts of the Connecticut colony at the time.

Mather compared the strength of the evidence from the recent European instances of witchcraft with his own case study from Connecticut. He cited, with approval, the story of the Swedish witches in *Saducismus Triumphatus* and a recent pamphlet that described the trial and execution of the Bideford witches at Exeter in 1682. He then

asserted that the guilt of the witch of Hartford, Rebecca Greensmith, was even more compelling:

> But the Instance of the Witch Executed in Hartford, here in New-England (of which the preceding Chapter giveth an account) considering the circumstances of that Confession, is as convictive a proof as most single examples that I have met with.[5]

Mather recounted how Ann Cole became unwell as a result of witchcraft. Ann had mysterious convulsions and named Greensmith as one of her tormentors. Greensmith, who was already in prison on suspicion of witchcraft, was confronted by those who had witnessed Ann Cole's fits. Her response was to confess that she had indeed bewitched Ann and was an active worshipper of the Devil.

> She likewise declared, that the Devil first appeared to her in the form of a Deer or Fawn, skipping about her, where with she was not much affrighted, and that by degrees he became very familiar, and at last would talk with her. Moreover, she said that the Devil had frequently the carnal knowledge of her Body. And that the Witches had Meetings at a place not far from her House.[6]

According to Increase Mather, Ann's confession included an admission that she had had sex with the Devil. Having described the accusation and the confession, Mather briefly alluded to the fact that Greensmith and her husband were hanged: 'Upon this Confession, with other concurrent Evidence, the Woman was Executed; so likewise was her Husband, though he did not acknowledge himself guilty.'[7]

We know from other sources that the couple were tried, found guilty and hanged in January 1663. Mather showed very little interest in the detail of the life of Rebecca Greensmith. It is only from other sources that we even know that her first name was Rebecca and that her husband was one Nathaniel Greensmith.

Increase Mather's interest was not in the personalities of the Greensmiths. The case intrigued him because it met his standard of incontrovertible proof that supernatural action had taken place. Like Boyle, Glanvill and More, Increase Mather was deeply interested in questions of proof and evidence. He considered that empirical proof of a witchcraft event depended upon the quality of the witnesses.

Mather's conviction that the witch of Hartford was guilty was based on a combination of credible testimony from different individuals: a victim who was respectable, witnesses who were trustworthy and a suspect who confessed. With such a strong evidence base, Mather concluded that it was 'past all doubt' that Ann was suffering from the supernatural attack of a witch.[8]

Having established 'proof' of the reality of the power of witches, Increase Mather set out to show that he did not believe all the stories that were told about the activities of witches. Here he demonstrated some independence of thought. The witch of Hartford claimed that she had sex with the Devil. Mather did not think this was possible, despite Henry More's claims to the contrary; the Devil had simply deluded her into thinking it to be true. Similarly, references to the transformation of witches into animals should not be accepted and were likely to be fantasies 'imposed' upon the minds of witches by the Devil. Again, this represented a different opinion to that expressed by More, who had argued that real animal transformation was possible.

In addition to making the case for witchcraft, Mather argued for the existence of houses haunted by active malevolent demons or poltergeists. For him, poltergeist phenomena and witchcraft were sometimes, but not always, related. It was possible for a house to be troubled by a demon because of witchcraft, for instance, but sometimes it appeared that the Devil was taking direct action without the mediation of a witch. He made explicit reference to the two most important cases studies of poltergeist activity highlighted by English writers: Robert Boyle's Devil of Mascon and Glanvill's Drummer of Tedworth.

Increase Mather had read widely, and his review of the literature of demonology included *The Devil of Mascon*. He summarised this as 'The Story of the Daemon which for three Moneths molested the House of Mr. Perreaud a Protestant Minister in Matiscon'. Mather accepted the veracity of the account. Based on lessons from the text, he urged his readers not to attempt dialogue with demonic spirits. He was also impressed by the investigation into the Tedworth case, and provided a substantial summary of it. He then presented three accounts from New England of similar phenomena, where the residents of houses were plagued by the activities of malevolent spirits.

Increase Mather continued to encourage anxiety in New England about witchcraft and the wiles of the Devil after the publication of *Illustrious Providences*. When a dancing school was opened in Boston in early 1685, Mather saw this as a threat from the Devil. He quickly published a pamphlet condemning dancing, explaining that it was closely associated with witchcraft. It was well known, he claimed, that dancing almost always took place when witches gathered together. Mather accepted the testimony of native Americans that the Devil appeared at their dances, which were similar to the covens of witches.

> It is known from their own Confessions that amongst the Indians in this America, oftentimes at their Dances the Devil appears in bodily shape, and takes away one of them alive. In some places of this Wilderness there are great heaps of Stones, which the Indians have laid together, as an horrid Remembrance of so hideous a fruit of their Satanical Dances.[9]

Cotton Mather and the case of Martha Goodwin

Increase's son, Cotton, also published a book about witchcraft before the outbreak of witchcraft hysteria at Salem. *Memorable providences relating to witchcraft and possessions* appeared in 1689. Like his father, Cotton considered that he was contributing to the scientific witchcraft literature pioneered by Glanvill and More. He stated that his aim was emulate the 'Great Names' who had written about the truth of witchcraft in England.

> I said Let me also run after them; and this with the more Alacrity because, I have tidings ready. Go then, my little book, as a Lackey to the more elaborate Essayes of those learned men. Go tell Mankind, that there are Devils & Witches.[10]

Cotton Mather further associated his treatise with Glanvill and More by his repeated use of the term 'Sadducees' to describe those atheistic sceptics who scoffed at the existence of witchcraft. His 'little book' was intended to show the errors of those who denied that the Devil was active in the world. Like his father, and Glanvill and More, Cotton Mather was keen to document case studies of authentic witchcraft that met a high standard of empirical proof, linked to the credibility of witnesses.

That which is Recorded in this Narrative, is worthy to be commended to the Notice of Mankind, it being a thing in itself full of Memorable passages, and faithfully recorded, acording to the Truth in Matter of Fact, scarce any Instance being asserted in it, but what hath the Evidence of many credible Witnesses, did need require.[11]

His father had presented the world with the story of Rebecca Greensmith, the witch of Hartford, and the bewitched child Ann Cole, as definitive proof of witchcraft in action. In a striking parallel, Cotton Mather told the story of Ann Glover, the witch of Boston, and the demonic possession of the child Martha Goodwin.

Increase Mather's conviction in the truth of the witchcraft in Hartford depended upon his faith in the testimony of one extremely trustworthy source. This came in the form of the letter he received from a respected fellow clergyman, John Whiting. Cotton Mather was similarly concerned to find an incontrovertible case of proven witchcraft and demonic possession. While Increase Mather sought out the testimony of credible witnesses, Cotton Mather looked for even more convincing evidence. He placed himself at the centre of the narrative by describing, in detail, his own investigation into the bewitchment of the children of the Goodwin family of Boston.

The villain of Cotton Mather's case study was an Irish immigrant called Ann Glover. Glover had been accused of harming the Goodwin children by witchcraft, and was hanged in November 1688. Just as Henry More had interrogated suspected witches in Cambridge Castle many years before, Cotton Mather interviewed Ann Glover when she was awaiting execution.

Mather was impressed by the fact that, during the preliminary investigation, Glover was unable to say the words of the Lord's Prayer correctly. This was a traditional test used to identify a witch. Mather described it as an 'experiment', as if it provided a form of scientific proof. He believed in the efficacy of the test, and explained that he had used this method, with the same results, on two other suspect witches.

An Experiment was made, Whether she could recite the Lords Prayer; and it was found, that tho clause after clause was most carefully repeated unto her, yet when she said it after them that

prompted her, she could not possibly avoid making Nonsense of it, with some ridiculous Depravations. This Experiment I had the curiosity since to see made upon two more, and it had the same Event.[12]

Before she was hanged, Glover announced that the illness of the Goodwin children would continue after her death because her accomplice witches would continue the attack. As Glover predicted, the symptoms of the children persisted after the execution. Determined to study demonic possession in a particularly thorough, scientific way, Mather took one of the children, Martha Goodwin, home to live with him for several weeks. He made detailed notes describing her behaviour during this time, and they form the centrepiece of *Memorable providences.*

> That I might have a full opportunity to observe the extraordinary Circumstances of the Children, and that I might be furnished with Evidence and Argument as a Critical Eye-Witness to confute the Saducism of this debauched Age; I took the Eldest of them home to my House.[13]

Cotton Mather's study of Martha's possession by demons resembled the clinical case studies based on observation that were undertaken by investigative physicians as part of the practice of medicine in the early modern period. He described her symptoms and conducted various tests to better understand the nature of the demon or demons that possessed her. Mather documented her bizarre behaviour; she claimed, for example, to have an invisible horse that she would often ride to meetings with her tormentors. Mather was interested in the intellectual and linguistic ability of the demons that possessed her, and tested their language skills and their ability to 'read his mind'.

Mather concluded *Memorable providences* with a postscript, informing readers that, despite the execution of Glover, the plague of witchcraft in Boston continued. Children were still under attack from organised witches. He stated that he looked forward to 'the Detection and the Destruction of more belonging to that hellish Knot'. Mather's advocacy of further persecution and the language that he used echoed that of Joseph Glanvill. In *Saducismus Triumphatus* Glanvill had described the witches of Somerset in very similar terms, calling them

a 'hellish knot', and expressing his frustration that they had not been properly 'exposed and punished'.

The behaviour of the Goodwin children in Boston in 1688 is similar in some ways to that of the girls in Salem who claimed to be bewitched in early 1692. The causes of the Salem hysteria are a subject of considerable scholarly debate. However, one contemporary had no doubt that an important contributory factor was the publication of the account of Martha Goodwin by Mather in *Memorable providences*. In 1700 Robert Calef published *More wonders of the invisible world*, in which he condemned Cotton Mather for his contribution to the loss of life in Salem. Calef claimed that the publication of the case study of Martha Goodwin encouraged girls in Salem to undertake copycat behaviour and did 'much to the kindling those Flames'.[14]

Hysteria in Salem

During the summer of 1692, twenty people were put to death in Salem, Massachusetts, following accusations of witchcraft. The crisis began when two young girls, Betty Parris and Abigail Williams, fell ill with convulsions, and complained that they were being attacked by local witches. The first suspects, named by the girls, were impoverished, marginalised local women. In the weeks that followed, more girls claimed to be bewitched, and an increasing number of suspects were named, including some from better-off backgrounds.

Increase Mather was personally absent from New England at the beginning of the crisis. He had been in London negotiating a new political relationship between Massachusetts and the government in England following the Glorious Revolution. He returned to Massachusetts in May 1692, together with William Phips, the newly appointed royal governor of the colony. Phips responded to the developing Salem crisis by setting up a special court to hear the cases. This court began proceedings in early June, when one Bridget Bishop was charged with witchcraft. She was found guilty and hanged. The trials continued over the summer. By the end of September, nineteen people had been hanged and one man had been pressed to death after refusing to plead.

The part played by Increase and Cotton Mather in events at Salem has been the subject of considerable debate ever since. The two men did not doubt that authentic witchcraft had occurred; the features of the alleged witchcraft were consistent with their views

and their reading of the European witchcraft literature. While both had previously promoted the idea that witches were active in New England, however, both urged caution on the judges during the trials of 1692. The call for caution centred on the use of 'spectral' evidence as conclusive proof of guilt. Increase and Cotton Mather held that witches could undertake out-of-body or 'spectral' witchcraft, but they also saw that there was a risk that the Devil could wickedly create a false apparition in order to implicate an innocent person.

Thomas Brattle's attack on the use of false science at Salem

There are clues in the trial transcripts that people in Salem were influenced by their reading of books like *Saducismus Triumphatus*. That was certainly the view of the eighteenth-century New England historian Thomas Hutchinson, who looked carefully at the transcripts. In about 1750 he wrote that 'all the examinations at Salem have, in almost all the circumstances, the like to match them' in the witchcraft stories of Joseph Glanvill.[15]

As Hutchinson pointed out, there were considerable similarities between Glanvill's accounts of witchcraft in England and the allegations made at Salem. One parallel between Salem and the world of *Saducismus Triumphatus* relates to the phenomenon of out-of-body attacks by witches. Glanvill told the story of how the Somerset witch Jane Brooks appeared in spectral form in the house of Richard Jones and was slashed at by another person present, sustaining a corresponding wound on her physical body. In similar fashion in Salem, Bridget Bishop allegedly appeared in spectral form to Mary Walcott. Her brother, Jonathan Walcott, could not see the apparition but slashed out in the direction indicated by his sister. Mary claimed that her brother had torn the clothes of the apparition. On 19 April Bridget Bishop was interrogated in the presence of her accusers. The investigating magistrate, John Hathorne, was particularly interested in the torn dress that she was wearing as possible evidence of the authenticity of the spectral event. Jonathan Walcott was present at the interrogation and explained how he had struck out at the spectral form of Bridget in a way that was consistent with the rip on Bishop's dress. It was evidence such as this that led to Bridget's execution.[16]

Glanvill and More promoted the idea, found in European sources, that witches applied a special ointment to their bodies before flying

in spectral form to meetings. The English writers had speculated on the possible function of the ointment. One of the Salem suspects was directly asked about this practice. On 21 July, Mary Lacey was interrogated and asked, 'Doe not ye Anoynt ye selves before ye flye?'[17] The investigating magistrates were aware of the witchcraft theory promoted by Glanvill and More.

Not everyone in Massachusetts was convinced about the guilt of the Salem suspects. One prominent individual in Boston considered that those investigating the Salem suspects were mistaken, and too much influenced by 'scientific' theories of witchcraft. In a letter written in October 1692, Thomas Brattle expressed grave reservations about what he saw as the muddled, quasi-scientific ideas that were used by the justices when they investigated the allegations of the 'afflicted children'. Brattle was, in effect, attacking the More–Glanvill witchcraft science that had become prevalent among some 'Salem gentlemen' and that had been promoted in New England by Increase and Cotton Mather.

Thomas Brattle did not defer to the intellectual and spiritual leadership of Increase and Cotton Mather. He was independently minded and had spent several years away from Massachusetts in London. Brattle was interested in modern science and corresponded with the London Royal Society about scientific matters.

In his 1692 letter, Brattle criticised the 'experiments' that were conducted during the preliminary investigations of the Salem suspects. The justices believed, in keeping with the theorising of Glanvill, that witches transmitted their malevolent power through the emission of toxic particles when they gazed upon their victims. Brattle was highly critical of the way, as part of the interrogation process, that suspects were forced to look at their supposed victims, and the assumption of guilt that was made when the 'looked at' children went into convulsions.

> The Justices order the apprehended to look upon the said children, which accordingly they do; and at the time of that look, (I dare not say by that look, as the Salem Gentlemen do) the afflicted are cast into a fitt.[18]

The 'Salem gentlemen' were, it seems, faithfully applying the ideas of Joseph Glanvill, who had proposed that 'pestilential spirits being

darted by a spightful and vigorous imagination from the eye, and meeting with those that are weak and passive in the bodies which they enter, will not fail to infect them with a noxious quality'. Brattle was deeply unimpressed by this theory of the emission of toxic particles by eyesight. He argued that other people present would surely be harmed by these malevolent rays.

> I would fain know of these Salem Gentlemen, but as yet could never know, how it comes about, that if these apprehended persons are witches, and, by a look of the eye, do cast the afflicted into their fitts by poisoning them, how it comes about, I say, that, by a look of their eye, they do not cast others into fitts, and poison others by their looks.[19]

Brattle was also sceptical about the theory that the witches could undo their witchcraft by touching their victims. The magistrates believed that the poisonous toxins transmitted by eyesight were somehow returned to the witches by the action of bodily contact with the 'victims'.

Brattle used the shorthand term 'Cartesian', that is derived from the theories of Descartes, to describe the false science of the investigating justices, and their belief in the power of witches to issue toxic particles by eyesight. He talked about how the 'Salem gentlemen' believed in the 'the doctrine of effluvia'. Descartes had attempted to explain magnetism as the action of very small particles emitted from the magnet, which he called 'effluvia'. Brattle explained that he respected Descartes but had no time for Salem's misguided 'Cartesians'.

Brattle was scathing in his critique of 'the Salem gentlemen'. They talked about 'the new philosophy', meaning the modern scientific approach, but the prevalent pseudoscience among some of the local elite 'rather deserves the name of Salem superstition and sorcery'.

In allocating blame, Brattle distinguished between the different roles of Increase and Cotton Mather. He praised Increase Mather for action he had taken to calm down the hysteria. By contrast, Brattle made an uncomplimentary reference to his son, Cotton Mather. He stated that some of the executed people were undoubtedly innocent. They behaved with remarkable dignity but were treated disrespectfully by 'Mr C.M.', who refused to pray with the condemned prisoners at the gallows.

After the killing

Following the last executions at Salem, both Increase and Cotton Mather began to write about the trials. Cotton Mather's book *The wonders of the invisible world* set out to justify the trials and confirm the guilt of those executed. Increase Mather took a different approach in his *Cases of conscience concerning witchcraft*. This focused on whether 'spectral' evidence was sufficient to convict a witch. He argued that it was not, by itself, reliable evidence because the Devil could create a false apparition of an innocent person, so that where the evidence was not incontrovertible suspects should be given the benefit of the doubt: 'I had rather judge a Witch to be an honest woman, than judge an honest woman as a witch.'[20]

While arguing for caution in the use of evidence, Increase Mather made it clear that witches should still be prosecuted where the evidence was secure. The execution of witches was justified if either the witch had made an unforced confession or two 'credible witnesses' could vouch for the reality of the witchcraft.

The personal contributions of the younger man, Cotton Mather, to the events of 1692 have been contested almost ever since and this remains a divisive issue among today's historians. In his book, *The wonders of the invisible world*, he sought to justify the conduct of the Salem witch trials, and his approach is similar, in some important respects, to that used by Joseph Glanvill as he went about writing *Saducismus Triumphatus*. Glanvill wanted to disprove the scepticism of John Webster; Cotton Mather sought to counter those who were critical of the executions at Salem. Glanvill used transcripts from the interrogations of Somerset 'witches' taken from the notebook of his friend, the magistrate Robert Hunt; Cotton Mather used a very similar source. On 20 September 1692 he wrote to the clerk of the court at Salem, Stephen Sewall, reminding him that he urgently needed extracts from the Salem court transcripts for his intended book.

That I may be the more capable to assist in lifting up a standard against the infernal enemy, I must renew my most importunate request, that you would please quickly to perform what you kindly promised, of giving me a narrative of the evidences given in at the trials of half a dozen or, if you please, a dozen, of the principal witches that have been condemned.[21]

Sewall obliged and Mather used the court records to highlight a selection of the Salem cases, with an emphasis on the evidence that demonstrated the manifest guilt of the accused.

Mather's debt to Glanvill can also be seen in the language he used. He was highly antagonistic towards one of the accused, Martha Carrier. He famously called her 'This Rampant Hag',[22] a phrase taken from Joseph Glanvill, who used the same insulting term to describe a suspect he particularly loathed, Margaret Agar of Brewham in Somerset.

Mather made explicit reference to *Saducismus Triumphatus* in order to reassure his readers in New England that the witchcraft outbreak in their midst was authentic, and entirely in keeping with similar phenomena in Europe.

> It may cast some Light upon the Dark Things now in America, if we just give a glance upon the Like Things lately hapening in Europe. We may see the Witchcrafts here, most exactly resemble the Witchcrafts there; and we may learn what sort of Devils do trouble the World.[23]

One European precedent that Cotton Mather used to justify the Salem executions came from Sweden, via the pages of Glanvill's *Saducismus Triumphatus*. In his book, Mather claimed that there was a high degree of similarity between the outbreak of witchcraft in Massachusetts and the witchcraft events in Sweden in 1669. He had read the account of events in Sweden in *Saducismus Triumphatus*. This section of the book was a translation from a German treatise about the Swedish witch trials, provided by Glanvill's friend Anthony Horneck. Mather was keen to emphasise the relevance of the Swedish parallel with Salem, and the importance of Horneck's translation.

> But is New-England, the only Christian Countrey, that hath undergone such Diabolical Molestations? No, there are other Good people, that have in this way been harassed; but none in circumstances more like to Ours, than the people of God, in Sweedland. The story is a very Famous one; and it comes to Speak English by the Acute Pen of the Excellent and Renowned Dr. Horneck.[24]

Mather proceeded to highlight, in some detail, specific similarities between the two cases in order to hammer home the message that the people of New England could rest assured regarding the authenticity of the Salem events because of the striking similarity to these well-attested events in Europe. His key source was *Saducismus Triumphatus*.

Cotton Mather and the plastic spirit of the world

After the trials, Mather had no doubts of the authenticity of witchcraft. Continuing to reflect on the scientific basis of sorcery, he was intrigued by an idea promoted by Henry More that there was an invisible spirit force at work throughout the world. More called this 'The Spirit of Nature' or the 'Hylarchical Principle'. More's Cambridge colleague Ralph Cudworth developed the idea that there was an unconscious spiritual force in the world which he termed 'Plastic Nature'.

In *The wonders of the invisible world* Mather briefly articulated the notion that witchcraft worked through the harnessing of this invisible spirit or 'The Plastic Spirit of the World'. He defined witchcraft as the manipulation of this natural force for malevolent purposes through a compact with evil spirits.

> Witchcraft seems to be the Skill of Applying the Plastic Spirit of the World, unto some unlawful purposes, by means of a Confederacy with Evil Spirits.[25]

Mather continued to muse on witchcraft as the manipulation of the 'plastic spirit' in the years that followed. There is no sign of any doubt on his part about the reality of witchcraft in his work. In a manuscript treatise dating from 1694–95, Mather returned to the concepts developed by More and Cudworth relating to the invisible 'Plastic Spirit'.

> Briefly, I have not yett altered my Opinion, That there is a Plastic Spirit permeating of the World, which very powerfully operates upon the more corporeal parts of it: and the Angels, both good and bad, are on account of the Natures, the most Able of all creatures, to Apply that Spirit unto very many and mighty purposes.[26]

The idea of the 'plastic spirit' was briefly fashionable in the mid-seventeenth century. Reputable scientists such as William Harvey used it as a possible explanation for the germination of life. By the end of the seventeenth century the idea had become outmoded, but Cotton Mather persisted with it.

More than thirty years after the events at Salem, Cotton Mather was still writing about the significance of the 'plastic spirit' when seeking to make sense of witchcraft. In 1724 he completed the text of a large book about medicine, *The Angel of Bethesda*. It was not published at the time. The text explored the notion that the elusive 'plastic spirit' might be central to a proper understanding of the functioning of the human body and the nature of sickness. Mather invented a new term for this force, which he called 'Nishmath-Chajim', based on a Biblical Hebrew phrase meaning 'breath of life'.

Mather again asserted his belief that witchcraft operated through the manipulation of the 'plastic spirit' or Nishmath-Chajim. He continued, as Glanvill had done sixty years earlier, to rail against the witchcraft sceptics or 'Sadduccees', calling for more scientific research into the way witches harnessed the power of 'Nishmath-Chajim'.

> In the indisputable and indubitable Occurrences of Witchcrafts (and Possessions) there are many Things, which, because they are hard to understand, the Epicurean Sadduccees content themselves, in their swinish Manner, only to laugh at. But the *Nishmath-Chajim* well understood would give us a marvellous Key to let us into the Philosophy of them.[27]

9

FRANCIS GRANT AND THE WITCHES OF RENFREWSHIRE

The lethal persecution of witches lasted longer in Scotland than in England. The last definite executions for witchcraft in England took place in 1682, whereas executions continued sporadically in Scotland until 1727. On 10 June 1697, seven people were executed for witchcraft in Paisley in Renfrewshire near Glasgow (confusingly, two of the victims had the same name so the number is sometimes wrongly reported as six). Another suspect died, mysteriously, in prison. In line with Scottish legal convention, the seven 'witches' were strangled at the stake and then burned.

The killing of the 'witches' at Paisley is sometimes called 'the last mass execution of witches in western Europe'. It is also significant because of the extent to which a key prosecuting lawyer was inspired by scientific explanations of witchcraft and tried to use the case to create a better scientific understanding of the way the Devil operated through witchcraft.

The last letter to John Aubrey

There is an important connection between John Aubrey and the story of the witches of Renfrewshire. Even before the executions, a Scottish friend wrote to Aubrey with the news that a major witchcraft investigation was taking place near Glasgow. On 27 May 1697, Professor James Garden of King's College, Aberdeen sent a letter to Aubrey, who was then in Oxford. The letter survives and is held by the Bodleian Library. The two men had been in correspondence

since 1692 regarding Scottish antiquities, folklore and supernatural phenomena, and several of Garden's letters have survived. Aubrey used information supplied by Garden about 'second sight' in Scotland in his book about the supernatural, *Miscellanies*, which had been published a year earlier.

Garden's letter indicates that Aubrey had written to him previously, enclosing three copies of *Miscellanies* and enquiring about further 'supernatural' material from Scotland for an envisaged second edition of the book. Looking back, there is some poignancy about the letter. In addition to news about the supernatural, Garden wanted to inform Aubrey that he had lost his university job at Aberdeen because of his refusal to swear an oath of allegiance to William and Mary as sovereign rulers of Scotland. Aubrey did not get to read the letter with the news from Scotland; he died at Oxford on 7 June 1697, before Garden's letter had arrived from Aberdeen and three days before the execution of the Paisley witches. There was to be no second edition of *Miscellanies*.

Oblivious to his friend's impending demise, Garden had sent thanks in his letter for the gift of the books. Despite his upset at losing his job, he tried to be helpful to his English friend. He could not think immediately of any additional 'supernatural' stories of the sort presented in *Miscellanies*, but he had heard news of a major case of witchcraft in Scotland which he thought would interest Aubrey. A young girl had accused local witches of harming her. She vomited strange objects, including coals, and claimed that she could see the spectral presence of her tormentors. The suspects were in prison awaiting trial.

> A strange passage hath fallen out of late near the town of Glascow, where a gentleman's daug[hter] of about 12 years of age, hath been miserably tormented by various distortio[ns] of her body swoonings, hanging out of her tongue to a great length, which is sometimes again pulled back into her throat casting out of her mouth straw, horse-dung, hott coals &c all which shee sayes is performed by witches whom shee senses and hears tho none else of the company doe, shee hath accused many who are in prison but now have confessed save two boyes.[1]

Garden was describing one of the most famous cases in the history of witchcraft in Scotland, the trial of the 'witches' of Renfrewshire which

ultimately led to the execution of seven people. He was remarkably well informed about developments in Paisley given that the events he was describing were still unfolding as he wrote and were taking place 150 miles from his home in Aberdeen. He wrote two weeks before the executions. It is clear from the letter that Garden was corresponding with an informant in Paisley, and already knew, even before the conclusion of the trial, that there was a plan to publish an account of the story as soon as the trial was concluded.

As Garden predicted, pamphlets about the case were soon published. One account came out in 1697, soon after the trial, entitled *A relation of the diabolical practices of above twenty wizards and witches of the sheriffdom of Renfrew*. Another treatise appeared in 1698 in two different editions, one published in Scotland and the other in England. The Edinburgh version was called *A true narrative of the sufferings and relief of a young girle*, while the London edition of the text bore the title *Sadducismus Debellatus*, meaning 'Sadducism Subdued'. This title was clearly an allusion to *Saducismus Triumphatus*.

The Preface to *A true narrative/Sadducismus Debellatus* unambiguously located the work in the anti-atheistic 'defence of belief in witchcraft' genre established by English intellectuals. Like More and Glanvill in England, the authors of this treatise saw proof of the authenticity of witchcraft as a way of defending belief in God: if evil spirts existed, then of course God existed. Scotland and England faced a shared challenge from 'atheism'. The text described how contemporary Britain was 'The Unfortunate Island', due to the prevalence of atheism. Christianity was under attack in an unprecedented way because, for the first time in history, atheists were organised. 'There was never before any Society, or Collective Body of Atheists till these dreggs of time.'[2]

In the late 1690s Scotland's ruling elite was anxious about the need to take a stand against 'atheism'. In 1697, the same year as the trial of the Renfrewshire witches, Thomas Aikenhead, an Edinburgh student aged just twenty, was executed for blasphemously denying the truth of Scripture. The 1698 treatise about the Renfrewshire witches made a reference to the Aikenhead case. It stated that the existence of the Devil and evil spirits 'was denied by Mr. Aikenhead'.[3] Among the Scottish elite there was a view that Christianity was under siege from the forces of darkness, including both atheistic sceptics like Aikenhead and witches.

Christian Shaw and the witches of Renfrewshire

The story outlined in *A true narrative/Sadducismus Debellatus* corresponds closely to the summary account that Garden provided to Aubrey in his letter. The 'gentleman's daughter' mentioned by Garden was a girl called Christian Shaw, whose father, John Shaw, was indeed a 'gentleman' and was the Laird of Bargarran, a settlement near Erskine, about 10 miles west of Glasgow. The girl claimed to be bewitched and demonstrated alarming symptoms including convulsions and vomiting strange material.

The pamphlet account was that Christian Shaw initially became unwell in August 1696. She had pains and frequent convulsions. In her fits she claimed that she was being tormented by two women, a young family servant called Katharine Campbell and an older local woman named Agnes Naismith. Christian told her parents that she could see spectral images or apparitions of Katharine and Agnes hurting her. The symptoms worsened over the months that followed, and Christian accused more people of harming her. She was sent to see Dr Matthew Brisbane, a leading Glasgow physician. Although Brisbane was reputed to be one of the best doctors in Scotland, Christian failed to improve under his care.

The treatise explained how John Shaw decided to use the law to pursue the witches who were apparently harming his daughter. He obtained a signed witness statement from Dr Brisbane confirming his view that the strange symptoms could not be explained away in straightforward natural terms. This statement by Brisbane included the curious assertion, later repeated by Garden in his letter to Aubrey, that Christian had vomited hot coals. In February 1697, some of the local suspects accused by Christian were arrested. Three young local people were among those interviewed and they proceeded to confess to witchcraft. They were Elizabeth Anderson, aged seventeen, and two young brothers, fourteen-year-old James Lindsey and eleven-year-old Thomas Lindsey. The confessions of Anderson and the Lindsey brothers were dramatic. They described the existence of an organised group of witches that had been responsible not only for the bewitching of Christian but also for a series of even worse atrocities. Babies were 'magically' strangled to death, the Erskine ferry had been deliberately capsized leading to the death of a nobleman and the ferryman, and the minister in Dumbarton, John Hardy, had been murdered by witchcraft.

These claims were taken seriously, and further investigations took place in the following weeks. Over twenty people were arrested and interrogated. Eventually, three men and four women were sent for trial. The court records make it clear that all the suspects were physically searched to see if they had a Devil's mark, and these marks were pricked to test whether the suspect was able to feel pain. The accused were all deemed to possess suspicious 'insensible' marks. After a trial by jury, all seven were convicted and executed.

Francis Grant: the learned prosecutor of witches

A true narrative/Sadducismus Debellatus was the work of several hands. At the heart of the publication is a chronological account of the bewitchment of Christian, which clearly drew upon information provided by the Shaw family. The treatise concludes with two documents written by prosecutor Francis Grant: his notes to the court in response to points made by the lawyers for the defence, and the concluding speech he made to the jury. Grant made substantial use of scientific reasoning as part of his successful attempt to dismiss the defence arguments and to ensure the conviction and execution of the accused.

It is possible to trace the evolution of the scientific witchcraft theorising of Francis Grant. He was born in about 1660. He had the benefit of an excellent education as a student at King's College, Aberdeen, between 1678 and 1682. It was at Aberdeen that Grant almost certainly encountered both the experimental science of the Robert Boyle circle and the witchcraft theories of Henry More. At this time, King's was a centre for the teaching of the new science and the philosophy of René Descartes and Henry More.[4] Grant almost certainly knew James Garden, who became professor of divinity at King's College in 1681. Grant was quite possibly the source of the information about the Renfrewshire case that Garden sent to Aubrey. Together with his brother, George Garden, who was a prominent local minister in Aberdeen, James was enthusiastic about the neo-Platonic philosophy of Henry More. George Garden was a regular correspondent with the Royal Society in London. Another King's College teacher, George Middleton, was also well-known for his commitment to the latest scientific and philosophical ideas.

After studying at Aberdeen, Grant enrolled as a law student at the university of Leiden in 1684. He returned to Scotland in about 1687, intent on a legal career. His plans were temporarily derailed by the

political turmoil of the period. Grant supported the deposition of King James VII (James II of England) in 1688 and published a legal treatise in 1689 justifying his overthrow. On the title page he demonstrated his commitment to modern learning by quoting Descartes: 'I affirm nothing, and I would have no one believe anything unless convinced by clear and irrefutable reasoning.'[5]

Grant had studied the works of Descartes at Aberdeen. In quoting Descartes, Grant was seeking to establish his credentials as a modern thinker, yet he had no difficulty at all reconciling this with his conviction regarding the undoubted truth of witchcraft. Philosophy, science and witchcraft were all taken seriously in the dominant intellectual circles of Aberdeen.

In another treatise, published in 1700, Grant urged judges and magistrates to use the full power of the law against the wicked. It was a dereliction of duty not to prosecute and punish wrongdoers severely. He reminded his readers that 'The Magistrates chastiseing of the Wicked is an Ordinance of God'. At the end of the treatise, Grant gave a summary of those laws he thought should be energetically prosecuted, with details of the due punishments laid down by Scottish law. The first of the laws he highlighted related to atheism and ordained that repeat offenders should be put to death. Grant wanted these laws to be vigorously implemented. He explained his view that, unless strenuously opposed, atheism or 'irreligion' would destroy social order because many people would only obey the law if motivated by fear of divine punishment for wrongdoing.

> Irreligion, of its own tendency, destroys a Common-Wealth: being as fatal to publick Societies, as it is to private persons: Because it dissolves these bands which are the cement and support of the same; for none will do right, or abstain from wrong, or is to be trusted; when he imagines his Interest or Ease; except in the fear of God.[6]

Grant's speech to the jury

Grant was a believer in the science of witchcraft. This is clear from the 1698 treatise, which includes the text of the concluding speech Grant made to the jury. He presented himself as the learned expert, able to place the facts of the case within a wider context of legal and scientific theory.

Grant sought to establish that the crime of witchcraft had undoubtedly taken place. In reviewing the evidence, he focussed almost exclusively on the story of Christian Shaw, devoting very little attention to the more serious charges that the witches had murdered babies and a local minister. The influence of Glanvill and More is evident. More had established tests for the credibility of witchcraft claims, relating both to the trustworthiness of witnesses and whether the witchcraft action created any tangible evidence.

For Grant, the evidence in the case met a high standard of proof. He reminded the jury that the girl's own accounts were endorsed by witness statements made by trustworthy people, such as the distinguished Glasgow physician, Dr Brisbane. He pointed out the observable physical effects of the magical attacks on Christian, such as the scratches caused by her invisible attackers.

In addition to testimony from several trustworthy witnesses, Grant invited the jury to consider the poor reputations of the accused, including the fact that some of them had been charged with witchcraft before. Grant placed substantial weight on the existence of the Devil's Mark on the bodies of all the suspects. He also emphasised that none of the suspects was capable of shedding tears, which was traditionally seen as a characteristic of those guilty of witchcraft: 'You see that none of· them do shed Tears, nor were they ever discovered to do it since their Imprisonment, notwithstanding their frequent Howlings.'[7]

Grant made remarks about the evidence against each one of the seven prisoners. He itemised their faults. Grant reminded the jury of some telling evidence relating to each individual suspect. James Lindsay was said by William Semple to have taken on the form of a bird and to have attacked him. Margaret Fulton was known locally to have spent time with the fairies. Grant was particularly venomous in his portrayal of Margaret Lang. She had been a respected midwife, so Grant needed to blacken her reputation with jury members, some of whom probably knew and liked her. He called her a 'Great Impostor' and a 'Master-piece of the Devil'.[8]

The speech to the jury devoted considerable attention to the status of the confessions that the court had heard. He emphasised the trustworthiness of the confession of the seventeen-year-old Elizabeth Anderson. She had testified against members of her own family, which would be irrational, said Grant, if she was not telling the truth. The court had heard testimony from two children. They had not

been asked to take an oath because they were underage, but Grant reassured the jury that their accounts could still be trusted.

Grant's speech concluded with a threat to the jury. If the guilty witches were acquitted, the jury would be share responsibility for their future crimes. The men of the jury had a solemn duty to convict the witches and ensure that by their deaths they were stopped from committing further atrocities.

> So if these Prisoners be proven legally guilty; Then, as to what is past, your Eye ought not to spare them, nor ought you to suffer a Witch to Live: And, as to the future; in doing otherways you would be Accessory to all the Blasphemies, Apostacys, Murders, Tortures, and Seductions, &c. Whereof these Enemies of Heaven and Earth, shall hereafter be guilty, when they are set at Liberty.[9]

Grant's speech was effective. After six hours of deliberation, the jury returned guilty verdicts on all the prisoners. The treatise states that unequivocally that the seven 'witches' were convicted and executed. In addition to Grant's accounts, court records from the case survive providing the identities of seven people who were executed by strangling and burning on 10 June 1697: Katharine Campbell, Agnes Naismith, Margaret Fulton, Margaret Lang, James Lindsay, and two men both called John Lindsay. Another prisoner, called John Reid, died in prison; his body was found strangled in his cell.

Grant and the scientific tradition of Glanvill and More

Grant's absolute conviction in the correctness of the death sentence he had secured for seven people was based on his reading of the prior scientific literature concerning witchcraft. Just as Robert Boyle claimed to have approached witchcraft claims with initial scepticism, Grant explained to the judges that his initial position was one of doubt but that the facts of the case demanded belief:

> I must confess that none could be more sceptical as to the Truth of such odd things as I had heard; nor inquisitive for canvassing the Reality, and Explications of them, then I was...But now, after all that I have seen, reasoned, and heard; I do acknowledge my self entirely captivated by the dictats of Natural understanding and common Sense, into a firm belief and perswasion, that,

as there is such a thing as Witchcraft, so it was eminent in its forementioned Effects; and that the seven Prisoners were some of the Witches.[10]

There is clear evidence that Grant had read *Saducismus Triumphatus* carefully. He adopted some of the witchcraft theorising of More and Glanvill, reiterating the logic, found in More and Glanvill, that the inability thus far to understand all aspects of the science of witchcraft was not a reason for doubting its authenticity. He drew a parallel with magnetism; we do not fully understand how magnetism works, but that should not lead us to question its reality.

> Proven facts must not be denied, tho' Philosophers have not yet certainly reached the Invisible manner of their Existtence: So in Nature, the Load-stone draws the Iron, the Compass turns always to the Poles, &c.[11]

Grant was influenced by the concept of so-called 'objects of sense' in suspected cases of witchcraft. Some claimed that witchcraft was imaginary, but how could that be true if tangible things, 'objects of sense', were involved in cases of alleged witchcraft? Joseph Glanvill used this term when arguing that concrete evidence, such as the pricked skin of a victim of witchcraft visibly harmed by pins or nails, was irrefutable proof of witchcraft authenticity.

> And to think that Pins and Nails, for instance, can by the power of imagination be convey'd within the skin; or that imagination should deceive so many as have been witnesses in Objects of sense, in all the circumstances of discovery.[12]

The same technical term, 'objects of sense', was used by Grant to make an identical point based on the events in Renfrewshire: 'The actual Murdering of Children by a Cord and Napkin; and the Tormenting of Others by Pins, &c. are plain Objects of Sense.'[13]

Like Glanvill and others, Grant endorsed the use of simple experiments to verify the truth of witchcraft claims. Glanvill had written about the experimental blindfolding of Richard Jones in Somerset in 1658. The boy was unable to see the people who touched him, but he had no problem recognising the touch of the 'witch'

Jane Brooks. Similarly, Christian Shaw had her head covered with a cloak, and was touched by one of the suspects and by other random bystanders. The touch of the accused induced instant agony for Christian, but she had no reaction to being touched by other people. Grant thought this important, and highlighted the 'Experiment' during his summary speech to the jury.

> Her falling in Fits upon the sight, or touch of her Tormenters, was no effect of Imagination: For she was fully hood-winked with a Cloak, so as she saw no Body whatsomever; yet upon the approach of her Tormenter, she immediatly fell down dead: Whereas she remained no ways startled upon the touch of any other: Which Experiment was tried for ascertaining this Mean of Discovery.[14]

Glanvill considered that witchcraft was real but not 'miraculous'; it did not involve the suspension of the laws of nature. Witchcraft worked instead by the supernatural harnessing of natural forces. Witchcraft was, as Glanvill said, 'ordinary and familiar in all natural efficiencies'. Grant agreed and expressed identical ideas during the trial at Paisley. He explained that witchcraft operated in a non-miraculous way, 'by Conjunction of natural Causes'. Witches probably harmed their enemies through the transmission of invisible 'poisonous Steems', comparable to the invisible toxins that caused the plague. Grant informed the court that witchcraft harm probably functioned in 'the same way as the invisible Pestilence does operat'.

Grant was intrigued by the invisibility of the witches. For him, as for other theorists, witchcraft was not fundamentally 'miraculous'. The Devil was a brilliant scientist and knew how to manipulate existing forces in a way that went beyond existing human scientific knowledge. He did not have the power to suspend the laws of nature, but his extraordinary proficiency in the science of optics made possible the invisibility of his witch followers.

Grant made an important assertion at Paisley about the power of the Devil: 'Satan's Natural Knowledge and acquired Experience, makes him perfect in the Opticks.'[15] This brief statement is built on a series of assumptions about science and witchcraft. The Devil is a fallen angel. As such he has, just like all other angels, a remarkable level of innate scientific 'Natural Knowledge'. The Devil has the further benefit of being thousands of years old and has enhanced

his scientific knowledge through millennia of 'acquired Experience'. The result was a level of scientific proficiency way beyond seventeenth-century human science.

In one important area, Grant disagreed with his learned predecessors Glanvill and More. The English writers had asserted that out-of-body witchcraft was entirely plausible, and that witches had the ability to leave their bodies behind at home when attending sabbat meetings or visiting the homes of their enemies. Grant rejected this. He stated that witches were physically present when they attended their meetings or travelled to the scenes of their crimes, being bodily transported from place to place through the air with the assistance of the Devil. This was completely credible because the Devil caused hurricanes, and very heavy objects could be transported in such storms.

> For the most part and ordinarly, the Witches are personally existent in the places where they appear; because it's more easy for the Prince of the Air to transport them in his Hurricanes which he can raise.[16]

Grant speculated on the mechanics of the flight of witches. He developed an original idea that flying witches must be equipped with an invisible mask; he called it 'a fence', meaning a protective barrier or a 'defence'. This allowed the witch to breathe normally while travelling at speed through the air. The Devil formed 'a Fence upon their Face, whereby the violence of the Air may be diverted from chocking them'. He also suggested the likely existence of an invisible vehicle that witches used when flying. He called it a 'Volatile Couch', using the word 'volatile', to mean 'flying'. The sides of the flying vehicle had the power to deflect light rays, thereby rendering the travelling witch invisible.

Grant had no doubt that the Renfrewshire witches had been able to visit Christian Shaw wearing a cloak of invisibility and had proceeded to harm her while being physically present but invisible. He developed his own distinctive theory that many of the events in Renfrewshire could be explained in terms of the Devil's optical magic which enabled witches to operate invisibly. Grant saw invisibility as a diabolical optical illusion. The Devil had the ability to 'bewitch the Eyes of others'. Grant suggested that the Devil had several scientific techniques at his command that could enable the kind of invisibility that had been employed in Renfrewshire. Grant identified three

methods which he thought the Devil used, in combination, to achieve this. First, the Devil was able to 'constrict' the pores of witches so that their bodies did not reflect light rays in the normal way. Secondly, the Devil could thicken or condense the air between witches and spectators so that light rays could not penetrate 'the interjacent Air'. Finally, he could influence the bodily liquids or 'humours' in spectators in such a way that their 'optick Nerves' were obstructed. The result of all these techniques was invisibility.

> He constricts the Pores of the Witches Vehicle, which intercepts apart of the Rayes reflecting from her Body; he condenses the interjacent Air with grosser Meteors blown into it, or other ways does violently agitate it which drowns another part of the Rayes: And lastly he obstructs the optick Nerves with Humors stirred toward them: All which joined together may easily intercept the whole Rayes reflecting from these Bodies, so as to make no impression upon the common sense.[17]

In developing these ideas Grant may have been influenced by another, much earlier Scottish expert on witchcraft, King James VI (James I of England). In his book about witchcraft, *Daemonologie*, first published in 1597, King James had speculated on the Devil's likely ability to thicken air and thereby create the illusion of invisibility.[18]

Grant theorised about the science of witchcraft. He also accepted the truth of some traditional beliefs about witches, such as their supposed inability to say the Lord's Prayer perfectly and the existence of the Devil's Mark.

Several instances of the Lord's Prayer 'test' had been described earlier in *Saducismus Triumphatus*. More had personally tried the test when interviewing suspects in Cambridge in 1646, although he later argued that it should be used with caution as a definitive form of proof. Grant expressed no such reservations and drew the attention of the jury to the fact that none of the Renfrewshire prisoners could successfully say the Lord's Prayer.

> None of the Prisoners that were Tried (tho most Sagacious and Knowing, and perfect in Memory, so that it could not proceed from Ignorance or Forgetfulness) could make out the attempt of saying the Lord's Prayer.[19]

Grant liked to theorise about the rationale underpinning traditional witchcraft beliefs. He told the jury at Paisley that the Lord's Prayer might have a particular significance to the Devil, who was offended by its pious sentiments and so took action to stop his adherents from reciting it.

Grant accepted the reality of the Devil's Mark and speculated, as Glanvill had done previously, on its scientific functioning. For him the existence of the mark was an important indicator of guilt. He remarked on several occasions about the fact that the Renfrewshire suspects bore a mark which was immune to pain. He speculated that witches probably received the mark at their first sabbat meeting, after they had made an initial contract with the Devil. The mark was painful and forced the witches to return to the Devil at a subsequent meeting hoping for some relief from the pain. The witches became physically addicted in this way to Devil worship.

> Commonly this mark being given at the first Meeting, does by its intolerable Pain, force the Witch to a second Randevouz for curing it, at which the poor wretch being under this furious necessity, fixes the Paction by renewing it with deliberation, having been diverted in the mean time from considering the Horridness of the first Engagement by the Pain.[20]

What really happened in the case of Christian Shaw?

Influenced by his scientific understanding of the reality of witchcraft, Grant failed, of course, to address and identify the true cause of Christian Shaw's illness. Grant had no doubts whatsoever about the authenticity of the witchcraft events in Renfrewshire. He went further and asserted that this was one of the world's more clear-cut instances of real witchcraft: 'Upon the whole I do believe; that there is scarcely a more rare providence of this nature in any true History.'[21]

His preoccupation with scientific thinking made Grant highly gullible. He had no problem accepting Christian Shaw's claims that she alone could see the witches enter the rooms of her family house when many other people were present because this was consistent with his theories of the science of witchcraft. He told the jury that they should accept Christian's evidence. The witches had almost certainly received assistance from the Devil, who had the ability to temporarily block the functioning of the eyes and ears of the other witnesses who could see nothing.

Severals of your number do know, that the Girle declared, that she saw and heard the Doors and Windows open at the Witches entry, when no doubt the Devil had precoudensed a soft stopage on the Eyes and ears of others, to whom that was unperceived.[22]

What really happened that led Christian Shaw to denounce so many people and cause so many deaths? Using a variety of contemporary sources, it is possible to construct a plausible interpretation of events. It seems highly likely that Christian Shaw was encouraged to denounce people as witches at the instigation of her parents. One object of their campaign, perhaps the key target, was a woman called Mary Morrison from the coastal town of Greenock.

The main narrative of events *A true narrative/Sadducismus Debellatus* was based on information supplied by the Shaw family. It is clear from this that, as early as January 1697, the suspects who were denounced by Christian included one who was from a higher social background than the others. She was described as 'the gentlewoman'. The diary of events assembled by Christian's family stated that this woman 'had been always one of her most violent Tormentors'. The initials of 'the gentlewoman' were given as 'M.M.' This mysterious individual played an increasingly important role in the drama over the following weeks.

Christian's illness persisted during the early months of 1697 and her denunciations of 'the gentlewoman' became more vociferous. It seems that her higher social status gave her some initial degree of immunity, and she remained at liberty for several weeks despite the accusations against her. It was not until 19 March that the commissioners, persuaded probably by John Shaw, Christian's father, agreed to issue an arrest warrant for 'the gentlewoman'. She was arrested dramatically in the middle of the night, and the next day was brought into the presence of Christian.

Following her night-time arrest, on 20 March 'the gentlewoman' was forced to confront Christian Shaw. This was the first time the girl had seen 'the gentlewoman' in the flesh, although she claimed to have seen her spectral form tormenting her many times before. On seeing her, Christian accused 'the gentlewoman' of having harmed her in spectral form. The family narrative permits the reader no doubt about the guilt of this mysterious figure. However, it seems that 'the gentlewoman' had some protectors. By 23 March 'the gentlewoman'

had been released on bail. The treatise makes it clear that the Shaw family were extremely disappointed by her release.

Other sources enable us to identify 'the gentlewoman' as Mary Morrison or Duncan, the wife of Francis Duncan, a ship's captain from the port of Greenock. It is clear from the 1697 treatise *A relation of the diabolical practices* that the young people who mysteriously confessed talked about the presence of someone with the codename 'Antiochia', who was present at their sabbat meetings, and who they described as 'the gentle wife of the Devil'. The implication of their confessions was that this woman was the leader of the coven, and jointly presided with the Devil himself over their meetings. The treatise identified 'Antiochia' as 'Mary Morison' and stated that she was one of fourteen suspects who were initially arrested but eventually not put on trial.[23] Witness statements from many other suspects survive. They repeatedly refer to the presence of 'Antiochia gentle wife of the Devil' at meetings of witches.[24] The consistency of the terminology is highly suspicious, and suggests that the suspects were asked leading questions about the presence of 'Antiochia' at their meetings.

It seems likely that Christian was encouraged by her parents to denounce Mary Morrison. She lived at some distance from Christian's home in Bargarran. They had not met before her illness. Why should a girl accuse someone that she did not know, who lived 15 miles away from her, unless she was prompted by others, such as her parents? It is clear from *A true narrative/Sadducismus Debellatus* that her father, John Shaw, was keen to see Morrison put on trial. At some personal inconvenience, he went in the middle of the night to Greenock to take part in her arrest.

John Shaw was related to Sir John Shaw, who was the dominant figure in the town of Greenock. For reasons that are not clear, it seems that the Shaw family, which had substantial property interests in Greenock, was at odds with Mary Morrison and her husband, who lived in the same town. Sir John Shaw of Greenock took part as a commissioner in the investigation into the bewitching of Christian Shaw.

The Shaw family did not give up on its attempts to establish the guilt of Mary Morrison after the trial of 1697. She was arrested in 1698, and again in 1699, in connection with other accusations of witchcraft. Sir John Shaw of Greenock was one of the commissioners in both these subsequent cases. The prosecution of Mary Morrison was only

abandoned in 1700, three years after she had been first denounced by Christian Shaw. There is a consistent pattern of hostility towards Morrison on the part of the Shaw family over several years.

Preoccupied as he was with the science of witchcraft, Francis Grant was oblivious to the strong evidence in favour of a Shaw family conspiracy to destroy Morrison and others. Seeing events through his scientific lens, Grant saw no need for any explanation other than that Christian had genuinely been bewitched and was telling the truth about the spectral attacks of Mary Morrison, 'the gentlewoman' who played the part of the Devil's wife at Renfrewshire sabbat meetings.

10

ASTROLOGY, RITUAL MAGIC AND WITCHCRAFT

The Fellows of the Royal Society of the Restoration period were divided in their views about astrology. John Aubrey was a great enthusiast for astrology and became increasingly fascinated by the subject from the early 1670s onwards as a consequence of the deepening of his friendship with Elias Ashmole. One of the first Fellows of Royal Society and the founder of the Ashmolean Museum in Oxford, Ashmole shared Aubrey's passion for astrology and was the leading patron of William Lilly, the pre-eminent astrologer of the age. Aubrey also knew Lilly and became an extremely good friend of Lilly's younger disciple Henry Coley.

While Aubrey and Ashmole believed in the explanatory power of astrology, some contemporaries condemned the subject, saying that it was little different from witchcraft. Lilly and Coley were both publicly accused of sorcery, and both were threatened, at different times, with prosecution for witchcraft.

The Royal Society was home to different schools of thought about witchcraft belief and astrology. The witchcraft sceptics rejected and ridiculed astrology as superstitious nonsense. The clerical believers in witchcraft, most notably Henry More and Joseph Glanvill, considered that predictive astrology (contemporaries called it 'judicial astrology') was only likely to be effective when the astrologer was assisted by the Devil, making it a close relation to full-blown witchcraft. The occult believers in the supernatural, such as Ashmole and Aubrey, endorsed astrology as a legitimate scientific activity and rejected the accusations that it was akin to witchcraft.

Lilly, astrology and witchcraft

By far the most influential and controversial astrologer of the seventeenth century was William Lilly. Aubrey was probably introduced to Lilly by Elias Ashmole, who had been a friend and supporter of Lilly since the 1640s. Aubrey mentioned Lilly in his works several times, occasionally critically but with no hint that he considered him to be in any way disreputable. When Aubrey got to know Lilly in the early 1670s, they talked about astrology, witchcraft and the supernatural. In his book *Miscellanies*, Aubrey alluded to a conversation with Lilly about a mysterious apparition that had recently been recorded in Gloucestershire.

> Anno 1670, not far from Cyrencester, was an Apparition: Being demanded, whether a good Spirit, or a bad? Returned no answer, but disappeared with a curious Perfume and most melodious Twang, Mr W. Lilly believes it was a Farie.[1]

Lilly believed in fairies, as did Aubrey. Aubrey and Lilly also discussed witchcraft and the counter-magic that could be used against the power of witches. Lilly recommended to Aubrey the display of horseshoes as a charm against witches and explained the protective power of the horseshoe in astrological terms. Aubrey drew upon this conversation in a passage about witchcraft in his study of folklore, *The remains of Gentilism*.

> To this purpose a Horse-shoe nailed on the threshold of the dore is yet in fashion: and nowhere so much used as to this day in the west part of London, especially the New-buildings: it ought Mr. Lilly says to be a Horse-shoe that one finds by chance on the Roade. The end of it is to prevent the power of Witches, that come into your house; and it is an old Use derived from the Astrological principle, that Mars is an Enemie to Saturne, under whom witches are.[2]

Aubrey was impressed by this astrological rationale for horseshoe magic against witches. He juxtaposed Lilly's views about the protective power of the horseshoe with beliefs about witchcraft found in classical Rome, quoting from Pliny's *Natural History* an account of how starfish, smeared in the blood of a fox, were placed on lintels

or door knockers in ancient Rome, serving a similar purpose to the horseshoes.

In *Miscellanies*, Aubrey made further reference to Lilly's views about how to combat witchcraft. He provided a recipe described as being 'against an evil tongue' (bewitchment), explaining that he had obtained it from Lilly. The counter-witchcraft magic recipe described by Aubrey in *Miscellanies* involved mixing poplar oil, vervain and hypericon. The herbs were to be heated using a red-hot iron or poker and, subsequently, either worn as an amulet or anointed on the back. Aubrey stated that Coley vouched for the efficacy of the charm: 'Mr. H[enry] C[oley] hath try'd this Receipt with good success.'[3]

By the time that Aubrey became acquainted with Lilly, the astrologer was already an elderly man. Lilly had come to prominence in the 1640s as an astrologer who supported the parliamentary forces in the struggle with Charles I. He became famous for his 'almanacs', annual publications with astrological predictions for the following year. His first almanac, published in 1644, was wildly popular and sold out within a week. He predicted a parliamentary victory for June 1645, and his reputation was secured when the royalists were defeated at Naseby in that month. In addition to writing annual almanacs, Lilly provided individuals with astrological consultations based on their horoscopes.

Lilly had many enemies and remained controversial figure for several decades. Right from the beginning of his career, he was accused of relying for his predictions on the assistance of the Devil. Lilly tried to defend his reputation. He published a textbook about astrology in 1647, and called it *Christian Astrology*, indicating by its title that he was an orthodox Christian and that astrology was not the work of the Devil. Far from being allied to witchcraft, he asserted, astrology could be used to identify witches and undo their work. In introductory remarks in the book, Lilly set out his intention to disprove those clerical critics of astrology who falsely claimed that astrology was literally 'diabolical'.

I lay downe the whol natturall grounds of the Art, in a fit Method: that thereby I may undeceive those, who misled by some Pedling Divines, have upon no better credit then their bare words, conceived Astrology to consist upon Diabolicall Principles: a most scandalous untruth, foisted into both the Nobility and Gentries apprehensions.[4]

The book attempted to characterise Lilly not as a sorcerer but as the enemy of witches. He listed concerns about being bewitched as one of the typical queries that he dealt with in his practice as an astrologer. He explained how an expert astrologer could use a horoscope to work out whether witchcraft was the cause of an illness.

> If the Lord of the twelfth be in the Ascendant, it argues Witchcraft, or that some evil spirit doth molest the party, or that some that are neer him or about him have evil tongues, or in plain terms, have bewitched him.[5]

Lilly explained how astrologers could provide powerful magic against witches, describing the use of anti-witchcraft horseshoe magic.[6] Get two horseshoes. One should be nailed to the doorway where the bewitched person lived; the other should be soaked 'in the Urine of the party so Bewitched'. More urine should be boiled in a pan, containing three horseshoe nails. It was necessary to repeat this procedure three times. The magic was best performed when the right lunar conditions applied: 'The operation would be far more effectuall, if you do these things at the very change or full Moon, or at the very hour of the first or second quarter thereof.'

In addition to the horseshoe charm, Lilly's book provided another, even more complex set of instructions for an alternative magical process that could be used against witches. Again, it involved the use of the bewitched person's urine. The bewitched were advised to follow the suspect witch back to her house and, once she was inside, to remove a tile or some thatch from over the door of her dwelling. The stolen tiles were to be heated on the fire and then doused in urine; the thatch should be first soaked in urine and then placed on a fire.

Actions such as the above would, according to Lilly, undo any malevolent incantations spoken by a suspected witch. This anti-witchcraft magic had little to do with manipulating the influence of the planets and was an articulation of widely held folk beliefs about the use of urine magic to combat witchcraft.

If Lilly hoped that the content of *Christian Astrology* would stop suggestions that he used witchcraft, he was to be disappointed. In the years that followed its publication, he was often denounced for using black magic to ascertain his predictions. In 1648 a royalist astrologer published an attack on Lilly suggesting that he relied on 'conference

with devils' to produce his almanacs. The pamphlet claimed that Lilly colluded with the Devil, who was himself 'the subtilest Astrologian in the world'.[7] Lilly, as one of the Devil's followers, was able to obtain secrets about the future from his evil master.

Accusations continued that Lilly's powers were derived from the Devil, and that he was guilty of witchcraft. In 1652 John Vicars published an angry attack which described Lilly as 'that impious witch or wizzard, and most abhominable sorcerer'. Vicars compared Lilly to the 'devellish Doctor Lamb'. This was a reference to John Lambe, the notorious London wizard who was lynched in 1628 and whose apprentice was Anne Bodenham, the 'witch' of Salisbury. Vicars stated that Lilly was carrying on Lambe's 'wicked Witcherie'.[8]

In 1654 Lilly came close to being tried for the capital offence of witchcraft. He was accused of sorcery by several witnesses, and the case went before the Middlesex magistrates. The magistrates were told by a woman called Anne East and others that Lilly had used 'inchantment, charm and sorcery' to locate lost and stolen property in contravention of the statute law of 1604 against witchcraft. This was a very serious accusation. If the Middlesex magistrates had accepted that there was a case to answer, Lilly would have been sent to the Old Bailey and put on trial for his life. Lilly explained that all he had done was straightforward astrology, which was not illegal. Fortunately for Lilly, he had some supporters among the Middlesex magistrates. After some debate, the case was against him was dropped.[9]

William Lilly remained influential, and controversial, throughout the 1650s. He was very busy. He made a good living both from his almanacs and from personal consultations. Lilly survived the political transition of the Restoration, and continued working under the new regime. After the Restoration, he was greatly assisted by the patronage he received from Elias Ashmole, who was an ardent and well-connected royalist but also a great admirer of Lilly's astrological skill.

Lilly continued his practice and publication of his almanacs after 1660. The accusations that he dabbled in black magic also continued. In 1664 Samuel Butler published an expanded version of his 'mock heroic' poem *Hudibras*. Sir Hudibras was a ridiculous knight errant based on Cervantes' Don Quixote. In the poem Butler satirised Lilly and other astrologers, recycling claims that they were guilty of witchcraft. A prominent character in the poem is the astrologer

Sidrophel, and it is widely believed that this character was based on Lilly. Significantly, the poem refers to Sidrophel not only as an astrologer but also as a 'cunning man' and a 'wizard', and he is directly accused of sorcery. Sidrophel is consulted by Sir Hudibras, who wants some advice about his love life. Hudibras loses patience with Sidrophel and suggests that his insights derive from a pact he has with the Devil. Sidrophel strongly denies the charge, and explains that he practises only lawful astrology, in just the same way that Lilly had denied charges of witchcraft.

> For I assure you, for my part,
> I only deal by Rules of Art,
> Such as are lawful, and judge by
> Conclusions of Astrology:
> But for the Devil, know nothing by him,
> But only this, that I defie him.[10]

'Sidrophel' became a term of abuse that could be levelled at any morally dubious astrologer. In 1699, long after Lilly's death, James Yonge published his pamphlet *Sidrophel Vapulans*. Yonge made many disparaging remarks about Lilly and stated his belief that astrology was allied to black magic and that, for many, involvement with astrology led ultimately to full-blown Devil worship.

> It's an Art not only near of Kin to Witchcraft, and Magick, but leads Men into it ... When Men become greedy of knowing things before hand, they bind themselves Apprentices to the Devil's Black Art.[11]

Disputing the legacy of John Dee

The debate about astrology in the mid-seventeenth century became intertwined with a dispute about the magic of John Dee, the Elizabethan astrologer, alchemist and polymath. Dee had claimed that he could predict the future by summoning angels using special incantations, mirrors or crystal balls and the power of a specially gifted medium known as a scryer. Even during his life, Dee was accused of seeking to communicate not with angels but with demons. Interest in angelic crystal magic continued long after his death in 1609, as did criticisms that his magic was a form of witchcraft.

One great admirer of John Dee was Elias Ashmole. In 1652 he published an anthology of English alchemy texts, *Theatrum chemicum Britannicum*. In this work, Ashmole wrote in praise of 'that most famous Artist, Doctor John Dee'. Dee, in Ashmole's view, had superb skills as a mathematician, alchemist and astrologer for which jealous people wrongly persecuted him.

> His great Ability in Astrologie, and the more secret parts of Learning (to which he had a strong propensity and unwearyed Fancy,) drew from the Envious and Vulgar, many rash, lewd, and lying Scandalls, upon his most honest and justificable Philosophicall Studies.[12]

Ashmole approved of Dee's astrological magic. He was also keen to establish the distinction between forbidden witchcraft and permitted ritual magic, angrily denouncing those who saw the magic of experts such as Dee as witchcraft.

The interest that Ashmole took in the spirit magic of Dee was not simply theoretical or academic. Ashmole had a reputation for having practised the spirit magic that Dee had pioneered. Sir Hans Sloane wrote that when an ambassador from Morocco visited London in 1682, Ashmole was asked to demonstrate the summoning of spirits through ritual magic. Ashmole declined, not because of his inability to call up spirits but in order to avoid the potential 'disturbances' that the spirits might cause.

> Mr Ashmole showed him, in a small turret, the instruments and the books used by Dr Dee and the gentleman Edward Kelly in their actions with spirits (some of which have been published by Casaubon). Upon which the ambassador asked Mr Ashmole to make some of these spirits appear so that he could speak to them about some events that were taking place in his country at the time. Mr Ashmole declined, in order to avoid, he said, the disturbances that they might cause.[13]

Other sources confirm that Ashmole was an active participant in ritual spirit magic. We know that he was constantly making talismans or 'sigils' to harness the protective power of angels. A manuscript in the Bodleian Library contains a spell for the invocation and binding of

a fairy which Ashmole appears to have used personally. MS Ashmole 1406 was intended to be used in a ritual to summon a particular fairy spirit called Elaby Gathen. Ashmole inserted his own initials (E.A.) into the text of the invocation. The purpose of the magic was for Ashmole, as a wizard, to obtain control over the fairy so that it would be forced to serve him. The language was superficially Christian but the magic was theologically ambiguous because fairies were widely seen as demonic rather than benign spirits. The magic was intended to force the fairy to appear in a crystal ball or glass.

> I E.A. call the[e] Elaby Gathen in the name of the father of the sonne and of the holy ghost ... I binde thee to give and doe thy true humble and obedient service unto me E.A. and never to depart without my consent and Lawfull Authoritie ... come and appeare presently to me E.A. in this christall or glasse meekely and myldely to my true and perfect sight and truly without fraud Dissymulation or deceite resolve and satisfye me in and of all manner of such questions and commands and Demandes as I shall either Aske Require desire or demande of thee.[14]

For Ashmole, alchemy and astrology and magic were closely connected. In his anthology of English alchemical texts, Ashmole commented on the way that the philosopher's stone might be used to facilitate a conversation with angels, which would unlock the secrets of the future. He was keen to give his personal reassurance (again referencing himself as 'E.A.') that this type of magic was divinely blessed and not in any way linked to witchcraft.

> It enables Man ... to Convey a Spirit into an Image, which by observing the Influence of Heavenly Bodies, shall become a true Oracle; And yet this as E. A. assures you, is not any ways Necromanticall, or Devilish; but easy, wonderous easy, Naturall and Honest.[15]

Ashmole was not alone in his wish to continue the practice of the spirit magic of John Dee, despite accusations that it was a form of witchcraft. Unpublished diaries in the British Library document the ritual magic of another group of English people who used Dee's crystal magic methods between 1671 and 1688. This group deliberately

emulated Dee's spirit magic, and their primary concern appears to have been enlisting supernatural help to locate hidden treasure.[16]

The clerical assault on astrology as a form of witchcraft

By the time of the Restoration in 1660, elite astrology of the type practised by Lilly and endorsed by Aubrey and Ashmole was under attack. Two major works appeared, both written from a clerical perspective and denouncing astrology as the work of the Devil. In 1659 the theologian Meric Casaubon published *A true and faithful relation*, which was a fierce critique of John Dee. This was followed in 1660 by Henry More's comprehensive assault on astrology in *An explanation of the grand mystery of godliness*. Both books equated astrology with witchcraft and, by implication, sought to denigrate the work of elite astrologers such as William Lilly.

The structure of Casaubon's 1659 book about John Dee is curious because the bulk of the text is made up of extracts from Dee's diary, not previously published, prefaced by a hostile introductory essay by Casaubon denouncing Dee. In Casaubon's view, Dee's astrology and magic depended upon the power of demons. Casaubon did not doubt that Dee was sincere when he claimed that he was communicating with angels, but considered that Dee was duped by skilful evil spirits, clever enough to take on the appearance of angels of light.

> His only (but great and dreadful) error being, that he mistook false lying Spirits for Angels of Light, the Divel of Hell (as we commonly term him) for the God of Heaven.[17]

Casaubon was dismissive of Dee's alchemy, suggesting that it was the Devil's handiwork.

> That which we call ordinarily, and most understand by it, The Phylosophers Stone, is certainly a meer cheat, the first author and inventor whereof was no other then the Divel.[18]

Casaubon's attack on Dee is, at first sight, puzzling. Why devote so much time and energy to publishing a condemnation of Dee in 1659? Dee had died fifty years earlier. The explanation seems to be that Casaubon was using his hostile assessment of Dee's work as an oblique way of criticising the views of some of his contemporaries.[19]

For Casaubon, Dee's spirit magic was misguided but authentic; Dee genuinely contacted spirits, but they were in fact evil spirits. The story of Dee was useful, therefore, because it proved that the spirit world existed, and served a similar function to the case studies of authentic demonic action promoted by More and Boyle in their conflict with Hobbes and his followers. By attacking Dee, Casaubon was also seeking to undermine the legitimacy of contemporary astrologers and their advocates, such as Ashmole.

More's *Explanation* went further than Casaubon's work in seeking to destroy systematically any claims that astrology was credible. He did not mention specific astrologers but, as the leading astrologer of his generation, Lilly was clearly a target. More lambasted 'the extreme folly and frivolousness of the pretended Art of Astrology'. His critique began with an attempt to demolish the claims of astrologers on up-to-date scientific grounds. A modern understanding of the solar system rendered ideas about planetary influence ridiculous. Astrologers were using the old cosmology of Ptolemy that had been destroyed by the Copernican revolution.

> The best jest of all is, that there is no such Zodiack in Heaven … For this Heaven and this Zodiack we speak of is only an old errour of Ptolemie's and his followers, who not understanding the true System of the world, and the motion of the Earth.[20]

Claims for the 'science' of astrology seemed absurd to More. So why did astrology sometimes seem to work? More's answer was simple: astrologers obtained assistance from evil spirits. Having savaged the ideas of Lilly and his followers on scientific grounds, More attacked them for practising a form of witchcraft and deriving their insights about the future from their partnership with the Devil. He suggested that astrologers were either cheats or witches, assisted in their work by 'vagrant Daemons of the Air'.[21]

More saw astrological practice as a continuation of ancient, pagan Devil worship. Any possible efficacy of astrology could only be explained in terms of assistance obtained from demons. He described the delight that demons probably experienced when they saw humans 'debased and intangled in so vile and wretched a mystery'. People dabbling in astrology risked losing their soul to the Devil. Accessing demonic forces through astrology would potentially create an implicit

contract between a human and the Devil. If astrological predictions proved correct this was, almost certainly, because the Devil had used his infernal powers to predict the future on behalf of the astrologer. As a result, one should be particularly suspicious of successful astrologers: 'By how much accurater their Predictions are, by so much the more cause of suspicion.'[22]

More emphasised that participating in astrology was unimaginably dangerous. For reasons that were not fully understood, merely asking a question of the future through astrology could give evil spirits legal rights over a human soul.

> For it is not unreasonable to think that by certain Laws of the great Polity of the Invisible World they gain a right against a man without explicit contract, if he be but once so rash as to tamper with the Mysteries of the Dark Kingdome, or to practise in them, or any way to make use of them.[23]

In 1676, More's disciple Joseph Glanvill joined in the clerical assault on elite astrology of the type endorsed by Ashmole and Aubrey. In his *Essays on several important subjects*, Glanvill characterised astrologers, both ancient and modern, as magicians and witches. For Glanvill, astrology was highly dangerous because it was a stepping stone towards diabolical black magic. The self-styled 'mystical students' of astrology were at best naïve, not realising the moral peril involved in astrology. It was a small step from astrology to full-blown witchcraft.

> Now those Mystical Students may in their first addresses to this Science, have no other design, but the satisfaction of their curiosity to know remote and hidden things; yet that in the progress being not satisfied within the bounds of their Art, doth many times tempt the curious Inquirer to use worse means of Information ... So that I look on Judicial Astrology as a fair Introduction to Sorcery and Witchcraft.[24]

Glanvill's observations were an attack on the strongly held beliefs of his fellow Society members Elias Ashmole and John Aubrey. Glanvill reflected that the wily Devil almost certainly used elite astrology as a means of ensnaring refined and educated people, while lower demons,

in the form of familiars, established dominion over common people. Glanvill described how the 'Ignorant and viler sort of Persons' came easily under the dominion of 'base and sordid Spirits' and then made explicit compacts with the Devil. Over-curious cultivated people were the prey of more subtle methods employed by a better class of demon, 'more Aiery and Speculative Fiends, of an higher rank and order'.[25] These refined demons used astrology and ritual magic to entice and ultimately enslave the educated.

The response of Ashmole and Aubrey

The enthusiasm of Ashmole and Aubrey for astrology was completely undiminished by the attacks of More, Casaubon and Glanvill. Indeed, Aubrey's interest in astrology and the occult *grew* after the Restoration. He admired the magic of John Dee, an admiration that was strengthened by the fact that the Elizabethan magician had been a friend of his own great-grandfather. Ashmole was also unrepentant about astrology and continued to promote the contemporary work of Lilly and the historic legacy of John Dee.

To Ashmole's astonishment and delight, previously unknown diaries by John Dee, describing his experiments with magic, were discovered in London in 1672. Ashmole obtained the diaries for himself. The discovery prompted Aubrey and Ashmole to discuss the need for an authoritative biography of Dee. In January 1673, Aubrey visited Dee's home in Mortlake, on behalf of Ashmole, and interviewed an elderly woman who remembered Dee. Ashmole followed this up with a visit of his own in August 1673.

While Aubrey was assisting Ashmole with research into the life of Dee, he was also spending substantial time in the company of his friend Henry Coley. Under the influence of Ashmole, Lilly and Coley, Aubrey became intensely interested in astrology and ritual magic, the disciplines that had been denounced as a form of black magic by Casaubon and More.

In his treatise about school education, Aubrey recommended that some boys should learn how to use crystals to foresee the future as part of their school curriculum. Throughout his adult life, Ashmole made and wore 'sigils', amulets in the form of embossed seals that were intended to harness angelic and planetary forces. Beliefs such as these were anathema to clerical commentators like Casaubon, More and Glanvill.

Aubrey and Ashmole continued with their private enthusiasm for the occult and did not react publicly to the anti-astrology onslaught of their learned clerics. However, another man with a similar view of astrology to theirs did speak up, publicly linking his defence of astrology to the reputation of Elias Ashmole. An astrologer and clergyman called John Butler, chaplain to the Anglo-Irish Duke of Ormond, attempted to rebut Henry More's assertion that astrology was a close relation to witchcraft, in a pamphlet published in 1680. The work was entitled *Hagiastrologia* and was dedicated to Elias Ashmole, who was addressed by Butler as 'My much honoured Friend'. In a dedicatory letter Butler asked Ashmole for support and protection. Butler's pamphlet directly criticised Henry More and asserted that there was a 'vast and wide' difference between 'Astrology and Sorcery'.[26]

Henry More was very unhappy about this attack and issued yet another pamphlet in 1681, denouncing Butler and reaffirming his own views about the close connection between witchcraft and astrology. He reprinted much of his 1660 treatise, adding a new commentary aimed at Butler. More was extremely abusive towards Butler, describing the other man's work as 'a flux or Diarrhoea of frothy wit and filthy language'.[27] More stuck to the position he had articulated in 1660. Many astrologers, he stated, derived their insights from witchcraft which involved 'the Confederacy of Infernal Imps, and the consulting with familiar Spirits'. Truthful astrological predictions were often the result of 'unlawful and Hellish assistances'. More had it on good authority that some astrologers used demons to conjure up images of future events. Astrology was either a worthless sham or the work of the Devil.

II

ROBERT BOYLE,
CHRISTIAN WIZARD?

Robert Boyle believed in the reality of magic and the existence of a spirit world of demons and angels. He seriously considered that he might have a calling to become a Christian magus, using ritual magic to communicate with angels. We do not know whether he ever practised angel magic but, without doubt, he was fascinated by the prospect and carefully weighed up the potential risks and benefits of using magical means to engage with the world of spirits.

Two key documents shed significant light on Boyle's interest in spirit magic. Unfortunately, neither is dated. From one source, we learn that there was a time when Boyle declined, after intense heart-searching, an invitation to use a special magical glass to communicate with spirits. The second source hints at the possibility that, at a later time, he revised his position, and decided that the moral dangers of angel magic were manageable and that there was a strong case for 'adepts', such as himself, to carry out magical operations in order to communicate with angels.

Boyle's interest in his own possible vocation as a magical practitioner needs to be put in context. As we have seen there was considerable discussion about the practice and morality of elite magic in Restoration England. Some prominent individuals, such as Elias Ashmole, considered that spirit magic was legitimate. Aubrey was also enthusiastic and recommended that crystal magic should be on the school curriculum. Other contemporaries, such as the clerical commentators More and Casaubon, denounced all attempts to invoke spirits. For them, all magic was a form of witchcraft.

Boyle was caught up in this clash of ideas. He was deeply religious and fretful about acting against God's wishes. He was mindful of the risk, highlighted by Casaubon, that by trying to contact angels one might accidentally communicate with demons. Yet, at the same time, Boyle was deeply attracted by the spirit magic tradition and the possibility of angelic assistance for human endeavour. Perhaps, he speculated, it was God's will that he should communicate with angels.

Most clerical commentators frowned upon all forms of magic, but the pious Boyle was prepared to distance himself from the clergy. In one book, *Final causes*, Boyle described clergymen as 'those Undervaluers of their own Species', meaning that they were too pessimistic about human potential. Significantly, the context for Boyle's description of the clergy as 'Undervaluers' is in the preamble to a reflection on how humans are capable of great things with assistance from angels.[1]

Boyle was intrigued by angels. He reflected, in his published works, about the interaction between humans and angels. God, he mused, had clearly created many types of angels with different functions. There was a form of celestial specialism and division of labour: 'God assigns them very differing and important Employments both in Heaven and in Earth.' For Boyle, it seemed that some angels were particularly tasked with having a protective role towards humanity, either a general responsibility or a ministry to specific groups of people. Some were instructed by God to intervene in the world to assist humanity, 'to endeavour the carrying on of Interfering designs'.[2]

The idea of protective angels, instructed by God to help people, fascinated Boyle. He saw strong scriptural support for belief in the existence of interventionist angels. Boyle highlighted the Bible story of Hagar, a slave who received angelic support at her time of need. There were other examples in scripture of whole 'companies of angels' being employed on earth to do 'good offices'. Boyle was struck by the way that the epistle of Saint Paul to the Hebrews in the New Testament described angels as 'Ministring Spirits'. Scripture seemed clear: some angels had a 'ministry' to the human race. Boyle mentioned this more than once in his work.

They are sometimes employ'd about Humane affairs, and that not onely for the welfare of Empires and Kingdomes, but to protect and rescue single Good men.[3]

The implication of these ideas, for Boyle, was clear and important. It seems that he saw no reason why he, as a good man, should not receive help from angels. At the same time, Boyle understood that any spirit magic could go disastrously wrong. Attempting to contact angels was potentially problematic; evil spirits could masquerade as angels.

In print, Boyle was, for the most part, coy about his interest in spirit magic. One rare exception can be found in *The excellency of theology*, published in 1674 but written in 1665. In this work, Boyle revealed that he personally knew several people who had undertaken illicit 'forbidden ways' of contacting spirits and had run the risk of being enslaved by demons.

> The Souls of inquisitive men are commonly so curious, to learn the Nature and Condition of Spirits, as that the over-greedy desire to discover so much as That there are other Spiritual Substances besides the Souls of Men, has prevail'd with too many to try forbidden ways of attaining satisfaction; and many have chosen rather to venture the putting themselves within the power of Daemons, than remain ignorant whether or no there are any such Beings.[4]

Boyle explained that he had heard privately from several ('divers') men who had tried forbidden magical methods.

> As I have learned by the private acknowledgments made me of such unhappy (though not unsuccessful) Attempts, by divers learned men (both of other Professions, and that of Physick,) who themselves made them in differing places, and were persons neither Timerous nor Superstitious.[5]

It seems that in the mid-1660s Boyle was discussing spirit magic with different individuals who had practical magical experience. They were 'learned'. Their experience was 'unhappy (though not unsuccessful)' indicating that, in Boyle's view, they had successfully established contact with spirits but the event had been 'unhappy', or troubling in some way.

Document 1: The Burnet Memorandum
While Boyle was, for the most part, publicly reticent about spirit magic, unpublished manuscript documents provide insights into

his thinking. In about 1680, Boyle revealed some of his personal secrets in conversation with his friend Gilbert Burnet. The notes that Burnet took following this conversation survive among the Boyle papers.[6] Boyle probably saw Burnet as his future biographer, and he shared his thoughts on some topics that mattered greatly to him. Significantly, much of the content concerns alchemy and magic, topics that fascinated Boyle. The two topics were linked in his mind. He was intrigued, it seems, by the idea that he might be able to become a Christian magus who used the alchemists' philosophical stone to communicate with angels.

Boyle told Burnet a series of stories about his close encounters with magic. One incident concerned a group of people in London who experimented with water magic, 'during one of the sea fights wee had with the Dutch'. Boyle was not present but heard about the episode from an unnamed eyewitness. The Memorandum noted that, at the time of the events, the roar of naval cannons could be heard in London. This detail probably relates to June 1667, when a Dutch naval fleet daringly attacked English ships on the Medway, just 30 miles from central London. We know from other sources, such as the diaries of Pepys and Evelyn, that there was panic in London as a result of the Dutch attack.

Burnet recounted Boyle's understanding of what occurred. At a social gathering in a London house, a pregnant woman expressed a wish to know what was going on in the naval battle that she knew was raging at the time. A wizard happened to be present. He was described as 'one being expert in the Art'. This expert offered to help the woman and organised a magical experiment, using a basin or pail of water, and making particular use of the pregnant woman's powers as a potential medium or 'scryer'. The magic worked and the pregnant woman, but no one else, was able to look at the water and see images of the Dutch and English ships in battle, and to follow the progress and outcome of the conflict.

> Tho the rest of the Company could see nothing yet she saw ships with English and Dutch colours engaging and beheld the issue of the battell.

Burnet's account suggests that this magical experiment was considered acceptable, and morally unproblematic, in the context of an upper-class

London household. No one appeared shocked by the presence of the wizard and his suggestion that magic should be used to understand better what was happening in the battle with the Dutch.

Boyle was impressed by what he had heard about this event. There is no indication that he was morally troubled by the account of the use of magic. Quite the contrary, Boyle was intrigued and wanted to know more. On hearing the tale, he decided to interview the woman to confirm the facts but, unfortunately, this was not possible because his eyewitness left England at short notice.

> The womans name was told and he Intended to have gone and asked her about [it] but he who told him of it went suddenly out of England and Mr B. had forgot her name.

This anecdote is revealing. It shows Boyle actively engaged in discussions about the efficacy of spirit magic in the 1660s. He was keen to collect and test stories such as this to ascertain the truth about magic. Boyle's working hypothesis was that this story appeared to be authentic. He was frustrated by his inability to follow up and test the veracity of the tale.

In addition to the tale of the magical viewing of the Chatham naval battle, Boyle also told Gilbert Burnet about three conversations with different 'learned' individuals about their experience with spirit magic. None of the three individuals were identified by name, but one was described as a prominent member of the Royal Society, and another as a 'foreign chemist'. These elite associates of Boyle's were interested in spirit magic and alchemy, and keen to understand the interrelationship between the topics. Both the unnamed Fellow of the Royal Society and the 'foreign chemist' told Boyle, independently of each other, that they had attempted to obtain information from demons about how to acquire the philosopher's stone. Boyle took this extremely seriously.

One story concerned strange events that had taken place in Venice. Burnet's account emphasised that his source was a wealthy gentleman, with senior Royal Society connections: 'He was a man of quality and Estate was of the Royall society and had been upon some occasion chosen President pro tempore.' Was this, perhaps, Sir Robert Moray? The description of the eyewitness as 'President pro tempore' of the Royal Society could be used to describe Moray, because he acted

as the temporary and unofficial President of the Society in its initial meetings before the first President proper was elected. We know that Moray was interested in the supernatural. He also spent the period 1655–60 in political exile on the Continent, although there is no evidence that he visited Italy in that time.

While not identifying the name of the Fellow of the Royal Society, Burnet made it clear that he was, according to Boyle, a highly reliable witness. Boyle trusted the 'gentleman' completely.

Before travelling to Venice, the 'gentleman' had been disappointed in love. Despite being spurned by the woman he loved, he had managed to obtain some of her hair by bribing her maid who took hairs from a comb. He kept the hair in a locket and took it with him on his trip to Venice. He was mortified when he lost the locket.

The 'gentleman' resorted to magic in order to try to retrieve the locket. He found a priest in the city who practised magic. The priest required an upfront payment, and then insisted that a virgin was needed to act as a spirit medium. The 'gentleman' found a nine-year old girl who was able to act as the 'scryer' or medium. The priest summoned spirits to a glass which were visible to the girl. The spirits took the form of 'pretty boys', and they showed the girl how the locket had been stolen by a servant. The 'gentleman' was completely convinced by the level of circumstantial detail obtained by the little girl. However, the servant identified as the thief had already been dismissed and had disappeared, so there was no way of getting back the stolen locket.

Although the locket was hopelessly lost, the 'gentleman' was impressed by the magical skill of the priest and the little girl. He made further use of their services, making several further visits to the priest, with the girl still acting as 'scryer'. The focus for these subsequent magical operations was alchemy. The 'gentleman' wanted insights from the spirits that would help him with the transmutation of base metal into gold. He had a recipe for making the 'philosopher's stone' and he asked the spirits to comment on the validity of the proposed method.

He came often with his Interpreter the girle who was to see for him and among things having got a processe of the Philosophers stone he brought it with him and made the Priest ask if it was a good one.

The spirits continued to take the form of the 'pretty boys'. The account makes it clear that the boys were demons and not angels. They did not cooperate with the 'gentleman'. They reacted very aggressively to questions about the philosopher's stone. When the questions were repeated, they threatened to beat the girl. The magician/priest ended the consultation, for fear that there would be terrible violence unleashed by the spirits.

> The girle said the boies lookt very angry but she saw nothing else so the question was repeated but then she said the boies lookt so on her that she was affrighted and feared they should beat her. So the Priest said he must presse it no further least the spirits should tear them to pieces.

Boyle had no doubt that this was a truthful account. He trusted completely the word of this 'gentleman', with his strong connections to the Royal Society. The anecdote concluded with an explanation that the 'gentleman's' encounter with demons 'drove him almost to madnes' and 'it raised in him a most confounding Melancholy'. He eventually recovered but was traumatised by the experience. This narrative from the Burnet Memorandum is completely consistent with Boyle's public statement that he knew 'learned' people who had privately told him about 'unhappy (though not unsuccessful) Attempts' to communicate with demons.

The learned 'gentleman' convinced Boyle that he had experienced a real encounter with demons in Venice. The Memorandum also provides another anecdote of Boyle's which indicated that he was invited personally to receive training in demonic spirit magic and that he had to think carefully about it before declining.

According to the Memorandum, Boyle's invitation to learn about magic came from an anonymous 'foreign chemist'; Boyle's use of the term 'chemist' implies that his acquaintance had an interest in alchemy as well as more conventional scientific knowledge. The 'chemist' met Boyle and offered to instruct him in the rituals of spirit magic, explaining how his own magical education had begun in France. He told Boyle the story of how, while travelling towards Charenton (today a suburb of Paris), he had met a mysterious Catholic clergyman in a tavern. They fell into conversation about the supernatural and the clergyman revealed that 'he had spirits at command and could

make them appear when he would'. The truth of this claim was then demonstrated, with apparitions of spirits summoned magically, first in the shape of terrifying wolves and later as beautiful courtesans.

Although the Burnet Memorandum does not explicitly state it, these spirits, like the 'pretty boys' in Venice, were manifestly malevolent demons and not angels. The conversation with the spirits embodied as courtesans, or high society prostitutes, turned to alchemy. The courtesan demons teased the 'chemist' about the philosopher's stone. One courtesan wrote down some instructions relating to the acquisition of the stone for him but they vanished with these notes before he could understand the insights.

> He asked them questions about the Philosophers Stone and as he thought one of them writ a paper which he read and as he thought understood but within a litle they vanished so did the paper and what was writ in it went clearly out of Memory that he could never trace it.

This experience convinced the 'chemist' of the authenticity of spirit magic and its relevance to his alchemical investigations. He told Boyle that since this chance meeting he had been on a mission to educate himself in the ways of ritual spirit magic. He had obtained a 'book of Conjuring', written in French, and used this to develop his skills in the summoning of spirits. The book was probably a so-called 'grimoire', an underground textbook of ritual magic. We know that these highly controversial works were circulating at the time in manuscript form. As we shall see, John Aubrey transcribed in its entirety one such magic textbook. The grimoires provided detailed instructions and incantations for wizards who wished to summon and control demonic spirits.

By the time the 'chemist' met Boyle he had, with the help of his book, achieved a good level of magical proficiency. He was ready to share his magical skills with Boyle. He offered to provide Boyle with guidance on the rituals necessary for the harnessing of spirit power.

With the help of the Burnet Memorandum, it is possible to reconstruct the argument that was made by the 'chemist' to Boyle as he tried to persuade him to participate in ritual demon magic. The procedures that he proposed to teach Boyle involved the summoning of evil spirits. This was permitted, he argued, but only if the invocation was not

done in association with the Devil. Good Christians could harness the extraordinary power of evil spirits if they went about it in the name of God. A 'time of fasting' was required to purify the Christian magician before engaging with demons. The right sacred vestments, 'incantations' and other rituals were required. These procedures are consistent with the magical methods recommended in grimoires of the period.

The 'chemist' saw the invocation of demons as a mechanistic form of magic; it worked automatically. If the right rules and procedures were followed, the Christian wizard could control demons without any need for a 'Compact' with the Devil.

> He thought it no sin for he said he made no Compact but did what he did by a rule like an Ordinary Receipt and if the Evill Spirits were subject to such rules eithe[r] [by] some Compact with those who had the secret first from whom it wa[s] conveyed downe, or by the lawes of the Creator he was not concerned in it.

This passage is extremely important for understanding what was being said to Boyle. The proposal was that Boyle should learn to summon and control demons or 'Evill Spirits'. The 'chemist' thought he was safe from sin because he was using second-hand, decontaminated magic. If anyone was guilty of a 'Compact' with the Devil, it was 'those who had the secret first'. Another argument was deployed: the demons would be controlled under the terms of divinely sanctioned principles, 'the lawes of the Creator'.

The 'chemist' was explaining to Boyle that the proposed demon magic was legitimate for Christians and was not witchcraft. A defining characteristic of a witch was that she had a compact with the Devil. Witches were, as a result of this contractual relationship, subject to the power of the Devil. Here, there was no compact, and the demons were controlled by God.

These were not arguments that would hold any sway at all with most orthodox theologians. Clerical writers such as Henry More and Meric Casaubon warned against the moral peril of summoning angels, let alone demons. The 'chemist' also disregarded the fact that the summoning of demons was, without doubt, illegal in seventeenth-century England. The witchcraft statute of James I, which was in force during Boyle's lifetime, explicitly condemned the summoning of evil spirits as a felony punishable by death.

Remarkably, despite the serious moral and legal problems involved, Boyle did not dismiss out of hand the invitation to participate in demonic magic. He took the offer very seriously, and sought advice from Burnet before making his final decision. He had doubts about the personal morality of the 'chemist', calling him a 'libertine'. Nevertheless, Boyle thought the man was genuine in his claims regarding his skills in spirit magic.

> Yet in these things Mr Boil saw no reason to disbeleeve him especially when he offered to satisfy him in it.

Gilbert Burnet explained in the Memorandum that he was personally consulted by Boyle about whether he should accept the offer to learn how to control evil demons. Burnet was asked by Boyle if the 'chemist' was right to suggest that there would be 'no sin' involved if a Christian wizard undertook magic with demons? Surprisingly, Burnet, who later became the Bishop of Salisbury, did not consider the issue to be clear cut. Burnet advised that the question of sinfulness was a matter of debate but urged Boyle to err on the side of caution. The proposed magic might not be sinful, but the risk to one's soul was too great. In the Memorandum, Burnet recalled his own words to Boyle expressing uncertainty but advising caution: 'I said as I could not directly say it was a sin yet it was a thing justly to be doubted of and therfore to be forborn.'

As a result of this advice from Burnet, Boyle finally decided to decline the offer of tuition in demonic spirit magic.

> He could make spirits appear and offer[ed] to satisfy Mr B by shewing him in a glasse of water strange representations, but he would not accept of it.

In addition to the 'chemist' and the Fellow of the Royal Society, Boyle discussed the practicalities of spirit magic with another learned associate. The Burnet Memorandum contains notes of a discussion that Boyle had regarding the use of a special glass to communicate with spirits.

Burnet related Boyle's reminiscences about 'another gentleman' who offered to instruct him in magic. This person brought a special magical glass to show Boyle, promising that he could teach Boyle to communicate with spirits. The 'gentleman' was obviously on very close terms with Boyle because he was able to refer to a matter of

great sensitivity: Boyle's sexuality. The 'gentleman' told Boyle that 'he did not doubt but he was a Virgin', meaning that he knew for sure that Boyle was a virgin. As a result of his status as a virgin, Boyle could be expected to be particularly proficient at seeing spirits. The magical proficiency of virgins was a commonplace idea at the time. As we have seen, during the events in Venice his informant, the Fellow of the Royal Society, was also told that a virgin would be needed to make contact with the spirits.

It seems highly unlikely that anyone other than a trusted friend could have such a conversation, relating as it did to Boyle's sexuality. Perhaps the closeness of his relationship with this unnamed 'gentleman' led Boyle to take this offer extremely seriously. Perhaps the gentleman was able to reassure Boyle that the glass would help him to communicate not with demons but with angels. Whatever the reason, Boyle felt an immensely powerful urge to try the magic. Burnet explained that Boyle told him how he inspected the magical glass very closely, and could see nothing untoward about it.

> He told me he lookt about it he saw it was an Ordinary double convexe glasse and had no angles in it by which tricks might have been put on those who lookt into it.

The language used in the Burnet Memorandum when recounting this event is quite extraordinary. Boyle told Burnet that he was overwhelmed with a wish to use the magic glass. The opportunity seemed more exciting than being offered control of an entire kingdom.

> He had the greatest Curiosity he ever felt in his life tempting him to look into it and said if a Crown had been at his feet it could not have wrought so much on him.

Despite his tremendous curiosity about the possibility of communicating with spirits, Boyle declined the opportunity. He told Burnet that he considered his decision to decline to be the single most important instance of willpower and self-control in his entire life: 'He overcame himselfe which he accounted the greatest Victory he had ever over himself.'

Boyle said 'no' to the friend who offered him a chance to communicate with angels. He had no doubt about the likely efficacy of the spirit magic; his concerns were moral. The most likely explanation

for his decision to decline was his anxiety that he might inadvertently communicate with demons, which would be deeply sinful.

Document 2: Dialogue on the Converse with Angels

Robert Boyle, like his contemporaries Elias Ashmole and John Aubrey, was greatly attracted to the idea of experimenting with magic in order to communicate with spirits. While Boyle was enthusiastic about the theory of angel magic, he was also plagued by doubts about the moral dangers of the practice. Neither Ashmole nor Aubrey, it seems, were subject to the same scruples.

The Burnet Memorandum describes how Boyle discussed contacting spirits with elite practitioners of magic, but eventually held back from active participation because of his moral concerns. Another undated source. produced probably later in Boyle's life, tells a slightly different story. A fragment of an unpublished treatise by Boyle has survived in which he comes tantalisingly close to endorsing the acceptability of practical spirit magic.[7]

Boyle constructed the treatise in the form of the script of an imagined conversation between learned companions who shared a love of philosophy. Although friends, they disagreed strongly about the wisdom of attempting to communicate with angels. In describing the disagreement, Boyle was articulating the inner conflicts he personally experienced as he wrestled with these issues. Although the document is fragmentary, in the text Boyle seems to be arguing, on balance, for the legitimacy of angel magic.

The imagined conversation centres on concerns about an absent friend, called Parisinus, who has recently become preoccupied with obtaining the philosopher's stone. He was interested not in the unworthy object of enrichment but in the possibility that the stone would enable him to make contact with angels. The friends of Parisinus disagreed as to whether his aspiration to communicate with angels was a good or bad idea. Speeches were made both for and against angel magic.

The text breaks off before the dialogue is complete, and before any resolution of the disagreement is achieved. There is, however, a summary of the arguments at the beginning of the treatise which gives some sense of the overall architecture of the treatise and the direction of travel of the debate. There are more arguments in favour of angel magic than against it and it does seem as if the treatise was

leading towards a positive conclusion about the moral acceptability of communicating with angels.

In the preamble, four arguments against angel magic were set out. They can be loosely paraphrased as follows:

1. There is a danger when communicating with angels that evil spirits will appear instead masquerading as benign angels.
2. Angel magic could be 'idolatrous' or sinful if the angels are offered worship which should only be reserved for God
3. The very existence of spirits is doubtful because many of the stories of witches and apparitions are fraudulent
4. It is not clear whether alchemical substances can definitely bring about contact between good spirits and alchemists

Boyle next proceeded to give nine reasons why contacting angels was a good idea. To some extent this list echoes the arguments against, rebutting some of the previous points and then providing further supportive points. The following list provides a loose paraphrase in modern English of the arguments in favour:

1. Some stories of witchcraft appear to be factually correct indicating that the spirit world is a reality
2. It should not be difficult for 'the Adepti' to distinguish good spirits from evil spirits
3. Angels should not be worshipped but that it is not the intention of 'the Adepti'
4. It is unlikely that the air and waters of the earth should be devoid of spirit creatures
5. Common assumptions about the number of spirits and number of types of spirit are likely to be wrong
6. There may be some sociable spirits and we know very little about how spirits are organised
7. There may be techniques for contacting spirits that we do not currently understand
8. It is wrong to assume that we cannot communicate with spirits because we cannot account for the way that methods of communication work
9. 'The Adepti' may have special privileges when it comes to contacting spirits.

The preamble looks like the synopsis of an overall argument in favour of angel magic. Arguments against are given first. These are then rebutted, and additional arguments in favour are deployed. Boyle gave many more reasons in favour of the practice of angel magic than against. The logic of the preamble, and the numerical weighting towards arguments justifying magical action, suggests that Boyle was moving towards a decision that angel magic was permitted.

Parisinus, the absent friend, appears to represent Boyle himself, as he fretted about engaging with angel magic. His close friend and spokesman, Arnobius, explained the thinking of Parisinus.

> The maine reason why Parisinus so much vallues and cultivates the study of Hermetick Phylosophy, is that he has a higher aime in it then you may suppose and hopes that the acquisition of the Philosophers-stone may be an inlett into another sort of knowledge and a step to the attainment of some intercourse with good spirits.

Having established that the absent Boyle character, Parisinus, is seriously considering using an alchemical substance to contact angels, the debate proper begins. This discussion echoes the structure of the preamble or synopsis. Arguments against contacting angels are given prominence in the early conversational exchanges and are then rebutted. A character called Timotheus is keen that Parisinus should be dissuaded from his plan to contact angels. He makes several points which relate closely to the arguments given in the synopsis. It seems unlikely that a physical substance, such as the philosopher's stone, should have the power to establish contact with incorporeal spirits. There is a danger that angel magic can degenerate into sinful idolatry through angel worship. The enterprise is dangerous because, in attempting to summon angels, one might summon a demon in the form of an angel. Timotheus emphasised that this risk could lead to a 'fatall mistake'.

> Even the divell can transforme himself into an Angel of light tis very dangerous to have, much less to procure the conversation of Angels for fear wee should by the deluding arts of spirits farr more knowing then men, be trapand into the fatall mistake of a divill for an Angell of light.

Arnobius, who is apparently close to Parisinus, does not accept these arguments. He says that Parisinus has heard this all before and is not convinced. Another character, Cornelius, chimes in and states that Parisinus will need to be given further, more convincing arguments to make him desist from his plan.

The discussion then changes direction and the enthusiasts for contacting angels take over the discussion. Arnobius reminds the group that spirits undoubtedly exist, citing the authenticity of witchcraft as proof. Here we seem to get close to Boyle's own views about witchcraft. Arnobius articulates the view of Parisinus (the Boyle character) that almost everybody rightly accepts the truth of witchcraft.

> That there are witches and magicians I presume Timotheus will not deny for besides the almost universall consent of mankind the scripture its selfe in divers places declares no less.

Cornelius adds that, even if there were no references to witchcraft in scripture, recent experience would prove the reality of demonic spirit magic.

> Our own times afford us undeniable instances of the converse of evill men with evill spirits and I my selfe know severall persons divers of them Physitians and men of parts and not superstitious but rather the contrary who have converse even in visible shapes and more then One of them against his will as themselves have complained to me.

The character called Arnobius proceeded to argue that, since it has been proven that witches can contact evil spirits, it should be entirely possible for good men to contact angels. The discussion turned towards proof of real-life instances of contact between good spirits and humans. Here, the logic was similar to that of More and Glanvill: convincing empirical evidence could verify the reality of contact between humans and spirits. One of the friends, Eleutherius, gave a detailed account of a distinguished mathematician and his encounters with the spirit world. This anecdote was, most likely, based on Boyle's own discussions with a respected associate, who had told him that he had communicated successfully with spirits. The mathematician had

been rescued from 'atheism' by learning about spirit magic. The text described how he had been recruited to the cause of 'atheism' by 'the subtilest Atheist of our times'.

The obvious candidate for such a description is Thomas Hobbes. 'The mathematician' was not English and was the subject of a foreign prince. This leads one to think that he was probably French, since Hobbes spent the whole of the 1640s in Paris, where he engaged with many French intellectuals. Eleutherius described how the 'mathematician' was mentored by another distinguished scholar, who persuaded him to turn away from atheism, drawing upon great spiritual insights derived from his participation in spirit magic. His mentor had 'conversations with good spirits' although the invocation process sometimes unintentionally liberated evil spirits, which led to 'unwellcome and uneasy' experiences.

Boyle's repeated use of the term 'adepti' is revealing. He saw himself, like the characters in his treatise, as one of the adepts, a learned elite of those seeking to master the mysteries of alchemy. Perhaps the most intriguing 'argument' is the final one in which Boyle explores the idea that 'adepti', such as he, were not subject to the usual rules that applied to others and which might cause them to shy away from the rewarding but potentially dangerous quest to communicate with angels. It is worth quoting this point in its entirety in Boyle's original prose: 'Such persons as the Adepti may well be supposed to be under a peculiar conduct and to have particular privileges.' The logic is clear. The ordinary moral rules forbidding magic may not apply to Boyle because he is one of the 'adepti'.

The Dialogue breaks off, unfinished, but with the direction of the argument established and heading towards endorsement of the legitimacy of angel magic. Parisinus, the Boyle character, is leaning towards a decision to become a practising Christian magus, engaged in angel magic.

Boyle was seriously tempted. We do not know whether he ever overcame his anxiety and participated personally in spirit magic. Elias Ashmole and John Aubrey were also interested in ritual magic and had none of the scruples that plagued Boyle. As we shall see in the next chapter, Aubrey promoted and undertook ritual angel magic, and appears to have gone even further and dabbled in black magic activities that involved using the power of demons.

I2

AUBREY'S MID-LIFE CRISIS

For over forty years, from the early 1650s onwards, John Aubrey devoted himself, with great energy and creativity, to an extraordinary range of scholarly pursuits. He was a ground-breaking researcher across an astonishing range of disciplines. Although the only book he published during his life was *Miscellanies*, his study of the supernatural, this represented only a small fraction of his written output. Aubrey also wrote, among other things, about education, geology, languages, archaeology, history, place-name study and folklore. His *Natural History of Wiltshire* contained radical ideas about geology and, by implication, the limitations of biblical accounts of the origins of the world. He made a major contribution to the development of anthropology and folklore studies with *The Remains of Gentilism*. His research transformed our understanding of those great prehistoric monuments Stonehenge and Avebury. His text on British antiquities, *Monumenta Britannica*, documented his pioneering approach to archaeology. Today, Aubrey is remembered, above all, for his great biographical work, *Brief Lives*. This collection of succinct accounts of the lives of distinguished people redefined the biographical genre with an innovative emphasis on the need for accuracy, balance and entertaining detail.

These astonishing scholarly achievements are even more impressive when one considers Aubrey's chaotic personal circumstances throughout most of his adult life. From 1652 to 1671 he was embroiled in a series of legal disputes and abortive attempts to achieve financial security through marriage. By 1671 he was ruined and was

forced for a while to go into hiding to avoid his creditors. Aubrey relied for the rest of his life on the charity of friends. From this time on he also lacked a fixed address. He stayed in various lodgings in London and as a guest in the country houses of his friends.

While Aubrey's plans for financial security were unravelling in the late 1660s, his appetite for intellectual pursuits was undiminished. In August 1667, at a time when he was embroiled in legal disputes, Aubrey met the Oxford antiquarian Anthony Wood, who shared many of Aubrey's interests in biography, history, heraldry and genealogy. Wood was working on a history of distinguished people associated with Oxford, and Aubrey soon became engaged in undertaking research for Wood. This partnership continued for the next twenty-five years and it eventually led Aubrey to write his own biographical masterpiece, *Brief Lives*.

The late 1660s and early 1670s was a time of creativity for Aubrey. It was also a period when Aubrey's preoccupation with the supernatural intensified. There was, it seems, a connection between his growing fascination with astrology and the worsening of his personal situation. He came to see the impact of invisible planetary forces as a reason why he was so unfortunate in his disastrous attempts to get married and achieve financial security. He also thought that it was likely that he had been the victim of witchcraft.

Aubrey's troubled situation in the 1660s appears to have led him to take a greater interest in the power of supernatural forces, both astrology and sorcery. In a series of astrological notes made after 1680, he highlighted the year 1666 as a personal turning point.

> 1666. This yeare all my businesses and affaires ran Kim Kam, nothing took effect, as if I had been under an evil tongue. Treacheries and Emnities in abundance against me.[1]

The phrase 'under an evil tongue' is significant; it was a euphemism for being a victim of witchcraft. Aubrey thought he had, possibly, been bewitched. In his autobiographical notes Aubrey also stated that he was convinced that from a young age he was personally prone to attack by witchcraft. At the time, the word *fascination* had as its primary meaning *witchcraft* or *enchantment*. Aubrey observed that, from childhood, he was 'mightily susceptible of Fascination'.[2]

Money matters

Aubrey's financial problems began in October 1652, when his father, Richard Aubrey, died, leaving him a portfolio of property but also substantial inherited debts, commitments to provide for his younger brothers and unresolved legal disputes. Having inherited his father's estate, Aubrey made a disastrous mistake. He decided to continue to pursue a legal claim over property in the Welsh border counties of Brecknockshire and Monmouthshire. Both father and son apparently felt that a great injustice had been done. In theory the disputed land was worth a huge amount of money, generating rents worth £1,600 a year. Aubrey claimed that the lands were his under the terms of the will of his great-grandfather William Aubrey, who died in 1595.

It seems unlikely that Aubrey ever had a realistic chance of overturning a property transfer that had taken place over fifty years earlier, but he was obsessed with the case and persevered. When he finally lost, he incurred substantial costs. In his autobiographical notes Aubrey stated that the case had cost him £1,200.[3] His mounting financial problems meant that he was obliged to sell his property in Herefordshire in the early 1660s to pay off some of his debts.

Aubrey saw marriage as a potential means of resolving his financial problems. In 1665, Aubrey began to court a wealthy Wiltshire woman called Joan Sumner. The plans went badly wrong. Their relationship turned sour, leading to litigation which appears to have precipitated Aubrey's complete financial ruin. Biographical studies have, to some extent, portrayed Aubrey as the wronged party in his dispute with Sumner. Anthony Powell described the events as the story of how Aubrey got 'into a mess' because of an unlucky encounter with 'a dangerous woman'.[4] In her 'fictionalised' biography/diary of Aubrey, Ruth Scurr suggested that Aubrey was the subject of a relentless legal campaign mounted by Joan Sumner.[5]

The suggestion that Joan Sumner was remorseless in her pursuit of John Aubrey through the courts is misleading. It was John Aubrey, not Joan Sumner, who began the costly litigation that took place between them. The plans for the marriage collapsed in the latter months of 1666, and in February 1667 Aubrey sued Sumner in the Church court in Salisbury for breach of promise. This was the first act in a sequence of legal complaints made both by Aubrey and Sumner. The subsequent sequence of events is not clear. At some

point in 1667 Joan Sumner sued Aubrey in the civil courts for debt, but it was Aubrey who struck the first blow.[6]

There seems to be no obvious reason to doubt the legitimacy of Sumner's fundamental complaint against Aubrey. The marriage contract involved her bringing property worth £2,000, which Aubrey would be able to access immediately after the marriage (although in fact Aubrey appears to have started spending Joan's money as soon as they became betrothed). Under the terms of the marriage contract, in the event of Aubrey predeceasing Joan Sumner she was offered as a dower or 'jointure' the Aubrey family farm at Easton Piercy, which would provide a home and could be expected to generate an annual income of £160. That sum would have been Joan's pension as a widow. The house at Easton would be hers for life.

She claimed that she was dismayed to discover that this offer of a jointure was effectively fraudulent because the house and farm at Easton had been used as collateral for Aubrey's debts. It was heavily mortgaged. Aubrey had borrowed the huge sum of £500 from one of his creditors, a man called John Scrope from the north Wiltshire village of Castle Combe, using the farmhouse and land at Easton as security for the loan.

Joan's version, which she explained to the court of Chancery, was that the existence of the mortgages on her jointure was not made clear to her. She was deceived by Aubrey who, at first, hid the fact that the house and farm were, in legal terms, 'encumbered'.

… this def[endan]t [Sumner] had a reall intent to marry the said Compl[ainan]t [Aubrey] if the Joynture which the said Compl[ainan]t made unto this def[endan]t had beene cleare and free from incumbrances which it was not …[7]

When Joan discovered that the property was mortgaged, she first tried to help Aubrey to pay off his debts and then thought better of it and pulled out of the proposed marriage. The facts suggest that this was an entirely reasonable course of action. She was right to be concerned about Aubrey's offer. Aubrey was in big financial trouble, and almost immediately after the wedding plans collapsed he was forced to sell the home and farm that was meant to give Sumner financial security. The correctness of her analysis is borne out by the fact that Aubrey was not only forced to sell Easton Piercy but also had to go on the run to avoid being arrested for debt by his creditors.

Several aspects of Aubrey's behaviour towards Joan Sumner seem highly questionable. She considered that he had deliberately deceived her on a matter that was vital for her long-term financial security. In addition, while Aubrey was courting Sumner, he treated her property as if it was already his own. Before the relationship had broken down Aubrey was able to get access to Joan Sumner's papers, including promissory notes resulting from loans that she had made. Aubrey took one of these bonds, worth the large amount of £200, and obtained payment from the debtor. Aubrey proceeded to keep the money, refusing to return it after the collapse of the marriage plans. Aubrey admitted to the court that this had indeed happened. His defence was that she had promised to marry him; he was still willing to get married and, as a result, the money was rightly his as her future husband.[8]

One aspect of the dispute between Aubrey and Sumner that has received no previous attention is the role of Aubrey's friend James Long, who undertook a campaign apparently intended to intimidate or punish Joan Sumner after she fell out with Aubrey. Long and Aubrey were near neighbours and great friends. As we have seen, James Long would act as an examining magistrate in the case of the Malmesbury witchcraft trial of 1672, shortly after the dispute between Aubrey and Joan Sumner.

Towards the end of 1666, at exactly the time that Sumner was disentangling herself from the proposed marriage, Long became engaged in a bitter dispute with Sumner over property rights in the north Wiltshire village of Sutton Benger where both Sumner and Long owned land. The exact sequence of events is unclear, but it seems that about the same time that Joan Sumner reneged on her promise to marry Aubrey, Long began to harass her. In February 1667 Joan Sumner complained to the court of Chancery that James Long during the previous months had illegally claimed ownership of some of her land in Sutton Benger, entering the land and chopping down a large amount of valuable timber. She claimed that she was having difficulty proving her ownership because, by some nefarious means, Long had obtained possession of her title deeds to her property in Sutton Benger.

... but by some sinister way or meanes [Long] hath gotten the sayd Deeds writeings and evidences out of yo[ur] Orators [Sumner] possession into his Custody ...[9]

How did Long obtain Joan Sumner's title deeds? The obvious explanation is that he received them from his good friend John Aubrey, who by his own admission had access to Joan Sumner's papers during the period of courtship. The men were in regular contact at this time. A letter survives from December 1667 – in the middle of the dispute – in which Long invited Aubrey to spend Christmas with him. The letter is very affectionate and Long called Aubrey 'my more then ordinary good neybour'.[10] The most plausible explanation is that Aubrey had acquired the deeds the previous summer when the marriage plans were being made and had provided them to his friend as part of a plan to intimidate or punish Joan Sumner because she had the temerity to reject Aubrey.

On 5 April 1670, Aubrey wrote to his friend Anthony Wood telling him both that he had finally concluded his lawsuit with Joan Sumner and that he was leaving his beloved Easton Piercy. The house and farm were sold. This did not suffice for Aubrey to pay his debts, however. His astrological notes for 1671 says simply: 'danger of Arrests'.[11] He was a homeless man on the run from his creditors. This was the time when Aubrey immersed himself in astrology. He fell under the influence of the astrologer Henry Coley, who almost certainly encouraged Aubrey in a range of beliefs about the supernatural including the authenticity of spirit magic of the sort promoted by John Dee.

Originally from Oxford, Coley moved to London and worked initially as a tailor. He taught himself astrology and mathematics, and in 1669 achieved celebrity status following the publication of the first edition of his guide to astrology, *Clavis astrologiae*. Coley and Aubrey met and became good friends. Coley made extensive use of mathematics in his horoscopes and Aubrey, who was a keen amateur mathematician, was impressed by his level of skill. Coley received the endorsement of Lilly and Ashmole and joined their circle of like-minded enthusiasts for astrology which included Aubrey. Coley worked on an expanded second edition of his book, which appeared in 1676. The new edition was dedicated to Ashmole and contained an enthusiastic note of approbation from Lilly. As an old man with failing health, William Lilly designated Coley as his successor. In 1675 they collaborated on the production of Lilly's annual almanac, *Merlini Anglici Ephemeris*, and they continued this collaboration for the rest of the decade. Lilly died in 1681, having granted Coley permission to continue to publish an almanac using this same title.

By August 1671, Aubrey was engaged with Coley on astrological matters. In that month Aubrey wrote to Anthony Wood telling him about Coley: a man from the city of Oxford who had written the book *Clavis Astrologiae*. Aubrey asked Wood for details of his birth so that Coley could cast an accurate horoscope. During the years 1672–74, Aubrey was a frequent visitor to Coley's London house at Baldwin's Gardens, near Gray's Inn Road. The closeness of their relationship at this time is demonstrated in the way that Aubrey, having no fixed address of his own, told his friends to write to him via Coley's address between May 1672 and August 1674.[12]

Coley helped Aubrey to make sense of the problems in his life through astrology. The astrologer analysed Aubrey's horoscope in detail and helped Aubrey to understand how his misfortunes could be entirely explained in terms of planetary influences. Coley's horoscope or 'nativity' for Aubrey survives in Aubrey's papers in the Bodleian Library. The horoscope commentary blamed his birth data for the 'superlative vexations' suffered by Aubrey relating to his plans for marriage. Aubrey had no need to take any responsibility for his troubles because the cause was planetary influence.

Aubrey probably found this analysis immensely reassuring. Although he admired Coley, he also sought out a second opinion for confirmation. Another London astrologer, John Gadbury, was consulted and came to similar conclusions about the astrological cause of Aubrey's marital misfortunes.

The influence of astrological thinking ideas at the time of crisis in the early 1670s can be seen in Aubrey's surviving correspondence. Armed with Coley's horoscope, Aubrey articulated his belief in a deterministic relationship between the configuration of the planets and human events. On 14 May 1673, Aubrey wrote to Anthony Wood. Aubrey was depressed. He explained his state of mind with reference to the influence of the planets and proceeded to put this in the context of a wider theory of how human fortune was entirely 'governed by the Planets'.

I could wish my selfe with you this moneth for 2 or 3 dayes to relaxe and revive my dull dejected spirit, which now after this Quartile Aspect of Saturn and Mars will be better about Whitsuntide; for we are governed by the Planets, as the wheeles and weightes move the Index of the Clock.[13]

It was no coincidence that, in the same letter in which the power of astrological forces was discussed, Aubrey also urged Wood to include Henry Coley's biography within a book he was writing about important people with Oxford connections. Aubrey was under Coley's spell. In his letter to Wood, he said of Coley that 'his Fame increases every day more & more'. A month later, on 17 June 1673, Aubrey wrote again to Wood using almost identical language, telling his friend to contact Coley to find out more about him and repeating that 'his Fame increases every day'.

Aubrey's admiration for Coley continued for the rest of his life. Many years after their first meeting, Aubrey considered Coley worthy to be included in *Brief Lives*. He gave a highly complimentary account of his friend, emphasising that he was remarkably erudite given that he was self-educated. Aubrey liked Coley as a man and talked about his exceptional good nature.

> He is a man of admirable parts, and more to be expected from him every day: and as good a natured man as can be. And comes by his learning meerly by the strong impulse of his genius. He understands Latin and French: yet never learned out of his grammar.[14]

Aubrey also turned to Coley for astrological insights relating to others. Such was his level of trust in Coley that he asked him to assist in one of his most important projects, his biography of Thomas Hobbes. While Hobbes was still alive Aubrey asked the philosopher for birth data so that Coley could cast an accurate horoscope. Hobbes, who thought astrology was nonsense, humoured his friend and provided the necessary information and Coley duly produced the horoscope.

Aubrey's admiration of Coley was not shared by everyone. Anthony Wood was unwilling to provide space for biographical information about Coley in his study of Oxford luminaries. As we shall see, Coley was attacked as someone who dabbled in witchcraft.

Aubrey and the angel magic of Henry Coley

During the early 1670s, Aubrey saw Coley at work and believed completely in the authenticity of the man's astrology. At the time, attacks on astrologers such as Lilly and Coley, denouncing them as either charlatans or sorcerers, were commonplace. In 1673,

for example, an anonymous pamphlet, *The character of a quack-astrologer*, suggested that astrologers were people who 'dabbled' dangerously on the edges of sorcery. Astrologers were essentially witches who lacked the courage to make a personal compact with the Devil, dealing instead with the Devil through indirect means.

> One that hath heard o' th' Black Art, and his fingers Itch to be dabbling in't, but wanting Courage to meet the Divel at a personal Treaty, chuses to deal with him obliquely.[15]

The character of a quack-astrologer described how customers or 'querents' of astrologers were overawed by the apparent occult knowledge of the expert practitioner who hinted at his association with demons: 'His prime task is to Con hard words, with which he startles his trembling Querents, who take them for names of his confederate Daemons, Asmodeus and Mefaustophilus.'

Aubrey spent considerable time in the 1670s at Henry Coley's house in Baldwin Gardens, where Coley conducted his astrology practice. He knew that, for a fee, Coley provided his customers with sigils, as well as horoscopes. Sigils were talismans – ideally made from stamped metal, though cheaper ones were made from paper – that sought to ensure good fortune by harnessing the power of angels.

In 1698, a year after the death of his friend John Aubrey, Coley was subject to a fierce attack in print for his practice of selling magical sigils. John Partridge, an astrologer who wanted to develop a new more scientific astrology, strongly disapproved of the way that Coley sold these superstitious talismans. Partridge accused Coley, and other sigil makers, of witchcraft. In a highly critical way, he listed some of the problems for which sigils were prescribed, such as winning fortune in love, avoiding pregnancy and ensuring marital fidelity.

> A Crew of Villains ... make and give Sigils and Charms to procure unlawful Love. To keep Maids from being got with Child. To keep Men and their Misses, and Ladies and their Gallants from parting. To make Men fortunate at Gaming. To make Men unable to enjoy other Women than their Misses. To make Men and Women fortunate in getting great Fortunes in Marriage. To make Women Barren or Fruitful, as they desire.[16]

Partridge gave details of the sigils available from Coley for different purposes and different prices. He provided an illustration of one of the charms, costing the large sum of 2 guineas. It was made not of metal but paper mounted on pasteboard. Partridge ridiculed the way that Coley packed such charms with geometrical elements: arcs, semi-diameters, sines, tangents and secants. The reverse of the sigil carried the name of the angel Raphael, indicating that the charm was linked to some form of angel magic. Partridge sarcastically recommended people needing worthless charms of this nature to go to Coley's house at Baldwin's Gardens, the same house where Aubrey had spent much time when visiting his friend. One charm, intended to ensure the faithfulness of a lover, cost as much as 6 guineas.

> Ladies and Gentlemen, you that are desirous of these ingenious Deceipts ... pray repair to Baldwin's Gardens, and there you may be furnish'd. One to keep your Gallants true to you, is six Guineas. One to keep you from being got with Child, two Guineas. One for Gaming, ten Shillings. One to make you fortunate in Play any one day, half a Crown. According to your Pocket, so your Price.[17]

This indictment of Coley concluded with a suggestion that disappointed customers of Coley's should threaten him, and other makers of sigils, with prosecution for witchcraft under the statute of King James I, unless he gave back the fees he charged: 'Let this Course be taken and you will soon spoil their Trade, and perhaps you may get Money by it too.'

There is no doubt that Coley offered sigils for sale and that the potency of the sigils was meant to be based on harnessing the power of angels. How far beyond this did Coley go? Did he use unlawful forms of ritual magic? There is undeniable evidence from John Aubrey that Coley was indeed practising illegal magic on behalf of his clients as early as the 1670s, when Aubrey was a frequent visitor to his home.

In the Bodleian Library is a manuscript of charms and incantations that was compiled from different sources by John Aubrey in the 1670s. One source is described as 'Henry Coleys Long Manuscript', which Aubrey describes as being like a 'shoppe booke' – in other words, a catalogue of products. Presumably, Aubrey came across the manuscript during one of his many visits to Coley's house in London.

Aubrey copied just one item from the magical catalogue, but this single short extract is explosive because it confirms that Coley was indeed engaged in illicit magic.[18]

The entry in question is the design for a magical sigil with an accompanying magic potion intended to enhance the power of the sigil. The purpose of the magic was to harness the influence of the planet Venus, almost certainly to induce a woman to accept the advances of any man who bought the sigil. The magical talisman was to be used in conjunction with a 'love potion'. For the full effect of the magic, the woman who was the target for the magic needed to be persuaded to drink the potion and smell its strong vapours. The amulet was to be engraved in tin, copper or brass.

The sigil was intended to invoke assistance for the wearer from an angel called Aniel or Anael, the special protective angel of Venus, planet of love. The word 'Venus' is very prominently displayed at the centre of the design of the sigil. The accompanying text explains the precise astrological time when the sigil should be manufactured. In keeping with the principles of ritual magic, the sigil should be made in a clean place when the skies were clear.

The magic potion was created by making a mixed paste from oil of mastic, clove, cinnamon and myrrh in a base of oats. The mixture was soaked in red wine. The paste was pressed on to the sigil to receive the engraved image, making 'a softe maske in the manner of wax'. This should be done on Friday, the day of Venus, at a special time dedicated to Venus. The person seeking the help of Venus needed to pray to the angel, asking for whatever specific assistance was sought in matters of love, 'with oration apt to thy Petition'. The charm is given in a highly truncated form but it seems that powder from the magical 'cake' was to be placed in a woman's drink, presumably without her knowledge, 'to drinke in the day and hour of Venus in the place where shee may smell it'. Coley was convinced of the efficacy of this magic. Aubrey copied his friend's optimistic words, 'great are the virtues of this sigil'.

Aubrey transcribed the name of the angel of Venus carelessly and incorrectly as 'Ariel'. There is no doubt that this was an error on Aubrey's part and that Coley's sigil was intended to work by summoning the power of Aniel or Anael. It was standard astrological theory at the time that there was a protective angel for each of the seven astrological 'planets' (the five classical wandering planets plus

the Moon and the Sun) and that the angel of Venus was called Aniel or Anael.

This 'love' magic would have been seen by many contemporaries as an act of witchcraft. There is no evidence, however, that Aubrey had any qualms about the morality or the legality of the charm. There is also nothing to indicate that he had any doubts about the likely effectiveness of the magic. Aubrey respected and promoted the astrological work of Coley, including, presumably, this use of spirit magic.

If challenged, Coley would probably have defended the 'love' magic by emphasising that the sigil and potion sought to enlist the support of an angel, a good spirit, rather than unleash demonic forces. Commentators such as More and Casaubon said that the distinction between good and bad spirits was spurious theologically and highly dangerous. It was possible, they said, for evil spirits to masquerade as angels. Demons were highly skilled but disgraced and 'fallen' angels, and were perfectly capable of duping humans who engaged in magic.

Spending substantial time with Coley in Baldwin Gardens during the 1670s, Aubrey saw at close range the work of an astrologer and magician. As we shall see in the next chapter, there is compelling evidence that, influenced by Coley, Aubrey also practised magic at this time. Aubrey was particularly interested in forms of 'love magic' intended to force women to have sex against their wishes.

13

THE WITCHCRAFT OF
JOHN AUBREY

Aubrey moved in circles where magic was practised. While Robert Boyle was tortured by scruples, Aubrey's friends Elias Ashmole and Henry Coley had no apparent qualms and both engaged in spirit magic. It seems that Aubrey was also an active magician.

In *Miscellanies* Aubrey published several pages of enthusiastic commentary on ritual spirit magic using crystal balls to summon spirits.[1] He clearly believed in the efficacy of this kind of magic. Aubrey also made explicit his endorsement of crystal magic in his unpublished treatise *Idea of an education*, which set out his ideas about school education. In the context of a broadly enlightened educational prospectus, Aubrey suggested that schoolboys should learn about foretelling the future using crystal balls, and those with a predisposition to 'scrying' should be taught how to communicate with the spirit world: 'Also let those (or the most innocent and Angelicall vertuouse youths) looke into Berills, or Cristalls.'[2]

In public, and in most of his private correspondence, Aubrey kept quiet about his personal life and his interest in 'love' magic. In *Miscellanies*, conscious that some critics saw crystal magic as a form of witchcraft, Aubrey presented his published insights in a way that emphasised the Christian orthodoxy of the procedures he described. He began his account of the use of crystal ball magic by attempting to locate the work of modern magicians who used crystals within a Biblical tradition. He briefly referenced contemporary academic writers who were interested in whether mysterious objects called

'Urim and Thummim', mentioned in the Book of Exodus, were precious stones that allowed the Israelite high priest to communicate with angels. He alluded to an epic poem by Abraham Cowley about the Biblical King David, suggesting that the tradition of using youths to mediate with angels could be traced back to the time of Biblical prophecy.

Aubrey gave a very full account of the angel magic practised by an astrologer and clergyman called Richard Napier. The choice of Napier was significant. Aubrey portrayed Napier as a man of God, a saintly figure who could not possibly be associated with the world of evil spirits. Aubrey's Napier was a Christian paragon, 'a Person of great Abstinence, Innocence, and Piety' who 'spent every day two Hours in Family Prayer'. His knees 'were horny with frequent Praying'. The message was clear: Napier manifestly derived his astrological predictions from angel magic and not diabolical sources.

Napier's key contact in the spirit world was the eminently benign Archangel Raphael. Many of Napier's clients were looking for help with medical conditions. Raphael gave him sound advice on the medical problems of his clients, instructing Napier as to whether each patient was curable. The archangel would help with other matters. Aubrey explained how Napier correctly predicted the birth of a Cheshire gentleman called George Booth, who later played a leading part in the Restoration of Charles II. This story proved beyond any doubt to Aubrey that Napier was genuinely guided by an angel in his predictions: 'It is impossible, that the Prediction of Sir George Booth's Birth, could be found any other way, but by Angelical Revelation.'[3]

Aubrey devoted a chapter of *Miscellanies* to the use of the crystal ball as a means of summoning angels. The centrepiece of the chapter was an illustration of an elaborate ritual crystal, decorated with the names of four angels and topped with a cross. Aubrey explained that this was one the treasures held by Sir Edward Harley in a special chamber at his country house at Brampton Bryan in Herefordshire. The crystal was one of great power. Aubrey recounted how it had been used successfully by both a clergyman and a miller from Norfolk. They were able to summon angels who provided medical guidance and recommended infallible cures.

In Aubrey's story of the Brampton Bryan crystal ball, there is, once again, a subtext regarding the Christian orthodoxy of this form of magic. Edward Harley was still alive at the time of the publication

of *Miscellanies*. He was well known and had a reputation as being a particularly serious and pious individual. Leading Nonconformist writer Richard Baxter described him as 'a sober and truly religious Man, the worthy Son of a most pious Father'.[4] Harley could not possibly be suspected as someone who favoured demon magic.

Aubrey's basic theory of spirit magic was essentially identical to that of John Dee. Beyond the material world of people and animals there was, Aubrey suggested, a very populous 'intellectual world' of invisible, immaterial good and bad spirits. These spirits could be contacted using ritual magic involving invocations, termed 'calls', and the magical power of crystals. Aubrey suggested that beryl was a particularly powerful magical crystal for summoning spirits. Spirit communication, using crystals, was best mediated by virtuous young boys or girls.

In keeping with the traditions of ritual magic, Aubrey mentioned the role that the use of incense could play in ensuring either that angels or demons could be enticed to appear before humans. Despite their immaterial nature, it seemed that both angels and demons found certain smells compelling.

> Good Spirits are delighted and allured by sweet Perfumes, as rich Gums, Frankincense, &c. Salt, &c. which was the reason that the Priests of the Gentiles, and also the Christians used them in their Temples, and Sacrifices: And on the contrary, Evil Spirits are pleased and allured and called up by Suffumigations of Henbane, &c. stinking Smells, &c. which the Witches do use in their Conjuration.[5]

Here, Aubrey lets the cat out of the bag. Crystal magic, invocations and incense were not exclusively about summoning angels; they were also techniques that 'the Witches do use in their Conjuration'. Crystals could be used to summon demons as well as angels. We know from another source that this was a topic of great interest to Aubrey.

Aubrey's magical notebook

In the Bodleian Library at Oxford University there is a curious manuscript in the handwriting of John Aubrey, catalogued as 'MS Aubrey 24'.[6] It sheds some intriguing light on Aubrey's interest in magic and suggests that Aubrey personally undertook

magical activities that would have been considered by some of his contemporaries as witchcraft. MS Aubrey 24 is a notebook of 105 sheets. The sheets are written on both sides, so that the notebook is in total over 200 pages in length. The first item, constituting 80 per cent of the total, is a textbook of ritual magic called '*Zecorbeni sive Claviculae Salomonis libri iv*', which can be translated as 'Zecorbeni or the Little Key of Solomon in four books'. The significance of the word 'Zecorbeni' is not clear.

In a note at the beginning of the text Aubrey indicated that he had transcribed the long magical treatise, *Zecorbeni*, in 1674 from an Italian manuscript. The precise source that Aubrey so carefully copied has never been identified but the text does survive in other manuscript versions, including several held today in the British Library. It must have taken Aubrey many hours to copy out the entirety of the lengthy manuscript, which occupies over 160 pages in MS Aubrey 24.

Zecorbeni, which Aubrey so meticulously transcribed, is a black magic textbook. It is a manual for those interested in summoning, controlling and deploying demons for magical purposes, including harming others and inducing people to be compliant in 'love' against their wishes. The manuscript is one of several surviving copies of a text that is generally known as *The Key of Solomon*. It was not published at the time because the contents were so scandalous.

The intended reader was a trainee wizard, interested in learning the techniques involved in the difficult business of summoning and controlling evil spirits. The authorship is a mystery. The treatise purported to be the work of King Solomon, the Biblical ruler who was thought to have mastered many of the secrets of nature. In fact, experts consider that texts of this kind, so-called 'grimoires', were first written in the late medieval period and were linked to the Jewish Cabbalistic tradition.

The theory and theology of the manipulation of the spirit world underpinning *Zecorbeni* was complex, involving not only controlling demons but also obtaining permission from God for the magic. Although the object of the exercise was to summon and command demons, the magician was advised to do this not in the name of the Devil but through the power of various names of God.

The manuscript describes the need to prepare for the engagement with demons through a process of purification. In the nine days before a conjuration of the spirits, the 'master' and any 'disciples'

should abstain from sex. They should then fast during the three days immediately before the 'experiment'.

The wizard was assumed to have at least one assistant or 'disciple'. Assistants had the responsibility for the equipment needed for spells, which included ritual swords and the foul-smelling incense that demons found attractive. Aubrey's transcript includes designs for the ritual swords, which he had carefully copied from his original. He also copied out many designs for so-called 'pentacles'. These were five-pointed talismans, drawn on virgin parchment in bats' blood, and intended to be used by the wizard when summoning spirits. The pentacles supposedly had the power to force demons to obey the presiding wizard.

In addition to the pentacle designs, the text also provided the words, in Latin, of a series of conjurations of spirits. They were to be used within a marked ritual circle. The manuscript gives generic conjurations and more specialist invocations for specific forms of magic. One conjuration was intended to grant the wizard invisibility, a skill which was of great interest to Aubrey. Different demons were instructed to help. One demon, called Alniras, played a leading part in the magic and was described in the manuscript as 'the master of invisibility'. The incantation required Alniras and his companions to provide invisibility at whatever time suited the magus.

Perhaps Aubrey was attracted to the *Zecorbeni* manuscript because of the prominence of 'love' magic within the text. Many of the pentacles and conjurations were concerned with inducing sexual compliance through magic. Several of the designs of the pentacles of Venus, carefully copied out by Aubrey, were intended to help the sex life of the aspirant wizard or his clients. One pentacle of Venus, for example, had the power to force a desired person to appear at the house of the magician. It was said to be of great power because it compelled the spirits of Venus to obey. Another pentacle of Venus could be used to induce sexual desire in targeted people.

In addition to the 'love' pentacles, Aubrey's *Zecorbeni* contains several more detailed descriptions of 'love' spells, intended to use the power of demons to turn a desired person into a compliant lover. In one 'experiment' incantations were performed, spirits were summoned, and a wax 'image' was 'consecrated' and then buried at a crossroads. The predicted result was the complete infatuation of a targeted woman. Another procedure used fruit as the magical

medium. The wizard was advised to choose a particularly beautiful fruit. An incantation was given that sought to use the power of 'all demons of the infernal abyss'. The wizard needed to persuade his victim to eat or at least touch the fruit. She would then be inflamed with desire and unable to rest until she had fulfilled the desires of the wizard. An alternative 'experiment' enabled the wizard to have a dream during which he had sex with the person he desired.

In yet another 'love' spell, the trainee wizard was given power over a large group of named, specialist demons, skilled in helping those looking for sex and capable of infusing wax 'images' with 'love' magic. The text describes these demons as 'ministers of love and fornication'. Four demon kings could also be summoned to reinforce the demonic 'love' magic: Oriens, Paymon, Egym and Amaymon. With their assistance, a targeted woman would be forced to present herself at the house of the wizard.

The most sinister sections of the text provided the wizard with advice on how demon magic could be used malevolently to hurt and kill others. Some of the talismans are introduced in the text as 'the pentacles of destruction and death'. One pentacle of Saturn is recommended for bringing about 'ruin, destruction, and death'. The reader was informed that spells should only be used on days that were suitable in terms of the dominant planetary forces. Particularly malevolent spells should be reserved for either Saturday, the day of Saturn, or Tuesday, when Mars was dominant. The text unambiguously described how the magician would need to choose such days if considering 'experiments' intended to cause the death of others.

Bringing about the physical harm of enemies involved both the choice of appropriate pentacles and the correct ritual use of a wax 'image'. The 'image' was first 'suffumigated' with incense. An invocation was said by the wizard, summoning a series of named demons including spirits called Dilapidator, Tentator, Somniator, and Seductor. The demons were ordered to infuse the wax with malevolent power. Once the 'image' had been 'consecrated' in this way it was buried, its evil potency further enhanced with another application of foul-smelling incense.

This is black magic. While the published spirit magic of *Miscellanies* was concerned with enlisting help from angels for good, the private black magic of *Zecorbeni* instructs the user on ways of using the

power of demons to persuade people to have sex against their will or to harm enemies.

Aubrey meticulously transcribed *Zecorbeni* without any comment, so it is difficult to understand his view of the black magic it contains. The final section of Aubrey's magic notebook in the Bodleian is different. This is a collection of many shorter charms and ritual magic incantations. It reads like the manual of a practising 'cunning man' or 'cunning woman'. Aubrey, it seems, saw his collection of spells as a guide to practical magic. His documentation of the spells concluded often with the words '*probatum est*', meaning 'proven [to work]'. On one occasion he wrote an equivalent statement in English: 'This hath bin often proved.' This was not a folklore investigation; Aubrey was interested in whether the magic he described had potency and could be used in action. It seems highly likely that he personally tried these spells, including those which enlisted the power of demons.

The purposes of the magic in Aubrey's collection of shorter spells were diverse but there was a preponderance of so-called 'love' charms. The aim of these spells was to allow the magician to alter the attitude of a woman towards a man who desired her, persuading her to have sex against her wishes. These spells were undoubtedly illegal at the time that Aubrey wrote them out. They also strike a modern reader as being exceedingly unpleasant.

Some of the charms involved placing a 'love' potion in a woman's drink. One such spell was described by Aubrey as being intended 'To obtaine the love of a woman'. It required the wizard first to cut open a turtle dove and cut out the heart 'all bloudy out of her belly'. The heart should be roasted, ground into a powder, and then slipped into the drink of the target woman: 'Give it her to drinke in Ale.'

Another charm also depended upon the fixing of a woman's drink. Aubrey described this as 'An experiment of love'. 'Powder of valeria' should be placed in the drink of the targeted woman, without her knowledge. In modern parlance. her drink was being spiked. The active ingredient, 'powder of valeria', was valerian, a herb which has a well-known sedative quality. Aubrey's notebook described how a man could take advantage of a woman once she had imbibed the drink: 'Let her drinke thereof and afterwards talke at her and she shall be very loving to thee.'

In describing yet another 'love' charm, Aubrey noted how a special magic symbol could be used to obtain 'love'. For the magic

to be effective a 'figure' or 'character' needed to be drawn on virgin parchment, using the blood of bats, and then carried in one's left hand and revealed only when one met the targeted woman. The result would be a compliant sexual partner: 'She will come to you that you may have your pleasure of her.' For Aubrey, this sex magic was powerful and potentially dangerous. Care needed to be taken not to show the charm when encountering anyone else. People accidentally exposed to the magic could be harmed or even killed: 'Take heed that you show it not to any but to her whom you desire, for if you doe the one will be mad & dye.' Aubrey recommended that this particularly potent 'love' charm should be first tried out on animals to test its effectiveness.

One of the crudest, and most bizarre, of Aubrey's 'love' charms began with the purchase of a mirror or 'looking glass' at a market. It was necessary to find two dogs coupling and place the mirror in contact with the dogs during the act. It was then necessary to arrange that the targeted woman should look into the mirror. The result would be that 'She will be constrained to love you'. This was one of many spells to, which Aubrey added the words, '*Probatum Est*'.

There is no indication at all that Aubrey considered these charms to be morally problematic; his only comments relate to whether the charms worked.

While several of the 'love' charms appear to be based on the harnessing of occult but natural forces, one charm is undoubtedly a form of black magic, deriving its potency from the action of demons. Aubrey entitled it 'A charme to make your Girle appeare'. It was intended to force a woman to appear at the house of a man who desired her and wanted her to be his 'girl'. The clear implication is that the bewitched woman would appear and willingly participate in sex with a man who has used the charm. The magic depends upon summoning three named demonic spirits, including Beelzebub.

The first instruction is that any man using the magic needed to get some money that a prostitute had been paid, for selling sex on a Sunday: 'Take money obtained for drudgery from a Harlot on a Sunday.' In this instance, 'drudgery' meant the demeaning work of the 'Harlot' or prostitute. The money was polluted because of its association with an act of gross immorality. It was the Devil's money. The level of pollution was presumably heightened because the prostitution had taken place on the holy day of Sunday.

Using this tainted money, the wizard was advised to buy wax and use it to make three candles. He was required, somehow, to have previously obtained three hairs from the woman he desired. Each hair was to be wrapped around one of the candles, and on each candle the name of a demon was to be written. The 'name of her whom you desire' was also written on each candle. The man undertaking the magic then went to his bedroom with the candles and lit each of them in turn. He waited until they had burnt out. After the ritual was complete, the man should simply wait for the arrival of the bewitched woman: 'She will presently come to her name and knock at the door then signe yourself with the Crosse and let her in, she will be of a cheerful mind and countenance.'

The operation is manifestly diabolical. The power of evil demons is being harnessed in order to force a woman to have sex against her real wishes. Aubrey's spell provides a very thin coating of Christian respectability by advising the man to make the sign of the Cross before letting her in to his house and bedroom. Even this would have appeared highly suspect to many contemporaries, who associated Catholic ritual with witchcraft.

There is no evidence that Aubrey disapproved of the idea of bewitching a woman in this way through the power of demons. He concluded his account of the spell in an entirely positive way with a statement suggesting that he believed in the efficacy of this particular charm, and a suggestion that he may have used it himself; this is the spell that bore the English label 'This hath bin often proved'.

These 'love' charms were undoubtedly illegal at the time that Aubrey wrote them out and perhaps even used them. The witchcraft statute of James I, which was in force at the time, explicitly condemned the summoning of evil spirits as a felony punishable by death:

> If any person or persons ... shall use, practise, or exercise any invocation or conjuration of any evil and wicked spirit: or shall consult, covenant with, entertaine, imploy, feed, or reward any evil and wicked spirit ... being of the said offences duly and lawfully Convicted and Attainted, shall suffer paines of death as a Felon or Felons.[7]

To modern eyes Aubrey seems guilty of a remarkable double standard. He and his associates condoned the prosecution and execution of

poor women for witchcraft while he was personally practising a form of illegal black magic.

Aubrey's later years

The sources examined in this chapter indicate that in the early 1670s Aubrey became particularly interested in 'love' magic: spells intended to force women to have sex against their wishes. The evidence indicates that Aubrey used these spells at this time. We know nothing about his intended targets; hard facts relating to Aubrey's relationships with women are difficult to ascertain after the failure of his courtship of Joan Sumner in the late 1660s. Aubrey's subsequent personal life is a mystery. Surviving sources provide some fragmentary clues. In May 1678, the clergyman and Fellow of the Royal Society Thomas Pigot described in a letter how he had spent a pleasant time in Oxford with 'Mr Aubery and his Lady'; Pigot said nothing about the woman's identity.[8] A year later, in June 1679, Aubrey wrote to Anthony Wood and mentioned in passing that he was on extremely good terms with a woman called Theodosia Ivie.

My faire Lady Thodos[ia] Ivy is my most intimate Shee-friend ...[9]

Theodosia Ivie was a notorious and controversial figure. Her husband, Sir Thomas Ivie, had denounced her for her infidelities in a pamphlet he published at his own expense in 1654. Among many other accusations Thomas accused Theodosia of trying to kill him through sorcery. Extraordinarily, the couple were eventually reconciled but by 1679 Theodosia was widowed and had remarried. She remained controversial and was constantly in the law courts because of accusations of sharp practice in the management of her property portfolio in east London. It is not clear whether Aubrey and Lady Theodosia were lovers. Theodosia came close to being hanged for fraud through forgery in 1687.

Aubrey died in 1697. His final years were troubled in many ways. He had a painful dispute with Anthony Wood, his friend and collaborator in biographical studies. He also argued with his brother, William, about the leasehold to the property in Chalke, in south Wiltshire. Despite these distractions, and his constant financial difficulties, he remained active as a scholar and researcher. His interest in the supernatural was undiminished. In 1694 he was engaged in

an investigation into 'second sight', the ability to foresee the future, supposedly possessed by some people in more remote parts of the Scottish Highlands. Aubrey corresponded with experts in Scotland who were able to provide him with information about this form of supernatural premonition, which he considered to be possibly authentic.

In 1696 Aubrey published his book about the supernatural, *Miscellanies*, and in doing so he affirmed that, at this late stage in his life, he remained firmly convinced about the reality of supernatural forces including witchcraft and spirit magic of the sort that he had been practising twenty years earlier at the time of the production of the manuscript about black magic that is now in the Bodleian Library.

Conclusion

BLINDED BY SCIENCE

In the 1680s Aubrey finalised the text of his *Natural History of Wiltshire*. In this he included remarks about James Long's intention to write a book about the trial of witches in Malmesbury in the previous decade. Aubrey stated that seven or eight old women had been hanged in this case. Other sources, including Long's own memoir of the events in Malmesbury, show conclusively that only two women were hanged. Aubrey did get one curious detail quite correct, however. He recalled that the witches had been accused of harming the horses of Henry Dennyng, a former alderman or mayor of the borough. Aubrey remembered the strange death of a gentleman's horses but completely forgot the rate of deaths among poor local women. The obvious explanation for this forgetfulness is that he simply took very little interest in the lives and deaths of marginalised elderly women who were accused of witchcraft.

Aubrey was not alone in his apparent indifference to the lives of the 'witches'. Elias Ashmole had little sympathy for disadvantaged women. There was, for him, an enormous difference between the cultivated male world of elite magic and astrology and the vulgar and questionable practice of 'cunning women'. He wrote in 1652 expressing his disquiet that many uneducated people were offering astrological services, contemptuously highlighting the fact that even 'Women are of the Number' of illiterate fortune tellers.[1] In the same year it seems that he made a considerable effort, motivated purely by curiosity, to attend the execution of a large group of women convicted of witchcraft.

Ashmole kept a diary. His entry for 2 August 1652 relates to a major witchcraft trial held at the Kent town of Maidstone: 'I went to Maidstone Assizes to hear the witches tried, and took Mr. Tradescant with me.'[2] Ashmole called the women 'the witches'. He had little doubt about their guilt. His travelling companion was John Tradescant the Younger, the collector and horticultural expert.

The outcome of the Maidstone trial was exceptional. It led to the execution of six women, the highest death rate for any witchcraft trial ever held in Kent. Ashmole's diary entry is misleading, however. He clearly implies that he went to hear for himself the testimony at the trial but that is not the case. The trial had concluded three days earlier on 30 July, when the six women were condemned to death. Word soon got back to London. Ashmole and Tradescant went not to hear the evidence but to see the executions. Why did Ashmole make his misleading diary entry? Perhaps he was a little embarrassed by his outing, which was, it seems, motivated by the entertainment value of six women being put to death for witchcraft.

Within the scientific literature of witchcraft there is a consistent lack of interest in the lives of those accused of being witches. The writers either ignored the suspects as individuals with distinct personalities or were openly contemptuous of them and their social background.

Henry More, in particular, seemed to have a visceral loathing of the women he called 'hags'. These women troubled him. As a young Cambridge academic in the 1640s More wrote 'philosophical' poems in which he made frequent reference to 'hags', making it clear how physically repulsive he considered them. He described the 'Foul tarry spittle tumbling with their tongue on their raw lether lips'. The image of the impoverished witch suckling her demonic familiar seems to have unsettled him. He told readers how foul fiends 'oft suck and nestle in their loathsome rags'. The breasts of witches were imagined as 'abhorred dugs by devils sucken dry'. The poems reveal a deep unease and marked antipathy towards women.

Other experts on the science of witchcraft routinely denigrated women. More's followers Henry Hallyday and Cotton Mather both echoed his misogynistic language. They described witches as 'hags' and copied More's phrase, 'loathsome rags', to describe the typical clothing of these women.

Ironically, Joseph Glanvill revealed his contempt for women in his correspondence with a particularly brilliant woman, Margaret

Cavendish, Duchess of Newcastle. Glanvill wrote to Margaret in 1667 attempting to convince her of the reality of witchcraft, arguing that it was inconceivable to him that such a person as a 'silly old Woman' might be capable of skilful magic without assistance from diabolical forces. How was it possible that poor cunning-women could possess knowledge that exceeded that of university-educated men and 'virtuosi' such as the aristocratic and gentry members of the Royal Society? For Glanvill, the most likely explanation was that they were working in confederacy with evil spirits, and it was the accomplice demons that enabled these naturally dull women to achieve anything. It did not occur to Glanvill that women without much formal education might be highly intelligent and might have access to knowledge, for example relating to plants and healing, that was part of a vibrant, popular oral non-academic tradition.

> But yet, Madam, your Grace may please to consider, That there are things done by mean and despicable persons, transcending all the Arts of the most knowing and improv'd Virtuosi, and above all the Essays of known and ordinary Nature. So that we either must suppose that a sottish silly old Woman hath more knowledge of the intrigues of Art, and Nature, than the most exercised Artists, and Philosophers, or confess that those strange things they performe, are done by confederacy with evil Spirits.[3]

To Glanvill, those accused of witchcraft came from a social group that was 'mean and despicable'. The suspects had the further disadvantage of being women and, therefore, likely to be particularly foolish or 'silly'. Given the innate dullness of common people, compounded by a female tendency to folly, any unusual skills or insights possessed by these women were most obviously explained in terms of external help that they had obtained from demons.

Francis Grant, the learned prosecutor of the witches at Paisley in 1697, applied the same logic when confronted in court by Margaret Lang, a local midwife accused of witchcraft. Lang was, he explained, surprisingly articulate and impressive when she spoke in her own defence. She spoke as well as a lawyer or a clergyman, and with knowledge and acuteness 'beyond her station'. He therefore concluded that she was manifestly being prompted by the Devil, who was in the

courtroom invisibly helping her. How else could the eloquence of a woman from such a background be explained?

This book has described the activities of a group of well-educated men who believed in witchcraft. It has also told the story of a group of people, mostly women, who were accused as witches. The persecution of women as witches after 1660 was endorsed, and given a veneer of intellectual respectability, because of the social standing and reputation of the learned advocates of the supernatural. Why should others reject the reality of witchcraft when a man such as Robert Boyle, the most distinguished scientist of his generation, believed in the authenticity of demon magic?

Henry More was convinced of the guilt of Anne Bodenham. Joseph Glanvill believed that Margaret Agar deserved to die because she was a 'rampant hag'. James Long lobbied the trial judge in Salisbury to ensure that Elizabeth Peacock was hanged. Cotton Mather had no doubts that Bridget Bishop was rightly hanged at Salem. Each man became a Fellow of the Royal Society. Viewing events and people through the lens of the false science of witchcraft, they had no doubt about the need for these women to be put to death.

The learned advocates for the authenticity of witchcraft were intelligent and well-educated men. However, their judgement was catastrophically distorted by a combination of their inability to empathise with women accused of witchcraft and their certainty in the truth of witchcraft. They were blinded by their science.

NOTES

Introduction

1. Bodleian Library, MS Aubrey 21.
2. John Aubrey, *Brief Lives*, ed. by Kate Bennett (2018) vol. 1 p. 432.
3. John Webster, *The displaying of supposed witchcraft* (1677), p. 293.
4. Richard Baxter, *The certainty of the worlds of spirits* (1691), p. 18.
5. Increase Mather, *An essay for the recording of illustrious providences* (1684), p. 186.
6. Cotton Mather, *Memorable providences relating to witchcrafts and possessions* (1689), p. 6.
7. Robert Calef, *More wonders of the invisible world* (1700), p. 152.
8. Henry More, *An explanation of the grand mystery of godliness* (1660), p. 339.
9. Henry More, *Philosophical poems* (1647), p. 275.

1 *John Aubrey's education in the supernatural*

1. John Aubrey, *Miscellanies* (1696), p. 105.
2. Ibid., p. 109.
3. John Aubrey, *Remains of Gentilism*, in *Three Prose Works*, ed. by John Buchanan-Brown (1972) p. 212.
4. Ibid., p. 213.
5. John Aubrey, *Natural History of Wiltshire*, Royal Society MS 92.
6. *Three Prose Works*, p. 143.
7. Ibid., p. 203.
8. Ibid., p. 204.
9. *Miscellanies*, p. 37–38.
10. *Brief Lives*, vol. 1 p. 175.
11. *Miscellanies*, p. 89.

12. Ibid., p. 90.
13. Ibid., p. 91.
14. *Brief Lives*, vol. 1, p. 432.
15. Thomas Browne, *Religio Medici* (1642), p. 89.
16. Ibid., p. 55.
17. Ibid., p. 56.
18. Ibid., p. 57.
19. Ibid., p. 56.
20. Ibid., p. 56.
21. Ibid., p. 57.
22. Ibid., p. 58.
23. Ibid., p. 58.
24. *Miscellanies*, Dedication.
25. Thomas Browne, *Pseudodoxia epidemica* (1646), p. 20.
26. Ibid., p. 37.
27. Ibid., p. 271.
28. *The Gentleman's Magazine* (May 1832), p. 408.
29. Ibid., p. 41.
30. John Aubrey, *The Topographical Collections* (1862), p. 257.
31. Kelsey Williams, 'Training the virtuoso: John Aubrey's education and early life', *The Seventeenth Century*, 27 (2012), pp. 157–182.
32. Samuel Hartlib quoted by Kate Bennett in her introduction to John Aubrey, *Brief Lives*, ed. by K. Bennett (2018), vol. 1, p. xxxv.
33. Francis Bacon, *The advancement of learning* (1605), p. 27.
34. *Religio Medici*, p. 130.
35. John Aubrey, *Brief Lives*, ed. by K. Bennett (2018), vol. 1, p. 200.
36. *Brief Lives*, vol.1 p. 199.
37. William Harvey, *On animal generation* (1653), p. 193.
38. Kate Bennett 'John Aubrey and the rhapsodic book', *Renaissance Studies* (2014), vol. 28, pp. 317–32.
39. *Brief Lives*, vol. 1, p. 570.
40. Ibid., p. 440.
41. Ibid., p. 440.
42. Ibid., p. 434.
43. Ibid., p. 440.
44. Bodleian Library, MS Aubrey 12.
45. *Brief Lives*, vol. 1, p. 251.
46. *Brief Lives*, vol. 2, p. 1358.
47. Bodleian Library, MS Aubrey 12.
48. *Brief Lives*, vol. 1, p. 3.
49. *The witch of Wapping, or An exact and perfect relation, of the life and devilish practises of Joan Peterson* (1652); *The tryall and examination of Mrs. Joan Peterson* (1652).
50. *The witch of Wapping*, p. 6.

51. *A declaration in answer to several lying pamphlets concerning the witch of Wapping* (1652).
52. Ibid., p. 6.
53. Ibid., pp. 8–9.
54. Blair Worden, *The Rump Parliament* (1977), p. 100.

2 Belief in witchcraft as the antidote to atheism

1. Thomas Hobbes, *Elements of the Law*. Written in 1640, published online at: https://www.constitution.org/th/elements.htm
2. Thomas Hobbes, *Leviathan* (1651), pp. 386–87.
3. Ibid., p. 7.
4. Margaret Cavendish, *The life of William Cavendish* (1667), pp. 144–45.
5. Ibid., p. 144.
6. Henry More, *An antidote against atheism* (1653), p. 126.
7. *Leviathan*, p. 7.
8. Henry More, *Observations upon Anthroposophia theomagica* (1650), p. 2.
9. Ibid., p. 37.
10. *Antidote*, p. 108.
11. Ibid., p. 16.
12. Ibid., pp. 124–25.
13. Ibid., p. 128.
14. William Drage, *Daimonomageia* (1665), p. 120.
15. Francois Perreaud, *The devil of Mascon* (1658). Boyle's statement is in the form of an introductory letter to the translator.
16. Ibid.
17. Ibid., Du Moulin's comments come in the form of a letter to Boyle.
18. Ibid.
19. Beale to Hartlib, 22 June, 1658. The letter has been digitised and is available at: https://www.dhi.ac.uk/hartlib/view?docset=additional&docname=YALE_12&termo=transtextmascon#highlight
20. John Gauden, *A sermon preached in the Temple-chappel* (1660), p. 58.
21. William Freke, *A full enquiry into the power of faith* (1693), p. 41.
22. Beale to Hartlib, 22 June 1658. The letter has been digitised and is available at: https://www.dhi.ac.uk/hartlib/view?docset=additional&docname=YALE_12&termo=transtext_mascon#highlight
23. Henry More, *A Collection of Several Philosophical Writings* (1662), p. 91.

3 The Royal Society and the supernatural

1. The most authoritative analysis of the official attitude of the Royal Society towards the supernatural is found in Michael Hunter, *The Decline of Magic* (2020), pp. 67–85.

2. Nathaniel Fairfax, *A treatise of the bulk and selvedge of the world* (1674), p. 141.
3. Robert Boyle, *Of the high veneration man's intellect owes to God* (1685), p. 75.
4. Robert Boyle, *The excellency of theology compared with natural philosophy* (1674), p. 53.
5. Ibid., p. 53.
6. *Of the high veneration*, p. 50.
7. *The excellency of theology*, p. 18.
8. *Miscellanies*, pp. 111–12.
9. Robert Plot, *The natural history of Oxfordshire* (1677), p. 143.
10. Ibid., p. 210.
11. Robert Plot, *The natural history of Staffordshire* (1686), p. 291.
12. Ibid., p. 304.
13. Robert Plot, *Quaer's to be propounded to the most ingenious of each county* (1674).
14. *Illustrious Providences*, The Preface.
15. Joseph Glanvill, *Plus Ultra* (1668), p. 91.
16. Ibid. p. 52.
17. Margaret Cavendish, *Letters and poems* (1676), p. 138.
18. Joseph Glanvill, *A blow at modern Sadducism* (1668), pp. 80–81.
19. Ibid., p. 93.
20. Ibid., p. 94.
21. *Supposed Witchcraft*, title page.
22. Ibid., p. 292.
23. Ibid., p. 278.
24. Ibid. p. 336.
25. Ibid., p. 80.
26. Ibid., p. 8.
27. Michael Hunter, 'John Webster, the Royal Society and The Displaying of Supposed Witchcraft (1677)', *Notes and Records of the Royal Society of London* (2016), volume 71, pp. 7–19.
28. Quoted in Michael Hunter, *The decline of magic* (2020), p. 109.
29. Quoted in Michael Hunter, *Robert Boyle 1627-1691: Scrupulosity and Science* (2000), p. 102.
30. Robert Boyle, *Works* (1778), vol. 6, p. 58.
31. Horace Welby, *Signs before death* (1825), p. 82.
32. Alex Craik, 'The hydrostatical works of George Sinclair', *Notes and Records of the Royal Society* (2018).
33. George Sinclair, *The hydrostaticks* (1672), p. 238.
34. Ibid., p. 245.
35. George Sinclair, *Satan's invisible world discovered* (1685), Preface.
36. Quoted in Hunter, *Scrupulosity and Science*, p. 102.
37. Joseph Glanvill, *A blow at modern Sadducism* (1668), pp. 39–40.

38. *The Gentleman's Magazine* (May 1832), p. 407.
39. Ibid., p. 408.
40. Ibid., p. 407.
41. Ibid.
42. Ibid., pp. 407-408.
43. Quoted in Michael Hunter, *Boyle Studies* (2015) p. 163.
44. *Boyle on Atheism*, ed. by J. MacIntosh (2006) pp. 257–58.
45. Robert Boyle, *Experimenta & observationes physicae* (1691), Advertisement.
46. Ibid.
47. Quoted and translated in Hunter, *Scrupulosity and Science*, p. 230.
48. *The Correspondence of Isaac Newton*, ed. by H. W. Turnbull (1961), vol. 3, p. 214.

4 *The science of sorcery*

1. Meric Casaubon, *A treatise proving spirits, witches, and supernatural operations* (1672), p. 143.
2. *A tryal of witches at the assizes held at Bury St. Edmonds* (1682), p. 41.
3. *A blow at modern Sadducism*, p. 14.
4. Increase Mather, *Angelographia* (1696), To The Reader.
5. *Miscellanies*, p. 147.
6. *A blow at modern Sadducism*, p. 28.
7. Walter Charleton, *Physiologia* (1654), p. 198.
8. *A blow at modern Sadducism*, p. 21.
9. Ibid., p. 28.
10. Henry More, *Philosophical poems* (1647), p. 27.
11. *Antidote*, p. 135.
12. Ibid., p. 135.
13. Ibid., p. 135.
14. *Three Prose Works*, pp. 226–27.
15. *Antidote*, p. 134.
16. Ibid., pp. 134–35.
17. *Strange and terrible news from Cambridge* (1659).
18. *Antidote*, p. 138.
19. Matthew Hopkins, *The discovery of witches* (1647), p. 4.
20. *Antidote*, p. 138.
21. Ibid., p. 138.
22. *The grand mystery of godliness*, p. 96.
23. Ibid.
24. *A blow at modern Sadducism*, p. 47.
25. Joseph Glanvill, *Essays on several important subjects in philosophy and religion* (1676), p. 24.
26. Ibid., p. 8.

27. *A blow at modern Sadducism*, p. 21.
28. Ibid., p. 50.
29. Ibid., p. 43.
30. Ibid.
31. Ibid., p. 44.
32. Ibid., p. 43.
33. Henry Hallywell, *Melampronoea* (1681), p. 17.
34. Ibid., p. 61.
35. Ibid., p. 62.
36. Ibid., p. 18.
37. Ibid., p. 75.
38. Ibid., p. 68.
39. Ibid., p. 100.
40. Ibid., p. 103.
41. *Sadducismus Debellatus* (1698), Preface.
42. Ibid.
43. *A tryal of witches at the assizes held at Bury St. Edmonds* (1682), p. 43.
44. *A blow at modern Sadducism*, p. 130.
45. *Sadducismus Debellatus*, p. 40.
46. *A natural history of Staffordshire*, p. 282.
47. *Melampronoea*, p. 62.
48. Cotton Mather, *The wonders of the invisible world* (1693), p. 8. Electronic Texts in American Studies, 19. Available at: https:// digitalcommons.unl.edu/cgi/viewcontent.cgi?article=1019 &context=etas
49. *Memorable Providences*, p. 34.
50. Ibid., p. 38.
51. Ibid., p. 39.
52. Ibid., pp. 7–8.
53. *Wonders of the invisible world*, p. 13.
54. Nathaniel Hodges, *Loimologia* (1672).
55. Thomas Brattle, Letter to unnamed clergyman, 8 October 1692, in *Narratives of the witchcraft cases*, ed. by George Burr (1914), pp. 169–90.

5 Henry More, John Aubrey and the witch of Salisbury

1. *Doctor Lambs darling* (1653), Title Page.
2. *The Salisbury Assizes, a ballad* (1653).
3. Edmund Bower, *Doctor Lamb revived* (1653).
4. Henry More, *Antidote* (second edition 1655), p. 190.
5. *Doctor Lamb revived*, p. 15.
6. Ibid., p. 36.
7. Richard Goddard's career is described in the History of Parliament Online available as: https://www.historyofparliamentonline.org/volume/1660-1690/

member/goddard-richard-1590-1666. His financial circumstances are described in James Waylen, 'The Wiltshire Compounders: Continued', *Wiltshire Archaeological and Natural History Magazine* (1888), p. 78.

8. *Doctor Lamb revived*, p. 9.
9. *Antidote* (second edition), p. 207.
10. Ibid., pp. 197–98.
11. Ibid., p. 198.
12. Ibid., p. 199.
13. Ibid., p. 203.
14. Ibid., p. 206.
15. Ibid., p. 207.
16. Joseph Glanvill and Henry More, *Saducismus Triumphatus* (1681), p. 43.
17. *Antidote* (second edition), p. 190.
18. *Doctor Lamb revived*, p. 21.
19. Ibid., p. 8.
20. *Saducismus Triumphatus*, p. 43.
21. Royal Society MS 92.
22. Ibid.

6 Joseph Glanvill and the witches of Somerset

1. Joseph Glanvill, *A philosophical endeavour towards the defence of the being of witches and apparitions* (1666), p. 61.
2. *A blow at modern Sadducism*, p. 125.
3. Ibid.
4. Ibid., p. 134.
5. Ibid. p. 135.
6. *Supposed Witchcraft*, p. 69.
7. *Saducismus Triumphatus*, pp. 126–27.
8. Ibid., p. 134.
9. James Sharpe, 'In search of the English Sabbat', *Journal of Early Modern Studies* (2013).
10. *Saducismus Triumphatus*, p. 157.
11. Ibid., p. 159.
12. Ibid., p. 32.
13. Ibid., pp. 136, 147, 156.
14. *Antidote*, p. 126.
15. *Saducismus Triumphatus*, pp. 138–39.
16. Ibid. p. 140.
17. George Kittredge, *Witchcraft in Old and New England* (1929), p. 274.
18. *Saducismus Triumphatus*, p. 141.
19. *Antidote*, p. 127.
20. *Saducismus Triumphatus*, pp. 137–64.
21. *Antidote*, p. 128.
22. Ibid., p. 124.

7 *James Long, John Aubrey and the witches of Malmesbury*

1. Royal Society MS 92.
2. Bodleian Library, MS Aubrey 12.
3. Ibid.
4. Ibid.
5. Ibid.
6. Ibid.
7. Ibid.
8. Ibid.
9. *The Gentleman's Magazine* (May 1832), p. 405.
10. The fragment of the 'book' was published in two parts.
11. The likely identity of More as the recipient of the letter was pointed out in Cathy Gere, 'William Harvey's Weak Experiment', *History Workshop Journal* (2001).
12. *The Gentleman's Magazine* (May 1832), p. 406.
13. Ibid.
14. Western Circuit Gaol Delivery Book, The National Archive ASSI 23. A transcription was published in Frederick Inderwick, *Side-lights on the Stuarts* (1891), pp 190–91.
15. *The Gentleman's Magazine* (June 1832), p. 490.
16. Ibid.
17. Ibid., pp. 490–92.
18. Ibid.
19. Ibid.
20. The will of Elizabeth Peacock, Wiltshire and Swindon History Centre, P3/P/358.
21. Roger North, *Notes of me* (2000), p. 190.
22. Ibid.
23. Long's parliamentary career is described in *The History of Parliament Online*: http://www.histparl.ac.uk/volume/1660-1690/member/long-sir-james-1616-92.

8 *Salem and science*

1. *Illustrious Providences*, p. 188.
2. Ibid., p. 202.
3. Ibid., p, 203.
4. Ibid., p. 124.
5. Ibid., p. 186.
6. Ibid., p. 138.
7. Ibid., p. 138.
8. Ibid., p. 199.
9. Increase Mather, *An arrow against profane and promiscuous dancing* (1684), p. 23.

10. *Memorable Providences*, p. 6.
11. Ibid., To The Reader.
12. Ibid., pp. 6–7.
13. Ibid., p. 18.
14. Robert Calef, *More wonders of the invisible world* (1700), p. 152.
15. Hutchinson's account, written in about 1750, was not printed at the time but was published in the nineteenth century as *The witchcraft delusion of 1692*, ed. W. F. Poole (1870). It available online at: http://salem.lib.virginia.edu/texts/tei/HutPool/.
16. The text of the interrogation of Bishop is available online at: http://salem.lib.virginia.edu/n13.html.
17. The text of the interrogation of Mary Lacey is available online at: http://salem.lib.virginia.edu/n87.html.
18. Thomas Brattle letter to unnamed clergyman, 8 October 1692, in George Lincoln Burr, ed., *Narratives of the witchcraft cases* (1914), p. 169–90.
19. Ibid.
20. Increase Mather, *Cases of conscience* (1693), p. 67.
21. *Letters of Cotton Mather, Samuel Sewall, John Callender, Adam Winthrop, and others*, New England Historic Genealogical Society Register (1870), pp. 107–08.
22. *Wonders of the Invisible World*, p. 103.
23. Ibid., p. 62.
24. Ibid., p. 110.
25. Ibid., pp. 105–06.
26. *Proceedings of the Massachusetts Historical Society*, vol. 47 (1914), pp. 221–74.
27. *Proceedings of the American Antiquarian Society* (1953), vol. 63, p. 184.

9 Francis Grant and the witches of Renfrewshire

1. The text of the letter is printed in K. J. Williams, 'The Network of James Garden of Aberdeen and North-Eastern Scottish Culture in the Seventeenth Century', *Northern Studies*, 47 (2015), pp. 102–30.
2. *Sadducismus Debellatus*, Preface.
3. Ibid.
4. Clare Jackson, 'Revolution principles, *ius naturae* and *ius gentium* in early Enlightenment Scotland: the contribution of Sir Francis Grant, Lord Cullen (c.1660-1726)', in Tim Hochstrasser & Peter Schröder, eds, *Early modern natural law theories: contexts and strategies in the early Enlightenment* (Kluwer: Dordrecht, 2003), pp. 107–40.
5. Francis Grant, *The loyalists' reasons for his giving obedience* (1689), Title page.

6. Francis Grant, *A discourse, concerning the execution of the laws, made against prophaneness* (1700), p. 16.
7. *Sadducismus Debellatus* (the pagination is defective in this pamphlet).
8. Ibid.
9. Ibid.
10. Ibid.
11. Ibid.
12. Joseph Glanvill, *A philosophical endeavour towards the defence of the being of witches and apparitions* (1666), p. 29.
13. *Sadducismus Debellatus.*
14. Ibid.
15. Ibid.
16. Ibid.
17. Ibid.
18. James VI, King of Scotland, *Daemonologie in forme of a dialogue, divided into three books* (1597), p. 39.
19. *Sadducismus Debellatus.*
20. Ibid.
21. Ibid.
22. Ibid.
23. T. P., *A relation of the diabolical practices of above twenty wizards and witches* (1697), p. 4.
24. Joyce Miller, 'Men in black', in J. Goodare, L. Martin, J. Miller, *Witchcraft and belief in early modern Scotland* (2008), p. 155. Miller identified twenty-one instances of witnesses naming Antiochia as the gentle wife of the Devil.

10 *Astrology, ritual magic and witchcraft*

1. *Miscellanies*, p. 67.
2. *Three Prose Works*, p. 321–22.
3. *Miscellanies*, p. 111.
4. William Lilly, *Christian astrology* (1647), Epistle Dedicatory.
5. Ibid., p. 465.
6. Ibid. pp. 465–66.
7. H. Johnsen, *Anti-Merlinus: or a confutation of Mr. William Lillies predictions* (1648), To The Reader.
8. John Vicars, *Against William Li-Lie (alias) Lillie* (1652).
9. William Lilly, *History of his life and times* (1822), pp. 167, 253–56.
10. Samuel Butler, *Hudibras* (1684), p. 357.
11. James Yonge, *Sidrophel vapulans* (1699), p. 37.
12. Elias Ashmole, *Theatrum chemicum Britannicum* (1652), p. 480.
13. Hans Sloane, *Memoir of John Beaumont*, ed. and trans. by Michael Hunter (2011), pp. 13–14.

14. Bodleian Library, MS Ashmole 1406, transcribed in K. M. Briggs, *The anatomy of Puck* (1959), pp. 249–50.
15. *Theatrum chemicum Britannicum*, p. 6.
16. Deborah Harkness, *John Dee's Conversations with Angels* (1999), pp. 222–23.
17. Meric Casaubon, *A true & faithful relation* (1659), The Preface.
18. Ibid.
19. The complex motives of Casaubon are explored in Stephen Clucas, 'Enthusiasm and 'damnable curiosity': Meric Casaubon and John Dee' in R. J. W. Evans and Alexander Marr, eds, *Curiosity and wonder from the Renaissance to the Enlightenment* (2006), pp. 131–48.
20. *The grand mystery of godliness*, p. 349.
21. Ibid., p. 359.
22. Ibid., p. 359.
23. Ibid. p. 359.
24. Joseph Glanvill, *Essays on several important subjects* (1676), p. 41.
25. Ibid., p. 42.
26. John Butler, *Hagiastrologia* (1680).
27. Henry More, *Tetractys anti-astrologica* (1681), Preface.

11 Robert Boyle, Christian wizard?

1. Robert Boyle, *A disquisition about the final causes of natural things* (1688), p. 83.
2. Robert Boyle, *Of the high veneration man's intellect owes to God* (1685), p. 50.
3. *The excellency of theology*, p. 16.
4. Ibid., pp. 2–3.
5. Ibid.
6. The 'Burnet Memorandum' is contained within the British Library manuscript, Add. MS 4229. It was edited and published in *Robert Boyle by himself and his friends*, ed. Michael Hunter (1994), pp. 26–34. The quotations in the remainder of this section come from this source.
7. Robert Boyle, *Dialogue on the Converse with Angels*, is printed as an appendix in Lawrence Principe, *The Aspiring Adept* (1998), pp. 310–17. The quotations in the remainder of this section come from this source.

12 Aubrey's mid-life crisis

1. *Brief Lives*, vol. 1, p. 441.
2. Ibid., p. 432.
3. Ibid., p. 434.
4. Anthony Powell, *John Aubrey and his friends* (1988), p. 116.

5. Ruth Scurr, *John Aubrey: My own life* (2016), p. 169.
6. *John Aubrey and his friends*, p. 126.
7. The National Archive (TNA), Chancery court papers, C 7/477/1.
8. TNA, Chancery court papers, C 8/268/24.
9. TNA, Chancery court papers, C 7/326/82.
10. Bodleian Library, MS Aubrey 12.
11. *Brief Lives*, vol. 1 p. 442.
12. *Brief Lives*, vol. 2, p. 1717.
13. Bodleian Library, MS Wood F 39.
14. Ibid.
15. J. S., *The Character of a quack-astrologer* (1673).
16. John Partridge, *Merlinus liberatus* (1698), no pagination.
17. Ibid.
18. Bodleian Library, MS Aubrey 24.

13 The witchcraft of John Aubrey

1. *Miscellanies*, pp. 128–38.
2. Bodleian Library, MS Wood F 39.
3. *Miscellanies*, p. 135.
4. Richard Baxter, *Reliquiae Baxterianae* (1696), pp. 59–60.
5. *Miscellanies*, p. 136.
6. Bodleian Library, MS Aubrey 24. The rest of this chapter is based on this source.
7. *An Act against Conjuration, Witchcraft and dealing with evil and wicked spirits* (1604).
8. Bodleian Library, MS Aubrey 13.
9. Bodleian Library, MS Aubrey 11.

Conclusion: Blinded by science

1. Ashmole, *Theatrum chemicum Britannicum*, p. 453.
2. Elias Ashmole, 'Diary', in *The lives of those eminent antiquaries Elias Ashmole, esquire, and Mr William Lilly* (1774), p. 316. The date of the trial is confirmed by the pamphlet *A prodigious and tragicall history of the arraignment, tryall, confession, and condemnation of six witches at Maidstone, in Kent* (1652).
3. Letter from Joseph Glanvill in Margaret Cavendish, *A collection of letters* (1678), p. 139.

BIBLIOGRAPHY

Anonymous, *A declaration in answer to several lying pamphlets concerning the witch of Wapping* (1652)

Anonymous, *The tryall and examination of Mrs. Joan Peterson* (1652)

Anonymous, *The witch of Wapping, or An exact and perfect relation, of the life and devilish practises of Joan Peterson* (1652)

Anonymous, *Doctor Lambs darling* (1653)

Anonymous, *The Salisbury Assizes, a ballad* (1653)

Anonymous, *Strange and terrible news from Cambridge* (1659)

Anonymous, *A tryal of witches at the assizes held at Bury St. Edmonds* (1682)

Ashmole, Elias, *Theatrum chemicum Britannicum* (1652)

Ashmole, Elias, 'Diary', in *The lives of those eminent antiquaries Elias Ashmole, esquire, and Mr William Lilly* (1774)

Aubrey, John, *Miscellanies* (1696)

Aubrey, John, *The Topographical Collections* (1862),

Aubrey, John, *Remains of Gentilism*, in *Three Prose Works*, ed. John Buchanan-Brown (1972)

Aubrey, John, *Brief Lives*, ed. by Kate Bennett (2018)

Bacon, Francis, *The advancement of learning* (1605)

Baxter, Richard, *The certainty of the worlds of spirits* (1691)

Baxter, Richard, *Reliquiae Baxterianae* (1696)

Bennett, Kate, 'John Aubrey and the rhapsodic book', *Renaissance Studies* (2014)

Bower, Edmund, *Doctor Lamb revived* (1653)

Boyle, Robert, *The excellency of theology compared with natural philosophy* (1674)

Boyle, Robert, *Of the high veneration man's intellect owes to God* (1685)

Boyle, Robert, *A disquisition about the final causes of natural things* (1688)

Boyle, Robert, *Experimenta & observationes physicae* (1691)

Boyle, Robert, *Works* (1778)

Boyle, Robert, *Robert Boyle by himself and his friends*, ed. Michael Hunter (1994)

Boyle, Robert 'Dialogue on the Converse with Angels', in Lawrence Principe, *The Aspiring Adept* (1998)

Boyle, Robert, *Boyle on Atheism*, ed. J. MacIntosh (2006)

Briggs, K.M., *The anatomy of Puck* (1959)

Browne, Thomas, *Religio Medici* (1642)

Browne, Thomas, *Pseudodoxia epidemica* (1646)

Burr, George, *Narratives of the witchcraft cases* (1914)

Butler, John, *Hagiastrologia* (1680)

Butler, Samuel, *Hudibras* (1684)

Calef, Robert, *More wonders of the invisible world* (1700)

Casaubon, Meric, *A true & faithful relation* (1659)

Casaubon, Meric, *A treatise proving spirits, witches, and supernatural operations* (1672)

Cavendish, Margaret, *The life of William Cavendish* (1667)

Cavendish, Margaret, *Letters and poems* (1676)

Charleton, Walter, *Physiologia* (1654)

Clucas, Stephen, 'Enthusiasm and 'damnable curiosity': Meric Casaubon and John Dee' in R. J. W. Evans and Alexander Marr, eds, *Curiosity and wonder from the Renaissance to the Enlightenment* (2006)

Craik, Alex, 'The hydrostatical works of George Sinclair', Notes and Records of the Royal Society (2018)

Drage, William, *Daimonomageia* (1665)

Fairfax, Nathaniel, *A treatise of the bulk and selvedge of the world* (1674),

Freke, William, *A full enquiry into the power of faith* (1693),

Gauden, John, *A sermon preached in the Temple-chappel* (1660)

Gentleman's Magazine, The (May 1832)

Gere, Cathy, 'William Harvey's Weak Experiment', *History Workshop Journal* (2001)

Glanvill, Joseph, *A philosophical endeavour towards the defence of the being of witches and apparitions* (1666),

Glanvill, Joseph, *A blow at modern Sadducism* (1668)

Glanvill, Joseph, *Plus Ultra* (1668)

Glanvill, Joseph, *Essays on several important subjects in philosophy and religion* (1676)

Glanvill, Joseph and More, Henry, *Saducismus Triumphatus* (1681)

Goodare, J., Martin, L., Miller, J., *Witchcraft and belief in early modern Scotland* (2008)

Grant, Francis, *The loyalists' reasons for his giving obedience* (1689)

Grant, Francis, *Sadducismus Debellatus* (1698)

Grant, Francis, *A discourse, concerning the execution of the laws, made against prophaneness* (1700)

Hallywell, Henry, *Melampronoea* (1681)

Harkness, Deborah, *John Dee's Conversations with Angels* (1999),

Harvey, William, *On animal generation* (1653)

Hobbes, Thomas, *Elements of the Law* (1640)

Hobbes, Thomas, *Leviathan* (1651)

Hodges, Nathaniel, *Loimologia* (1672).

Hopkins, Matthew, *The discovery of witches* (1647)

Hunter, Michael, *Robert Boyle 1627-1691: Scrupulosity and Science* (2000)

Hunter, Michael, *Boyle Studies* (2015)

Hunter, Michael, 'John Webster, the Royal Society and The Displaying of Supposed Witchcraft (1677)', *Notes and Records of the Royal Society of London* (2016)

Hunter, Michael, *The Decline of Magic* (2020)

Hutchinson, Thomas, *The witchcraft delusion of 1692*, ed. W. F. Poole (1870)

Inderwick, Frederick, *Side-lights on the Stuarts* (1891)

J. S., *The Character of a quack-astrologer* (1673)

Jackson, Clare, 'Revolution principles', in Tim Hochstrasser & Peter Schröder, eds., *Early modern natural law theories: contexts and strategies in the early Enlightenment* (2003)

James VI, King of Scotland, *Daemonologie in forme of a dialogue, divided into three books* (1597)

Johnsen, H. *Anti-Merlinus: or a confutation of Mr. William Lillies predictions* (1648)

Kittredge, George, *Witchcraft in Old and New England* (1929)

Lilly, William, *Christian astrology* (1647)

Lilly, William, *History of his life and times* (1822)

Mather, Cotton, *Memorable providences relating to witchcrafts and possessions* (1689)

Mather, Cotton, *The wonders of the invisible world* (1693)

Mather, Cotton et al,, *Letters of Cotton Mather, Samuel Sewall, John Callender, Adam Winthrop, and others,* New England Historic Genealogical Society Register (1870)

Mather, Increase, *An essay for the recording of illustrious providences* (1684)

Mather, Increase, *An arrow against profane and promiscuous dancing* (1684)

Mather, Increase, *Cases of conscience* (1693)

Mather, Increase, *Angelographia* (1696),

More, Henry, *Philosophical poems* (1647)

More, Henry, *Observations upon Anthroposophia theomagica* (1650)

More Henry, *An antidote against atheism* (1653)

More Henry, *An antidote against atheism* (1655)

More, Henry, *An explanation of the grand mystery of godliness* (1660)

More, Henry, *A Collection of Several Philosophical Writings* (1662)

More, Henry, *Tetractys anti-astrologica* (1681),

Newton, Isaac, *The Correspondence of Isaac Newton*, ed. H. W. Turnbull (1961)

North, Roger, *Notes of me* (2000)

Partridge, John, *Merlinus liberatus* (1698)

Perreaud, Francois, *The devil of Mascon* (1658)

Plot, Robert, *Quaer's to be propounded to the most ingenious of each county* (1674)

Plot, Robert, *The natural history of Oxfordshire* (1677)

Plot, Robert, *The natural history of Staffordshire* (1686)

Powell, Anthony, *John Aubrey and his friends* (1988)

Scurr, Ruth, *John Aubrey: My own life* (2016)

Sharpe, James, 'In search of the English Sabbat', *Journal of Early Modern Studies* (2013)

Sinclair, George, *The hydrostaticks* (1672)

Sinclair, George, *Satan's invisible world discovered* (1685)

Sloane, Hans, *Memoir of John Beaumont*, ed. and trans. Michael Hunter (2011)

T. P., *A relation of the diabolical practices of above twenty wizards and witches* (1697)

Vicars, John, *Against William Li-Lie (alias) Lillie* (1652)

Webster, John, *The displaying of supposed witchcraft* (1677)

Williams, Kelsey, 'Training the virtuoso: John Aubrey's education and early life', *The Seventeenth Century*, 27 (2012)

Williams, Kelsey, 'The Network of James Garden of Aberdeen and North-Eastern Scottish Culture in the Seventeenth Century', *Northern Studies* (2015)

Worden, Blair, *The Rump Parliament* (1977)

Yonge, James, *Sidrophel vapulans* (1699)

INDEX